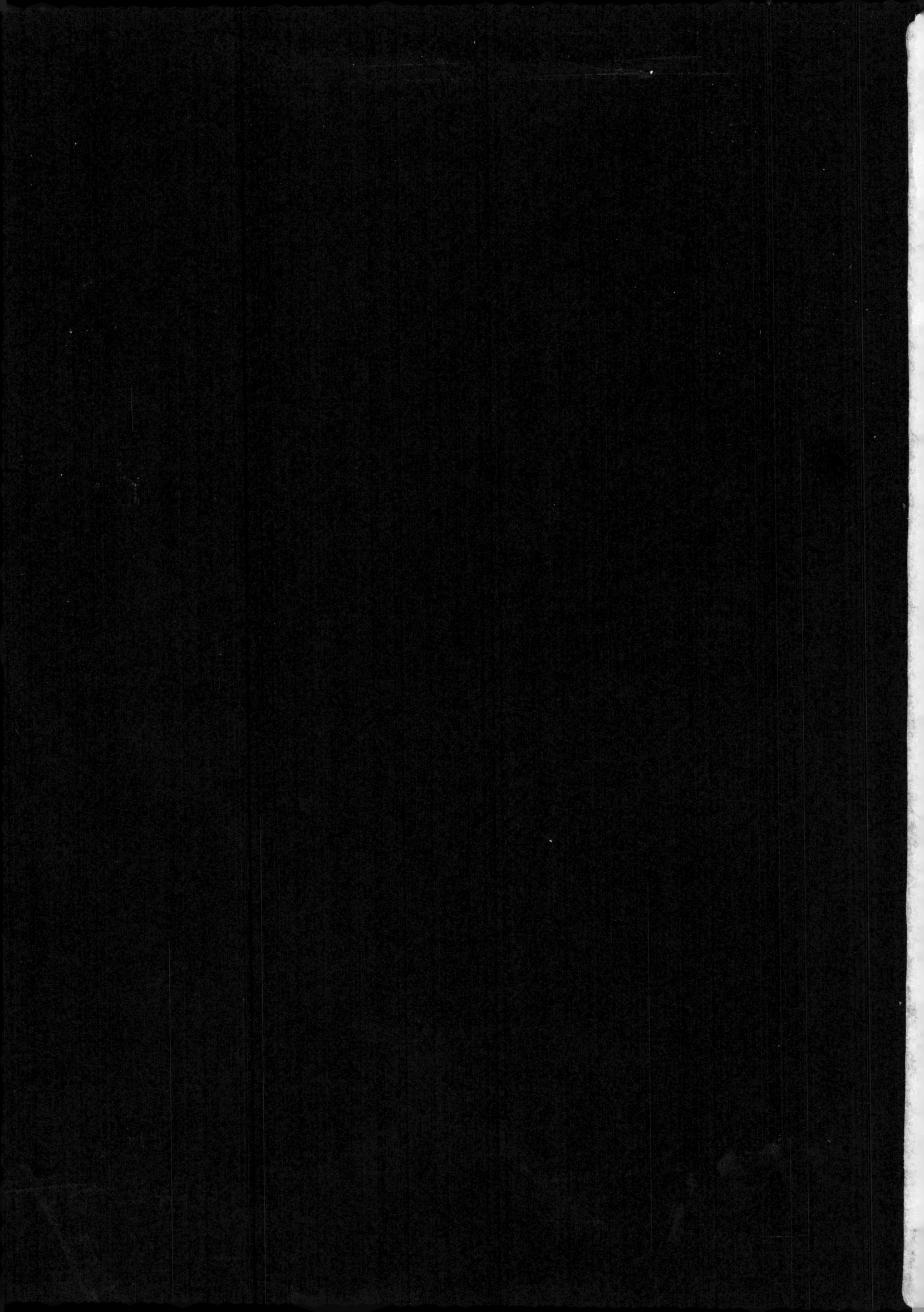

# THE DESIGN HOTELS™ BOOK

ORIGINAL HOTELIERS, INFLUENTIAL
DESIGNERS AND ARCHITECTS, AND A CURATED COLLECTION
OF 289 INDEPENDENT HOTELS WORLDWIDE

# HOTELS

**CASA FAYETTE**
Guadalajara, Mexico
*Page 60*

# ARTISANSHIP IN HOSPITALITY

*A love for craft is what defines great hoteliers—artisans who provide meaningful experiences for their guests.*

For lovers of boutique hotels, this is a golden age. An ever-increasing number of such properties are opening around the world, from Buenos Aires to Los Angeles to Tokyo to London, giving travelers a newfound appreciation for the unique and the exceptional.

The most remarkable of these hotels have passionate owners behind them, people who are driven to create something individual and authentic that guests can truly see and feel. It's difficult to run a good hotel unless you are in the community and understand the expectations of your guests. Hoteliers who craft meaningful experiences that matter are the ones who truly stand out. These are Originals with a passion for genuine hospitality and cultural authenticity, people who, by embracing an artisan's mentality, create something significant through relentless attention to individualism and detail.

To achieve the highest degree of aesthetic integrity, our Originals frequently choose to work with the most creative artists in the design world today. This is why last year, we proudly introduced our Influencers List—honoring 10 architects and designers who are beacons of individuality and expression today. Our premiere Influencers List included such celebrated names as Boon, Dirand, Conran, Urquiola, and Lissoni—creative souls who are inspiring and affecting the work of designers and architects around the world.

This year, the tradition of honoring the "masters of the amazing" continues. Once again, we worked closely with Robert Klanten, co-founder, publisher, and CEO of gestalten—someone who is on the pulse of the architecture and design worlds. Together, we searched for those special people whose creative expression prompts

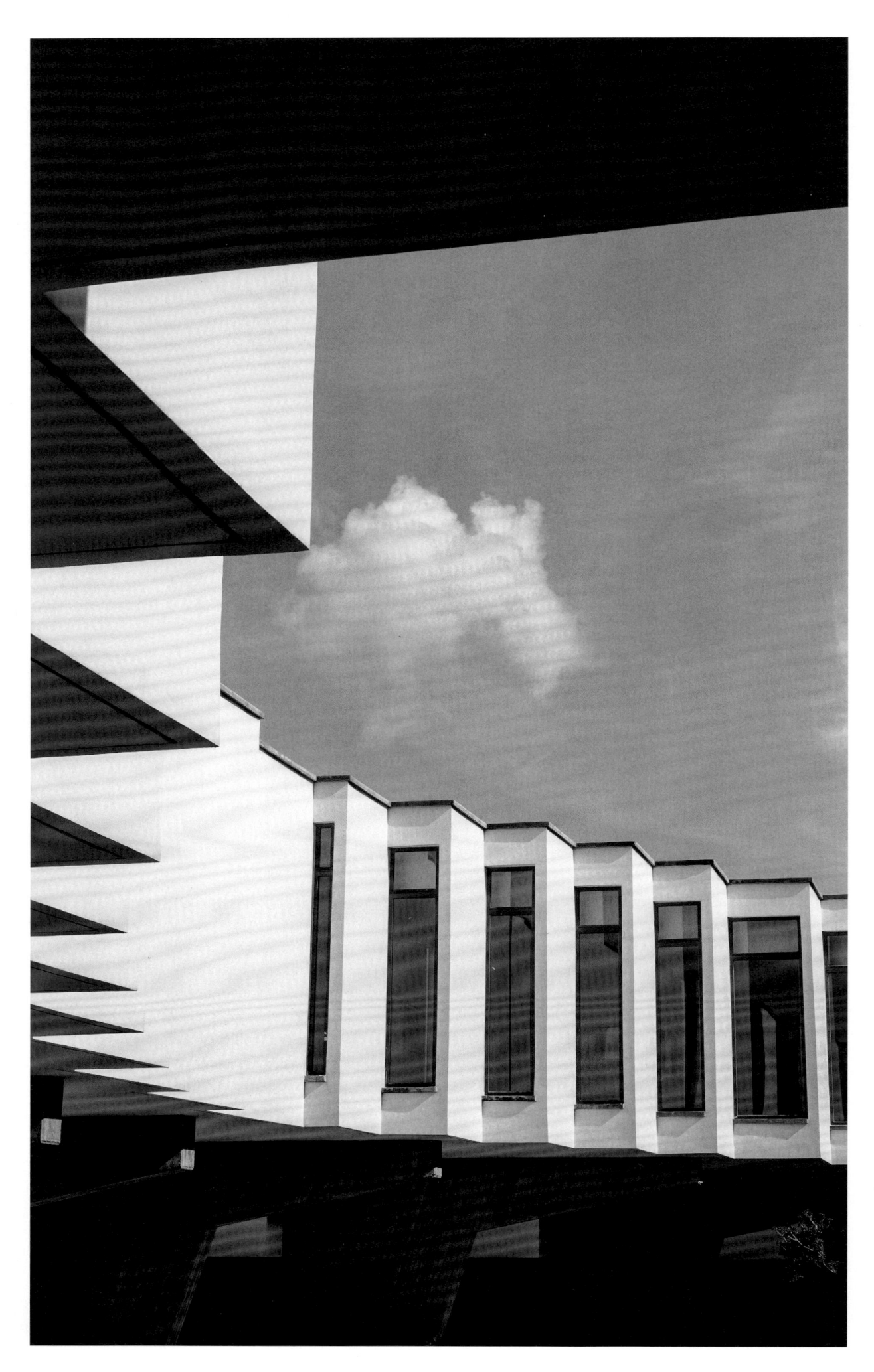

**ELMA ARTS COMPLEX LUXURY HOTEL**
Zichron Ya'akov, Israel
*Page 402*

admiration from consumers and emulation from colleagues. In creating our Influencers List 2016 we wanted to recognize those whose dynamic way of thinking captures the feel of the land and the emotionality of a destination.

Take, for example, Monika Gogl. This renegade Austrian architect utilizes local materials and striking minimalism to alter the very meaning of Alpine architecture, as she does at Wiesergut—a stunning hotel hideaway masterfully retro-fitted into a 14th-century estate in Saalbach-Hinterglemm, Austria. Or consider Space Copenhagen. This Scandinavian duo seemingly exploded on the scene with their design for Noma, which has won best-restaurant-of-the-year honors four of the last six years. Its effort to create an atmosphere in sync with a restaurant's cuisine philosophy has hugely influenced restaurant design. And now with Manhattan's

11 Howard, in SoHo, the duo once again adheres to an aesthetic mission to go far beyond the expected. And then there's Matteo Thun, whose bold vision is reflected in a wide array of mediums, from hotels and restaurants to bathrooms, kitchens, furniture, ceramics, watches, and beyond. Perhaps most notable is his dedication to sustainability, a personal and professional passion that has lead to the eco-friendly, provocatively designed Vigilius Mountain Resort in South Tyrol. Along with Gogl, Space Copenhagen, and Thun, our Influencers List 2016 features 10 creative minds who are shaping design today.

In addition, this year we are introducing 22 hotels to a portfolio that now includes 289 member properties in 55 countries and 181 destinations. Indeed, our ever-expanding portfolio now reaches into new corners of the world with

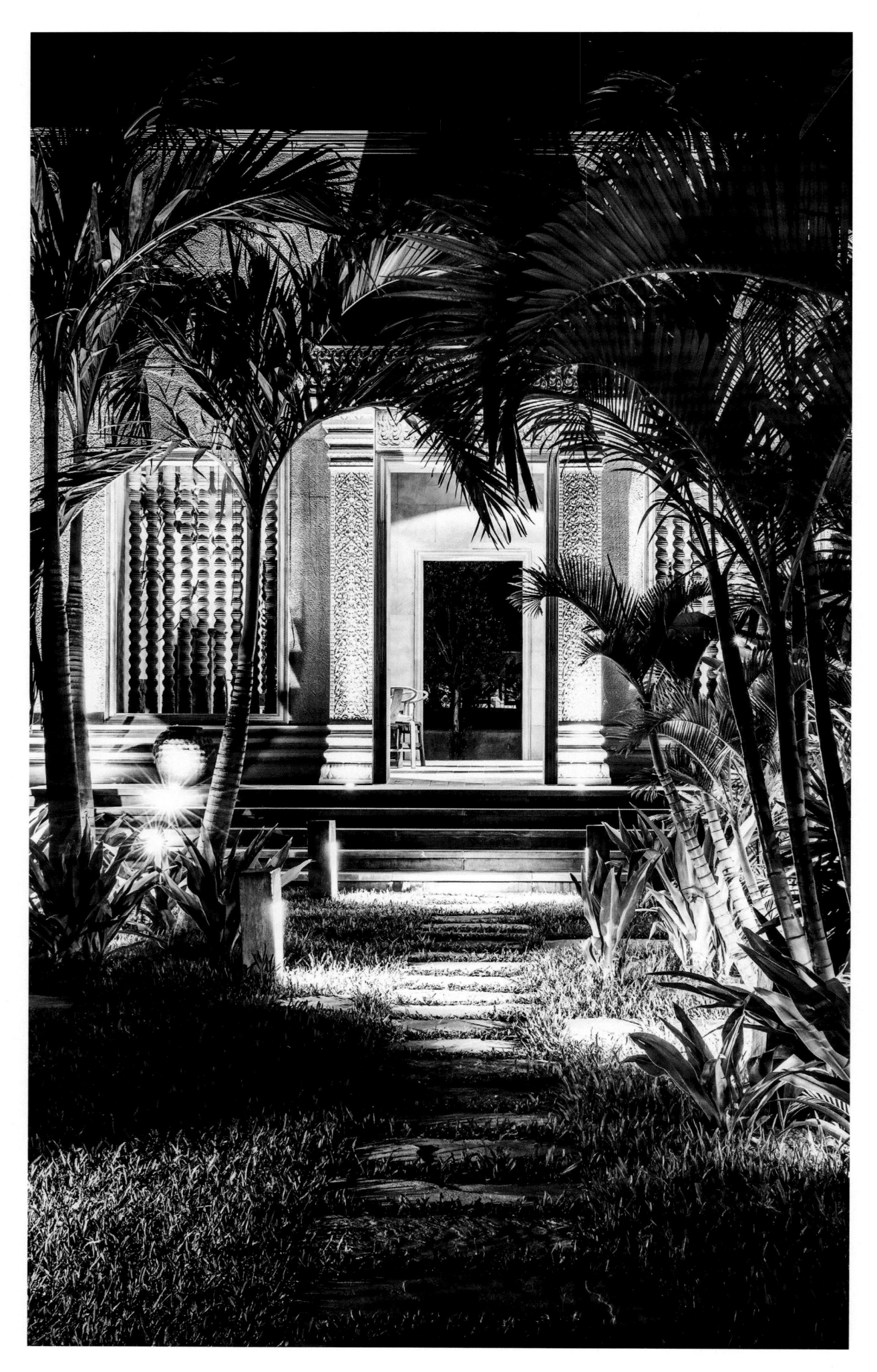

**PHUM BAITANG**
Siem Reap, Cambodia
*Page 430*

singular expressions of contemporary design in places like Zanzibar, where internationally renowned, Prague-based studio Jestico + Whiles has crafted the garden-like paradise of Zuri Zanzibar along a 300-meter stretch of private and pristine beach on the Indian Ocean. Equally exotic is Phum Baitang, in Cambodia's Siem Reap, with its wooden villas that serve as a luxury gateway to Angkor's World Heritage Sites. This year also welcomed the addition of an exquisite new property from Grupo Habita, who worked closely with Milanese interior design team Dimorestudio to create Casa Fayette, a stunning reinterpretation of Art Deco and Guadalajara's first design-led hotel. And we saw *Qvest* magazine founder and Editor-in-Chief Michael Kaune unveil his first hotel, a neo-Gothic architectural wonder filled with Kaune's personally curated collection of furniture, contemporary art, and photography.

It is indeed a golden age for design-driven hotels. And each is the product of brave and creative souls who are driven, above all, to create original experiences for their guests—moments that matter, as they happen, and which linger long after.

**CLAUS SENDLINGER**
*Founder & CEO Design Hotels™*

INDIA MAHDAVI

SPACE COPENHAGEN

KIT KEMP       MONIKA

GOGL  GERT WINGÅRDH

JEAN-MICHEL

WILMOTTE  TARRUELLA

TRENCHS STUDIO

DUANGRIT BUNNAG

MATTEO THUN

COLIN SEAH

# The Influencers 2016

Design Hotels™ celebrates some of the most influential designers and architects curating spaces around the world today. Meet this year's selected ten.

*India Mahdavi, France*

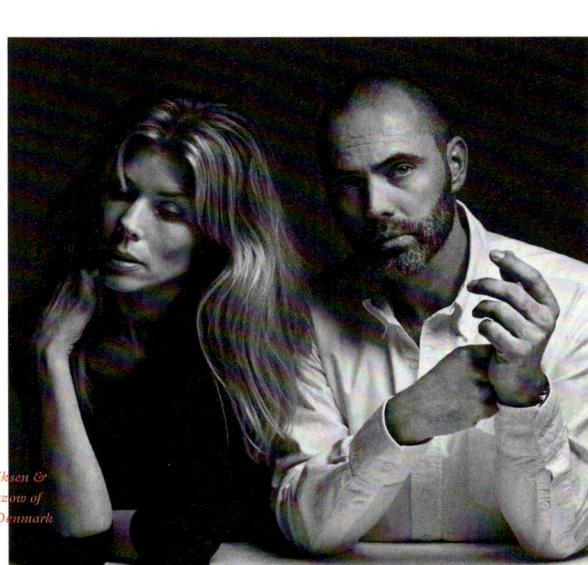

*Signe Bindslev Henriksen & Peter Bundgaard Rützow of Space Copenhagen, Denmark*

## INDIA MAHDAVI

Influenced by her early years living in many countries, Mahdavi has become a beacon of influence herself. She imbues each project—whether it's architecture, scenography, furniture, objects, or interiors—with bold doses of color. Yet her virtuosic use of color and form displays a reverence for history and cultural pedigree, as well as a fearless sense of wonder. As a result, her interiors create a single cohesive vision that resonates with each location. It's little surprise then that Mahdavi's sophisticated look is incomparable in the design world today.

Page 36

## SPACE COPENHAGEN

This hugely influential duo from Scandinavia creates unexpected designs that are born from its Nordic heritage but achieve a relevancy and influence that knows no borders. Space Copenhagen's portfolio of interiors spans numerous national landmarks and demonstrates the pair's preference for "composing" space and organic materials, for creating atmospheres tied to nature, and for celebrating a need for the tactile. Little wonder then that Space Copenhagen's design work spans lighting, furniture, hotels, and private residences—not to mention the interior of one of the world's best restaurants.

Page 78

*Kit Kemp,*
*United Kingdom*

*Monika Gogl,*
*Austria*

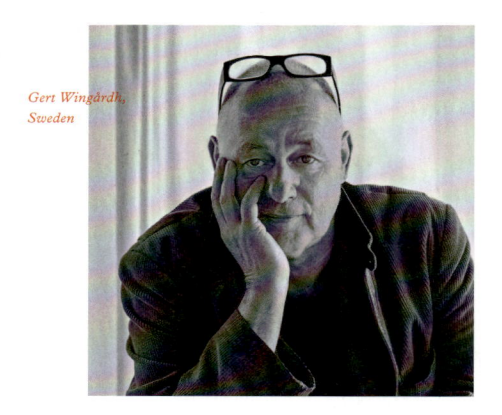

*Gert Wingårdh,*
*Sweden*

*Jean-Michel Wilmotte,*
*France*

## KIT KEMP

It seems there are simply not enough adjectives in the hospitality world to describe this dynamic, colorful, inimitable design icon. Kemp's bold, original looks have been transforming London since she founded Firmdale Hotels in 1985 alongside her husband Tim, and now stretch well into Manhattan. Kemp's uplifting and eclectic aesthetic includes a quirky British style, with charming nods to traditionalism, but with plenty of modern craft thrown in for good measure. It is a voice that bravely and ceaselessly reaches for new registers in her undying quest to create the vital, the beautiful, and the extraordinary.

Page 90

## GERT WINGÅRDH

The most influential Swedish architect working today, Wingårdh is a titan in the field, having won Sweden's most presti-gious architecture award, the Kasper Salin Prize, five times. Though he's a legend at home, the prolific Swede is in equally great demand throughout the world, with his work on display seemingly everywhere, from the American capital to Berlin. His style is limited only by his limitless imagination and includes private villas that seem to grow organically from the granite rocks around them. More than an architect, Gert Wingårdh is a national —and international—treasure.

Page 116

## MONIKA GOGL

Working in a famous mountain region that is overloaded with design clichés, this Austrian architect has transformed the very vernacular of Alpine architecture. Gogl's unmistakable style is wholly her own: a clean minimalism of muted tones and panoramic vistas thanks to a generous use of floor-to-ceiling glass, with acute tailoring to the landscape that maximizes interaction with nature. Her award-winning work, from ski resorts to retail showrooms to nightlife destinations and community centers, is refreshingly modern, and it's influencing mountain architecture the world over.

Page 186

## JEAN-MICHEL WILMOTTE

Whether he's taking on an iconic building or an entire city, Wilmotte has become the supreme master of transformation. He has helped reshape both the Louvre and Moscow itself, bringing his signature elegance to architectural legends as well as to urban masterplanning. Yet his industrial design also demonstrates an equal degree of brilliance and is reflected in everything from architectural lighting fixtures to utilitarian pocketknives. It seems everything Wilmotte sets his sights on becomes an award-winning triumph.

Page 230

*Sandra Tarruella & Ricard Trenchs*
*of Tarruella Trenchs Studio, Spain*

*Duangrit Bunnag*
*of DBALP, Thailand*

*Matteo Thun,*
*Italy*

*Colin Seah*
*of Ministry of Design,*
*Singapore*

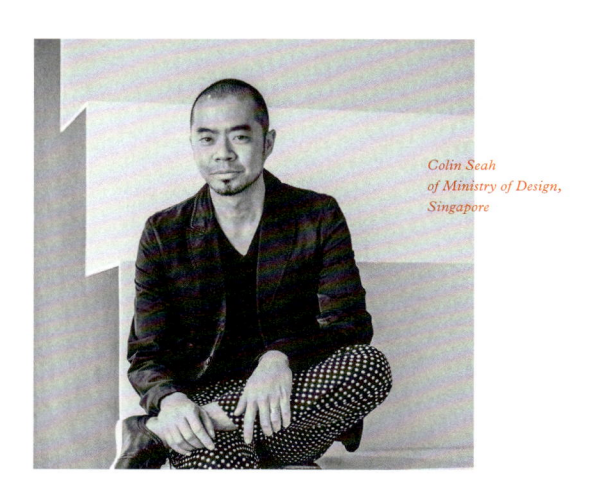

## TARRUELLA TRENCHS STUDIO

Through her innate understanding of space, color, and the power of these elements to stimulate creativity and a sense of community, this Barcelona legend is crafting interiors that attract artists and fellow designers who come to be inspired. As part of the design duo Tarruella Trenchs Studio, Tarruella has transformed Barcelona's dining and hospitality scenes. But her success has taken her even farther afield—London, Toulouse, Dubai, and beyond—where she has become, quite simply, the go-to designer for the world's most prestigious chefs.

Page 266

## MATTEO THUN

A modern-day Renaissance Man, Thun demonstrates an innate brilliance for converting simple forms into works of art. The result is an influence that spans the globe, with his designs for such manufacturers as Artemide, Driade, Flos, FontanaArte, Illy, Porsche, Villeroy & Boch, Zucchetti, and many others. A common thread unites the work of this multi-award-winning Italian architect and designer: a thorough understanding of materials and technologies, an ability to simplify forms and functionality, and a deeply held belief in the importance of sustainability.

Page 318

## DUANGRIT BUNNAG

A visionary force throughout his native Thailand and beyond, Duangrit Bunnag has demonstrated a refined skill for creating spaces of leisure, be they remote monastic getaways or casual gathering places in the middle of a city. From award-winning tropical resorts to work showcased as part of the 2012 Venice Architecture Biennale, Bunnag creates buildings that assert themselves boldly into a landscape yet also seem organically at one with their setting. His distinctive style is characterized by the harmonious unity of seemingly opposing forces: the assertive geometry of his structures alongside the organic elements that occur in nature.

Page 422

## COLIN SEAH

This former teacher at the University of Singapore's Department of Architecture is now creating daring designs that are earning him the highest honors, including Designer of the Year by International Design Awards and the Gold Key Award (the highest international hospitality accolade). Seah's success lies in finding a space's relevancy through reinvention and personal interaction—and in an undying modesty. In short, this Singaporean's firm, Ministry of Design (MOD), creates refreshingly un-egotistical work that enables a theatrical and true sensory experience to come alive.

Page 436

# Americas

HOTELS

## 38

COUNTRIES

**Argentina, Belize, Bonaire, Brazil, Canada, Colombia, Grenada, Jamaica, Mexico, Panama, Saint Lucia, United States** »

BRAZIL

# Hotel Pulitzer

Nestled between the frenetic hustle of Microcentro and the leafy old-world charm of the Recoleta—a well-heeled district known to locals as "Little Paris"— Hotel Pulitzer offers visitors to Buenos Aires a unique vantage from which to take in this electrifying city. Housed in a contemporary construction by acclaimed architect Guillermo Roitenberg, its design elements subtly harken back to the Art Deco heritage of Argentina's Golden Age. Inside, Lázaro Rosa-Violán's crisp interiors exude understated cosmopolitan chic with steel-trimmed modular furniture, myriad mirrors, and trompe l'oeils of latticed woods. A striking palette of bold aqua-marine, cool whites, rusts, and bold blacks prevails throughout. Hotel Pulitzer also offers countless opportunities for its guests to relax and unwind. During summer months, poolside chaise longues beckon guests to stretch out and bathe in the sun, eight stories above the bustling Buenos Aires streets. Upstairs at the thirteenth-floor Sky Bar, superbly mixed drinks flow while sultry, sun-kissed patrons take in the sunset alfresco. Should guests choose to unwind more privately, each of the hotel's 104 rooms and suites contains its own temple of relaxation: a sleek, black-tiled bathroom complete with a hydromassage bath and aromatic oils. Step outside and you are right in the heart of historic Buenos Aires, mere steps away from the city's choice of cultural offerings, such as the National Museum of Fine Arts, Florida Street, and San Martin Square. —

WHERE
Buenos Aires
Argentina

MEMBER SINCE
07/2012

ARCHITECTURE
Guillermo
Roitenberg
(RG Arquitectos)

DESIGN
Lázaro Rosa-Violán
(Contemporain
Studio)

ROOMS
104

RATES
USD 130–230

MEET THE ORIGINAL
Jorge Roig Ortiz

# Hotel Unique

WHERE
São Paulo
Brazil

MEMBER SINCE
12/2002

ARCHITECTURE
Ruy Ohtake

DESIGN
João Armentano

ROOMS
95

RATES
BRL 934–17,381

Rising above the well-heeled residential area of Jardins in São Paulo like a graceful ocean liner, Hotel Unique is sculptural architecture at its most original—and a must for savvy architecture fans and well-traveled urbanites alike. The spacey, green-weathered copper that adorns the façade stretches across the building's unusual shape, a large inverted arch with circular windows like oversize portholes. The effect of the geometric forms, dark glass, and desert gardens is nothing less than spectacular. Constructed by Ruy Ohtake, the visually stunning Hotel Unique is a reference in modern architecture. The dramatic exterior seamlessly continues indoors, where the reception area and adjacent bar are both lit by a huge wall of transparent glass. Sharp angular forms throughout give the spectacle an even grander sense of clarity. Dramatic 80-foot high hollows and corridors in the interior define the curved design that is reflected in each unique room, where there are no right angles. The public spaces, meanwhile, are toweringly high, geometrically aligned, and carefully choreographed. Contemporary design from João Armentano mixes modern amenities and maximum comfort, all wrapped up in a sleek package. The 95 rooms and suites combine high-tech details with natural elements to create an otherworldly effect. A carefully choreographed spectrum of circles and squares, ellipses and sine curves flow in and out of each other, but are softened by wooden flooring, sleek white furnishings, and transparent glass tables and fittings. —

# Felissimo Exclusive Hotel

One of Brazil's most understatedly extra-ordinary beach properties, Felissimo Exclusive Hotel is a lesson on how luxury need not be excessive. The 10 secluded rooms and lofts here present an air of simple opulence with warm native woods, wide-open verandahs, and sun loungers that enable one to take in the incredible mountain and beach scenery. The former home of owners Grace and Robert Schramm, Felissimo Exclusive Hotel began as a small bed & breakfast thanks to their penchant for entertaining. The hotel is painstakingly decorated with elements inspired by their travels. Having no experience in hospitality, the couple enlisted the help of Terence Schauffert Reiser, a retired surf pro, self-professed beach bum, and owner of the award-winning Praia Brava Kiwi bar down the road from the hotel. Together, they are setting a new path for hospitality in Balneario Camboriu—one that is authen-tic, heartfelt, and stripped back. The hotel also focuses on personalized and discreet service, which guests can enjoy at the intimate pool and hot tub area, as well as on the gazebo-style deck of Bistro Felissimo. Here, local and international travelers alike find one of the region's most acclaimed gourmet eateries and cocktail bars. With "smiles, states of joy, and simplicity" on the wish list of its owners, Felissimo is both a welcoming hideout and a grand departure point for all that this particularly stunning plot of paradise has to offer. —

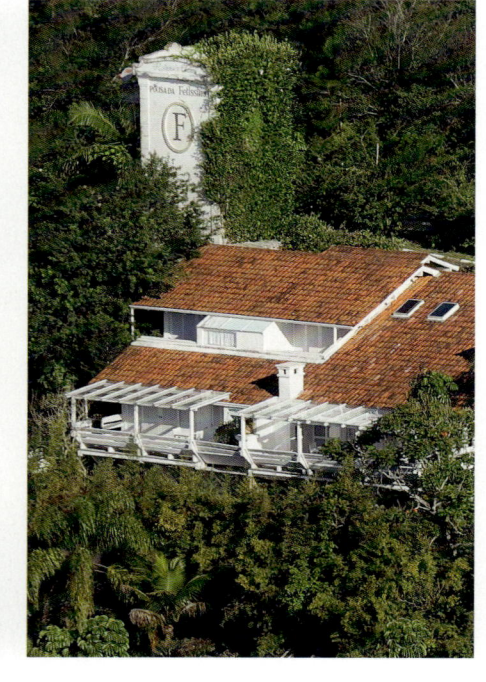

| WHERE | ROOMS |
|---|---|
| Balneario Camboriu Brazil | 10 |

**MEMBER SINCE**
06/2014

**RATES**
BRL 575–940

**ARCHITECTURE**
Ligia Sievert

**MEET THE ORIGINALS**
Terence Schauffert Reiser,
Grace Schramm,
Robert Schramm

**DESIGN**
Paulo Alves

# Insólito Boutique Hotel

WHERE
Buzios
Brazil

MEMBER SINCE
10/2010

ARCHITECTURE
Octávio Raja
Gabaglia,
Luiz Fernando
Grabowsky
(Studio Grabowsky)

DESIGN
Emmanuelle Meeus
de Clermont
Tonnerre

ROOMS
20

RATES
BRL 908–3,124

MEET THE ORIGINAL
Emmanuelle Meeus
de Clermont
Tonnerre

Just a two-hour drive from the bright lights of Rio de Janeiro, there is an oasis of calm awaiting guests at the Insólito Boutique Hotel—a resort that combines personalized service with a beachfront experience and ambience that revitalizes the soul. Nestled in a rocky hillside, with stunning views of Ferradura Beach, the solar-heated Insólito blends perfectly into its natural surroundings thanks to the skills of celebrated architect Octávio Raja Gabaglia. The hotel's 20 rooms are full of arts and crafts from Brazilian legends, local artisans, and socially responsible companies, reflecting the style of its owner, the French-born Emmanuelle Meeus de Clermont Tonnerre. She has lovingly chosen and curated each room's unique theme; whether the theme celebrates

Cultura Negra, South American photography, or Brazilian modern art, prepare to have your senses wowed. All rooms come with a king-size bed, LCD TV, DVD player, WiFi, iPod docking station, and plenty of interesting books. Most rooms have a verandah with a whirlpool and panoramic ocean views, while the suites also come with a lounge and an American bar where guests can mix their own *cachaça* drinks. The hotel owns two speedboats with which guests can discover over 20 neighboring beaches on the peninsula whenever they choose. When guests want to mingle, they can enjoy drinks in the pool bar, or they can dine at the 3,000-square-meter beach lounge, which has become "the place to be" for locals and guests alike. —

# Kenoa – Exclusive Beach Spa & Resort

**WHERE**
Barra de São Miguel
Brazil

**MEMBER SINCE**
09/2010

**ARCHITECTURE / DESIGN**
Osvaldo Tenório

**ROOMS**
11

**VILLAS**
12

**ROOM RATES**
BRL 1,337–2,411

**VILLA RATES**
BRL 2,253–4,253

**MEET THE ORIGINAL**
Pedro Marques

Kenoa – Exclusive Beach Spa & Resort is located on Brazil's stunning northeast coast, caressed by an emerald-colored, seemingly infinite ocean and miles of pristine white beach. Its position just nine degrees south of the equator ensures year-round summer temperatures. When founder Pedro Marques first dreamed up the lush haven, he envisioned a place that would provide mental, physical, and environmental equilibrium. Keen on environmentally conscious solutions, such as recycled glass water bottles, tree trunks of reclaimed wood, energy-saving LED lights, locally produced foods, and even non-ironed staff uniforms, the eco-chic retreat's intimate setup offers repose for those ready to wind down. Each of the 23 exclusive villas and suites abounds with unique features, from unparalleled views over the neighboring sanctuary to private pools and outstanding interior design interspersed with indigenous works of art. A Shiseido-equipped spa, fitness center with ocean views, wine bar, lounge, and world-class cuisine tantalize the senses and satisfy the soul. Situated on the sandy white beach of Barra de São Miguel, 30 kilometers south of Maceio, the capital of the state of Alagoas, the hotel confidently stands out as much as it blends in with the overwhelming natural beauty of its unique location, defining a whole new realm for nature-friendly well-being. —

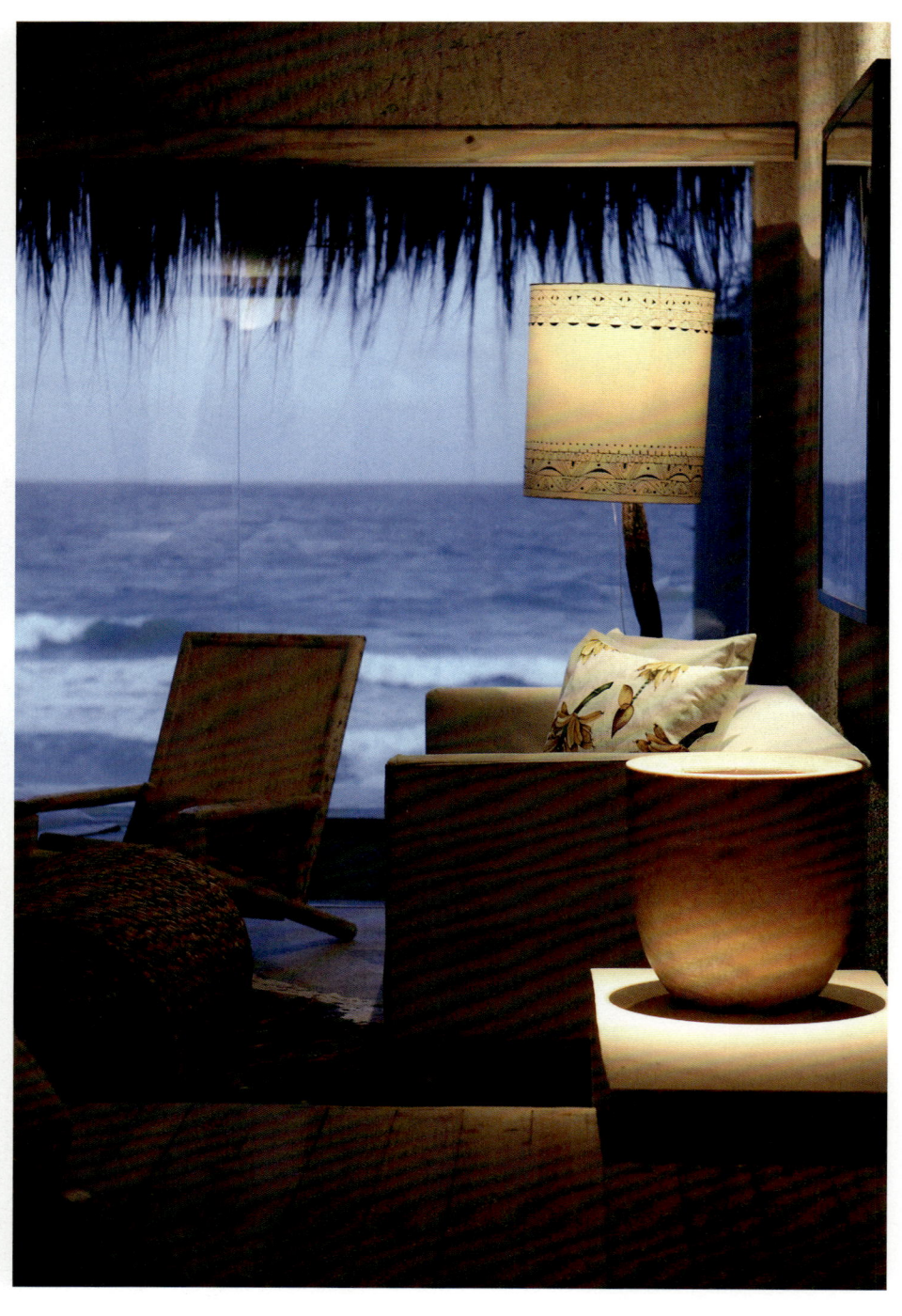

# B.O.G. Hotel

**WHERE**
Bogotá
Colombia

**MEMBER SINCE**
10/2011

**ARCHITECTURE**
Guillermo Arias
(Octubre)

**DESIGN**
Nini Andrade Silva

**ROOMS**
55

**RATES**
USD 260–600

**MEET THE ORIGINAL**
Nini Andrade Silva

With a design inspired by two of Colombia's richest minerals—gold and emeralds—the geometric B.O.G. Hotel, in the north of Bogotá, is a perfect base from which to explore this burgeoning city. All 55 rooms by award-winning designer Nini Andrade Silva focus on golden tones, greens, grays, and beige combined with natural stone, bronze, mirrors, mosaics, and tinted glass to create pared-down and restful spaces. The in-room decor is intentionally simple, yet every comfort is ensured, including soundproofed windows, 500-thread linens, and bathroom products and scents exclusively designed for the hotel. After a day discovering the vibrant surroundings, the rooftop's heated swimming pool offers a welcome respite, with views over the city. B.O.G. Hotel is also home to one of Colombia's best restaurants, helmed by internationally renowned chef Ramón Freixa, which aims to preserve and enhance the country's gastronomic heritage, using traditional ingredients to create fusion dishes that blend international flavors with long-standing, local recipes. Located in the exclusive neighborhood of La Cabrera, the B.O.G. Hotel is surrounded by the main luxury shops of the city, the biggest financial district in the country, and a wide range of food and cultural venues that guests can enjoy during their stay. —

# El Otro Lado

Panama's steamy rainforests, swampy mangroves, and kaleidoscopic coral reefs are all within easy reach of El Otro Lado, a remote retreat on 110 hectares of land that prides itself on local integration. Guests are invited to sit back and take in these idyllic surroundings while sipping a passion-fruit mojito, and are encouraged to discover more about the region's Afro-Panamanian heritage. Situated near Portobelo, and adjacent to centuries-old fortifications that are a UNESCO World Heritage Site, the surrounding jungle buzzes with natural life. This thriving landscape provides the backdrop for endless hours of relaxation. But there are countless options to explore should an active mood strike you, including fishing, rainforest tours, and snorkeling at one of the nearby beaches, transported by one of the hotel's four motor launches. With a tropical soundtrack curated by renowned broadcaster Gladys Palmera, it's possible to gaze across an azure bay to Portobelo, a 400-year-old town built by Spanish colonists. Closer by, sensory thrills come straight from El Otro Lado's interiors, which integrate Arte Povera with 20th-century sculptures and contemporary black-and-white photography throughout the hotel's five villas. Social activity centers on the Gazebo—the hotel's restaurant, bar, and lounge—adorned with carnival masks and white sofas splashed with brightly colored cushions. Here, chefs bring Caribbean ingredients and colonial flavors together nightly, and guests can while away hours gazing over the infinity-edge pool, which appears to flow seamlessly into the pristine bay. —

**WHERE**
Portobelo
Panama

**MEMBER SINCE**
10/2011

**ARCHITECTURE**
Jorge Zarak
(Ecléctico)

**DESIGN**
Ecléctico

**ROOMS**
5

**RATES**
USD 490–690

**MEET THE ORIGINAL**
Jorge Zarak

# Laluna

**WHERE**
Morne Rouge
Grenada

**MEMBER SINCE**
08/2001

**ARCHITECTURE**
Gabriella Giuntoli,
Salvatore Perna,
Carmelina Santoro

**DESIGN**
Bernardo Bertucci

**ROOMS**
16

**VILLAS**
3

**ROOM RATES**
USD 375–1,230

**VILLA RATES**
USD 1,660–2,950

**MEET THE ORIGINAL**
Bernardo Bertucci

Trickling down a picturesque hillside in Grenada and overlooking Portici Beach, Laluna stirs a tasty mélange of Caribbean, Balinese, and Italian design elements to create a smart and utterly tropical hotel. Designed by Gabriella Giuntoli, who has built villas for Giorgio Armani and Sting, Laluna is a masterpiece on ten acres of untouched land in the West Indies, surrounded by emerald hills, crystal waters, and leafy bougainvillea-filled grounds. Each of the 16 traditional, thatched-roof cottages offers an open-air bathroom, an exquisite line of bath products made exclusively in a monastery in the Italian Alps, and a king-size Balinese bed that opens onto an expansive private veranda with a plunge pool. A selection of three-, four-, and five-bedroom luxury villas designed by Sicilian architect Salvatore Perna sleep up to 10 people and feature spacious outdoor living spaces, perfect for small groups or families. The Asian spa features parallel treatment rooms that are convertible into a single unit for couples massage, and there is a tatami room with comfortable tatami cushions for massage, and the wet room, in which a Vichy shower gives the sensation of soft rain, is used between mud applications and massages. As the sun sets, guests can dine at the beachside Italian restaurant, and watch the silver moon, Laluna's namesake, rise in the cobalt sky. —

# Piet Boon
# Bonaire

Creativity knows no bounds. Just ask Piet Boon, who gets as excited designing a luxury Manhattan apartment as he does furniture, motorboats, even wallpaper. The world-class designer is literally everywhere these days, and no place more beautiful than Bonaire, a sand-fringed escape in the former Dutch Antilles.

Few Caribbean islands are as inviting as Bonaire, so it made perfect sense for the designer to lend his brilliance (and his name) to Piet Boon Bonaire, a collection of nine individually styled villas. Four of these villas are directly on the oceanfront, with ultra-spacious and expertly crafted living spaces leading out onto private terraces that feature pools and easy access to the sea. Five additional villas sit further back from the shore but just like the oceanfront properties, they are unmistakably the work of the design icon, who has a reputation for designing bespoke, luxurious ocean villas worldwide.

Set along the waterfront in Kralendijk, the island's tiny capital, Piet Boon Bonaire is just 50 kilometers from Curaçao and 80 kilometers from Venezuela. It's a tranquil place where flamingos as pink as cotton candy strut through the peaceful salt ponds, and loggerhead turtles swim through the turquoise seas. "For me," he says, "Bonaire is the picture you see when you close your eyes and dream of the Caribbean."

Although each of the nine sophisticated villas at Piet Boon Bonaire were designed with an individual concept in mind, they all share many of the same elegant design traits. Natural materials and subdued shades help to ensure a sense of continuity between the villas, the private gardens, and their thatched gazebos, which have unforgettable views of the sparkling Caribbean. Like the island's traditional cunucu houses, the villas of Piet Boon Bonaire are designed to be cooled by the constant breezes, thus making them energy efficient.

Inside the villas, space, elegance, and Boon's own renowned craftsmanship reign. Warm sunlight floods in through wide windows, while lofty ceilings and dark stone floors ensure a cool, fresh feel. Occasional bursts of brightness add just the right amount of Caribbean spice.

One of the most high profile designers to come out of the Netherlands, Boon began his career as a building contractor and master craftsman; it is here where his love of natural materials and signature details developed. "I was always getting in trouble with the architects," he reminisces. "I tried to do the architecture myself, but I wasn't always successful. I ended up doing a lot of the interiors as well. My motto has always been: I won't design something if I can't build it myself."

But getting back to those cooling breezes of Bonaire. For Boon, these meant more than just an energy efficient design opportunity. The windy island also allows him to indulge in one of his favorite activities: kitesurfing. "I grew up in a family with three boys and my father insisted we do sports every day," he says. "When I was young I even thought I wanted to become a professional athlete. Bonaire is perfect for kitesurfing, which is perhaps my greatest passion."

Clearly, the island has made a big impression on the celebrated designer. "I've been coming to Bonaire for the last 25 years. I love the people, the relaxed atmosphere, and the unique natural beauty. Bonaire has stolen my heart," he says.

And then he adds a line that could easily be said by many fans of his design work, as well as guests of Piet Boon Bonaire. "It's simply paradise." —

"I grew up in a family with three boys and my father insisted we do sports every day," he says. "When I was young I even thought I wanted to become a professional athlete. Bonaire is perfect for kitesurfing, which is perhaps my greatest passion."

PIET BOON

WHERE
Kralendijk
Bonaire

VILLAS
9

MEMBER SINCE
10/2013

RATES
USD 500–1,415

ARCHITECTURE
Piet Boon

MEET THE ORIGINAL
Piet Boon

DESIGN
Karin Meyn

Piet Boon

# El Secreto

**WHERE**
Ambergris Caye
Belize

**MEMBER SINCE**
08/2013

**ARCHITECTURE**
Abraham Saade

**DESIGN**
Abraham Saade,
Aldonza Prioux
(Dominion
Corporate Housing)

**VILLAS**
13

**RATES**
USD 450–1,150

**MEET THE ORIGINALS**
Abraham Roffe,
Abraham Saade

The secret is out. Located 30 minutes away from the town of San Pedro, the largest on Belize's Ambergris Caye, is El Secreto boutique resort, an intimate 13-villa resort surrounded by the lush and natural beauty of an island setting. Accessible only by boat to the hotel's private pier, El Secreto is a totally unique experience in a region that remains largely undiscovered, and where the stunning Great Blue Hole submarine sinkhole and Barrier Reef lie only a short distance away. Each thatched-roof villa has been designed with the locale in mind, the impressive environs taking center stage in each accommodation by way of ocean views and landscaped grounds. El Secreto Restaurant offers guests the best organic ingredients the island has to offer and the Ikal spa acts as the ultimate gateway to total relaxation with its program of Mayan influenced treatments. Contemporary yet bucolic, El Secreto is setting a new standard for the Caribbean resort: A boutique retreat created with respect for its surroundings while offering high-end comforts and modern conveniences to savvy travelers. —

# Boucan
# by Hotel Chocolat

Saint Lucia's oldest cocoa estate—a 140-acre plantation surrounded by steamy rainforests—provides a fitting location for Boucan, the first hotel by the founders of luxury chocolate firm Hotel Chocolat. Chefs here use cocoa to complement seafood, leafy salads, and estate-grown herbs and fruits. The Cocoa Juvenate Spa also harnesses cocoa's antioxidant power for use in a heady combination of massages and body wraps. Set 300 meters above sea level and shaped by skilled builders, all 14 of the Rabot Estate's lodges have open-air rainforest showers and views of the cone-shaped volcano Petit Piton. The eight largest lodges also ben efit from private verandahs that look out over mountains and seascapes. After taking a chocolate-making tour with the restaurant's chef, guests can drench themselves in Club Boucan's black-quartz infinity pool or sip prosecco at the bar. For chocoholics and eco-conscious design lovers, the place feels a lot like heaven.  —

| WHERE | VILLAS |
|---|---|
| Saint Lucia | 14 |
| West Indies | |
| | RATES |
| MEMBER SINCE | USD 450–650 |
| 10/2012 | |
| | MEET THE ORIGINALS |
| ARCHITECTURE | Peter Harris, |
| Phil Buckley | Angus Thirlwell |

DESIGN
Angus Thirlwell,
Terry Moore Design

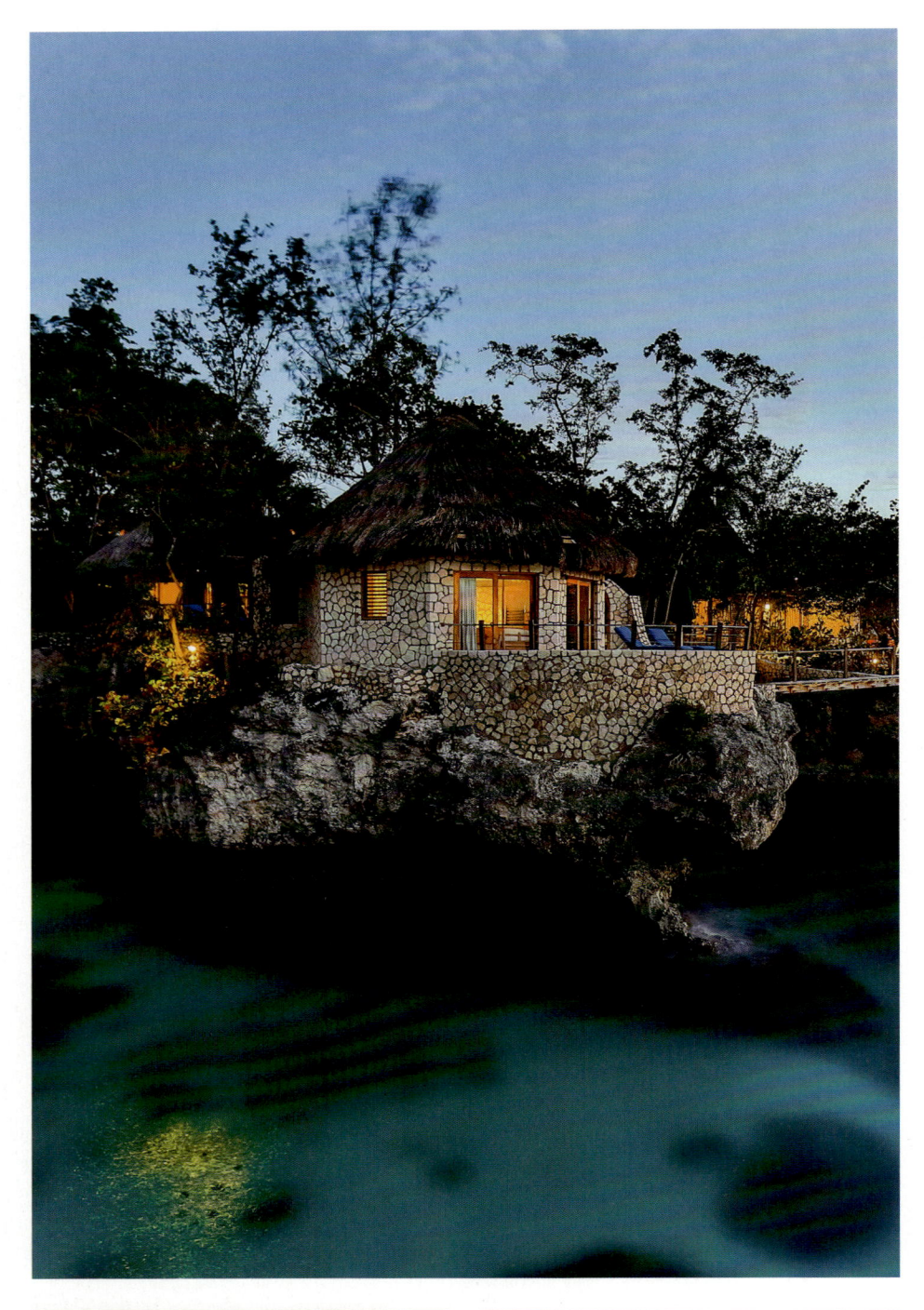

# Rockhouse Hotel

Perched upon the scenic cliffs of Negril's Pristine Cove in Jamaica, the Rockhouse Hotel beckons to romantics and adventurers alike. The resort designers sought to create a harmonious and respectful insertion into the jungle-like environment. Emphasis was placed on simple and strong forms, local timber and thatch to merge with the fully-grown garden, and stone to integrate with the surrounding volcanic rock landscape. The award-winning Rockhouse Restaurant is the central point of the Rockhouse "village," spectacularly perched on a deck suspended above the cove, overlooking the sparkling turquoise waters of the Caribbean Sea. Guests can enjoy a decidedly more local beat at the Pushcart Restaurant & Rum bar located at the edge of the property, featuring live reggae music and a menu inspired by the best of Jamaican street food. Alternatively, the Pool Bar & Grill offers breathtaking ocean views and memorable Jamaican sunsets from the stunning infinity pool deck. But the true highlights are the hexagonal, thatched-roof bungalows or "rock houses" looking out on either the aquamarine Caribbean waters or the hotel's expansive, lush gardens. Rockhouse also offers a number of studios and deluxe standard rooms located in a traditional hotel-style block of connected rooms with water views, outdoor showers, and private balconies. Each room features custom-made furniture, hand-crafted from local wood, adding to the overall in-tune-with-nature ambience. Throughout the property, ladders and stairs carved into the rock provide easy access to the water, while a temple-like spa pavilion—complete with a massage cabana, Caribbean drench hut, yoga pavilion, and new Holistic Bath House—rounds out this laid-back haven of relaxation. —

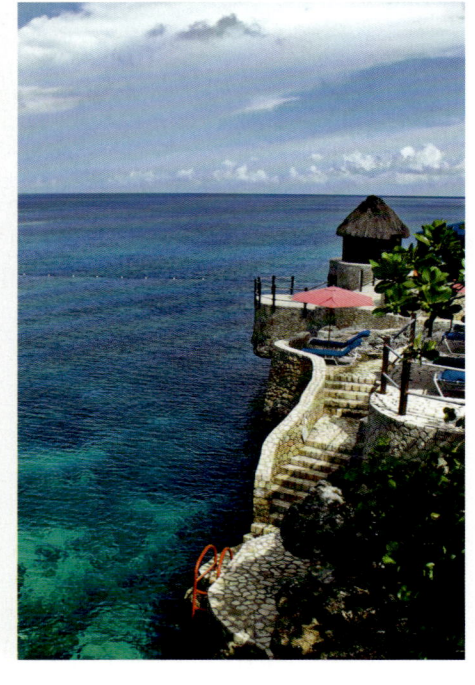

| | |
|---|---|
| **WHERE** Negril Jamaica | **ROOMS** 14 |
| **MEMBER SINCE** 02/2000 | **VILLAS** 20 |
| **ARCHITECTURE** Christopher Whyms-Stone (Cornerstone Design Ltd) | **ROOM RATES** USD 95–225 |
| | **VILLA RATES** USD 195–495 |
| **DESIGN** Jean-Henri Morin (Atelier One) | **MEET THE ORIGINAL** Paul Salmon |

# Downtown Mexico

**WHERE**
Mexico City
Mexico

**MEMBER SINCE**
01/2012

**ARCHITECTURE**
David Cherem
(Cherem
Arquitectos)

**DESIGN**
Pablo Igartúa,
Rodrigo Berrondo
(Paul Roco)

**ROOMS**
17

**RATES**
USD 175–390

**MEET THE ORIGINALS**
Carlos Couturier,
Moisés Micha

Blending authentic colonial 17th-century grandeur with a raw industrial edge, Downtown Mexico integrates local indigenous culture into its concept while celebrating its location in the Centro Histórico of Mexico City. Known as the "Palacio de los Condes de Miravalle," the hotel sits comfortably next to other colonial landmarks on the cobbled streets of this UNESCO World Heritage Site. For each of their properties, owners Carlos Couturier and Moisés Micha use a local team and integrate the local culture into the concepts. Such was the case when lovingly renovating Downtown Mexico, one of the oldest residences in the area that still maintains this particular Mexican viceregal style. Characteristics such as ornate detailing around the windows of the façade and a stone-forge staircase with intricate handrails take their place alongside gray volcanic rock walls and handmade cement tiles. The 17 rooms and suites possess a stripped-back, bohemian-chic elegance. They range from the simple and unadorned, decorated with little more than gray walls and tiled floors, to the stylish, with light timber detailing, exposed concrete walls, and vaulted high brick ceilings. Street-side rooms have balconies, while the others look over the lush and perfectly manicured patio. This palace grandeur is contrasted by the edgy character of the immense terrace which covers the entire rooftop. —

# Distrito Capital

Surprising interiors, dazzling panoramic views, and double-height ceilings are a few of the eye-catching highlights of Distrito Capital. Located in the highest area of Mexico City—the skyscraper district of Santa Fé—this hotel is a testament to how cool Mexico's capital has become in recent years. Designed around the idea of creative minimalism, the thirty well-appointed guestrooms and suites look more like chic art spaces than hotel rooms. Any visitor will be simultaneously awed by impeccable design touches and delighted by personal service flourishes. Fashionable without being zeitgeist-y, the inviting decor allows visitors to truly kick back and relax. The hotel is punctuated by vintage furnishings courtesy of famous mid-century designers. And Parisian interior designer Joseph Dirand has successfully created thought-provoking social spaces within the property, such as a lounge-friendly pool area and several spectacular terraces. In fact, the Patricia Silvera-curated restaurant on the fifth floor is one of Mexico City's newest and smartest meeting places. Guests will feel like they've stepped into their dream apartment.

For Carlos Couturier and Moisés Micha, building hotels that reflect their surroundings is more than just a job—it's a passion that drove these two Mexican entrepreneurs to leave their respective former careers in citrus farming and investment banking. In 2000, Couturier and Micha launched Grupo Habita, a diverse collection of exquisite hotels that has grown to include 14 properties with new properties opening in Guadalajara, Chicago, and LA over the next two years. Today, Couturier and Micha sit on the boards of Mexico City's most prestigious fine arts institutions, while often hosting art openings at their esteemed boutique hotels. Ambitious but fun-loving, well-traveled but tied to their Mexican roots, the dynamic duo was awarded Team of the Year 2011 by *Fizzz Magazine*. —

| WHERE | ROOMS |
|---|---|
| Mexico City Mexico | 30 |

RATES
USD 175–935

MEMBER SINCE
01/2009

MEET THE ORIGINALS
Carlos Couturier, Moisés Micha

ARCHITECTURE
David Cherem, Diámetro Arquitectos

DESIGN
Joseph Dirand
(Joseph Dirand Architecture)

# India

## MAHDAVI

INFLUENCED BY HER EARLY YEARS LIVING IN MANY COUNTRIES, MAHDAVI HAS BECOME A BEACON OF INFLUENCE HERSELF. A VIRTUOSO USE OF COLOR AND FORM, A REVERENCE FOR HISTORY AND CULTURAL PEDIGREE, AND A FEARLESS SENSE OF WONDER HAVE GIVEN RISE TO A SOPHISTICATED LOOK THAT IS INCOMPARABLE IN THE DESIGN WORLD TODAY.

*"The location and space are the starting
point of all of my projects.
Each project tells that inner story."*

INDIA MAHDAVI

"My life started in Technicolor," designer India Mahdavi has said, recalling the "bright American hues" of an early childhood stint in Cambridge, Massachusetts. Although she didn't stay there long—due to her parents' itinerant lifestyle, Mahdavi, who was born in Tehran, subsequently grew up in the United States, Germany, and France—the influence of these early Technicolor memories have pervaded the wide breadth of her work. From her Paris office, which she founded in 1999 after working for Christian Liaigre in the earlier part of that decade, she imbues each project—whether it's architecture, scenography, furniture, objects, or interiors—with bold doses of color. And, despite her lack of a permanent childhood home (or perhaps because of it), Mahdavi has come to specialize in creating homes for others, with residences from California to Cap Ferret.

"You can't pin it down to a specific influence or reference," French interior designer Yann Le Coadic once said of Mahdavi to *The New York Times*, describing the sheer eclecticism of her work and its refusal to be described as a single style. Indeed, this ethos of diverse elegance comes as little surprise, given the diversity of her formal experiences: Mahdavi holds an architecture degree from the École des Beaux-Arts in Paris, but also spent an industrious year in New York studying furniture design at Parsons, industrial design at Cooper Union, and graphic design at the School of Visual Arts. There were also those seven years she worked under the minimalist style of Liaigre, as well as a lifetime of international travel and the diversity of her own heritage. She credits her affinity for layered patterns to her Iranian background, and her masterful *art de vivre* to her upbringing in the sophistication of France. The two are readily apparent in her interiors, which mine local culture for inspiration and, combined with her own style, create a single cohesive vision that resonates with each location. "Mix is a must," as she herself once put it—a lesson she learned very early on.

This lesson is used to full effect at Condesa *df*, the Mexico City hotel that serves as a calming oasis in the midst of a bustling urban center. Mahdavi and architect Javier Sánchez transformed a 1928 French neoclassical apartment block into a chic hotel and nightlife destination in the city's artistic Condesa district. Taking cues from the lauded, and devoutly Catholic, Mexican architect Luis Barragán, Mahdavi aimed for a monastic tranquility in each of the 40 guestrooms. Minimal and airy, they brim with natural light and connect to the outdoors via generous terraces and floor-to-ceiling windows. The common spaces pack more of a punch, dominated by cool shades of green and turquoise on the walls. Their brightness is tempered by the many flourishes of rich woods and an eclectic mix of Mahdavi's custom furniture: sculptural tables, floral motifs, and cowhide-upholstered armchairs. It was here that Mahdavi debuted her much-loved Bishop Stool in ceramic, a playful seat that brings to mind an oversized version of its namesake chess piece.

In addition to interiors, Mahdavi applies her colorful élan to furniture and objects. Her two rue Las Cases shops, both down the street from her studio in Paris, and the occasional exhibition with New York design gallerist Ralph Pucci or Beirut's Carwan Gallery, are full of the liveliness of Pop Art. Her Joker table rests on a faceted ceramic base decorated with a spiraling checker pattern; meanwhile her Vera Cruz table's organically plump base, recalling the fluid sculptures of Henry Moore, rests on the opposite end of the aesthetic spectrum.

## SIDE NOTES

NAME *India Mahdavi*

COMPANY NAME *IMH Interiors*

COMPANY HEADQUARTERS *Paris*

NUMBER OF PEOPLE IN COMPANY *20*

WEBSITE *india-mahdavi.com*

SIGNATURE PROJECTS *Mexico City: Condesa df
London: The Gallery at sketch; suites at
Claridge's; Coburg Bar at The Connaught;
Bungalow 8 Paris: Germain Paradisio;
Germain; Café Français; Maison Thoumieux
Courchevel, France: L'Apogée Courchevel*

## SIGNIFICANT AWARDS

2015 *Restaurant & Bar Design Awards, Best
UK Restaurant and Best London Restaurant
for The Gallery at sketch*

2015 *The Great Indoors Award, Relax &
Consume category for The Gallery at sketch*

2015 *Time Out Love London Award, Best
Mayfair Restaurant for The Gallery at sketch*

2015 *Honored as an Officer of Arts and Letters
by the French Ministry of Culture*

2014 *AD 100 List*

2014 *AD España, Special Award for
International Design*

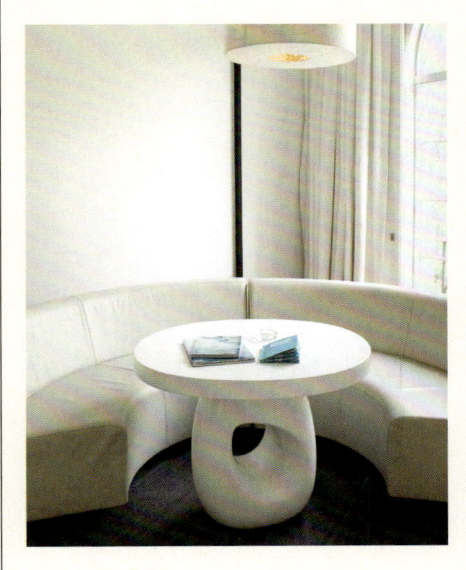

*At Mexico City's Condesa df, Mahdavi's
lacquered fiberglass Vera Cruz table reflects
the fluid modernity that she brings to the
entire hotel.*

A recent collaboration with historic French textile producers Cogolin resulted in Jardin intérieur, a whimsical series of sumptuous, brilliantly colored velvet rugs that feel like geometrically pruned swathes of moss underfoot.

In sleek destinations for the fashionable throughout the world, Mahdavi's smart, eclectic, chic aesthetic is high in demand and never muted. In 2007, she designed the interiors of London's Bungalow 8, a VIP-only outpost of the ultra-hip New York nightclub, in Covent Garden. With broad black-and-white stripes running down the stairwell and across the walls, the interiors are as audacious as the crowd. In 2014, she made her mark inside the trendy restaurant and cocktail bar, The Gallery at sketch, where the interiors are covered in a bubble-gum-pink monochrome and furnished with plush velvet banquettes and luxe brass detailing. The decidedly feminine Art Deco take on the traditional brasserie won two coveted 2015 Restaurant & Bar Design Awards—one for best UK restaurant and other for best London restaurant. The eatery also won The Great Indoors Award in the Relax & Consume category, and the Time Out Love London Award for best Mayfair restaurant. Elsewhere—Paris, to be exact—in Gilbert and Thierry Costes' Café Français, blue velvet curtains harmoniously cohabitate with voluptuously curved red leather banquettes, glowing golden walls, and sky-blue frescoed ceilings. In Hong Kong's Dragon-i, the prevailing theme is red, thanks to the glowing, dragon-printed lanterns adorning the ceiling.

Each space evokes a wholly unique mood. "The location and space are the starting point of all of my projects," says Mahdavi. "Each project tells that inner story."

*Text: Janelle Zara*

1

1 *For a Charles-de-Gaulle airport food court, Mahdavi used plush velvet and leather furnishings in hues of peacock blues, turquoise, and lime greens to offset rich brass details, parquet flooring, and high concrete arches.*

2 *Mahdavi's Gelato collection of chairs is designed with bold-colored mohair, velvet, and leather, while her Week End tables are made from laminate wood, rattan, and brass.*

2

**3** *The Alber table, made from black-colored walnut and brass; Casanova table lamp, from glass and brass; and Landscape vase, designed for Carwan Gallery, on display in Mahdavi's Paris showroom.*

**4** *A once-traditional brasserie on Paris's Place de la Bastille, Mahdavi's Café Français is now an Art Deco-tinged space with gilded walls, red leather banquettes, a sea of welcoming blue, and heavenly frescoes.*

**5** *Mahdavi's Jelly Pea Sofa gets its name from jelly bean sweets.*

4

3

5

# Condesa*df*

Tucked between historic façades on a tree-lined road in Mexico City's stylish Condesa neighborhood, the Condesa*df* fuses the spirit of its bohemian surroundings with a playfully simple design aesthetic. Housed in a 1928 building in the French neoclassical style, the hotel is filled from head to toe with custom furniture designed by Paris-based India Mahdavi, stone tiles, and an abundance of local color. The feel is modern yet warm, hip but not haughty. The 40 rooms and suites were inspired by the tranquillity of monastic bedrooms—but without a lack of amenities, of course. The result is calming, airy spaces, some of which open onto wooden terraces. But the most prominent interior feature is the flora-filled inner courtyard, El Patio, where a destination restaurant serves delicious fare in a series of scattered, privacy-optional rooms both indoor and out. Downstairs, a basement bar offers a whimsically modern cocktail spot, while further aloft, the rooftop bar La Terraza affords stunning castle views. At the charmingly named Myself area, a hammam, thermal bath, wet area, and gym invite guests to indulge in relaxation. Meanwhile, an overarching floral theme—visible on everything from cushion covers to chopstick wrappers—serves to enhance the relaxed warm-weather vibe. —

**WHERE**
Mexico City
Mexico

**MEMBER SINCE**
11/2003

**ARCHITECTURE**
Javier Sánchez

**DESIGN**
India Mahdavi

**ROOMS**
40

**RATES**
USD 225–850

**MEET THE ORIGINALS**
Carlos Couturier,
Moisés Micha

# Habita

WHERE
Mexico City
Mexico

MEMBER SINCE
09/2000

ARCHITECTURE /
DESIGN
Enrique
Norten (Ten
Arquitectos),
Bernardo
Gómez-Pimienta

ROOMS
36

RATES
USD 215–520

MEET THE ORIGINALS
Carlos Couturier,
Moisés Micha

Like an ice cube on a hot street corner, Mexico City's Habita exudes cool luxury at the heart of this simmering metropolis. The complete makeover of the 1950s building has encapsulated the 36-room hotel in a sensational floating glass box suspended from the five-story structure's façade, mediating views and providing a stylish privacy for the cosmopolitan jet set. Sandwiched between new and old façades are original balconies and new corridors. Contemporary art includes Jan Hendrix's metal mural hanging in the reception area; the guestroom space contains only a bed, Eames chairs, and a cantilevered pane of glass serving as both desk and table, while everything else is concealed behind a polished paneled wall—a spatial clarity that gives travelers peace of mind. The daylight from the floor-to-ceiling glass windows and doors onto balconies is aesthetically matched by Artemide and Flos lamps. The ground-floor Mexican bistro and rooftop pool and bar offer radical refueling and spectacular views after explorations among the chic boutiques and tree-lined boulevards of the fashionable Polanco district. —

# Habita Monterrey

Why would a discerning world traveler want to check into the Habita Monterrey? Because it's the seventh property by Mexican hoteliers Grupo Habita—a group known for its style, energy, innovation, and even intuition. Because the 39-room building is a curvilinear vision in clean, clear black and white, and an homage to classic mid-century design. The creative spirit who created the hotel's bold look is none other than Joseph Dirand, who has often been associated with the stark, monochromatic approach found here. Indeed, the hotel is such a stunning welcome to the area that it has become a hopping nightlife and social hub in the northern Mexican city of Monterrey, at the crossroads between the United States, Mexico, and the world. Revelers and landscape lovers alike can often be found on the hotel's rooftop terrace, replete with pools, a bar, and jaw-dropping 360-degree views of the mountainous surroundings—and all beneath a cool concrete canopy. Guests at Habita Monterrey find not just wireless Internet, but also a computer, which is to be expected at a hotel where the five-star service is always cordial, never cold. Chef Marco Aceves' restaurant, Lobby, along with a music concept by Parisian DJ Monsieur X, make eating and lounging here

unforgettable. No wonder Dirand is so proud of the results. Or as he puts it, "When you realize it is a success it's nice to think everyone is having his or her own experience of this space and time, which is amazing."

For Carlos Couturier and Moisés Micha, building hotels that reflect their surroundings is more than just a job—it's a passion that drove these two Mexican entrepreneurs to leave their respective former careers in citrus farming and investment banking. In 2000, Couturier and Micha launched Grupo Habita, a diverse collection of exquisite hotels that has grown to include 14 properties with new hotels opening in Guadalajara, Chicago, and LA over the next two years. Today, Couturier and Micha sit on the boards of Mexico City's most prestigious fine arts institutions, while often hosting art openings at their esteemed boutique hotels. Ambitious but fun-loving, well-traveled but tied to their Mexican roots, the dynamic duo was awarded Team of the Year 2011 by *Fizzz Magazine*. —

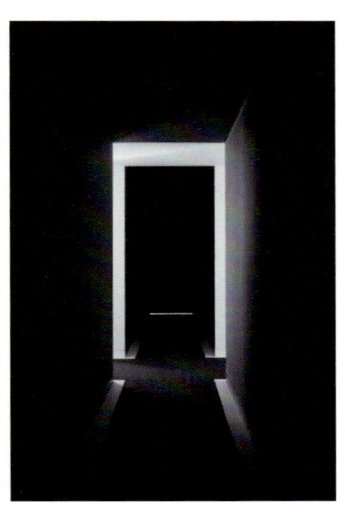

WHERE
Monterrey
Mexico

MEMBER SINCE
01/2009

ARCHITECTURE
Agustin Landa

DESIGN
Joseph Dirand
(Joseph Dirand
Architecture)

ROOMS
39

RATES
USD 180–990

MEET THE ORIGINALS
Carlos Couturier,
Moisés Micha

# La Purificadora

Located in the historic center of Puebla, a colonial city on the road between Mexico City and Veracruz, La Purificadora is the new incarnation of a late 19th-century factory long used to purify water for the production of ice. The tradition of purity is still the guiding leitmotif at this minimalist yet modern and edgy hotel designed by Legorreta + Legorreta, the sixth by Mexico's trend-setting Grupo Habita. The retention of many of the building's original elements, including crumbling walls and stone aqueducts, lends La Purificadora an air of authenticity, while modern juxtapositions like a glass-walled swimming pool and sleek purple lounge chairs create a clean, sophisticated ambience. The stunning mix of new and old is also found in the rooftop terrace with lively bar and pool, ground-floor patio, restaurant, library, and wine cellar. Most of the hotel's 26 guestrooms—including three suites with private whirlpools—offer spectacular views of the hotel gardens and the city center beyond, a UNESCO World Heritage Site. As one would expect from the innovative hoteliers at Grupo Habita, La Purificadora offers travelers and locals alike a comforting yet always stimulating experience, a mix of tradition and contemporary flavor in its purest form. —

WHERE
Puebla
Mexico

MEMBER SINCE
09/2006

ARCHITECTURE
Ricardo Legorreta,
Víctor Legorreta
(Legorreta +
Legorreta)

DESIGN
Serrano Monjaraz
Arquitectos

ROOMS
26

RATES
USD 145–470

MEET THE ORIGINALS
Carlos Couturier,
Moisés Micha

# Boca Chica

Just steps from an idyllic cove, Boca Chica is a grand addition to Acapulco. Once the playground of the Hollywood elite, this upscale area first came to prominence when Orson Welles filmed The Lady from Shanghai in the old city center in the late 1940s. Located in the district of Caleta, the 36-room hotel was constructed in the late 1950s next to the glamorous Club de Yates and the famed Los Flamingos Hotel. Today, the vintage exterior looks like it's straight out of a 1950s movie set, but inside, the reinvigorated interior has been chicly remodeled by designers Frida Escobedo and José Rojas. Vintage pieces were curated by Mexican contemporary artist Claudia Fernández, and the spacious, tropically designed rooms come with large hammocks, outdoor living rooms, and private gardens. Guests can have a soothing massage downstairs, sip a frozen margarita at the popular in-house disco, hang out on a pool terrace, or order 24-hour sushi room service. —

WHERE
Acapulco
Mexico

MEMBER SINCE
03/2009

ARCHITECTURE
Antonio Peláez

DESIGN
Frida Escobedo,
José Rojas

ROOMS
36

RATES
USD 145–355

MEET THE ORIGINALS
Carlos Couturier,
Moisés Micha

# Hotel Escondido

Perhaps one of the most important elements of good design is that it feels like a living, breathing part of its surrounding environment. Grandeur in the wrong setting can feel, well, wrong. Just as casual beach-chic in a glitzy city neighborhood can also miss the mark. Few understand this concept of creating something unique, that also fits within its world, as well as hoteliers Carlos Couturier and Moisés Micha. In the tiny town of Puerto Escondido, on a pristine stretch of Oaxacan coastline that has long been loved as a top-ten surfing spot and fishing destination, the duo behind Grupo Habita built Hotel Escondido. Matching the right design, look, and feel with this pristine setting, they created a private paradise that instantly caught the eye of design lovers, but that also seemed a natural extension of the beach itself.

Carlos Couturier sums up the strategy they apply with each of their hotels: "We use a local team every time we build a hotel, and we read the surroundings and their traditions to integrate the local culture into our project." The results speak for themselves. Hotel Escondido offers a modern take on the traditional Oaxacan beach hut, cultivating a sophisticated atmosphere with a cheerful, centrally located bar and an underground dance club. Each of the 16 bungalows emphasizes a commitment to local tradition and design with traditional palapa rooftops on each hut and a purely Mexican color scheme throughout.

The local feel, of course, isn't limited to a Couturier and Micha exterior. Here at Hotel Escondido, for example, minimal yet comfortable design elements feature tropical wooden floors, stucco walls, and polished concrete. And all of it is amplified by the myriad opportunities that the resort offers guests. Surfing, boating, and kayaking lessons occur steps from the door of the bungalows, while those wishing to explore the surrounding area can visit the nearby lagoon. Guests wishing to recharge after an action-packed day in the surf or surrounding nature can recline by their own private pool and sundeck, unwind with an in-room massage, and enjoy locally sourced dishes inspired by the internationally renowned Oaxacan cuisine.

For Carlos Couturier and Moisés Micha, building hotels that reflect their surroundings is more than just a job: It is the passion that drove these two Mexican entrepreneurs to leave their respective former lives in the citrus growing business. They met during university and quickly became friends, ending up joining forces in the real estate business. The transformation to building a hotel collection focused on art and design came naturally; both are avid art collectors and active in the Mexican art community.

Couturier and Micha are passionately committed to investing in the regions in which they build their hotels, from Mexico to the United States. Both are naturally very mobile, jet-setting from one art fair and hotel to the next, but without ever losing track of home and their families.

All this travel is a result of the duo's bold vision and success. In Mexico City, where they have become incredibly successful with Grupo Habita, Couturier and Micha sit on the boards of the city's most important fine arts institutions and host artists' openings at their esteemed boutique hotels which include: Azúcar, Boca Chica, Condesa*df*, Deseo [Hotel + Lounge], Distrito Capital, Habita, Habita Monterrey, La Purificadora, Maison Couturier, Downtown Mexico, and Endémico. In Manhattan, where they have the Hôtel Americano, they know the best places to find everything from pizza to fine arts photography, bespoke fragrances, and antique watches.

Together, Couturier and Micha make a perfect pair: They are ambitious but fun-loving, well-traveled but immensely tied to their Mexican roots. "Even if we're successful at something, we don't repeat it," Couturier says. "We like this sense of passion and audacity."

Those two words—passion and audacity—are a perfect way to describe the mindset behind Hotel Escondido, which is a high-style hangout for the thrill seeker or the laid-back beachgoer. Those who have already visited this natural jewel, nestled between the Pacific Ocean and the Sierra Madre del Sur mountain range, pay it the ultimate compliment, saying that it has a great contemporary feel but looks as if it's been here for ages. In other words, exactly what Carlos Couturier and Moisés Micha had planned from the start. —

More from Grupo Habita:

MEXICO
Acapulco, Boca Chica → P. 045
Guadalajara, Casa Fayette → P. 060
Mexico City, Condesa*df* → P. 040
Mexico City, Distrito Capital → P. 034
Mexico City, Downtown Mexico → P. 033
Mexico City, Habita → P. 041
Monterrey, Habita Monterrey → P. 042
Playa del Carmen, Deseo [Hotel + Lounge] → P. 052
Puebla, La Purificadora → P. 044
Veracruz, Azúcar → P. 051
Veracruz, Maison Couturier → P. 050

UNITED STATES
New York City, Hôtel Americano → P. 070

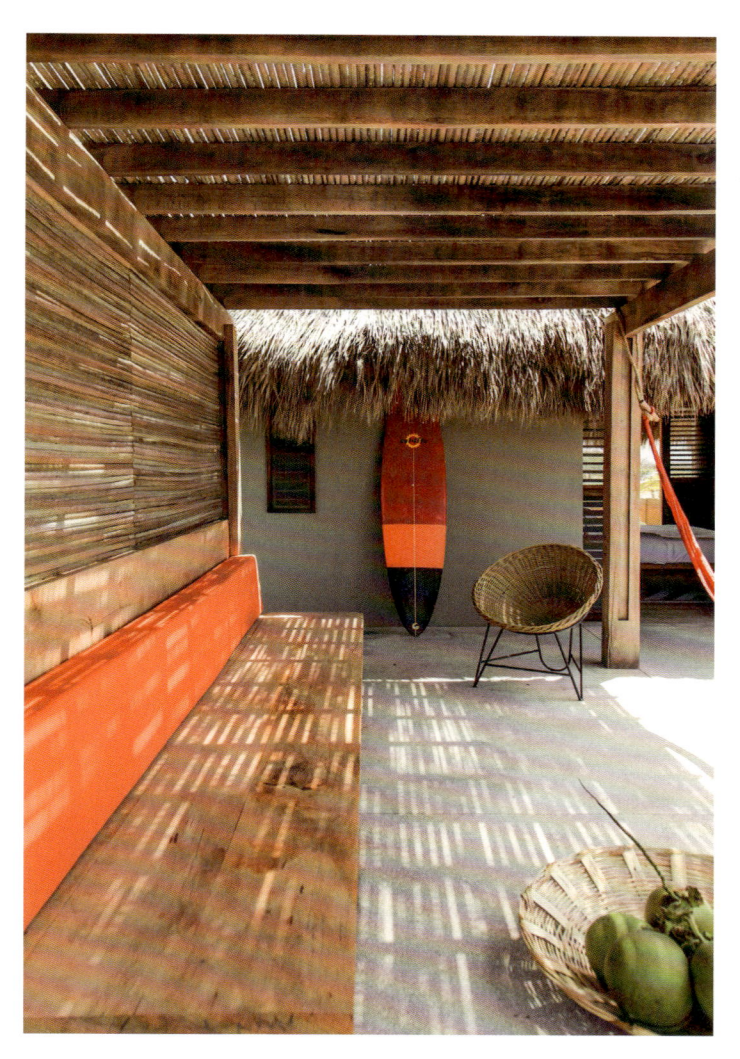

| WHERE | ROOMS |
|---|---|
| Puerto Escondido | 16 |
| Mexico | |
| | RATES |
| MEMBER SINCE | USD 310–535 |
| 01/2013 | |
| | MEET THE ORIGINALS |
| ARCHITECTURE / | Carlos Couturier, |
| DESIGN | Moisés Micha |
| Federico Rivera Río | |

"We use a local team every time we build a hotel, and we read the surroundings and their traditions to integrate the local culture into our project."

CARLOS COUTURIER

# Maison Couturier

WHERE
Veracruz
Mexico

MEMBER SINCE
09/2009

ARCHITECTURE /
DESIGN
Carlos Couturier

ROOMS
18

RATES
MXN 1,900–2,700

MEET THE ORIGINALS
Carlos Couturier,
Moisés Micha

Built by French immigrants in the 19th century, Maison Couturier is an agricultural estate in the tropics of Veracruz, Mexico. Based on family traditions handed down through generations, the resort preserves the heritage of its French founders in this secluded tropical enclave. Maison Couturier is a place where guests and visitors alike can come to breathe in the fresh scent of nature and drink of the refreshing waters of history preserved. Guests can choose between eight bungalows and the landowner's suite, "la chambre du maître," in which they can enjoy massages, private terraces with hammocks, and all of the amenities of contemporary living, such as wireless Internet, air-conditioning, and plasma-screen televisions. The restaurant in the main house draws on the best of the French bucolic culinary tradition, offering its guest *fait maison*. Guests are also invited to enjoy a cocktail full of fresh local fruit at the bar, sit by the pool in the shade of a palm, or partake in an excursion to the region's secret archaeological sites. When the best of the Mexican and French traditions are combined, along with a splash of contemporary luxury, the result is pure, natural bliss … and that is what Maison Couturier provides. —

# Azúcar

From the founders of ultrahip Mexican hotels Condesa*df* and Deseo [Hotel + Lounge] comes Azúcar, named for the sugar cane grown in the state of Veracruz, where this hideaway is located. The "sweet" resort is effortlessly elegant, featuring 20 low-lying whitewashed *palapas* (bungalows), each topped with a thatched roof.
"I wanted to recuperate a lifestyle gone by," explains hotelier Carlos Couturier.
"To give guests the pleasures of simple things." Thus, chairs are reproductions of those his grandparents had on their 1930s ranch, and each bungalow is named after a Veracruz sugar mill. A back-to-basics white-on-white aesthetic offers an authentic style that both hearkens to the past and fulfills the modern traveler's aesthetic demands. A locally made hammock stretches across the private patio featured in every *palapa*, inviting guests to swing as the Gulf breezes blow; the airy ease makes the resort a haven for those weary of mass tourism. Highlights include a relaxing *biblioteca* (library) where guests can lounge in wicker chairs under an open thatched ceiling, as well as an outdoor spa that features a yoga space and an array of holistic spa services. True to its name, Azúcar is like a sweet treat that keeps guests coming back for more. —

| WHERE | VILLAS |
|---|---|
| Veracruz | 20 |
| Mexico | |
| | RATES |
| MEMBER SINCE | MXN 1,770–7,900 |
| 07/2006 | |
| | MEET THE ORIGINALS |
| ARCHITECTURE | Carlos Couturier, |
| Elías Adam (Taller | Moisés Micha |
| de Arquitectura) | |
| DESIGN | |
| Carlos Couturier | |

# Deseo [Hotel + Lounge]

**WHERE**
Playa del Carmen
Mexico

**MEMBER SINCE**
07/2001

**ARCHITECTURE**
Moisés Ison,
José Antonio
Sánchez (Central de
Arquitectura)

**DESIGN**
Héctor Galván
(Omelette)

**ROOMS**
15

**RATES**
USD 160–440

**MEET THE ORIGINALS**
Carlos Couturier,
Moisés Micha

A glowing white two-story structure in the mellow fishing village of Playa del Carmen, the Deseo has become one of the hottest spots on the Yucatan Peninsula. Created by the groundbreaking Mexican Grupo Habita, the hotel evokes the charm of the Caribbean coast while creating a level of sophistication aimed directly at the discerning international style connoisseur. The hotel's focal point is the lounge area, which combines the functions of lobby, restaurant, bar, and pool. Set on a raised open-air platform, it is furnished with comfortable Belize chairs, generous daybeds, and breezy linen curtains that contribute to the relaxed Caribbean atmosphere and encourage social inter-action. The DJ's chilled-out tunes provide the perfect sonic backdrop to the comfortable setting. Each of the 15 sound proof rooms and suites provides a literally and emotionally cool retreat from the heat with the help of cream marble floors and a natural color palette designed to soothe both the eye and the mind. Comfortable, visually striking guestrooms boast fun details like sliding wood doors, beach fiesta kits, and hammocks. More traditional style elements, like the imposing stone entrance modeled on a Mayan temple, manage to ground the design concept with local tastes. —

# Hotel La Semilla

Hotel La Semilla owners Alexis Schärer and Angie Rodriguez have infused the hotel with a strong sense of Mexican heritage with a global flavor. The couple chose the name Semilla, meaning seed, and it's with their loving attention to detail that they've planted new experiences for guests to take home. Located in the trendiest part of the coastal resort town Playa del Carmen, Hotel La Semilla is surrounded by charming boutiques and cafés in the midst of cenotes, jungle terrain, and a Mayan ruin. With its laid-back atmosphere and its "Rough Luxe" design, the hotel embraces the imperfection created by the wear and tear of time. Schärer and Rodriguez have carefully blended re-used materials, polished concrete, handmade mosaics, and mismatched vintage furniture to create a vibe that is authentic and unpretentious. With hospitality in Schärer's bloodline, combined with Rodriguez's talents in photography, jewelry design, and painting, the globetrotting couple took inspiration from their years of experience and travels. To add to the homey atmosphere, the owners are on hand in the Cocina Loft restaurant, either serving breakfast (the only meal served at the hotel) or for a chat. Guests are also encouraged to explore the owner's favorite restaurants—ones that offer up a truly local experience—or to bring their own food and beverage into Hotel La Semilla to be enjoyed in any of the lounge spaces or even in the garden surrounded by candles. At La Semilla, the timeless white palette throughout translates into a seaside chic that is home on the shores of the Caribbean. —

WHERE
Playa del Carmen
Mexico

MEMBER SINCE
03/2014

ARCHITECTURE /
DESIGN
Andres Ocejo,
Angie Rodriguez,
Alexis Schärer

ROOMS
9

RATES
USD 180–250

MEET THE ORIGINALS
Angie Rodriguez,
Alexis Schärer

# Casa Malca

One of the world's best-preserved coastal Mayan sites, Tulum, is a beacon for those who enjoy their culture and history set in paradise along a spectacular Caribbean coastline. But Tulum is also a place of myth and mystery. Here, the energetic pull of the Mayans and their many temples, which tower atop majestic cliffs, evoke passion and inner power among visitors. Here, too, on the most exclusive and quiet southern end of Tulum, one finds Casa Malca. Set on perhaps the widest of the endless white sand beaches found in this corner of the Yucatan Peninsula, the 8-room resort marries three spiritually inspiring elements—art, nature, and laid-back luxury. The driving force behind the property, Lio Malca, is a lion in the art world, having specialized in works by contemporary and modern masters, such as Jean-Michel Basquiat and Keith Haring, while launching retrospectives at New York's Whitney Museum and other top venues. For Casa Malca, which is by far the largest house on the Tulum beach, he brings artwork worthy of a museum. But Casa Malca is also set in a natural wonderland surrounded by a lush jungle. And to best showcase it, Malca has built a staircase to the roof, which affords guests access to a bar and

the best spot in Tulum to take in the sunset. The luxury at Casa Malca, meanwhile, is felt by all the senses thanks to a large welcoming pool, cuisine that is nurtured with local ingredients and respect for local products, and an eco-friendly living environment that immerses one in a beautiful, earthy, and unforgettable charm.

Since his emergence in the New York art world in the early 1990s, Lio Malca has specialized in works by contemporary masters while collaborating and assisting on major worldwide retrospectives at the Brooklyn Museum NY, Beyler Foundation Basel, Musee d'Art Moderne de la Ville de Paris, and other top venues. Today Malca is celebrated for recognizing the talent of many top contemporary artists at a very early stage of their careers, Vik Muniz among them. At Casa Malca, he proudly showcases a carefully selected roster of Modern and Contemporary Masters, displaying a socially progressive and visually commanding international collection. —

| WHERE | ROOMS |
|---|---|
| Tulum | 8 |
| Mexico | |
| | **RATES** |
| **MEMBER SINCE** | USD 450–1,200 |
| 01/2015 | |
| | **MEET THE ORIGINAL** |
| | Lio Malca |

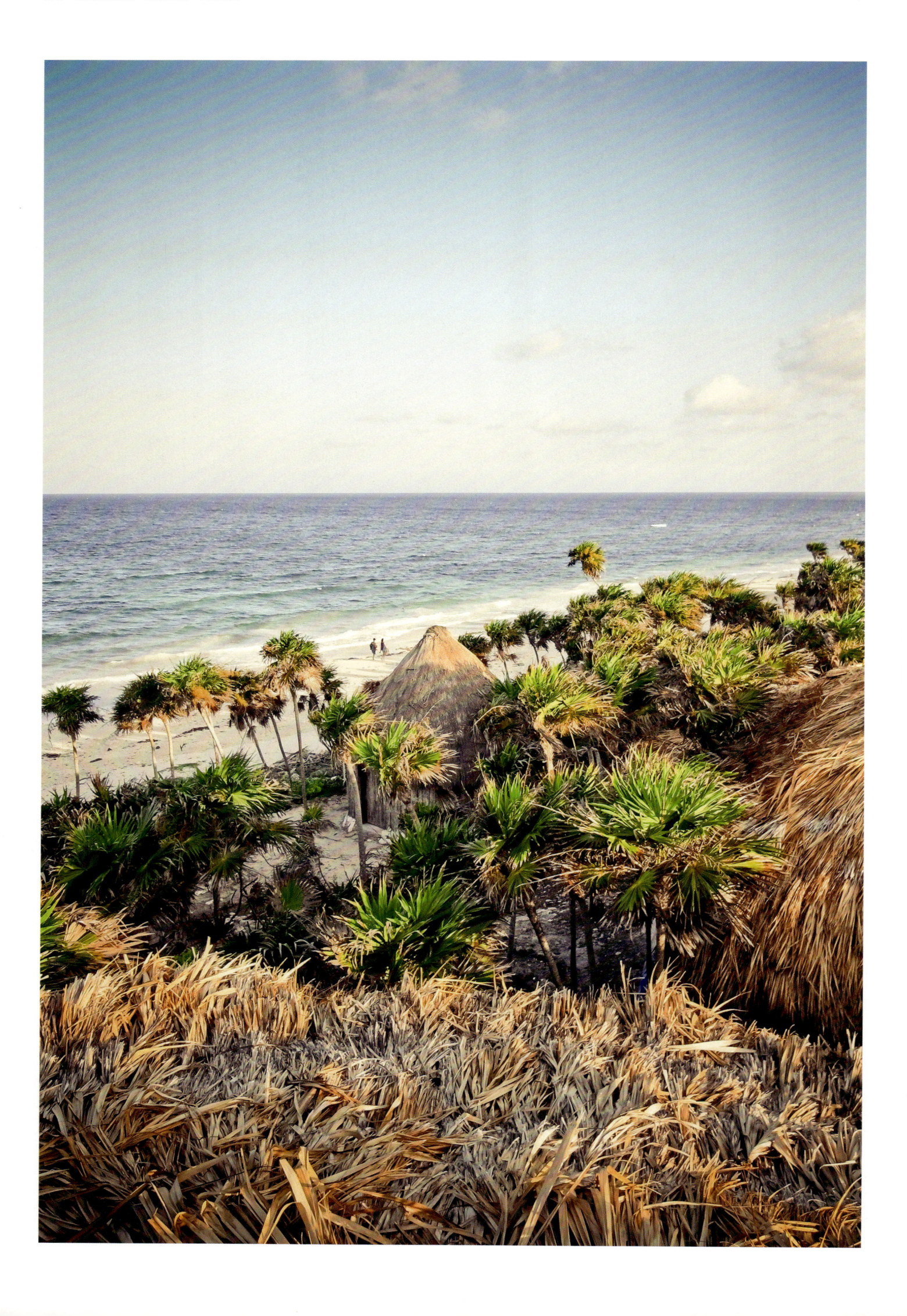

# Papaya Playa Project

Cocooned by the jungle, on a pristine stretch of the Caribbean coast lies a raw-luxe camp with an urban spirit—a communal playground for a creative community seeking reconnection with nature and themselves. Together with Emilio Heredia, owner of the existing Papaya Playa Beach Bungalow Resort, Design Hotels™ has created a destination in paradise. The 80 cabanas and two villas possess a rustic charm and celebrate the luxury of simplicity, with something to suit every need and budget— from Casitas with large private terraces, to modest shared Jungle Cabanas with bunk beds and a communal bathhouse. The resort's restaurant overlooks the azure waters, where diners can enjoy freshly baked goods straight from the clay oven and locally-sourced specialties prepared on the open-air grill. Directly on the beach, drinks and snacks are served from late morning until late evening at the resort's Beach Club. Completing the holistic circle, the Sensorial Spa uses Mayan shaman secrets, going beyond the usual wellness offerings, with the aim of nurturing the mind as much as the body.

The spa is a vibrant indoor and outdoor space on the beach, where in addition to massages and beauty treatments, guests can also enjoy yoga, tai chi, meditation, as well as fresh juices, snacks, tea, and smoothies. Being linked to the best DJs in the world, Papaya Playa makes music a key component of the experience with impromptu jam sessions in the sand, ambient beats at the spa, and celebrations to welcome the arrival of every full moon.

Emilio Heredia has spent the last 30 years dedicated to his own spiritual development through the study of yoga, in its different forms, religion, philosophy, metaphysics, karate, the Tao, and Corporal Psychotherapy. Emilio's business expertise are equally profound. With degrees in Electronic Engineering and Finance, he has served as chairman of various financial institutions in Mexico and New York. Intrigued by the magic and mysticism of the Mayan culture, Emilio moved to Tulum 12 years ago. He came with the vision of merging his passion for personal development with his financial know-how to create a sustainable community that learns from and gives back to the local Maya. —

| | |
|---|---|
| **WHERE** Tulum Mexico | **ROOMS** 80 |
| | **VILLAS** 2 |
| **MEMBER SINCE** 12/2011 | |
| | **ROOM RATES** USD 105–900 |
| **ARCHITECTURE / DESIGN** Design Hotels™ Design Team | |
| | **VILLA RATES** USD 1,500–6,000 |
| | **MEET THE ORIGINAL** Emilio Heredia |

# Rosas & Xocolate

WHERE
Mérida
Mexico

MEMBER SINCE
10/2008

ARCHITECTURE
Juan Carlos Galván,
Salvador Reyes Rios
(Reyes Ríos +
Larraín Arquitectos)

ROOMS
17

RATES
USD 245–695

MEET THE ORIGINAL
Carol Kolozs

Rosas & Xocolate is designed for guests who take romance seriously. Located in Mérida, the capital of the Mexican state of Yucatan, this all-natural getaway lies in the rich area where the Mayan civilization first discovered cocoa and offered it up to their gods. With Rosas & Xocolate, hotel owner Carol Kolozs has breathed new life into the once glorious avenue of Paseo de Montejo, now the cornerstone of the cultural capital's rehabilitation. Reconstituted from two colonial mansions, and winner of *Architectural Digest's "Iconos del Diseño 2011"* for the best architectural restoration in Mexico, Rosas & Xocolate offers a haute-pueblo experience that perfectly melds the charm of the historic mansions with modern amenities, such as state-of-the-art entertainment systems and dazzling open-sky bathtubs for guests who desire the utmost in under-the-stars indulgence. Upping the romance factor, fresh-cut roses are placed liberally throughout the 17 rooms and suites, and chocolate-based spa treatments and sweet-smelling amenities are lovingly engineered by master chocolatier Mathieu Brees, the force behind the hotel's own Belgian-Mexican fine chocolates boutique. The hotel's stylish use of local materials such as hand-fabricated cement tiles and chucum stucco allows guests of Rosas & Xocolate to fully experience Yucatan's old-world charm together with the city's contemporary spirit. —

# Flor de Mayo
# Hotel & Restaurant

**WHERE**
Cuernavaca
Mexico

**MEMBER SINCE**
09/2012

**ARCHITECTURE**
Yamile Márquez,
Francisco Elías
(Elías Arquitectura)

**DESIGN**
Francisco Elías
(Elías Arquitectura)

**ROOMS**
24

**RATES**
USD 185–305

**MEET THE ORIGINAL**
Benjamin Pacheco

In ancient Mesoamerican cultures, the five petals of the Flor de Mayo's blossom represented the five senses. Continuing that tradition comes the Flor de Mayo Hotel & Restaurant, where you'll find a plethora of sensory delights in the midst of Cuernavaca's natural beauty. Sight: Floral exuberance surrounds you at the Flor de Mayo, beginning with the namesake tree flourishing on the hotel's central patio. Blossoming vegetation winds its way around the patio's steel columns, the organic fusing with the man-made. The architecture combines the building's 19th-century past with contemporary design and floral ornamentation. The hotel's surroundings are also a visual treat; from the terrace, enjoy views of downtown Cuernavaca as well as the Popocatépetl and Iztaccihuatl volcanoes. Sound: A line of ceramics developed especially for the hotel includes the flower-shaped iPod speakers found in every room. Smell: Taking advantage of the bounty of the Morelos Valley, Flor de Mayo offers organic shower products made with floral extracts and honey, produced by a local organization. Taste: At the restaurant, chef Victor Olvera's seasonal cuisine fuses Mexican and Asian influences, using local fruits, vegetables, and flowers to delight the palate. You can also enjoy a selection of appetizers and aperitifs at the poolside Arriba Bar. Touch: Relax at the spa, where treatments use flowers and soil from the premises to create a unique experience. —

# Casa Fayette

When Carlos Couturier recently spoke before an important hotel tradeshow in Miami, he discussed the value of building hotels that build communities. There are few people on the planet more qualified to address this theme—except perhaps Couturier's business partner Moisés Micha. Together, the duo make up Grupo Habita, which has used its small but impeccably designed and conceived hotels to shape communities and neighborhoods in cities, resort towns, beaches, and beyond in their native Mexico, to say nothing of the Chelsea neighborhood of New York City.

Their latest addition—Casa Fayette, in Guadalajara's booming Lafayette district—masterfully showcases all of Grupo Habita's strengths. The hotel itself is a 37-room Art Deco stunner that blends early 20th-century architecture with the polished grandeur of a heavenly tower. Local architectural firm Estudio5 transformed a 1940s mansion into Guadalajara's first design-led hotel. But the exterior is only part of the bold story told here. Inside the hotel, Milanese design team Dimorestudio incorporated elements from Mexico, Italy, and a host of European designers, to give the interior global eclecticism that mimics the inspirations behind the neighborhood in which it sits.

And it's this attention to its neighborhood and the surrounding city that makes Casa Fayette so special. Second only to Mexico City, Guadalajara is considered one of Mexico's most exciting destinations. In close proximity to downtown, the neighborhood of Colonia Lafayette—also known simply as Lafayette—is Guadalajara's up-and-coming hotspot, with new restaurants, cafés, and bars attracting locals and internationals alike. Thanks to its university and a handful of contemporary art galleries, including Casa Rombo and Galería Vertice, the quarter has become a magnet for creatives. Which brings us back to perhaps Grupo Habita's biggest strength: Casa Fayette has not just entered this vibrant scene, it has become a critical and invigorating part of it. The hotel is a driving force in the neighborhood—the meet-up spot for artists and intellectuals.

For both Micha and Couturier, building hotels that fit perfectly into their surroundings is more than just a job—it's a passion that drove these two Mexican entrepreneurs to leave their respective former careers in citrus farming and investment banking. The duo met at university and quickly became friends, ending up joining forces in the real estate business. The transformation to building a hotel collection focused on art and design came naturally, and in 2000 Couturier and Micha launched Grupo Habita, a diverse collection of exquisite hotels that has grown to include more than a dozen properties. They are both avid art collectors and active in the Mexican art community. Couturier and Micha are passionately committed to investing in the regions in which they build their hotels, from Mexico to the United States. Both are undoubted jet setters, traveling from one art fair and hotel to the next, but without ever losing track of home and their families. They also sit on the boards of Mexico City's most prestigious fine arts institutions, while often hosting art openings at their esteemed boutique hotels. Ambitious but fun-loving, well-traveled but tied to their Mexican roots, the dynamic duo was awarded Team of the Year 2011 by *Fizzz Magazine*.

And now, thanks to the addition of Casa Fayette, one more accolade can be added to Couturier and Micha's growing list of praise. This one comes from Skift, the most visited travel industry news site in the U.S., which recently stated: "Grupo Habita shows how a small hotel group with impeccable insight into today's travel trends can make a big impact on the international hotel scene." Small but important—Grupo Habita would have it no other way. —

More from Grupo Habita:

MEXICO
Acapulco, Boca Chica → P. 045
Mexico City, Condesa*df* → P. 040
Mexico City, Distrito Capital → P. 034
Mexico City, Downtown Mexico → P. 033
Mexico City, Habita → P. 041
Monterrey, Habita Monterrey → P. 042
Playa del Carmen, Deseo [Hotel + Lounge] → P. 052
Puebla, La Purificadora → P. 044
Puerto Escondido, Hotel Escondido → P. 046
Veracruz, Azúcar → P. 051
Veracruz, Maison Couturier → P. 050

UNITED STATES
New York City, Hôtel Americano → P. 070

WHERE
Guadalajara
Mexico

MEMBER SINCE
12/2014

ARCHITECTURE
Estudio5

DESIGN
Britt Moran,
Emiliano Salci
(Dimorestudio)

ROOMS
37

RATES
USD 160–1,500

MEET THE ORIGINALS
Carlos Couturier,
Moisés Micha

# Hotel Matilda

Nestled among terracotta houses and colonial-era church spires, Hotel Matilda distinguishes itself from the rest of the UNESCO-listed San Miguel de Allende through its edgy, modern decor of sleek lines and smooth surfaces that invites visitors to take a closer look. Expat artists have gathered in this colonial city for generations. That's why these cobbled streets were the ideal location for this hotel with its eclectic collection of contemporary art. Beyond the wooden gates, works by emerging and established stars of the Mexican art world define the spaces and give the hotel the mien of an art gallery. While some rotate, most of the pieces are on display permanently, such as the Diego Rivera portrait of the hotel owner's mother, Matilda, which hangs in the lobby. The minimalist motif continues in the 32 rooms and suites with a white and graphite color scheme and marble floors juxtaposed with bold turquoise accents. Awaiting guests at the holistic spa are an intimate indoor/outdoor relaxation lounge, an authentic hammam, and the first and only hotel Apothecary Concierge who prepares personalized artisanal beauty and body products. Enrique Olvera created a must-visit restaurant for foodies called Moxi, which means "craving" in the local Otomi language. The bar's innovative cocktails are crafted from indigenous fruits and herbs. Hotel Matilda has forged an identity as a cultural hub of San Miguel, with exhibits by noted artists, extravagant gourmet dinners, and such special events as art festivals, DJ dance parties, and tequila tastings.

American art collector Harold Stream has deep Latin American roots and has worked in the hospitality industry since the 1970s. Along with the director Bruce James, who has guided some of the most iconic luxury hotels in Mexico, Stream has created a hotel that embraces his vision of future hospitality. "While the typical hotel in San Miguel de Allende immerses guests in the historical past, Hotel Matilda embraces the lifestyle of today's travelers and offers them enriching new cultural and personal experiences," he said. "From an ambience filled with engaging modern Mexican art to bold new variations on Latin dishes, the hotel takes tradition and moves it forward into the future." —

Bruce James & Harold Stream

**WHERE**
San Miguel
de Allende
Mexico

**MEMBER SINCE**
10/2011

**ARCHITECTURE**
Marco Martinez
Valle (Marco
Martinez Valle
Arquitectura),
Sebastian Zavala

**DESIGN**
Meredith Mills,
Chad James
(McAlpine, Booth &
Ferrier Interiors)

**ROOMS**
32

**RATES**
USD 354–894

**MEET THE ORIGINALS**
Bruce James,
Harold Stream

# Gramercy Park Hotel

There is a moment in the film "The Diving Bell and the Butterfly" when we are all alone with the protagonist's thoughts, locked in a world where we can perceive but not communicate, where we can think but not connect.

This feeling of solitary engagement is, in a very small way, what travelers waking up in a new city can feel. We have entered a strange world where the customs, the food, even the language can be alien to what we know. It's little surprise then that the director of that powerful film, Julian Schnabel, should create a hotel that so understands the traveler's sense of alienation yet instantly overcomes it through the silently powerful world of art.

Gramercy Park Hotel, set in the heart of Manhattan, directly across from the lush, private park that gives this 185-room stunner its name, is alive with a visual language all of its own. Here, one finds one-of-a-kind furnishings, paintings, and sculptures created and curated by Schnabel that makes this more than just a unique luxury property. It is itself a work of art.

Opening its doors for decades to international artists, literati, fashion designers, and intellectuals, Gramercy Park Hotel was built in 1925 on a site that was previously home to the quintessential New York architect Stanford White. By the early 2000s, the elegant Renaissance Revival building was in distinct need of a makeover.

Minimalist architect John Pawson was tapped to refine the exteriors and, along with Schnabel, joined the grand efforts to take the Gramercy Park Hotel into the next century. The latter's use of elements like textured, reclaimed wood make the soaring public spaces feel both earthy and sculptural. Together with real estate mogul and art collector Aby Rosen and Studio 54 co-founder Ian Schrager, Schnabel transformed the century-old Gramercy Park

Hotel—once the headquarters for high bohemia—into an exquisite gallery hotel infused with intense feeling and opulent tactility.

Gramercy Park's genteel glamour is indeed a rare feat. Schnabel approached the design more as a painter than a decorator. Bespoke furnishings adorn each of the guestrooms, which are richly layered with velvet curtains, leather wing chairs, and original art by David Salle, Robert Mapplethorpe, and Jean-Michel Basquiat. Sensual fabrics and a Renaissance-inspired color palette give guests the feeling of floating through a living masterpiece.

The property's seven specialty suites are each unique, with spacious living rooms; some also come with dining rooms and bathrooms featuring custom sculpted soaking tubs. A highlight of securing a room at this legendary hotel is getting a key to the exclusive Gramercy Park, the only gated private patch of green in Manhattan.

With a lushly landscaped rooftop garden, al fresco dining, and engagingly designed interior spaces, the hotel also offers many evocative places in which to lounge. Danny Meyer's Maialino achieves the rare feet of not only connecting the powerful and purpose-filled, but welcoming the traveler who simply seeks to relax over coffee. Gramercy Terrace, meanwhile, is a private roof club and landscaped garden that serves as a sanctuary from the city. And the eclectically decorated and candlelit Rose Bar and Jade Bar both have a long list of classic and exotic cocktails—two adjectives that could well describe its clientele.

Gramercy Park Hotel is filled with spaces that get you thinking. They connect you with those around you—even if you don't say a word. But perhaps Schnabel himself best sums up the allure of the hotel. "Basically, I'm a painter," he says, "I built a place I'd like to be in." —

WHERE
New York City
United States

MEMBER SINCE
06/2011

ARCHITECTURE
Robert T. Lyons,
John Pawson

DESIGN
Julian Schnabel

ROOMS
185

RATES
USD 425–5,000

MEET THE ORIGINAL
Julian Schnabel

# Hôtel Americano

A decade after bringing a distinctly high-design sensibility to cities and resorts in their native Mexico, Carlos Couturier and Moisés Micha are tackling an entirely different market: New York City. With their Hôtel Americano, located in the heart of Chelsea's art gallery district, the partners celebrate their love of contemporary art and their passion for Manhattan. As Couturier explains, "We want to tell a story about Latin America and New York. A New Yorker is always an Americano, because New Yorkers live in a city where they have to adapt all the time." Hôtel Americano has a cool industrial Manhattan veneer but a warm Latin soul. The 56-room hotel features decidedly Mexican touches, such as an outdoor rooftop pool, along with New York-style details such as iPads in every room, which are full of recommendations for the best local galleries, restaurants, and shops. Hôtel Americano has two restaurants and bars, as well as locally produced bicycles that guests can use to explore the High Line and Hudson River Park. "New York can be overwhelming for visitors. In our hotel, guests feel safe, and they feel comfortable," says Micha. "We have this Latin American approach, so that you'll feel the warmth."

For Carlos Couturier and Moisés Micha, building hotels that reflect their surroundings is more than just a job—it's a passion that drove these two Mexican entrepreneurs to leave their respective former careers in citrus farming and investment banking. In 2000, Couturier and Micha launched Grupo Habita, a diverse collection of exquisite hotels that has grown to include 14 properties with new properties opening in Guadalajara, Chicago, and LA over the next two years. Today, Couturier and Micha sit on the boards of Mexico City's most prestigious fine arts institutions, while often hosting art openings at their esteemed boutique hotels. Ambitious but fun-loving, well-traveled but tied to their Mexican roots, the dynamic duo was awarded Team of the Year 2011 by *Fizzz Magazine*. —

More from Grupo Habita:

WHERE
New York City
United States

MEMBER SINCE
01/2011

ARCHITECTURE
Enrique Norten
(Ten Arquitectos)

DESIGN
Arnaud Montigny
(MCH Arnaud
Montigny)

ROOMS
56

RATES
USD 375–695

MEET THE ORIGINALS
Carlos Couturier,
Moisés Micha

Carlos Couturier & Moisés Micha

Kit Kemp

# Crosby Street Hotel

Tim and Kit Kemp, champions of the London hotel world, have ventured across the Atlantic with the Crosby Street Hotel—reinventing their singular, eloquent aesthetic to match the individuality of New York's abiding cultural hub, SoHo. Each of the 86 individually designed rooms in this eleven-story edifice boasts a flat-screen LCD television, DVD/CD player, iPod docking station, WiFi, Rik Rak bathroom amenities, high ceilings, and warehouse-style, full-length windows. The upper-floor suites offer unparalleled luxury and an impeccable 360-degree view of one of the world's most vibrant and glamorous skylines. The brasserie-style Crosby Bar, serving fresh, seasonal food, with its beautiful gray oak floors, a long pewter bar, and broad windows and doors facing a lush courtyard sculpture garden, juxtaposes the best of UK and NY traditions: afternoon tea and the perfect cocktail. Guests can also take their meals in the commodious bar, enjoy the serenity of the sumptuous drawing room, hold meetings in one of the spacious and stylish event, meeting, or screening rooms, or finally release the day's tension in the fully equipped gym. Sometimes it takes the fresh eye of a foreigner to perfectly capture the essence and spirit of a city.

Firmdale Hotels owns and operates eight hotels in London and one in New York City. Bold colors, contrasting fabrics and patterns, and one-off pieces from around the globe combine to create the Kit Kemp look. The guests are a vital part of each hotel's design and they always have a point of view. Kit says "It's really fantastic that we're attracting guests who are adding their touches to the hotel. And, at the end of the day, it is about the guest. If we make people feel like individuals, then they want to contribute something." —

| WHERE | ROOMS |
|---|---|
| New York City | 86 |
| United States | |
| | RATES |
| MEMBER SINCE | USD 555–5,000 |
| 09/2009 | |
| | MEET THE ORIGINAL |
| DESIGN | Kit Kemp |
| Kit Kemp | |

# The Ludlow Hotel

Sometimes you find a hotel. And sometimes that hotel finds you. For prolific New York hoteliers Sean MacPherson and BD Hotels owners Ira Drukier and Richard Born the latter was definitely the case when they stumbled upon a derelict building right in Manhattan's sizzling Lower East Side neighborhood.

Abandoned by its original developers after the financial crash, the structure, with its solid brick façade and factory casement windows, fit seamlessly into its historic locale. And what history! Here, in a neighborhood famed for its "Gangs of New York" era, its Jewish immigration, and its wild art and music scenes, the Ludlow Hotel was born.

Connecting a rich past with a vibrant neighborhood scene today, the 175-room Ludlow comes alive as soon as you walk through the steel and glass doors of the lobby and into a lounge with oak-paneled walls, antique chandeliers, and Parisian- and New Orleans-inspired craft cocktails. The rooms have a lofty industrial vibe thanks to those big windows, furry throws on chairs, and lavish bathrooms. And the hotel's restaurant, Dirty French by Major Food Group, serves inspired Gallic classics with a New York sensibility.

But more than just a hotel and restaurant, The Ludlow has become what all hotels aspire to: A fixture in the neighborhood that attracts locals as well as guests. And it starts with the welcome. The lobby garden is flooded with plenty of natural light, while exotic hanging fixtures soften the industrial vibe of the building. But it's the lobby atrium that steals the show, harkening back to the days when downtown lofts would host one-off parties in which a mix of creative people were thrown together. "Those spaces were magnets," MacPherson says. "We'd like The Ludlow to function as a living room for the neighborhood."

The hotel is certainly off to a good start, hitting all the right design notes. A glorious distressed limestone fireplace dominates the lobby lounge. Marble mosaic floors, an eclectic mix of vintage furniture and handpicked finds, and striking art create both a private and personal feel, like a New Yorker's downtown living space. No surprise then that The Ludlow attracts the many creative types who live in the neighborhood.

That sense of being in an intimate part of the city and the local community is not limited to the hotel's inviting public spaces. The Ludlow's Terrace suites come with a sizeable outdoor space where guests can enjoy breakfast and city views that literally connect one to Manhattan's Lower East Side. Set between the Bowery and the East River, and Canal Street and East Houston Street, the Lower East Side is the place where New Yorkers come to express themselves and be a part of the young, hip scene that gave birth to CBGB and its successors. It's crowded and pulsing with energy, yet those who live here—or come for a great meal at a great price or a long, slow coffee in a cool café—would have it no other way.

The Ludlow is now certainly a part of this rich neighborhood's equation, because, as MacPherson notes, the best hotels have human fingerprints: "I don't need to like a person's style," he says, "but I want to feel their presence and a sense of place." That sense of place is alive and well at The Ludlow Hotel. —

| WHERE | ROOMS |
|---|---|
| New York City United States | 175 |
| MEMBER SINCE 03/2015 | RATES USD 245–2,450 |
| ARCHITECTURE / DESIGN Sean MacPherson | MEET THE ORIGINALS Richard Born, Ira Drukier, Sean MacPherson |

# Space

## COPENHAGEN

"SCANDINAVIAN DESIGN" IS A LABEL THAT THIS DUO
UNDERSTANDS YET TRANSCENDS IN ITS MISSION TO CREATE
UNEXPECTED LOOKS THAT ARE BORN FROM ITS
NORDIC HERITAGE BUT ACHIEVE A RELEVANCY THAT
KNOWS NO BORDERS.

*"We are Scandinavians, so that is our background and cultural heritage. But we also find the stereotype look perceived as Nordic a bit boring and misconceived."*

SPACE COPENHAGEN

"Nordic is not a certain look," says Signe Bindslev Henriksen, co-founder of the Danish design firm Space Copenhagen. While she and partner Peter Bundgaard Rützou understand that their Scandinavian heritage plays an integral role in their design practice, they believe that their aesthetic is more complex than a simple catchphrase like "Scandinavian design." "It is more a certain feel, a preference for composing space and using organic materials, an atmosphere, an interest in nature, a need for the tactile. It's personal, honest, and can take form in many different ways—it can be melancholic and dark, rough or smooth, light and poetic," says Henriksen of Space Copenhagen's design work, which spans lighting, furniture, hotels, and private residences (not to mention the interior of one of the world's best restaurants).

This familiarity with the subtle, sometimes contradictory, nuances of Nordic culture made the two Royal Danish Academy of Fine Arts graduates an ideal match for acclaimed Danish chef René Redzepi's 2012 renovation of Noma, the two-Michelin-star Copenhagen restaurant that tops the World's 50 Best Restaurants list year after year. His approach to cuisine—a focus on naturally sourced, seasonal ingredients remixed in unexpected ways (he serves oysters with gooseberry and buttermilk, for example, on top of stones plucked directly from local waters, giving guests a literal "taste" of the immediate environment)—has been effectively translated into the decor.

"We worked from our intuition, creating a dreamy atmosphere that seemed in sync with the building and the philosophy of the cuisine, rather than following a certain style," Henriksen said in 2012, shortly after the reopening. The team had shed the traditionally warm, golden tones of the dining room

in favor of a more Nordic flavor that speaks both of the local natural resources as well as the restaurant setting's chilly northern climate. They shifted the interior color scheme to one of deep blacks and smoky grays—expressed in wood, stone, leather, and fur—with a few bright flourishes of brass. They also added their own furniture range, a series of sofas and chairs called the Rén Collection designed for Stellar Works, distinguished by its Danish Modern silhouettes spiced with influences borrowed from Japan and China. The resulting space emphasizes the quintessentially Scandinavian extremes of richness and austerity, of wildness and elegance. Redzepi described the end result as if the restaurant had moved 100 kilometers north.

Space Copenhagen is equally adept at taking on landmarks of national heritage. For example, with the historic silver house Georg Jensen, the pair designed its Beijing retail spaces and a few *objets d'art* infused with a dose of humor, including assertively asymmetrical, organically shaped bowls of mirror-polished stainless steel.

Space Copenhagen's wide appeal extends across the ocean to New York City, where its unique take on, and departure from, Scandinavian design pervades. Here, in Manhattan's vibrant SoHo district, the duo has designed the newly opened 11 Howard, a sleek, 221-room boutique hotel.

With this neighborhood-defining project, hotelier Aby Rosen's vision was to create both a seamless experience for hotel guests and a cultural hub for the surrounding, artistically minded neighborhood, complete with a lounge-like lobby where both guests and locals can casually interact. Enter Space Copenhagen. The design team gutted a characterless structure, reinventing the interiors

## SIDE NOTES

NAMES *Signe Bindslev Henriksen & Peter Bundgaard Rützou*

COMPANY NAME *Space Copenhagen*

COMPANY HEADQUARTERS *Copenhagen*

NUMBER OF PEOPLE IN COMPANY 12

WEBSITE *spacecph.dk*

SIGNATURE PROJECTS *Copenhagen: Noma; Geist; Balthazar at Hotel D'Angleterre; Fritz Hansen showroom; Café at Louisiana Museum of Modern Art Beijing: Georg Jensen retail outlet New York: 11 Howard Products: Rén Collection for Stellar Works; Liquid Collection for Georg Jensen*

## SIGNIFICANT AWARDS

2013 *Restaurant & Bar Design Award, Shortlist for Balthazar*

2013 *Wallpaper\* Design Award, Best Restaurant Shortlist for Geist*

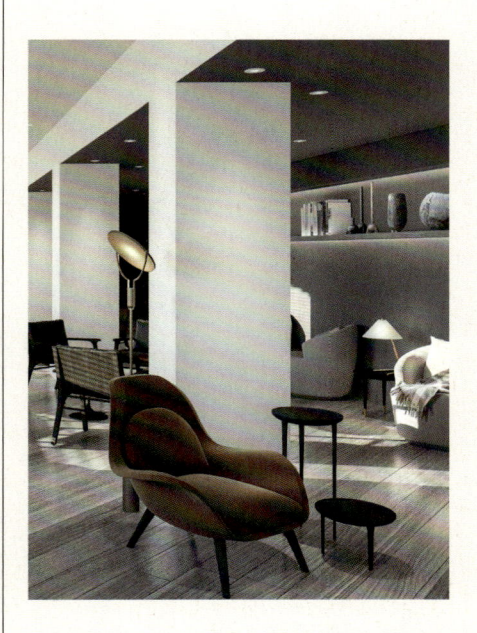

*For 11 Howard, in New York City's fashionable SoHo district, the design team gutted a characterless structure built in 1961, and reinvented the space with a dose of Scandinavian minimalism.*

with a dose of Scandinavian minimalism and focusing on details both large and small. The rooms contain custom furniture and lighting by Danish brands Mads Raaschou and Gubi, with a few pieces by Space Copenhagen themselves, and the floors, designed especially to welcome bare feet, feature oak planks combined with soft natural bamboo area rugs. All rooms have beautiful high ceilings and windows that allow for an abundance of natural light, with a materials palette—subtly-hued variations of wood, warm metals, velvet, and wool—that will grow in character as they age.

Aging gracefully, of course, is a cliché of timeless Scandinavian design, but Space Copenhagen's aesthetic mission goes beyond the limits of clichés.

"We were born and have grown up in the north. We are Scandinavians, so that is our background and cultural heritage," Henriksen acknowledges, getting back to that "Scandinavian designers" label that the pair understand though are hesitant to embrace. "But we also find the stereotype look perceived as Nordic a bit boring and misconceived." And there is most definitely nothing boring about Space Copenhagen. Through its masterful art of remixing, the pair brings the traditions of their heritage into the 21st century and—given the flood of acclaim the work receives—to ever-increasing locations throughout the world.

*Text: Janelle Zara*

1 *For Noma, in Copenhagen, frequently called the world's best restaurant, the design team perfectly achieved a calm, earthy experience that balances the rough, the refined, and the elegant.*

2 *Acknowledging the exquisite craftsmanship of the 1950s while offering modern flavor in a succinct and simple way, Space Copenhagen designed a collection of chairs and tables that were produced in 2011 by Fredericia Furniture.*

3 *An exercise in contrasts, the designers' Copenhagen Pendant line combines the classic and the modern, the maritime and the industrial.*

1

2

3

**4 + 5** *For Fiskebar, a fish restaurant set in Copenhagen's old meat-packing district, the duo combined traces of the setting's former history with an urban and eclectic sense of industrial poetry.*

**6** *Space Copenhagen's design for Restaurant Kul is ambitious and coolly dark, creating a mood that perfectly fits a California-inspired, charcoal eatery that focuses on multinational grilled cuisine.*

4

5

6

# 11 Howard

11 Howard, a 221-room boutique property in New York City's fashionable SoHo district, combines cutting-edge Scandinavian design with socially conscious hyperlocalism. More than just an ideal vantage point for downtown exploration, the property is an art spectacle in itself and a community hub partnered with a range of local businesses and nonprofits. Set to open in March, 11 Howard describes its raison d'etre as "conscious hospitality." This begins with the hotel's design by Space Copenhagen, a Danish firm known for its out-of-the-ordinary approach to interior spaces and responsible for, among others, the interiors of Copenhagen's Noma, frequently called the world's best restaurant. 11 Howard is Space's first project of its kind in New York, and a true standout in the city's hotel world, with an emphasis not just on form, but on long-term function. The design team has gutted a characterless structure, reinventing the interiors with a dose of Scandinavian minimalism. The rooms contain custom furniture and lighting by Danish brands Mads Raaschou and Gubi, with a few pieces by Space Copenhagen themselves, as well as the oak-plank floors with soft natural bamboo area rugs. Consciousness at 11 Howard also extends to its intuitive, discreet flow of service, which incorporates technology for self-check-in and smart room service delivery. Add to that world-class food and beverage offerings by famed restaurateur Stephen Starr; a dynamic co-working space, the 11H Collective; collaborations with standout contemporary artists, such as Katie Yang, Dan Attoe, and Hiroshi Sugimoto, and involvement with a number of nonprofit organizations and businesses (Global Poverty Project, Conscious Commerce, and others) in an effort to give back to the community and to the world, and you have an unrivaled downtown hub—cool, creative, and always conscious.

"I love SoHo," says Frankfurt-born, New York-based developer Aby Rosen, reflecting on the neighborhood of his hotly anticipated new hotel, 11 Howard. "I love the SoHo that used to be. I still love it because of its architectural importance. I think we add to the neighborhood because we are not a cookie-cutter hotel." An influential real estate entrepreneur and co-founder of RFR Holding, Rosen's notable projects include the Seagram Building and the Lever House in New York, among others. In addition to holding properties from Manhattan to Tel Aviv, Rosen also owns an impressive and ever-expanding collection of art, featuring works by Andy Warhol, Jeff Koons, and Damien Hirst. —

| WHERE | ROOMS |
|---|---|
| New York City | 221 |
| United States | |
| | RATES |
| MEMBER SINCE | USD 250–700 |
| 10/2015 | |
| | MEET THE ORIGINAL |
| DESIGN | Aby Rosen |
| Anda Andrei | |
| (Anda Andrei | |
| Design), | |
| Space Copenhagen | |

# Washington School House

Built in 1888 and named after George Washington, the Washington School House was one of the three original schools in Park City, Utah. In its current life as a hotel, it remains just as exclusive. The 12-room property is curated with a collection of Swedish and French antiques, vintage modern art, exquisite fabrics, and striking chandeliers. In lieu of a reception desk, a staff member greets you and will likely become your personal concierge. Don't be surprised if you are quickly on a first name basis.

A heated pool and hot tub chiseled into the mountainside ensure that guests can relax outdoors no matter the season. The hotel's location is a year-round destination, with the celebrity-infused Sundance Film Festival in winter and world class skiing basically at the doorstep (the hotel living room, with its massive gold gilt mirror, is a popular après ski spot). In summer, plenty of mountain biking/hiking trails, concerts, and art/music festivals keep the crowds coming back. —

WHERE
Park City
United States

MEMBER SINCE
06/2014

ARCHITECTURE
Trip Bennett
(Bennett and Assoc.)

DESIGN
Paul Wehsener,
Shannon Wehsener,
(Paul Allen Design)

ROOMS
12

RATES
USD 295–2,495

# Hotel Healdsburg

Located in the heart of California's north Sonoma wine country, Hotel Healdsburg stands on a historic town square, minutes away from some of the world's best vineyards. The three-story stucco building's warm ambience invites guests to embrace the healthy local lifestyle. Light floods through French doors leading onto private balconies, and artfully landscaped garden paths snake through the well-kept grounds. A recently refurbished pool area, by award-winning Andrea Cochran Landscape Architecture, now includes a bar and dining space, large chairs for lounging in the olive grove, custom-made dining tables, pool furniture from Janus et Cie, and Mamagreen Lounge Chairs. Culinary pleasures can be found at Cal-Italian restaurant Pizzando, which serves up pizza from a wood-fired oven and provides all-day room service and pool service. But the highlight is star chef Charlie Palmer's Dry Creek Kitchen restaurant, a celebration of fresh seasonal ingredients straight from the Healdsburg Farmers' Market, served either indoors or out on a garden patio overlooking the historic plaza—usually with a bottle of exclusive local wine. Twice a week, the hotel hosts complimentary tastings featuring local wineries, while live jazz plays in the Grand Fireplace Lounge, completing the picture of tranquil sophistication. The guestrooms, all of which recently underwent a complete update by Myra Hoefer Design in collaboration with David Baker Architects, feature custom-made beds and drawers made from three locally salvaged ancient bay laurel trees, as well as marble dining tables, linen and woven chairs, original artwork from Wade Hoefer, and handmade pottery from local designer Jered Nelson. —

**WHERE**
Healdsburg
United States

**MEMBER SINCE**
01/2001

**ARCHITECTURE**
David Baker +
Partners Architects

**DESIGN**
Frost Tsuji
Architects,
Myra Hoefer Design

**ROOMS**
56

**RATES**
USD 399–820

**MEET THE ORIGINALS**
Circe Sher,
Merritt Sher

# Hotel St. Paul

WHERE
Montreal
Canada

MEMBER SINCE
01/2000

ARCHITECTURE
In Situ Design

DESIGN
Acanto Design

ROOMS
119

RATES
CAD 179–649

MEET THE ORIGINAL
Ana Borrallo

Given that this ten-story high-rise is often described as "muscular Beaux Arts" in style, it comes as a surprise that the Hotel St. Paul's interior is so soft and ethereal. Located in one of Montreal's hippest quarters and housed in what was one of the city's first high-rises when it was built in 1900, the hotel artfully blends old and new. Several majestic details, such as a massive lobby fireplace, now covered in a layer of translucent alabaster, reveal the property's rich history. The rest has been charged with a contemporary flair that has long attracted the attention of design aficionados as well as travelers looking for urban elegance. Drawing inspiration from the Canadian landscape, guestrooms feature fire, ice, earth, and sky, as abstract metaphorical design themes that comfort and soothe guests in different ways: Earth rooms are solid, grounded, and tactile in their colors and textures, while sky rooms are atmospheric spaces that focus on light and air. Furnishings and accents in silk, stone, and metal are consistently understated, while windows on each of the hotel's nine floors of guestrooms afford beautiful views of the skyline and Montreal's historic Old Port. —

ICELAND

PAGE 088–395

# Europe

HOTELS

## 198

COUNTRIES

**Austria, Belgium, Bulgaria, Croatia, Cyprus, Czech Republic, Denmark, Finland, France, Georgia, Germany, Greece, Hungary, Iceland, Italy, Malta, Norway, Poland, Portugal, Russia, Slovenia, Spain, Sweden, Switzerland, The Netherlands, Turkey, Ukraine, United Kingdom »**

UNITED KINGDOM

Lond

13

PORTUGAL

SPAIN

Madrid

4

15°E  30°E

60°N

NORWAY
SWEDEN
FINLAND
RUSSIA

Stockholm **6**

DENMARK

Hamburg **7**  Berlin **7**
POLAND

Frankfurt **6**  GERMANY

Paris **9**  Munich **3**  CZECH REPUBLIC
UKRAINE

Vienna **6**

HUNGARY

FRANCE  CROATIA  45°N

BULGARIA  GEORGIA

Barcelona **5**  ITALY  Istanbul **6**

Mallorca **4**  GREECE

Athens **5**  TURKEY

MALTA  CYPRUS

30°N

# Kit

## KEMP

DYNAMIC, COLORFUL, INIMITABLE—HER BOLD, ORIGINAL LOOKS
HAVE TRANSFORMED THE LONDON HOSPITALITY LANDSCAPE,
RAISING THE BAR TO A LEVEL FEW OTHER DESIGNERS
CAN REACH. AND NOW SHE'S DOING THE SAME IN MANHATTAN,
WITH A SECOND HOTEL OPENING THIS YEAR.

*"When we're in the planning phase of a big project,*
*I never really go for mood boards*
*and I don't like seeing things on computers.*
*Instead, I begin with color and texture."*

KIT KEMP

London has a wonderful heritage as a buzzy, creative hub, a center of culture and design where new ideas often debut before becoming global trends. Currently, in the world of interior design—and specifically hotel design—there's been a noticeable move towards a more relaxed version of luxury. This is in no small part thanks to the colorful style of the award-winning design director of Firmdale Hotels, Kit Kemp. Her uplifting and quirky British style, has charming nods to traditionalism, with plenty of modern craft thrown in for good measure.

Alongside her husband, Tim, the couple founded Firmdale Hotels in 1985 and have gone on to launch eight London hotels, including Ham Yard, The Soho, Covent Garden, Charlotte Street, Haymarket, Number Sixteen, Knightsbridge, and Dorset Square hotels, and Crosby Street Hotel in New York. Her striking interiors have made each of their properties much sought-after destinations not only for guests, but for locals to socialize. As well as being hotspots for movie premiere parties, fashion events, and book launches, a Firmdale hotel bar is likely to include an A-list celebrity or two.

Kemp's recognizable signature is a perfect blend of vital and cheerful patterns, bold shades, and light-filled spaces that flow beautifully, all of which she fills with specially commissioned furniture and lighting, cleverly sourced art and sculpture, her own-designed pieces, and a treasure-trove of one-off finds from around the world. Her skill lies in extraordinary attention to detail and her innate ability to make everything fuse seamlessly and stylishly together, giving each hotel a unique sense of warmth.

Kemp, a trained graphic designer, but self-taught interior designer, explains how it all started. "Tim and I both hated staying in hotels and we wanted to achieve something that was rather different from a formulated, cellophane-wrapped experience, which is what we felt most hotels gave us at that time." She continues, "I always felt confident designing our first place. You know what it's like when you're young: it's like giving a child a Picasso and telling her to copy it—your ignorance carries you through. I was confident and bossy even then, I wasn't going to let anyone else do it." Since then, Kemp's nine strong, in-house design team, which includes two of her three daughters, has tackled each of her increasingly ambitious projects to great acclaim.

Kemp has described her aesthetic as "colorful and carefree" and steers clear of anything that hints at a formula, instead opting for a more playful sensibility and unlikely combinations that somehow always work brilliantly. No doubt her free-flowing ease of expression stems from her creative process. "When we're in the planning phase of a big project," she says, "I never really go for mood boards and I don't like seeing things on computers. Instead, I begin with color and texture. I love natural shades from the earth such as ochre, terracotta, sienna, indigo, and white. It's then about where you bring in the strength of color and where you cut back."

While each of her hotels looks decidedly different, there's enough of a uniting common thread to link them all. Her fondness for fabric on walls is one such theme. "I love the look," she says. "It's very tailored and cosseted, but also in a practical sense, it softens acoustics and is less easily damaged than painted surfaces." She is also greatly influenced by her love of travel and the crafts she finds all over the world. "India is definitely part of my source of inspiration," she explains. "I go quite regularly—the fabrics

## SIDE NOTES

NAME *Kit Kemp*

COMPANY NAME *Firmdale Hotels*

COMPANY HEADQUARTERS *London*

NUMBER OF HOTELS IN THE GROUP *9*

WEBSITE *firmdalehotels.com*

SIGNATURE PROJECTS *London: Ham Yard Hotel; The Soho Hotel; Covent Garden Hotel; Charlotte Street Hotel; Haymarket Hotel; Number Sixteen; Knightsbridge Hotel; Dorset Square Hotel New York: Crosby Street Hotel*

## SIGNIFICANT AWARDS

2015 *New London Architecture Award for Ham Yard Hotel*

2015 *Condé Nast Traveller (UK) Readers' Travel Awards, Best Hotel in the World for Design for Ham Yard Hotel*

2015 *Condé Nast Traveler (USA) Readers' Choice Awards, Best Hotel in London for The Soho Hotel*

2015 *Westminster Society Award for Contribution to Urban Vitality for Ham Yard Hotel*

2014 *Independent Hotel Show Awards, Independent Hotelier of the Year*

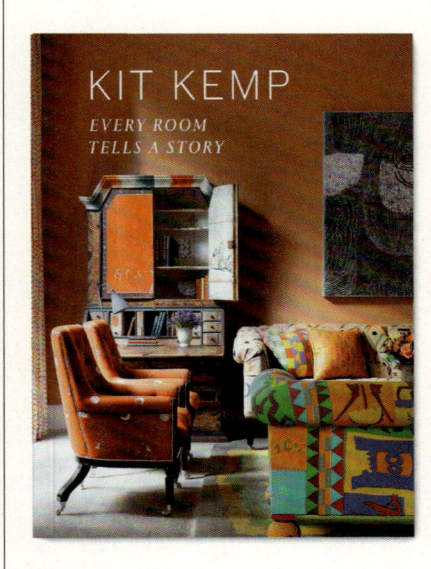

*When it comes to a hotel room, Kit Kemp is a master storyteller. Happily, those stories are also lovingly assembled in her book, Every Room Tells a Story.*

1

2

3

4

5

are just so wonderful. Also, if I'm working on a special commission, it's so easy to change the width of a carpet or to hand-block colors to my specifications. They have that expertise. I also love to source things from decorative fairs and dealers who know me from over the years. Much of the art and commissioned pieces are by young artists starting out. I love that sense of discovery and hopefully we're giving them a helping hand early on in their careers."

As well as her thriving interior design studio, Kemp has created embroidered fabrics for Chelsea Textiles; a fabric and rug collection for Christopher Farr; a bone china service for Wedgwood; a collection of furniture and home products for lifestyle store Anthropologie; and a bespoke range of bath and body products, Rik Rak, available in all Firmdale hotels. She has also recently published her second book, *Every Room Tells a Story*.

Next up is another hotel in New York, Firmdale's second. The Whitby Hotel, which opens September 2016, is located on West 56th Street between 5th and 6th Avenues and will have a similar scale and architecture to the Crosby Street Hotel, also a new build. Here, the entire top floor will feature a headline two-bedroom suite with two terraces facing both north and south. The 15-story, 86-rooms-and-suites hotel will also be home to the ground floor Whitby Bar, as well as a drawing room and small terrace. The lower floors will include several private event spaces and a 120-seat, state-of-the-art cinema.

"I'm delighted about this new place," Kemp says of The Whitby. "I absolutely love the entire exciting process and can't imagine ever not doing it." Which is just as it should be since her legions of fans, famous or otherwise, couldn't imagine that either.

*Text: Becky Sunshine*

1 *Kemp's colorful take on contemporary English design at Soho Hotel's Refuel Bar & Restaurant, in London, perfectly complements the eatery's fresh, modern cuisine.*

2 + 5 *For the Crosby Street Hotel, in New York's SoHo district, Kemp achieves an American flair without abandoning her British roots.*

3 + 4 *Kemp has created an exclusive 13-piece home furnishings collection for Anthropologie entitled Folkthread, which includes furniture, textiles, and wall and window decor.*

# Dorset Square
# Hotel

The minute critics say you have a "look" is the minute you have to reinvent yourself. Fortunately for Kit Kemp, the bold visionary genius behind Firmdale's ever-expanding, ever-popular quiver of boutique hotels, her career has produced a constant series of reinventions and transformations. How else to explain the fact that she and Firmdale keep winning just about every important design award there is to win, from the Andrew Martin International Interior Designer of the Year in 2008, to the Queen's Award for Enterprise in 2000, 2006, and 2009.

This list of hospitality masterworks includes Dorset Square Hotel in London's Marylebone, an exciting residential area within easy reach of the city's theater and financial districts. And for Kit and her husband Tim, the property is something of a homecoming—it was their very first property, which they originally bought in the 1980s, and have now reacquired.

The couple has always had an affinity for this property, and understandably so. After an extensive refurbishment, the English country style has been replaced by Kit Kemp's signature stamp:

bold colors, contrasting fabrics, and one-off art pieces and furnishings. The interiors at Dorset Square Hotel are intriguing and engaging, from the plush guest drawing room with an open fireplace, to the lively bar and brasserie that features specially commissioned wallpapers and hand-woven carpets. Kemp believes that "hotels should be living things, not stuffy institutions."

This mantra is clearly illustrated in the hotel's 38 individually designed bedrooms, many of which look onto the leafy green private garden square. Each room follows a different color scheme and is adorned with items that Kemp has gathered from around the globe. They come in all shapes and sizes, including quaint attic rooms complete with sloping rooftops. Throughout the hotel, guests discover luscious new fabrics from Kemp's exclusive collection with Christopher Farr and hand-woven carpets from Argentina.

As the hotel is set in central London, it is surrounded by shops, restaurants, and world-class galleries, and many of its rooms

WHERE
London
United Kingdom

MEMBER SINCE
03/2012

DESIGN
Kit Kemp

ROOMS
38

RATES
GBP 165–390

MEET THE ORIGINAL
Kit Kemp

and suites overlook the private garden square that was originally Thomas Lord's first cricket ground. This little piece of history has influenced the hotel's decor, with an interesting collection of cricket memorabilia displayed throughout. Kemp's signature style is at its most tailored in the Marylebone Room, where gray-wool-clad walls and chairs form an utterly stylish setting.

Dorset Square Hotel also has a special charm thanks to the fact that it resides in a beautiful Regency Townhouse and its placement on this verdant corner of Marylebone's Dorset Square. But for Kemp, the show takes place both outside and in. And its "in" where she has the most control of things—touching almost every area of the hotel. Why have a hand in so many elements? "The devil is in the details," says Kemp, offering an insight into her magic. "The height and shape of a headboard, the detail on a valance, the trims used on soft furnishings—it can be the smallest thing that captures one's imagination in a room."

So how do those critics who try to peg Kemp describe her look? Many say it reflects a fresh, modern English style. But that seems an oversimplification for a look that continues to surprise. Mixing eras with state-of-the-art technology, Kemp is self-taught and follows no rules but her own. If push came to shove, one might say that her style and pioneering work strike the perfect balance between classicism and modernity.

Kemp herself has a far simpler answer—one that is at the heart of hospitality. "I want people to feel good when they stay with us," she says. Enough said. —

More from Firmdale Hotels:

## Covent Garden Hotel

In the midst of the theater district's drama, this refined, modern hotel certainly holds its own among the stars. Guests are greeted by grand curtains at the reception before entering the stage of aged woods, dignified architecture, and head-turning interiors by Kit Kemp. Her trademark abstract and figurative upholstery patterns turn up in demi-canopies, decorative headboards, flowing drapes, and even matching wallpaper. The bustling Brasserie Max is a favorite pre- and post-theater haunt for locals and visitors.

WHERE
London
United Kingdom

MEMBER SINCE
01/2001

DESIGN
Kit Kemp

ROOMS
58

RATES
GBP 235–1,845

MEET THE ORIGINAL
Kit Kemp

## Charlotte Street Hotel

Kit Kemp has created yet another enticing abode at the Charlotte Street Hotel, where paintings by the famous early 20th-century Bloomsbury Group hang comfortably alongside French stone fireplaces and deliciously overstuffed armchairs an sofas. Joining Kemp's collection of modern British art are pieces especially commissioned for the hotel, such as the mural by Alexander Hollweg in the Oscar Bar and Restaurant.

WHERE
London
United Kingdom

MEMBER SINCE
01/2001

DESIGN
Kit Kemp

ROOMS
52

RATES
GBP 225–1,235

MEET THE ORIGINAL
Kit Kemp

# Ham Yard Hotel

**WHERE**
London
United Kingdom

**MEMBER SINCE**
10/2013

**ARCHITECTURE**
Woods Bagot

**DESIGN**
Kit Kemp

**ROOMS**
91

**RATES**
GBP 310–3,500

**MEET THE ORIGINAL**
Kit Kemp

In an area known for its theaters, shopping, and restaurants, the new Ham Yard Hotel is a destination in its own right. Just behind the Piccadilly Circus in a neglected corner of Soho, the new-build hotel has brought vitality to the area starting with a striking contemporary façade by local architects Woods Bagot. The 91-room hotel has also provided the area around Regent Street with new green spaces—five majestic oak trees were brought in specially and a leafy garden is planned for the roof. Inside, Kit Kemp wields her signature magic with lively colors, bright custom-made fabrics, and an innate sense for infusing warmth into a space. The British designer has also made British art, both known and

upcoming, a big part of this London hotel experience starting with a Tony Cragg sculpture in the courtyard. A pedestrian shopping area with 13 individually chosen shops by Kemp herself, a vintage bowling alley, and a 190-seat theater are all pointers to why the Ham Yard is the new neighborhood high point. —

# Number Sixteen

Only the corresponding house number suggests that the white-stucco Victorian terrace, situated just steps from London's major museums and Harrods, is the hotel Number Sixteen and not an upscale private residence. As in the other Kit Kemp properties in town, the designer's custom textiles in each of the 41 individually outfitted guestrooms are a study in elaborate detail and dramatic patterns. Guests can mingle in the hotel's handsome drawing rooms, and some guestrooms have private courtyards overlooking the hotel's stunning English garden. One drawing room is adorned with rose prints and oil paintings. The eclectic furnishings—a mix of antique, contemporary, and ethnic accents—keep the aesthetic fresh and elegantly eccentric. Number Sixteen's sense of subdued, relaxed modernity is brought to its apex in the conservatory and exquisite private garden, whose reflecting pond, fountain, and lush foliage offer precious seclusion amid the city bustle. —

| | |
|---|---|
| **WHERE** London United Kingdom | **ROOMS** 41 |
| **MEMBER SINCE** 06/2007 | **RATES** GBP 150–350 |
| **DESIGN** Kit Kemp | **MEET THE ORIGINAL** Kit Kemp |

# Knightsbridge Hotel

Within walking distance of Harrods and Harvey Nichols, the Knightsbridge Hotel is a chic addition to the luxury hotels owned and designed by Kit Kemp. Contemporary British art and African woodwork bring surprises to the otherwise traditional lobby, drawing room, and library. Bold fabrics envelop the suites and rooms, running riot with stripes, florals, and geometric designs.

WHERE
London
United Kingdom

MEMBER SINCE
06/2007

DESIGN
Kit Kemp

ROOMS
44

RATES
GBP 200–700

MEET THE ORIGINAL
Kit Kemp

# The Soho Hotel

At 96 rooms, The Soho Hotel is one of hoteliers Tim and Kit Kemp's largest London properties. Kit Kemp's contemporary British style is firmly founded on using top-notch furnishings and materials in artful combination with a plethora of styles, colors, and patterns. It's hard to miss the impressive ten-foot-tall Botero sculpture in the lobby.

WHERE
London
United Kingdom

MEMBER SINCE
01/2004

DESIGN
Kit Kemp

ROOMS
96

RATES
GBP 235–3,450

MEET THE ORIGINAL
Kit Kemp

# Haymarket Hotel

Fusing contemporary and classical references in an ultra central London location, the Haymarket Hotel asserts itself as a bold step away from cookie-cutter minimalism. Originally designed by John Nash, the master architect responsible for most of Regency London, including Buckingham Palace, Trafalgar Square, and the adjoining Haymarket Theatre, the hotel's exterior greets guests with rows of dramatic columns running the length of Suffolk Place. Yet even as the noble lineage of Nash's building is preserved, guests are invited to luxuriate in co-owner Kit Kemp's "modern English" interior design. Art lovers will appreciate the verve with which the airy sepia-gray lobby, filled with marigold and oak furniture, showcases a large stainless steel Tony Cragg sculpture and paintings by British treasure John Virtue. Aesthetes will also admire the color schemes in the library and conservatory, which frame handpicked antiques. Physical and visual pleasures merge in guestrooms overflowing with inviting pillows, luscious textures, cloth-covered walls, custom-made furniture such as Shagreen coffee tables with ivory wood-toned details, and Rik Rak bathroom amenities. Modern English with a classic pedigree: The timeless Haymarket Hotel has it all—and brings it all together effortlessly. —

WHERE
London
United Kingdom

MEMBER SINCE
06/2007

ARCHITECTURE
John Nash

DESIGN
Kit Kemp

ROOMS
50

RATES
GBP 235–3,500

MEET THE ORIGINAL
Kit Kemp

# Boundary

Lovers of art, admirers of design: Boundary welcomes you. Located amid the plentiful galleries of London's famed Shoreditch quarter, Boundary is a celebration of fine art and design for the sophisticated traveler. Its 12 elegant, contemporary guest-rooms are each inspired by a legendary designer or design movement, from Young British to Bauhaus, Eileen Gray to Le Corbusier. Above, five suites, including four duplexes, range from Modern Italian to Modern Chinoiserie, featuring private outdoor balconies. Boundary gastronomy is just as expertly curated as Boundary design. The main restaurant pays homage to the timeless recipes and traditions of England and France: Roast leg of lamb and rib of beef are presented for Sunday lunch, and various English game birds are offered seasonally. The Boundary Bar's wine list includes over 500 artisanal growers and aristocratic estates from around the world. Upstairs, a separate kitchen and bar serve the Boundary Rooftop, a 48-seat grill restaurant with an open fireplace set in the midst of a stunning garden by Nicola Lesbirel with 360-degree views over London. The hotel is also home to Albion, a ground-floor bakery, café, and specialty British food shop, with pavement seating directly on Boundary Street. —

| | |
|---|---|
| WHERE | ROOMS |
| London | 17 |
| United Kingdom | |
| | RATES |
| MEMBER SINCE | GBP 190–550 |
| 06/2009 | |
| | MEET THE ORIGINALS |
| ARCHITECTURE / | Peter Prescott, |
| DESIGN | Sir Terence Conran |
| Conran & Partners | |

# Blakes Hotel

If you ever needed reassurance that the spirit of adventure is alive and well, even in the center of London, Blakes is it. Designed by former Bond girl Anouska Hempel, now known globally for her striking interior designs, this recently refurbished multimillion-pound couture hotel is a world of grandeur and exoticism. Behind the black Victorian façade, you'll find a tantalizing fusion of Eastern and Western styles. Polished mirrors bounce rich walnut tones around the lobby, creating a sense of decadence and theater, while the acclaimed subterranean restaurant attracts some of the world's most famous movie stars, artists, and designers. Each of the 45 refurbished guestrooms at Blakes takes inspiration from a different far-off land. There's the Corfu Suite, which centers on a tall four-poster bed swathed in romantic pure-white muslin, and the Empress Josephine Suite, where opulent shades of ebony and gold shroud the tented bed. TVs, telephones, and iPod docks by Bang & Olufsen make it possible for every room to function as a self-contained hideaway. And with staff placing a special emphasis on guests' privacy, even the luscious shared courtyard feels secluded and cocoon-like. As Hempel herself says, "Blakes is a world within a hotel. It exudes luxury with imagination, and combines fine living with a sense of theater and panache."

New Zealand-born film and television actress-turned-hotelier Anouska Hempel is one of the world's most celebrated designers and a noted figure in London society. Her work spans architecture, interiors, furniture, fashion, landscape, and product design. Laced with utopianism, Hempel's aesthetic is a fusion of west and east, whether she's working in a classical or contemporary vein. Her first venture, Blakes Hotel in South Kensington, was created in 1978 as the world's first luxury boutique hotel. More recently Hempel teamed up with hotelier Meir Abutbul, whose first business in the UK was the café chain Apostrophe, and opened the eighty-bedroom boutique hotel La Suite West, bordering London's Hyde Park. Leading a prestigious team of architects and designers, Hempel passionately practices her mantra: "design, refine, and repeat." —

WHERE
London
United Kingdom

MEMBER SINCE
02/2011

ARCHITECTURE
Claire Braybrook,
Martin Goddard,
Anouska Hempel

DESIGN
Anouska Hempel

ROOMS
45

RATES
GBP 228–720

MEET THE ORIGINALS
Meir Abutbul,
Anouska Hempel,
Navid Mirtorabi

"My passion is for the details. I'm interested in every room, every corridor, every doorknob. That, for me, is the fun of creating a hotel from scratch."

DAVID LOEWI

# South Place Hotel

Located where the sophisticated City of London meets the Cultural East End, South Place is the ideal base from which to explore, connect, or rejuvenate. With interiors by Conran & Partners, South Place is the first hotel from international restaurateurs D&D London. A focus on food is evident throughout, with two restaurants and four bars that attract both hotel guests and a crop of loyal Londoners. Angler is a rooftop seafood restaurant with a Michelin star, an air of relaxed elegance, and a stunning roof terrace. Serving comfort food with particular attention to provenance, ground-floor restaurant 3 South Place opens early for breakfast, weekends for brunch, and serves candlelit dinners until late. The hotel's public spaces are vibrant; contemporary designs are accented with an enticing mixed-media art collection. Digital print wallpaper, resin artefacts, and programmable pixel walls provide a window into London's dynamic art scene. In each of the 80 bedrooms, guests will find thoughtful details and the latest technologies that anticipate the needs of business and leisure guests alike: fresh lemons and limes, push-button black-out blinds and mood lighting, Bang & Olufsen televisions with free in-room cinema, prints from contemporary London artists, and even hangover kits. On the first floor, the Spy Garden offers a retreat to hotel guests along with Le Chiffre, the residents' games room. Here you will also find five meeting and private dining rooms as well as a well-equipped gym, sauna, and steam room. Enthusiastic and knowledgeable staff offer a warm welcome, and are always on hand to help guests create meaningful experiences and discover the real London outside.

South Place is the first hotel from restaurant group D&D London, which owns and operates over 30 of the foremost restaurants in London, Paris, New York, and Tokyo. CEO and Chairman Des Gunewardena created D&D along with Managing Director David Loewi in September 2006 when they led the buyout of Conran Restaurants. After a postgraduate degree in Swiss Hotel Training, Loewi has accumulated over 25 years experience in the London hospitality industry, while the Sri Lankan-born Gunewardena studied economics at Bristol University and is an expert on financing, property, and design. With South Place, near Liverpool Street Station, the men have struck a balance between the business bustle of the nation's financial center and the creative abandon of one of London's hippest neighborhoods. —

| WHERE | ROOMS |
|---|---|
| London | 80 |
| United Kingdom | |
| | RATES |
| MEMBER SINCE | GBP 152–1,200 |
| 06/2012 | |
| | MEET THE ORIGINALS |
| ARCHITECTURE | Des Gunewardena, |
| Allies & Morrison | David Loewi |
| DESIGN | |
| Tina Norden | |
| (Conran & Partners) | |

Des Gunewardena & David Loewi

# Town Hall Hotel & Apartments

The year 2010 marked the opening of the Town Hall Hotel & Apartments in the former Bethnal Green Town Hall in East London. Just two minutes from the Bethnal Green tube station, with ideal connections to West London and the city's financial district, the beautifully restored space stylishly incorporates contemporary interior restructuring into the elegant period property—an ideal space for any business or luxury traveler. The refined Art Deco entrance hall's sweeping marble staircase and glass-domed ceiling whisk guests into the enthralling experience that the Town Hall so gracefully provides. The Town Hall Hotel & Apartments' 98 guestrooms and apartments juxtapose original structural elements with clean, contemporary custom furnishing and the most advanced luxury technology. The establishment also offers ample conference space, such as its unique Council Chamber, which can seat up to eighty people, or the 220-square-meter contemporary De Montfort Suite, which comfortably accommodates an exceptional private event experience for up to 100 people. The Town Hall is also proud to call itself the home of Chef Lee Wescott's fine

dining restaurant, Typing Room—as well as its very own distillation bar, Peg + Patriot. Recreational facilities such as a gymnasium and a full-length swimming pool are also available.

Loh Lik Peng's global lifestyle draws him to different places for different reasons. The intimate scale of Dublin reminds him of his childhood, while London's East End is all about the energetic vibe and the sense that new things are happening all the time. He opened his first venture, Hotel 1929, in a former brothel in Singapore's red-light district in 2003. With its swanky design and instant buzz, 1929 became a popular destination for travelers and locals alike. Three years later, he opened the New Majestic and upped the style quotient in Singaporean hospitality even further. More properties followed in Singapore, where he now lives, and London, Shanghai, and Sydney. And not one of them is located in what your average guidebook would have considered the "right" kind of neighborhood—that is until his properties have put their once-undesirable districts on the style map. —

| WHERE | ROOMS |
|---|---|
| London | 98 |
| United Kingdom | |
| | RATES |
| MEMBER SINCE | GBP 160–3,000 |
| 10/2009 | |
| | MEET THE ORIGINAL |
| ARCHITECTURE | Loh Lik Peng |
| Nathalie | |
| Rozencwajg, | |
| Michel da Costa | |
| Gonçalves | |
| (Rare Architecture) | |
| | |
| DESIGN | |
| Camiel Weijenberg, | |
| Talenia Phua | |
| (Makemei) | |

# The Thief

With Oslo's most spectacular location on the coast of the capital's new waterfront district Tjuvholmen, The Thief will steal you away from everyday life. Located next to the iconic new Astrup Fearnley Museum of Modern Art designed by renowned architect Renzo Piano, The Thief offers the utmost in luxury by providing an individually tailored experience to each customer. Looking out over the canals of Tjuvholmen and the Oslofjord, most of the 116 bespoke rooms offer brilliant waterfront views. The interior of the hotel reflects the innovative spirit of its surroundings: original artwork, selected by famed curator Sune Nordgren, lines the walls, while furniture chosen by Anemone Wille-Våge reflects up-to-the-moment design without sacrificing comfort. Known in the 18th century as "Thief Island" because of its role as a prison islet, the waterfront district of Tjuvholmen is now home to one of Scandinavia's most exciting urban renewal projects. Not only is it a thriving center for business, art, and nightlife; it's also become a dazzling showcase of contemporary European architecture, culinary experiences, and Scandinavian design. International-caliber restaurants, cozy eateries, and high-quality galleries sit side by side on car-free streets and squares. No matter if you've come to Oslo for its thriving cultural and culinary scene or rapidly expanding business opportunities, whether you want to read a book in the comfort of the fireside library lounge, enjoy a drink in Tjuvholmen's only hotel bar, or find a memorable setting for your next conference or event, doors are open to you at The Thief.

Petter A. Stordalen is a self-made business baron. Through a series of bold acquisitions, Stordalen came to own Nordic Choice Hotels, the leading Nordic hotel company encompassing 170 hotels, five hotel chains, and 10,000 employees, along with Nordic Hotels and Resorts, a collection of independent hotels that includes The Thief and Copperhill Mountain Lodge. He got his start working in his father's grocery store, and by age 24 he was manager of Norway's largest shopping center. As the nation's ninth-richest man, Stordalen has become one of Scandinavia's most recognizable entrepreneurs, known for his dynamic motivational speeches and extravagant theatrics. A former Ironman racer, Stordalen is also an environmental activist and philanthropist. —

More from Nordic Hotels & Resorts:

DENMARK
Copenhagen, Skt. Petri → P. 129

SWEDEN
Åre, Copperhill Mountain Lodge → P. 114
Stockholm, Nordic Light Hotel → P. 114

WHERE
Oslo
Norway

MEMBER SINCE
06/2012

ARCHITECTURE
Ajas Mellbye
(Mellbye Arkitekter AS)

DESIGN
Anemone Wille Våge

ROOMS
116

RATES
NOK 2,090–30,000

MEET THE ORIGINAL
Petter A. Stordalen

Petter A. Stordalen

> "It was the perfect place for a hotel like the one I wanted to create. I'm a proud hotel nerd, and this time I knew I had to do something new, something I'd never done before. I wanted The Thief to lead the way in the redemption of the area."

PETTER A. STORDALEN

# Copperhill Mountain Lodge

Surrounded on all sides by the breath-taking Jämtland mountains, the inviting Copperhill Mountain Lodge is the first ski resort in Åre, Sweden, with a focus on design. Created by Peter Bohlin of Apple Store fame, the chic, earth-toned guest-rooms and après-ski hangouts look out over Scandinavia's largest ski area.

**WHERE**
Åre
Sweden

**MEMBER SINCE**
09/2008

**ARCHITECTURE**
Peter Bohlin
(Bohlin Cywinski
Jackson),
Richard Tegnér
(AIX Arkitekter)

**DESIGN**
Ann Marie Ekroth
(Koncept),
Anemone Wille Våge

**ROOMS**
112

**RATES**
EUR 195–395

**MEET THE ORIGINAL**
Petter A. Stordalen

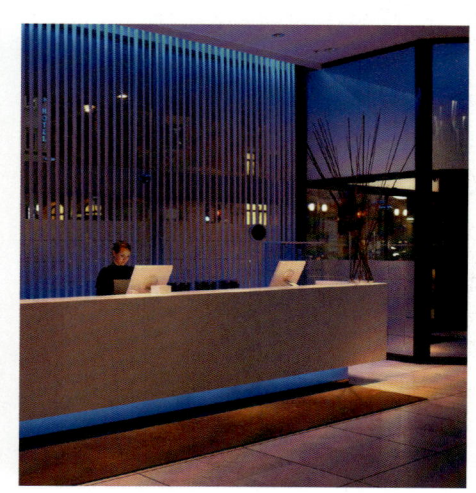

# Nordic Light Hotel

Nordic Light Hotel separates itself from the crowd right from the lobby. The hotel has an addition to the Living Room lobby—The Crooked Leg, a restaurant and bar where good food and company ranks far above any frills. Located in the center of Stockholm and easily accessed by the adjacent Arlanda Airport rail link and Central Station, the hotel is attractive not only to the business community, thanks to its unique meeting rooms, but also to weekend visitors keen to experience life in the cosmopolitan capital for themselves.

**WHERE**
Stockholm
Sweden

**MEMBER SINCE**
12/2000

**ARCHITECTURE**
Rolf Löfvenberg

**DESIGN**
Lars Pihl,
Jan Söder

**ROOMS**
175

**RATES**
SEK 1,180–4,180

**MEET THE ORIGINAL**
Petter A. Stordalen

# Nobis Hotel

The two grand 19th-century buildings housing the 201-room Nobis Hotel in Stockholm were originally built and used as residential apartments. "It's always been a fascinating place in Stockholm," says owner Alessandro Catenacci, of Norrmalmstorg Square, the most valuable real estate in the Swedish version of Monopoly, and within walking distance of the city's best shopping, restaurants, and bars. The hotel's interiors ooze history, yet they still have the crisp look typical of the renowned Swedish architectural firm Claesson Koivisto Rune, whose understated yet always luxurious Scandinavian aesthetic shines through. A cathedral-like lounge with 28-meter ceilings is situated in a vast 800-square-meter public space. The smaller Gold Bar sumptuously exemplifies its name with walls and ceilings covered with golden mirrors. Nobis Hotel offers guests a number of restaurants, including the new version of Stockholm's legendary Italian restaurant Caina, which now serves a menu of simple and delectable Italian cuisine by the hot, young, talented Swedish chef Isabella Morrone. Service is always personal, and guestrooms are designed to feel like rooms in an elegant home, gradually put together over time and not merely assembled. Tying the hotel together is a sense of individuality and a uniquely Swedish brand of luxury that's far less about show than about feel. "We believe strongly in Sweden that luxury is not always big spaces and the most expensive things," says Sandro Catenacci. "It's a quality that feels different." —

WHERE
Stockholm
Sweden

MEMBER SINCE
08/2010

ARCHITECTURE /
DESIGN
Claesson Koivisto
Rune

ROOMS
201

RATES
SEK 1,590–25,000

MEET THE ORIGINAL
Alessandro
Catenacci

# Gert

## WINGÅRDH

THIS PROLIFIC SWEDE IS A LEGEND IN HIS HOME COUNTRY AND IN DEMAND THROUGHOUT THE WORLD. HIS STYLE SEEMS LIMITED ONLY BY THE POWERS OF HIS IMAGINATION, WHICH ARE AS BOUNDLESS AS HIS INFLUENCE ON YOUNG ARCHITECTS EVERYWHERE.

*Gert Wingårdh has created some of the most striking and significant buildings in Sweden, and is a flag carrier for Nordic design around the world.*

When the Swedish Institute published a list of 24 masterpieces of Swedish architecture, Gert Wingårdh was represented not once or twice or even three times. He was, in fact, the only architect singled out four times. To put that into context, Gunnar Asplund, who created Stockholm's iconic Public Library and the Woodland Cemetery, a UNESCO World Heritage Site, only got two mentions. When *Dagens Nyheter*, one of the country's leading newspapers, published an article in 2007 listing the 12 most exciting architectural projects in the land, five of them were Wingårdh designs. In 1988, Wingårdh won Sweden's most prestigious architecture award, the Kasper Salin Prize, which is presented by the Swedish Association of Architects. Then he won it again in 1993. And also in 2001, 2006, and 2007.

He is, by any measure, the most influential Swedish architect working today, and yet, Wingårdh is an unconventional titan. When not working in Gothenburg, where his company is headquartered (with additional offices in Stockholm and Malmo), he spends much of his time in a relatively small, red-painted house that sits beside the sea just outside the town of Marstrand on Sweden's west coast. It seems to be a quiet, bucolic existence. He prefers to eat at home with his wife rather than going out for a meal. ("After 20 years of us consistently declining dinner party invitations, our friends are resigned to it," he told a Swedish journalist.) However when it comes to his professional life, there is no false modesty. He has created some of the most striking and significant buildings in Sweden, and is a flag carrier for Nordic design around the world. This is the man who established a bastion of Scandinavian cool in the heart of the

American capital with House of Sweden, the Swedish embassy in Washington D.C. He also designed the Swedish embassy in Berlin. Visitors arriving at Stockholm's main airport, Arlanda, can hardly fail to notice the striking black-and-white control tower he created and, as they drive into the capital, they will pass another Wingårdh landmark, Victoria Tower. This tower, which is covered in triangular panes of multicolored, mirrored glass, is the second tallest building in the country, and one that has earned him something of a reputation as setting the benchmark for the skyscraper in Sweden.

Wingårdh was born in 1951 and raised in the towns of Skövde and Gothenburg. The construction industry runs in his genes: His father managed a cement factory that his grandfather had founded. Wingårdh studied history and theory of art before turning to architecture, and in 1975, at the age of 24, he founded his own company.

The range of projects he's worked on is extraordinary, varying wildly in terms of style and size. In Lerum, Sweden, players at Öijared golf club utilize a clubhouse dominated by a 36-sided glass façade, while swimmers in Landskrona can splash about in his aquatic center, which has water running down its glass exterior. One of his most glittering designs—quite literally—is Sven-Harry's, an arts center in a public park in Stockholm. The exterior is clad in a copper alloy that doesn't darken (called, appropriately, Nordic Royal) so the building retains the appearance of a gilded jewel box set among the trees. Enter Sven-Harry's and ascend through the galleries to the top floor and it comes as something of a shock to find what appears to be an 18th-century manor

## SIDE NOTES

NAME *Gert Wingårdh*

COMPANY NAME *Wingårdh Arkitektkontor AB*

COMPANY HEADQUARTERS *Gothenburg*

NUMBER OF PEOPLE IN COMPANY *160*

WEBSITE *wingardhs.se*

SIGNATURE PROJECTS *Washington D.C.: House of Sweden, Swedish Embassy Berlin: Swedish Embassy Malmo, Sweden: Emporia shopping center Gothenburg: Universeum Science Center and Aquarium Stockholm: Arlanda Airport control tower*

## SIGNIFICANT AWARDS

2012 *World Architecture Festival Award for Victoria Tower*

2008 *World Architecture Festival Award for K:fem shopping center*

2007 *Kasper Salin Prize for House of Sweden*

2007 *American Architecture Awards for House of Sweden*

2006 *Kasper Salin Prize for Aranäs Senior High School*

2005 *Prince Eugen Medal*

2001 *Kasper Salin Prize for the Auditorium and Student Union at Chalmers University of Technology*

*Wingårdh's Stockholm Arlanda Airport tower, which mixes graphic clarity with touches of 1950s design, won a 2002 European Award for Excellence first prize.*

1  *Universeum Science Center and Aquarium, in Gothenburg, Sweden, is a stunning (and award-winning) example of eco-conscious design; it has minimal energy requirements, water is recycled within the structure, and the roof can be equipped with solar collectors.*

2  *One of the tallest buildings in Stockholm, Wingårdh's Victoria Tower features a façade crafted with eight different types of colored glass, the effect of which is a sweeping, visual sense of randomness.*

I

house on the roof. It's a replica of the home of the founder, Sven-Harry Karlsson, displaying his private art collection.

While Wingårdh is a master of statement buildings, he can also blend in with his surroundings. Some of his private villas, such as the sublime Villa Astrid on Sweden's west coast, seem to grow organically from the granite rocks around them. In Stockholm, this ability to subtly create a design at one with its surroundings can be seen at the Miss Clara hotel. Wingårdh remade the interior of the building that was originally built as a girls' school in 1910. The hotel stands on one of the busiest streets in town and the public areas feel connected to the bustle and life of the city. Bedrooms, on the other hand, have an almost monastic air of calm about them and are simply furnished with dark woods and white walls. The building's Art Nouveau origins are respected and celebrated throughout.

Despite his standing in Sweden, it has not been all smooth sailing for Wingårdh. His plan for a huge skyscraper at Telefonplan, in Stockholm, was cut down to size by the country's defense industry, which said it would interfere with technical systems. It was originally envisioned as northern Europe's tallest apartment building, a monolith that would soar up to 75 stories and be visible for miles around, but the latest plans saw it lopped off at a mere 45 meters, barely clearing the surrounding rooftops. Another plum project in the Swedish capital, the new Nobel Center, was awarded to English architect, David Chipperfield.

However, there are plenty of other buildings in the pipeline that are going ahead—not least a stunning extension to Liljevalchs art gallery in Stockholm—which will doubtless lead to more prizes. Few designers have the versatility and intuition of Gert Wingårdh, and he shows no signs of abdicating his position as Sweden's most influential architect.

*Text: Stephen Whitlock*

2

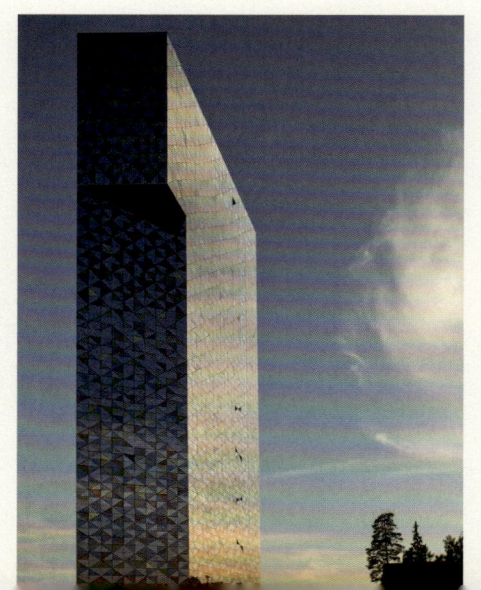

**3** *Emporia, in the Swedish city of Malmo, is a bold urban planning project that houses retail, offices, and housing, with shops grouped around colored atriums featuring assorted themes.*

**4** *When transforming a school-house into Miss Clara, Wingårdh ensured that warm, personal spaces were bathed in maximum sunlight.*

**5** *A glittering wonder thanks to a copper alloy exterior that doesn't darken, Wingårdh's Sven-Harry's arts center, in a public park in Stockholm, slyly references the city's traditional ochre façades.*

3

4

5

# Miss Clara
# by Nobis

It takes a creative mind to transform a former school building into a talk-of-the-town, design-driven hotel. Thankfully, architect Gert Wingårdh was chosen for the job. Not too long ago, according to a Swedish national daily newspaper, this much-celebrated Swede was responsible for seven of the twelve hottest architectural projects in Stockholm.

One look at the 92-room Miss Clara and you get why. Among Stockholm's most treasured Art Nouveau buildings, the former Ateneum girls' schoolhouse was built in 1910 and lovingly restored under the direction of Wingårdh, with a palpable respect for its heritage as its driving mission.

High ceilings, expansive windows, and grand rooms—hallmarks of the building's original architects Hagström & Ekman—remain gloriously intact. Here, one finds a seamless incorporation of soft and graceful organic lines, as well as the integration of more classic features, such as wood paneling. "You might say that we've started from the lines of the original architecture and elaborated them in a kind of abstract, modern day Art Nouveau," Wingårdh explains.

This original-meets-the-abstract concept flows into the rooms and suites, which follow the Swedish architect's unique concept of creating an outward-facing property, with the windows fronting Sveavägen boulevard taking center stage. Guests can expect a chic intermingling of gorgeous herringbone parquet floors, marble bathrooms, retractable workspaces, and contemporary riffs on the property's history through furniture pieces and installations.

Inspired by the building's origins, Wingårdh's interiors not only harken back sympathetically to the Art Nouveau movement, but offer subtle hints of femininity in a nod to the property's schoolhouse past. Swedish materials, such as limestone, oak, and natural leather have been used liberally alongside that parquet flooring and those stunning arched windows. Specially crafted pieces include in-room storage units that stretch the length of the window wall and incorporate pullout work desks and luggage storage.

WHERE
Stockholm
Sweden

MEMBER SINCE
08/2013

ARCHITECTURE /
DESIGN
Gert Wingårdh
(Wingårdhs)

ROOMS
92

RATES
SEK 1,490–11,000

MEET THE ORIGINAL
Alessandro
Catenacci

At street level, a vibrant restaurant and bar thrive on the urban buzz of the evolving Stockholm City district, welcoming guests and savvy locals alike. Conversely, the gym, sauna, and relaxation lounge easily absorb the bustle of the neighborhood outside, making this chic bolthole a choice venue for both business and pleasure.

Indeed, creating a provocative space that is both a retreat from the world and a magnet for its creatives is a specialty of Italian-born Alessandro Catenacci, the driving force behind many of Stockholm's top restaurants, nightclubs, and hotels. This includes Miss Clara, as well as the Opera House restaurant complex, complete with Operakällaren and Café Opera—Sweden's most famous restaurant and nightclub. And it also includes Nobis Hotel, Stockholm's grandest property on the bustling Norrmalmstorg square.

Says Catenacci of his success, "I sometimes look at myself in the mirror and think, 'Am I really good at anything, or was it just luck?'" Perhaps the word that the modest Catenacci is really looking for to describe himself is "driven." After all, anyone who has the courage to take on a legendary building and the smarts to hire a leading-edge architect, isn't lucky. Like Miss Clara itself, he is at the top of his class. —

More from Nobis Group:

SWEDEN
Stockholm, Hotel J → P. 125
Stockholm, Hotel Skeppsholmen → P. 124
Stockholm, Nobis Hotel → P. 115
Stockholm, Stallmästaregården → P. 127

Alessandro Catenacci

**"We try to infuse personality into our hotels. We don't look outside for inspiration. We go our own way. What really matters is the personality you can offer."**

**ALESSANDRO CATENACCI**

# Hotel Skeppsholmen

On the small vibrant island of Skeppsholmen in the city center of Stockholm, Hotel Skeppsholmen resides in two long buildings that date back to 1699, when the "Long Row" was built to house Sweden's Royal Marines. Casually luxurious, ultramodern, and historically protected, Hotel Skeppsholmen gives visitors to Stockholm a taste of the old, a twist of the new, and a whole lot of charm. The Swedish historic landmark is married with the very best of contemporary Swedish cuisine, art, design, fashion, and music, partnering with iconic brands such as Acne and the renowned Swedish Museum of Modern Art. Ideal for both the active and the culturally curious guest, the quaint yellow building is next door to the Museum of Modern Art and the fascinating Swedish Museum of Architecture. The area's gorgeous antique ships and waterfront restaurants are also within walking distance. Design Team Claesson Koivisto Rune fittingly chose "fog" as the hotel's artistic theme, evoking the enchanting maritime surroundings with a soft color scheme and peaceful atmosphere to create an eco-certified urban oasis. —

| | |
|---|---|
| **WHERE** | **ROOMS** |
| Stockholm | 77 |
| Sweden | |
| | **RATES** |
| **MEMBER SINCE** | SEK 1,795–10,000 |
| 08/2010 | |
| | **MEET THE ORIGINAL** |
| **ARCHITECTURE** | Alessandro |
| Erséus Arkitekter | Catenacci |
| | |
| **DESIGN** | |
| Claesson Koivisto | |
| Rune | |

# Hotel J

**WHERE**
Stockholm
Sweden

**MEMBER SINCE**
08/2000

**ARCHITECTURE**
Johan Nyrén

**DESIGN**
Millimeter
Arkitekter,
R.O.O.M.

**ROOMS**
158

**RATES**
SEK 1290–4590

**MEET THE ORIGINAL**
Alessandro
Catenacci

On the water's edge at Nacka Strand, Hotel J has its own 25-berth guest harbor and offers sweeping views of the Royal Djurgården, the island of Lidingö, and the boats on Saltsjön. The architects have transformed the 1912 brick building into a stylish shrine to seafaring—and an American one at that. The concept draws on the nautical design of historic America's Cup J-Class boats and the distinct feel of the New England coast. The evocative red, white, and blue of the stars and stripes invite visitors from across the Atlantic to feel completely at home. But guests from anywhere will appreciate the homey feel of white wood, cotton textiles, and solid oak furniture. In the lobby, fireside seats afford wide-angle views of the islands near Stockholm, just 15 minutes' sailing time away. The 158 guestrooms, in five different categories, feature natural materials such as wooden trim and fine linens that evoke an authentic feeling of comfort and ease. There are also four suites with a separate sleeping area on the upper floor, downstairs lounge, balcony, and views over the sea. There are two meeting and function villas: J's Fabrikörsvilla and the historic J's Tornvilla. The bar and lounge in J's Tornvilla is decorated in the relaxed and comfortable style of New England yacht clubs. At the water's edge, marine brasserie Restaurant J is a culinary and visual experience with views over the bay and simple, sophisticated brasserie cuisine focused on seafood. —

# Stallmästaregården

Stallmästaregården, Stockholm's first ever inn, has attracted gourmands ever since Queen Kristina's visit in the mid-1600s. Hotelier Alessandro Catenacci has transformed the waterside retreat into a peaceful place for an idyllic getaway. The rooms and suites emulate Swedish decor of the 18th century and there are historic meeting rooms for up to 200 visitors. In the classically Swedish main restaurant, chefs serve local dishes from an open kitchen. Just a walk from the city center, the hotel offers uplifting views over the bay of Brunnsviken.

| WHERE | ROOMS |
|---|---|
| Stockholm | 49 |
| Sweden | |
| | RATES |
| MEMBER SINCE | SEK 1,095–6,000 |
| 10/2011 | |
| | MEET THE ORIGINAL |
| ARCHITECTURE | Alessandro |
| Rits Arkitekter AB | Catenacci |
| DESIGN | |
| Richard Lundberg | |

# Elite Plaza Hotel

Elite Plaza Hotel is housed in a stately, palatial building dating back to 1889 in downtown Gothenburg. All of its original features have been carefully preserved, from the venerable stucco ceilings to the English mosaic floors, and now blend harmoniously with elements of modern art and design. This has generated a truly unique environment at Elite Plaza Hotel—an environment where the satisfaction and utmost comfort of guests is the highest priority.

| WHERE | ROOMS |
|---|---|
| Gothenburg | 127 |
| Sweden | |
| | RATES |
| MEMBER SINCE | SEK 950–25,000 |
| 09/2001 | |
| | MEET THE ORIGINAL |
| ARCHITECTURE | Bicky Chakraborty |
| Lars Helling | |
| DESIGN | |
| Christer Svensson | |
| (Gunnar Svensson | |
| AB), Stylt | |
| Trampoli AB | |

# Avalon Hotel

The Avalon Hotel in central Gothenburg is an oasis of inspiration. The urban location offers access to shopping, restaurants, culture, and nightlife, while excellent, personal service and modern design perfect the experience down to the smallest detail. The unique interiors feature a curated selection of Scandinavian design pieces and exciting artworks, while the award-winning architecture is both contemporary and timeless. The façade, with its signature rooftop glass swimming pool that protrudes over Kungsportsplatsen, has become an iconic element of the Gothenburg skyline. Every effort has been made in creating a serene indoor environment, making the Avalon Hotel an ideal retreat from the rigors of work and city life. The walls of the hotel are home to an art collection that appeals even to the most discerning art lovers. Each of the 101 rooms is uniquely furnished in a minimalist Scandinavian style, with a purity and attention to detail that inspire creativity and relaxation. Select rooms have unique features such as a generous balcony, an open-plan bathroom, a private gym, or a circular bed. The same relaxed, international atmosphere that pervades the design can be enjoyed at the bar and restaurant, which offers dishes made from seasonal ingredients and a fine selection of wine and cocktails. During the summer, Avalon Outside is an excellent watering hole right at the center of Gothenburg. —

| WHERE | ROOMS |
|---|---|
| Gothenburg | 101 |
| Sweden | |
| | RATES |
| MEMBER SINCE | SEK 1,245–12,495 |
| 03/2007 | |
| | MEET THE ORIGINAL |
| ARCHITECTURE | Torbjörn L. |
| Semrén & Månsson | Johansson |
| DESIGN | |
| Input Interiör | |

# Fabriken Furillen

WHERE
Gotland
Sweden

MEMBER SINCE
08/2012

ARCHITECTURE /
DESIGN
Johan Hellström

ROOMS
18

RATES
SEK 2,090–4,190

MEET THE ORIGINAL
Johan Hellström

Far from the busy urban hum of Stockholm, in a northeastern corner of the island of Gotland, lies the remote peninsula of Furillen. A military area until the early 1990s, it is still largely unknown to tourists. Here, craggy limestone formations stand starkly beside deserted beaches, and sea birds nest among the ruins of an old gravel quarry. This is a wild, romantic, brutally beautiful Sweden. One arrives in the medieval city of Visby, a UNESCO World Heritage Site surrounded by ancient stone walls. From there, it's a 45-kilometer drive to Fabriken Furillen, a striking gray structure and eco-friendly masterpiece created by photographer Johan Hellström. Inside, you experience a warmly welcoming interior that utilizes modern Scandinavian design and incorporates myriad shades of gray and white. In the restaurant, formerly a factory workers' canteen, heavy chains still hang from the ceiling. Sleep in a grand studio, a spacious suite, or one of 15 double or twin rooms, where you'll enjoy a magnificent view of the Baltic or the quarry's dramatic gravel hills. Alternatively, find perfect solitude in one of two electricity-free hermit cabins on the peninsula's southern tip. Visitors can discover the fishing hamlet of Lergrav, take a ferry to the island of Fårö and experience the surroundings that inspired Ingmar Bergman, or traverse the hidden reaches of the peninsula on a "Skeppshult" bicycle, provided free of charge. Afterwards, enjoy a meal in the restaurant, prepared with local and seasonal ingredients fresh from the hotel's own farm. —

# Skt. Petri

Situated on a beautiful street in Copenhagen's quaint, trendy Latin Quarter, Skt. Petri is a fine example of superior minimalist Scandinavian design—with a warm, welcoming glow. Gliding up to the sexy, light-filled lobby on the escalator is the first of many quirky experiences created by Danish design studio Erik Møllers Tegnestue at the Skt. Petri—a renovated 1930s department store named after the famous church nearby. The mezzanine lobby is filled with clean lines and curves, and the glamorous large rings of light hanging overhead crown the soaring space. The lobby Restaurant Petri is open in the summer to a soothing courtyard garden; the lobby also showcases the elegant nightspot Bar Rouge, one of Copenhagen's most exclusive lounges. One of Denmark's leading visual artists, Per Arnoldi, selected a tricolor scheme for both public and private spaces: bright whites contrasting with his signature cool blues and vivid reds adorn the hotel's interiors down to the smallest accessory. This kind of attention to detail is also evident in impeccable, personal service that makes the 268-room hotel feel much smaller. The Skt. Petri is all about modern comfort and magnificent to-the-point functionality. —

WHERE
Copenhagen
Denmark

MEMBER SINCE
10/2013

ARCHITECTURE
Erik Møller
Arkitekter,
Millimeter
Arkitekter

DESIGN
Per Arnoldi

ROOMS
268

RATES
DKK 1,190–3,590

MEET THE ORIGINAL
Petter A. Stordalen

## Klaus K

Located in the late 19th-century Rake building, the hotel Klaus K is inspired by Finland's national epic saga, the Kalevala. This inspiration is expressed on an intimate human scale throughout the space. The hotel also has two unique restaurants. Toscanini serves delicious dishes originating from Tuscany, with an interior inspired by the Finnish national painter Akseli Gallen-Kallela, who spent time in Florence studying fresco painting technique. The Livingroom is an environment where guests (especially non-hotel guests) can be themselves and enjoy the stimulating yet relaxed atmosphere, have an afternoon cappuccino, a fresh cocktail, or a game on the custom billiard table. Events such as brunches and wine tasting dinners are held in the restaurants, as well as in the Ahjo Bar and Club. With space for up to 350 people, the club is a meeting place for guests and young urbanites who like good music and unique cocktails, served up in a welcoming atmosphere that stays true to its origins. —

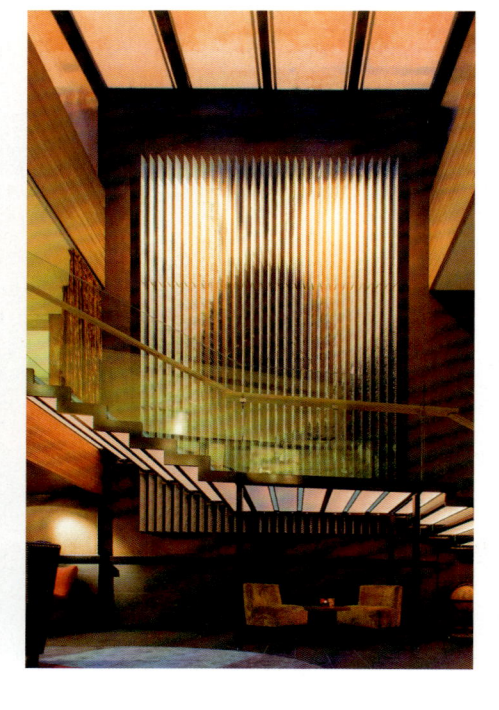

**WHERE**
Helsinki
Finland

**MEMBER SINCE**
01/2005

**ARCHITECTURE**
Antti-Matti Siikala
(SARC Architects)

**DESIGN**
Erik Nissen
Johansen (Stylt
Trampoli AB)

**ROOMS**
171

**RATES**
EUR 155–1,023

**MEET THE ORIGINALS**
Mia Cederberg-
Skvorc,
Marc Skvorc

# 101 Hotel

**WHERE**
Reykjavik
Iceland

**MEMBER SINCE**
09/2001

**ARCHITECTURE /
DESIGN**
Ingibjörg S.
Pálmadóttir

**ROOMS**
38

**RATES**
ISK 59,900–
158,900

**MEET THE ORIGINAL**
Ingibjörg S.
Pálmadóttir

101 Hotel is undeniably cool. For Iceland's foremost foray into the realm of design-led hotels, owner and designer Ingibjörg S. Pálmadóttir has transformed the Icelandic Social Democratic Party's former home into the quintessence of Nordic style. This former office building erected in the 1930s is now Iceland's casual-chic lightning rod, where guests and locals gather in the communal lounge around tree-trunk tables and classic pieces by Eero Saarinen and Philippe Starck, all bathed in the warm glow of the wood-burning fireplace. The bar's spare, masculine style is an innovative mixture of Chinese lacquered tables, wooden blocks, and Edwardian chairs. In contrast is the restaurant's feminine atmosphere, where a white dimpled mural runs alongside the glass roof, and guests can perch on iconic Eros chairs. Throughout the public areas, monochromatic design and clear lines showcase the hotel's collection of art by Icelandic artists. But coolness melts away in the guestrooms' rustic warmth, which includes heated oak floors, white Italian bed linen, matte and glossy black furnishings, Artemide lamps, and a bathroom with a freestanding bathtub waiting to be filled with geothermal waters. —

# Ion Luxury Adventure Hotel

For those of us who have yet to journey to Iceland and only have a vague, often chilly idea of what might be in store for us there, it pays to remember this expression: "Greenland is ice, but Iceland is green." Or put another way, Iceland is a verdant and stunningly beautiful land packed with unexpected joys for the first-time traveler. Sigurlaug Sverrisdóttir, the driving force behind Ion Luxury Adventure Hotel, is no stranger to either the unexpected pleasures of travel or those found in her home country of Iceland. A former cabin-crew member, she has organized adventure tours to Switzerland and provided training and recruitment services to airlines.

In other words, Sverrisdóttir has just what it takes to pull off such a mesmerizing property as Ion. She has the adventurous spirit that one immediately sees in the hotel, which is carved almost defiantly into its rugged Icelandic setting, and the grounded business sense and organizational acumen to make it all work. But "adventurous and grounded" are only two of the many words that seem to embody the hotel. Others, including "fire and ice" and "hot and cold," are typical of the opposites that find themselves yoked together when bold modern design meets this country's incomparable natural landscape.

Situated in Nesjavellir, by Lake Thingvallavatn on the southwest part of the island, Ion offers guests convenient access to all parts of Iceland, from the volcanic marvels of Mount Hengill to the urban sophistication of Reykjavik nearby. Here, the unique landscape plays a pivotal role in the rich design of the hotel, which leans heavily on sustainable practices and the natural features of the island.

Throughout the hotel's 45 rooms, guests discover a mellow mix of concrete chic and earthy ambiance, combined with the warm accents of locally salvaged driftwood and lava; all deftly handled by Santa Monica-based design studio Minarc. Fair-trade organic linens and wooden flooring are found in all accommodations, where the sustainable ethos of the hotel is also realized via water-saving shower systems, and beds and chairs made from recycled materials.

Of course, long before you even see the hotel's interior and its innovative and sustainable design, the property itself stands out in the landscape like a modern-day knight in armor atop a series of pillars dramatically jutting out of the slopes of Mount Hengill. This metaphor of strength and power is no accident. Ion's austere past as an inn for workers at the Nesjavellir Geothermal Power Station served as the canvas for it's future as a chic bolt-hole. The abandoned building was acquired in 2011 and—with the assistance of Minarc—renovated, with a new wing added. The new elements of the structure were built using a prefabricated panelized building system, which exceeds environmentally safe building standards.

In addition to that "green is ice and ice is green" expression, there's another keen observation worth keeping in mind, one that might inspire you to see Iceland and Ion Luxury Adventure Hotel. This one comes from the hotel itself. When asked to describe how they saw themselves in the world, this is how they replied: "Built and operated with emphasis on the utmost respect for nature that inspires, revitalizes, and allows guests a retreat from the everyday, Ion is a hotel where rooms are transformed into personal theatres as nature's most spectacular light show, the Northern Lights, comes to life." We couldn't agree more. Let the show begin. —

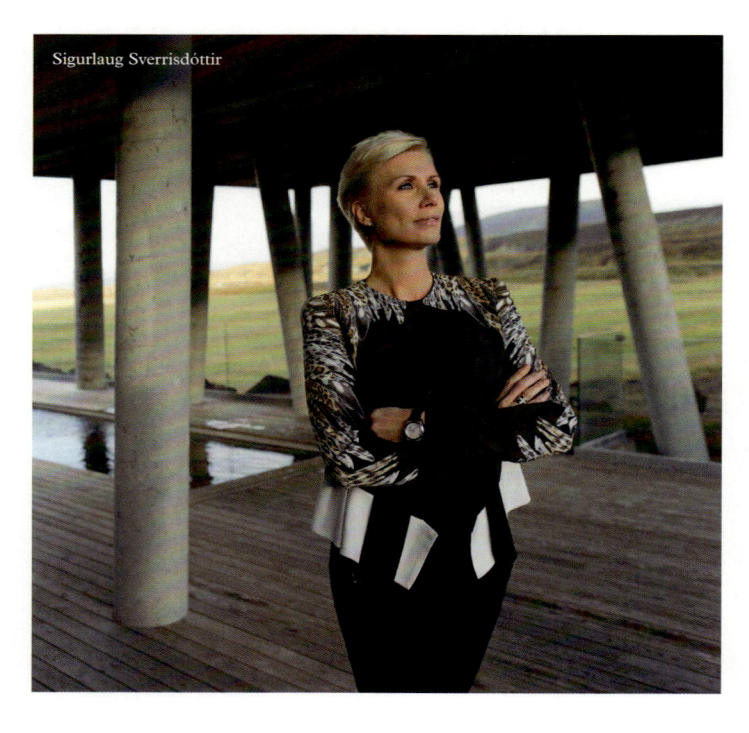

Sigurlaug Sverrisdóttir

| WHERE | ROOMS |
|---|---|
| Nesjavellir Iceland | 45 |
| **MEMBER SINCE** 10/2013 | **RATES** ISK 33,500–51,000 |
| **ARCHITECTURE** Tryggvi Thorsteinsson (Minarc) | **MEET THE ORIGINAL** Sigurlaug Sverrisdóttir |
| **DESIGN** Erla Dögg Ingjaldsdóttir (Minarc) | |

*Ion Luxury Adventure Hotel*
*Nesjavellir, Iceland*

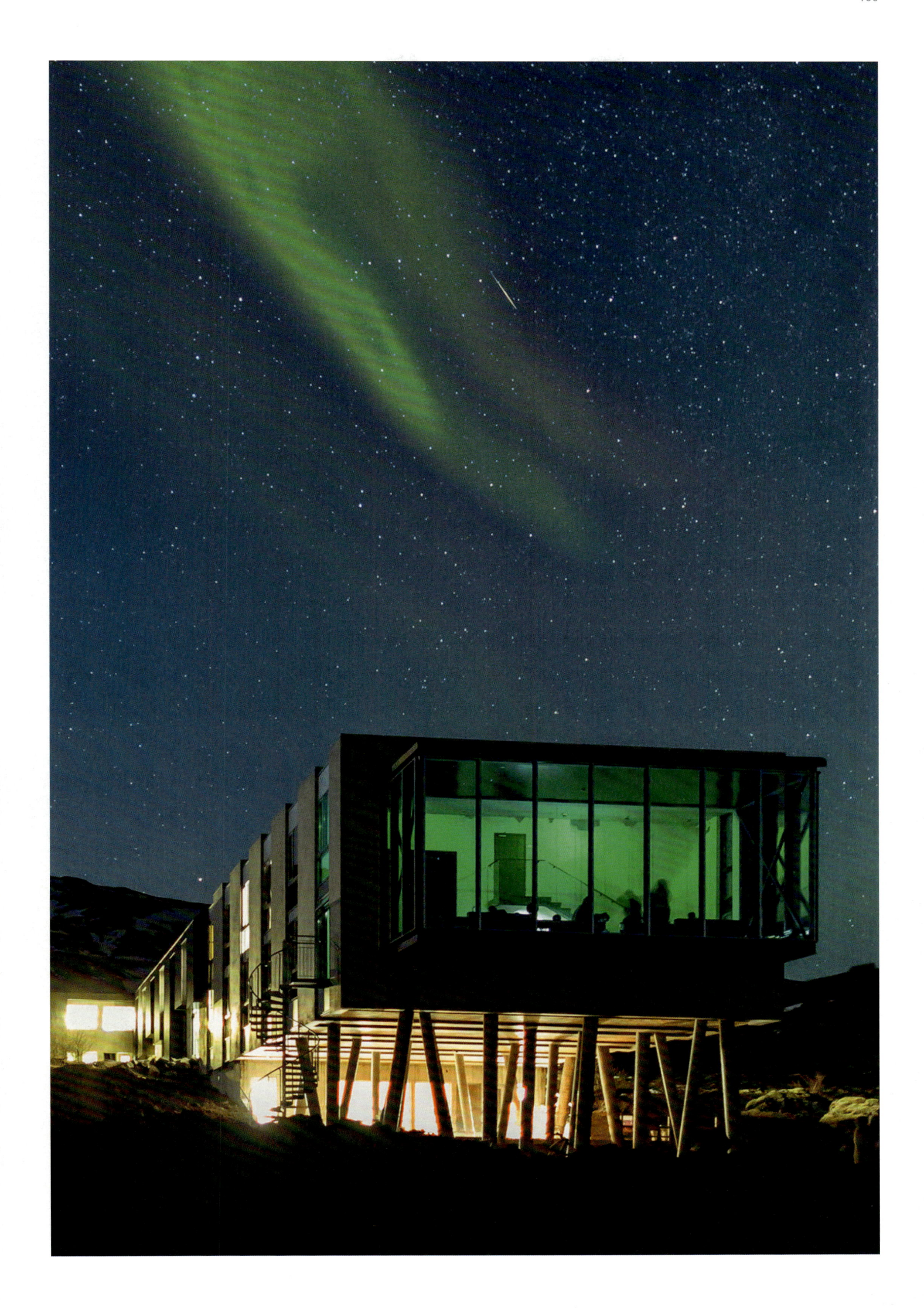

# Sir Albert

**WHERE**
Amsterdam
The Netherlands

**MEMBER SINCE**
09/2014

**ARCHITECTURE /
DESIGN**
Alon Baranowitz,
Irene Kronenberg
(Baranowitz +
Kronenberg
Architecture)

**ROOMS**
90

**RATES**
EUR 169–750

**MEET THE ORIGINALS**
Bram van der Hoek,
Liran Wizman

Worldly, well-traveled, uber-stylish, and passionate about what's next, the Sir Albert guest finds the discernment he craves in this dazzling city residence facing the Rijksmuseum and set in the pulsing De Pijp district, a lively melting pot of cultures with multiple cuisines, hopping bars, and fantastic cafés. Here at Sir Albert, the guest's unique experience begins immediately upon entry when a personal host greets him in his cozy study for check in. Home to a well-stocked library, a pleasant fireplace, and the perfect company for tea or Champagne, this study is just the type of place where you'd expect to find an aristocrat at his leisure. In fact, amid Sir Albert's sanctuary of sublime furniture

and art one often finds city locals who have come for upper class Japanese dining at IZAKAYA Asian Kitchen & Bar and the restaurant's adjoining private terrace with sweeping city views. All rooms, from Sir Boutique to Sir Albert's Residence, have large windows that bathe each space in bright daylight and the pulse of the city, yet inside one still feels a sense of privacy rarely found at hotels. Little wonder Sir Albert has been awarded Netherlands Leading Boutique Hotel two years running. —

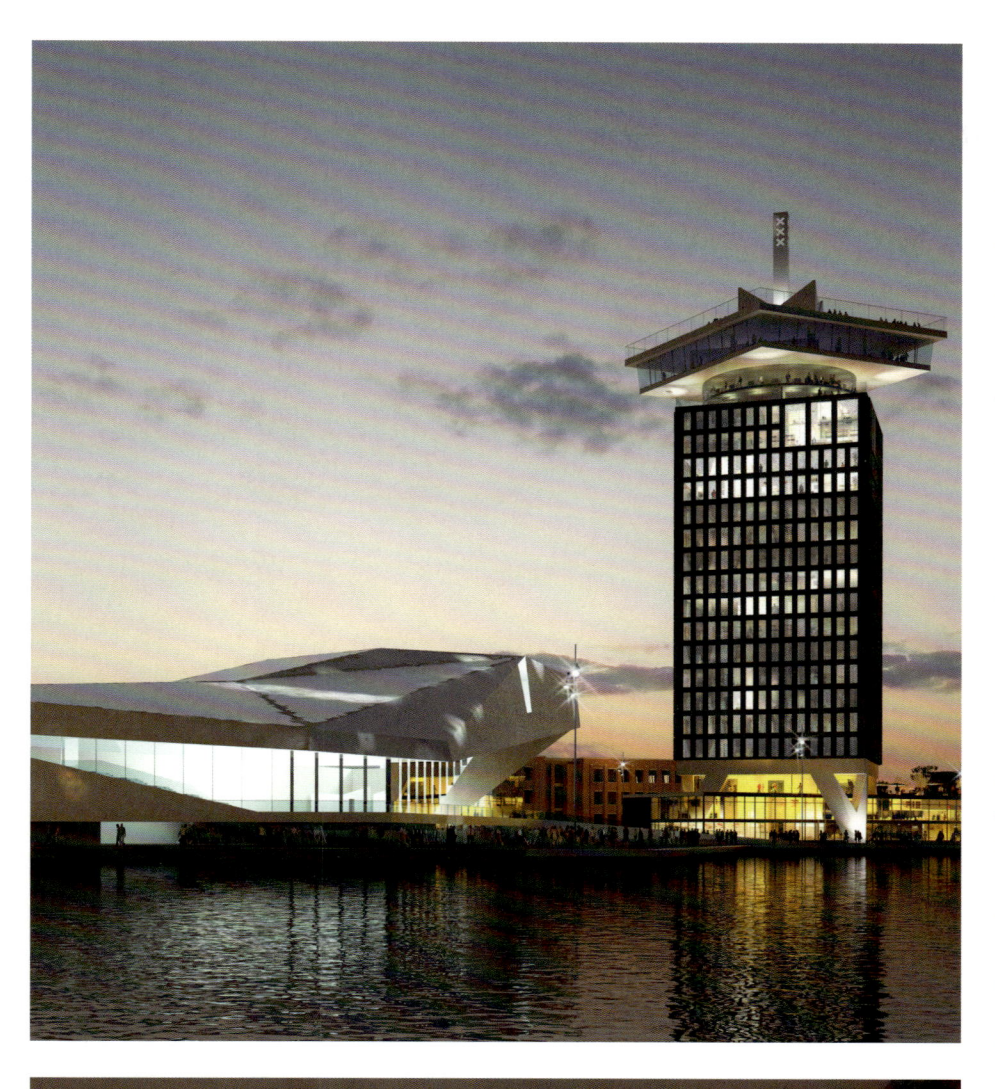

## Sir Adam

Set to open in spring 2016, Sir Adam is the newest outpost of Sir's now-expanding boutique empire, and its second in Amsterdam. Located in the iconic A'DAM Tower, built in 1971 on the Amsterdam IJ-river waterfront, the 110-guestroom Sir Adam offers not only stunning views of the historic city, but also a mix of shops, cafés, offices, a revolving rooftop restaurant, observation deck, and a rooftop swing that sends adventurers flying above the water below. The tower is also in close vicinity to many of the city's hippest movers and shakers, while the hotel's neighbors within the building include the internationally renowned music and entertainment companies MassiveMusic and ID&T and, at the top of the tower, MADAM, Amsterdam's highest nightclub. Fittingly, Sir Adam also includes a state-of-the-art gym, a beer garden, and cool, creative studios where guests can collaborate—perfect for small gatherings, product launches, photo shoots, receptions, meetings, and events of all kinds. ICRAVE, the renowned New York-based design studio, is responsible for Sir Adam's rooms and a "living lobby" called The Butcher Social Club, and in keeping with Sir Adam's music focus, its mezzanine will also include a "music library" with carefully curated tracks. It's the perfect, stylishly artful home base from which visitors can embark on their own journey into the creative heart of Amsterdam. —

| WHERE | ROOMS |
|---|---|
| Amsterdam | 110 |
| The Netherlands | |
| | RATES |
| MEMBER SINCE | EUR 189–850 |
| 10/2015 | |
| | MEET THE ORIGINALS |
| ARCHITECTURE / DESIGN | Bram van der Hoek, |
| Arthur Staal, | Liran Wizman |
| Claus van | |
| Wageningen | |
| Architecten, | |
| ICRAVE | |

# Kruisherenhotel Maastricht

Located in the city center of Maastricht, this renovated 15th century monastery of the "Crutched Friars" offers a breathtaking synthesis: its veritable Gothic façade encloses a sleek, dressed-down modern interior. Many innovative solutions for structural challenges—such as a glass elevator connecting the church to the monastery area—only confirm the notion that the sobriety of the interior's modern style is a perfect match for a late-medieval architectural expression of religious virtue. The 60-room Kruisherenhotel Maastricht complex consists of the original monastery as well as a Gothic church, which now houses the reception area and several hotel facilities, including conference rooms, a library, a boutique, a restaurant, and a wine bar. Another spectacular feature is the newly installed mezzanine, where guests are served breakfast while taking in views of Maastricht through the chancel windows. The *espace vinicole* is no less stunning, both for its impressive offering of wines as well as the strikingly large glass vault which houses them. The interior is matched by beautiful monastery gardens—a haven in the midst of a vibrant city center.

Camille Oostwegel is every inch a Limburg hotelier. As a young boy, he developed a passion for history, culture, and gastronomy. In 1969, he began his studies at the Hotel Management College in Maastricht, before working at various branches of Novotel, during which time he quickly became operations director and advisor for the first Novotel branches outside France. Oostwegel returned to Limburg and made his debut as an independent entrepreneur, starting with his first restaurant, Kasteel Erenstein. All of his hotels and restaurants are housed in monumental buildings that he restored to their former glory, including the Kruisherenhotel Maastricht, where smart design lives between heaven and earth. —

| WHERE | ROOMS |
|---|---|
| Maastricht | 60 |
| The Netherlands | |
| | RATES |
| MEMBER SINCE | EUR 244–544 |
| 01/2005 | |
| | MEET THE ORIGINAL |
| ARCHITECTURE | Camille Oostwegel |
| Rob Brouwers | |
| (Satijnplus | |
| Architecten) | |
| | |
| DESIGN | |
| Henk Vos | |
| (Vos Interior) | |

# Mainport

Wellness is a recurring theme at Mainport, a harbor-hugging city hotel with an envy-inducing location in central Rotterdam. Many of this sleek black building's 215 rooms have facilities usually reserved for hotel spas, like oversized hot tubs with views across the city or private Finnish saunas. Regardless of which room guests choose, the informal eighth-floor Spa Heaven will be waiting, complete with its sultry Turkish steam room and rejuvenating hammam complex, where pores are unblocked and muscles slowly massaged on warm marble tables. The Life Fitness Gym is right next door. Wide glass windows wrap around the waterfront building, shaped by MAS Architecture, allowing guests to see and feel the vibrancy of the inner harbor, with its famous cable-stayed bridge and easy water-taxi connections. Designer Feran Thomassen created the five-star interiors that make subtle nods to far-flung places, without forgetting that Rotterdam is the hotel's "main" port. Even the chefs of the quayside Restaurant Down Under offer a culinary world tour with a menu that includes Argentinian steaks to Japanese sashimi. Add butler service, 600 square meters of flexible meeting space, and a gold sustainability certification from Green Key, and you have a hotel worthy of its location in Europe's largest port. —

WHERE
Rotterdam
The Netherlands

MEMBER SINCE
12/2012

ARCHITECTURE
At Tuns (MAS
Architecture)

DESIGN
Feran Thomassen
(Feranhugo Interior
Architecture)

ROOMS
215

RATES
EUR 110–450

MEET THE ORIGINAL
Karin Geurts

# The Dominican

Behind Brussels' famous theater and opera house La Monnaie, The Dominican weds historicity with forward-thinking, eclectic design. The renowned Dutch duo FG Stijl and architect Bart Lens designed the hotel's sweeping archways, which channel the spirit of the Dominican abbey that stood on this site in the 15th century. A stroll through the monastery corridor evokes an almost medieval feeling of elegance with original Belgian stone flooring, and the Grand Lounge, considered the heart of the hotel, calls to mind the extravagance of old European decadence in its soaring windows and exquisite metalwork. The 150 guestrooms and suites sit around an inner courtyard and feature a rich combination of contemporary design and luxurious textiles. It's a wonderful respite from the continent's new governmental hub, and a space in which old and new Europe effortlessly meld. —

**WHERE**
Brussels
Belgium

**MEMBER SINCE**
08/2006

**ARCHITECTURE**
Bart Lens
(Lens°Ass)

**DESIGN**
FG Stijl

**ROOMS**
150

**RATES**
EUR 140–1,550

**MEET THE ORIGINAL**
Alfred Bree

# The Royal Snail

WHERE
Namur
Belgium

MEMBER SINCE
11/2013

ARCHITECTURE /
DESIGN
Olivier Simon
(Buro5)

ROOMS
30

RATES
EUR 98–253

MEET THE ORIGINAL
Vincent Dardenne

Crafted and served by locals, Namur's Royal Snail offers guests an authentic impression of this corner of Wallonia. Featuring 30 unusually decorated rooms and suites—some framed by views of the Meuse—the intimate bolthole is as much a place to relax as it is a springboard to explore the rest of southern Belgium. Inspired by folklore and the historic characters who have made the story of Namur, every facet of the hotel—from the name of the restaurant to the hotel logo—is wholeheartedly steeped in the area's past and present. A vertical garden featuring 600 plants blankets the hotel's façade; a small taste of the innovative design that lies beyond, masterminded by local firm Buro5 and Parisian studio Muzeo, whose 10 unique themes permeate the rooms. Use of the multifaceted spa, outdoor pool, and manicured gardens is encouraged all year round, and the landmark restaurant, L'Agathopède, entices guests and locals alike with an innovative menu. —

# The Mandala Hotel

Potsdamer Platz is the German capital's epicenter of modern architecture, which puts The Mandala Hotel in good company. With an unassuming entrance and cozy lobby, the owner-managed luxury residence provides long-term, business, and leisure guests discreet relief from the area's bustle. Most rooms face the inner courtyard, and service is impeccably professional but never intrusive. Interiors pare luxury down to its serene and subtle essence, but spare no expense with furnishings by Donghia and Chinese antiques hand picked by proprietor Lutz Hesse. Windows of the second-floor Qiu Restaurant & Bar hideaway offer glimpses of the rush outside, but the mohair sofas and water cascading down a Bisazza glass mosaic wall are welcome distractions. The Michelin-starred restaurant, Facil, is hidden on the fifth-floor courtyard, which is nearly entirely open-air in summer. In the spacious guestrooms, handcrafted tables and ornaments provide solid accents among the soft colors of raw silk curtains and cherry-wood floors. The 600-square-meter, top-floor Ono Spa is a world of holistic well-being high above Berlin. Lucky guests get panoramic city views during indulgent treatments tailor-made for those who value individualism and privacy. —

WHERE
Berlin
Germany

MEMBER SINCE
01/2004

ARCHITECTURE
Ulrike Lauber,
Wolfram Wöhr
(Lauber + Wöhr)

DESIGN
Lutz Hesse

ROOMS
158

RATES
EUR 170–3,800

MEET THE ORIGINALS
Christian Andresen,
Lutz Hesse

# Hotel Zoo
# Berlin

Hotel Zoo, once the pride of Berlin's Kurfürstendamm, has risen again following extensive renovations by American design team Dayna Lee and Ted Berner. Together, they have revitalized the iconic venue by embracing its past glory while installing a firm sense of modernity. Built in 1889 as a private residence, the building's legacy as a hotel began in 1911. Once the official VIP hotel to the Berlin International Film Festival, the grand catwalk was tread by the likes of Romy Schneider and Sophia Loren. The building's reincarnation sees soaring ceilings restored and the original brick and steel work revealed. Touches of fantasy permeate the public spaces, where Alice-in-Wonderland whimsy is invoked with playful proportions. The spacious rooms and suites are equally eccentric, featuring bespoke furnishings and bold Berliner spirit. Luxurious fabrics and contemporary furniture are mixed with keepsakes from the past, as though traces of the original family still remain. At the heart of the hotel, the welcoming Living Room entices guests to linger, and a double-sided fireplace flickers both inside and into the open-air Winter Garden. Local DJ talent spins in the lively Grace Bar, home to the city's creatives and scenesters from near and far.

The conceptual design of Hotel Zoo Berlin has been created by Dayna Lee and Ted Berner. It has been a natural pairing from the start. With their talented team at Powerstrip Studio, Lee and Berner have a unique style for which they have become renowned: luxurious but never decadent, elegant but always invitingly comfortable, fresh and emotional. Multi-disciplinary and well rehearsed, their studio specializes in conceptual design with projects in the USA, Europe, Asia, and the Caribbean—ranging from resorts to urban towers. With backgrounds in television, fashion, and motion picture industries, both Lee and Berner have received Emmy Award nominations for Outstanding Art Direction and Gold Key accolades for their hotel design projects. —

WHERE
Berlin
Germany

MEMBER SINCE
12/2013

ARCHITECTURE
Alfred Messel

DESIGN
Dayna Lee,
Powerstrip Studio

ROOMS
145

RATES
EUR 200–2,500

MEET THE ORIGINAL
Dayna Lee

# Cosmo Hotel
# Berlin Mitte

Situated in the heart of Berlin's Mitte district, the Cosmo Hotel Berlin Mitte is the perfect urban retreat for travelers who appreciate individualized style and hospitality. From its elegant and timeless Scent restaurant, serving international dishes made from local, sustainable and organic ingredients, to its 84 minimalist-designed rooms and relaxation spaces, it offers cosmopolitan citizens personal attention and access to the best of real Berlin. The hotel's dedicated concierge service reserves tables at the hippest restaurants, opens doors to the city's chic and underground clubs, and leads guests to the latest art and culture destinations or to the top boutiques to splurge on Berlin style. Cosmo understands what its guests need: direct access to the right places in the right parts of the city. Cosmo's design and outlook epitomizes the flavor of contemporary Berlin: a juxtaposition between light, inviting spaces, and the gritty, insular underground, an ever-evolving hub of cultural activity where artists, architects, designers, and other creatives continually redefine their city and regularly launch international trends. Cosmo is the ideal location both for first-timers discovering this vibrant city and for regular visitors who want the easiest access to all of their favorite haunts while enjoying the utmost in comfort, luxury, and style. —

| | |
|---|---|
| **WHERE**<br>Berlin<br>Germany | **ROOMS**<br>84 |
| **MEMBER SINCE**<br>07/2009 | **RATES**<br>EUR 104–359 |
| **ARCHITECTURE**<br>Peter Deluse<br>(SEHW<br>Architekten) | **MEET THE ORIGINAL**<br>Gösta Gassmann |
| **DESIGN**<br>Anja Kalusche<br>(Duka Design),<br>3deluxe-Biorhythm | |

# Provocateur Berlin

Opulent glamour meets industrial rawness at Provocateur, designed by Saar Zafrir and primed to seduce design aficionados and luxury lovers alike. The 59-room property offers more than indulgence for the eye, however, with Indochine-Parisian cuisine served in the restaurant headed by Duc Ngo—whose beloved eateries have reshaped the German food scene—and a bar co-created by the Frankfurt-based, award-winning Roomers Bar team. Situated close to Berlin's lively Kurfürstendamm, the property also poises guests for exploration of the capital's newly revitalized City West.

**WHERE**
Berlin
Germany

**MEMBER SINCE**
09/2015

**ARCHITECTURE**
Baranowitz +
Kronenberg
Architecture

**DESIGN**
Saar Zafir

**ROOMS**
59

**RATES**
EUR 100–560

**MEET THE ORIGINALS**
Micky Rosen,
Alex Urseanu,
Liran Wizman

# Sir Savigny

Among the bookshops and cafés of Savignyplatz in Berlin's Charlottenburg district, Sir Savigny is a perfect gateway to a reinvigorated neighborhood. Creativity permeates the 44-room boutique property, with its library in The Kitchen, rotating art exhibitions, and convivial communal table. To satisfy earthier appetites, The Butcher serves top-notch Angus beef—available via a dial-a-burger button in the guestrooms—while the hotel's interiors abound with alluring contrast: cool metals glint against calfskin and wood; Art Nouveau mingles with mid-century modern; and tradition comes into artful contact with on-trend contemporary accents.

**WHERE**
Berlin
Germany

**MEMBER SINCE**
10/2015

**ARCHITECTURE**
Baranowitz +
Kronenberg
Architecture

**DESIGN**
Saar Zafir

**ROOMS**
44

**RATES**
EUR 120–650

**MEET THE ORIGINALS**
Bram van der Hoek,
Liran Wizman

# Das Stue

It's not often that a successful architect jumps into the design arena and becomes an even more successful designer. For Spanish-born Patricia Urquiola, that leap put her name squarely among the top designers in the world.

Moving from Spain to Milan, Urquiola studied with the acclaimed Italian architect and industrial designer Achille Castiglione and subsequently headed the product development of internationally acclaimed furniture company De Padova. During this time, she designed her first pieces of furniture, thus beginning her meteoric ascent to become the leading voice in modern design we know today.

It makes perfect sense, then, that Urquiola would bring her vision to Das Stue, in Berlin's leafy Tiergarten park. Under her inspired guidance, the hotel made a big, transformative jump of its own. Occupying a 1930s building, the hotel was originally the site of the city's Royal Danish Embassy. Now, as a hotel, it still incorporates the prominence of its classicist façade and the natural beauty of its park address, formerly the city's royal hunting grounds, but it also welcomes guests into a warm environment that feels anything but stiff or foreboding as an embassy might.

Not far from the Neue Nationalgalerie, the Berlin Philharmonie, Potsdamer Platz, and the grand shopping boulevard Kurfürstendamm, Das Stue is centrally located in an idyllic setting. The owners have created a sophisticated urban retreat with immediate access to the city's countless attractions. The hotel is awash in personalized comforts and feels much like the living room of a well-connected Berliner (fitting, as Das Stue is the Danish term for "living room"). It also houses the hotel's much-heralded, one-Michelin-star Cinco restaurant.

Urquiola fully realized her signature sleek, comfortable, and elegant design look by installing this "living room" feel throughout the property. The subdued modern decor of the 77 guestrooms emphasizes polished surfaces and rich fabrics, and most

have views of either the animals in the neighboring Berlin Zoo or the Tiergarten. Thanks to its former life as an embassy, the rooms and suites in the old part of the hotel benefit from high ceilings and generous space. The large rooms in the hotel's new building are equally charming thanks to floor-to-ceiling views, hardwood floors, and their elegant design; 14 rooms feature terraces and balconies. Das Stue has also incorporated eco-friendly heating amenities, furthering the hotel's concept of bringing together the historic, the modern, and the contemporary in a remarkable and replenishing symbiosis. And all of this can be felt to maximum effect in Das Stue's public spaces, which offer a striking yet cozy mélange of areas where guests can lounge, such as the hotel's library with its couches and chairs in muted shades of yellow, rust, and gray.

For the architect taking on this structure's conversion from embassy to hotel, the challenge was clear: Maintain the grandeur, but make it inviting at the same time. The Potsdam-based firm Axthelm Architekten rose perfectly to the occasion. Working with a building originally built in the 1930s, the architects wisely kept the structure's diplomatic spirit alive by preserving its stately architecture and modernist façade, which was designed by German architect Johann Emil Schaudt (1871–1957) and inspired by Danish Classicism. With some subtle and some bold touches, the architects renovated the old embassy to invoke a calming ambiance, utilizing open spaces and contemporary minimalist design. Axthelm Architekten also added a new wing on the building's former back courtyard, which is clad in a floral-patterned concrete surface acting as an elegant counterbalance to the rough-dressed stone of the main building.

For Urquiola, the idea of taking something old and filling it with new life and new purpose is exactly the kind of challenge she thrives on. "In everything I do, I begin with memory, but I rethink it in a new way," she says. From embassy to a stunningly grand yet inviting hotel, Das Stue is old memories transformed into new magic. —

WHERE
Berlin
Germany

MEMBER SINCE
06/2010

ARCHITECTURE
Johann Emil
Schaudt,
Annette Axthelm
(Axthelm
Architekten)

DESIGN
LVG Arquitectura,
Patricia Urquiola
(Studio Urquiola)

ROOMS
77

RATES
EUR 250–3,500

MEET THE ORIGINALS
Daniel Aristot,
Aurora Fierro,
Juanjo Gimeno

# 25hours Hotel Bikini Berlin

In the urban jungle of Berlin, the City West area stands out. Every day, thousands of residents and visitors walk along the lively shopping street Kurfürstendamm and past the Kaiser Wilhelm Memorial Church with its bomb-damaged spire that bears witness to the destruction of World War II, recalling Berlin's history amid its vibrant present. It all comes together in the Bikini Berlin complex, an exciting redevelopment project centered on an ensemble of iconic 1950s-era buildings between Kurfürstendamm and the Berlin Zoo. 25hours Hotel Bikini Berlin, the first Berlin property from celebrated hotel group 25hours, puts urban explorers right in the middle of this developing intersection of past and future, nature and culture. Located in a ten-story high-rise, the hotel sits among historic buildings, including the Zoo Palast cinema and the so-called Bikinihaus, a unique postwar architectural icon. The project is an urban oasis where visitors and Berliners live, work, shop, and play. One of the cornerstones of the project is 25hours Hotel Bikini Berlin's rooftop bar and restaurant, with its wide-open design and 360-degree view. On one side, the wide green expanses of Tiergarten park and the animals in the Berlin Zoo; on the other, the bustling Breitscheidplatz and majestic Kaiser Wilhelm Memorial Church. This duality carries over to the interior of the hotel as well, with a playful "urban jungle" concept, orchestrated by forward-thinking local designer Werner Aisslinger. Of the 149 rooms, half face the zoo and follow a "jungle" design scheme, with warm colors, natural materials, and floor-to-ceiling windows that offer direct views of the monkey enclosure. In contrast, rooms facing the city center have a rougher, edgier feel.

The vanguard 25hours Hotel Company returns the tradition of the grand old hotel to contemporary form with its inventive, made-to-measure hotels with "freshly interpreted service" where the staff maintains a concierge-level attentiveness, while invoking a laid-back, authentic atmosphere. Each 25hours hotel tells a story via design concepts built from organic narratives inspired by the hotel's location, as well as pure imagination. Ardi Goldman is their resident visionary, from real estate development down to the finest detail of decor; Stephan Gerhard keeps his sharp Swabian eye turned to the numbers; Kai Hollmann is the grand seigneur of Hamburg's hospitality industry, and CEO Christoph Hoffmann claims the title of unwitting captain of their cunning fleet. —

| WHERE | ROOMS |
|-------|-------|
| Berlin | 149 |
| Germany | |
| | RATES |
| MEMBER SINCE | EUR 120–300 |
| 12/2012 | |
| | MEET THE ORIGINALS |
| ARCHITECTURE | Stephan Gerhard, |
| Hild und K | Ardi Goldman, |
| Architekten, | Christoph |
| Paul Schwebes, | Hoffmann, |
| Hans Schoszberger | Kai Hollmann |

DESIGN
Werner Aisslinger
(Studio Aisslinger)

Ardi Goldman, Christoph Hoffmann, Stephan Gerhard & Kai Hollmann

# Cerês

Located in the hub of Rügen's most famous resort town, the award-winning Cerês is a fine example of contemporary climate-centric building. Each room emphasizes a sense of space, carefully selected to the smallest details, and comes equipped with a balcony or terrace that showcases a panoramic view of the island's white sand beaches and glistening blue water. The effect is mesmerizing, as if the Caribbean has been transplanted to northeastern Germany.

WHERE
Rügen
Germany

MEMBER SINCE
11/2007

ARCHITECTURE /
DESIGN
Moritz Lau-
Engehausen

ROOMS
50

RATES
EUR 158–898

MEET THE ORIGINAL
Moritz Lau-
Engehausen

# The George

Offering 125 smartly dressed guestrooms and suites, Hamburg's The George is an ingenious interpretation of an English-style social club. A pioneer in St. Georg, one of Hamburg's most multifaceted neighborhoods, the hotel is a shining example of private and elegant business chic in a thoroughly modern Hanseatic city.

WHERE
Hamburg
Germany

MEMBER SINCE
09/2007

ARCHITECTURE
Thomas Ritscher
(GRS Reimer
Architekten)

DESIGN
Tom Schlotfeldt,
Sibylle von Heyden

ROOMS
125

RATES
EUR 147–462

MEET THE ORIGINAL
Kai Hollmann

# Gastwerk
# Hotel Hamburg

Seasoned hotelier Kai Hollmann turned Hamburg's 19th-century municipal gasworks (or *Gaswerk*) into Europe's first loft-style hotel as easily as he dropped a "t" into its name, instantly transforming the red-brick complex into a "guest works" in every sense. Natural light floods into the atrium lobby's heights through two enormous arched windows and the glass roof. A gigantic, green industrial machine and an old tower clock serve as reminders of the building's days as a power station. Suspended overhead is a bridge leading to the white modern elements housing the guestrooms, where interior designers Regine Schwethelm and Sibylle von Heyden have created an ambience combining modern functionality with original features and materials. When visiting Mangold, the in-house restaurant, guests will enjoy a creative cuisine composed of the freshest ingredients from all around the globe. The Moroccan-influenced Day Spa offers a sauna, steam bath, massages, Ayurveda, and beauty treatments. Neutral light and soothing textures soften the rough industrial structure, giving its once purely functional form new life. Guests can kick back in comfy rooms with exposed brick walls and arched multipaned windows, then head down to business meetings in the ultramodern conference rooms (seven of them!) or to the buzz of the low-lit bar, which is just as popular with locals as with visitors. —

WHERE
Hamburg
Germany

MEMBER SINCE
12/1998

ARCHITECTURE
Klaus Peter Lange
(Architekten Lange
& Partner)

DESIGN
Regine Schwethelm,
Sibylle von Heyden

ROOMS
141

RATES
EUR 120–450

MEET THE ORIGINAL
Kai Hollmann

# 25hours Hotel HafenCity

**WHERE**
Hamburg
Germany

**MEMBER SINCE**
09/2010

**ARCHITECTURE**
Böge Lindner K2
Architekten

**DESIGN**
Conni Kotte,
Stephen Williams
Associates,
Eventlabs

**ROOMS**
170

**RATES**
EUR 115–250

**MEET THE ORIGINALS**
Stephan Gerhard,
Ardi Goldman,
Christoph
Hoffmann,
Kai Hollmann

Reviving and reinventing Hamburg's old harbor quarter into a hub of urban life that features restaurants, shops, and the world-class Herzog & de Meuron-designed Elbe Philharmonic Hall, HafenCity is Europe's largest development project of the 21st century. In the midst of it all stands the 25hours Hotel HafenCity, the first hotel development to open in this neighborhood. The hotel draws from the area's rich maritime history in a radical re-imagining of a traditional seamen's club, complete with 170 cabin-style suites, a rooftop sauna, Heimat restaurant, bar, art gallery, and a conference room housed in a repurposed shipping container. For Christoph Hoffmann, CEO of the 25hours

Hotel Company, design is an expression of the company's philosophy. Each hotel design finds inspiration in its location, thus each is organically distinctive. The hotel's narrative is inspired by 25 personal chronicles collected by storyteller Markus Stoll and gathered in a "ship logbook" in each cabin. The ground floor recreates the rough world of a contemporary harbor, with old import/export crates, timber planks, and stacks of oriental carpets. As the mood shifts from daytime to evening, the ground floor's laid-back lounge becomes a buzzing bar that is the place to be for guests and locals alike. —

# Side

Jan Störmer's glass and steel architecture is the soaring stage for dramatic lighting by theater virtuoso Robert Wilson. The stark drama is softened through interiors by Milan designer Matteo Thun, whose rounded surfaces and carefully chosen colors create aesthetic warmth and vitality. Hovering above a futuristic atrium is the eighth-floor lounge where Thun suggests weightlessness with improbably curved furniture and floating disk lighting.

**WHERE**
Hamburg
Germany

**MEMBER SINCE**
04/2000

**ARCHITECTURE**
Jan Störmer
(Störmer Murphy
and Partners)

**DESIGN**
Matteo Thun

**ROOMS**
178

**RATES**
EUR 160–1,050

**MEET THE ORIGINAL**
Gregor Gerlach

# 25hours Hotel Number One

High-end, retro design furnishings from across Europe set the mood in this laid-back, moderately priced hotel. Interior design firm Dreimeta's core idea was to create convertible spaces both for guests and for private functions. Guests can settle in style at the restaurant Esszimmer, serving as a breakfast, lunch, dinner, and bar area. Alternatively, people lounge by the fireplace and jukebox in the hotel's Living Room or, in the summer season, bathe in the sun on the roof-deck. 25hours Hotel Number One's hottest addition is the foodtruck Burger de Ville, serving burgers out of a converted Airstream.

**WHERE**
Hamburg
Germany

**MEMBER SINCE**
06/2003

**DESIGN**
Armin Fischer
(Dreimeta),
Sibylle von Heyden

**ROOMS**
128

**VILLAS**
1

**ROOM RATES**
EUR 95–425

**VILLA RATES**
EUR 515–1,165

**MEET THE ORIGINAL**
Kai Hollmann

# East

Since its opening in a former iron foundry situated in Hamburg's famed St. Pauli entertainment district, East has evolved into its own cosmos. Chicago-based architect-designer Jordan Mozer created an ornate environment with floor-to-ceiling curtains, handmade furnishings, and wrought-iron fixtures, all illuminated by candlelight. Bright tones, futuristic curved forms, and subtle references to Eastern culture are complemented by the textures of natural fabrics and leather. At the center of it all, the three-story Eurasian restaurant and lounge space never fails to elicit impressed gasps from first-time visitors. Four pillars soar from the ground to the top floor, while dramatic lighting illuminates parts of the original exposed-brick foundation. Beyond the main restaurant are several separate bar areas and an interior courtyard decked out in stone, timber, and greenery. But the focus is not only on the visual design: The use of scent creates instantly recognizable identities for each area of the hotel— ginger, cinnamon, mandarin, jasmine, and lotus—a lasting experience for all five senses. Set over several stories, 128 rooms, lofts, and suites range in size from 25 to 150 square meters. Interlocking public spaces offer a multitude of diversions, such as a spa zone, a high-tech gym, a private screening room, and the private members club Uppereast. All of this is complement-ed by a management team whose concept of hospitality is so warm and welcoming that even the employees don't like to leave. Like a balanced chi, East presents the perfect blend of gastronomy, hospitality, and nightlife. —

WHERE
Hamburg
Germany

MEMBER SINCE
06/2003

ARCHITECTURE / DESIGN
Jordan Mozer
(Jordan Mozer and
Associates)

ROOMS
128

RATES
EUR 160–850

MEET THE ORIGINAL
Christoph Strenger

## Sir Nikolai

Perched on the Nikolaifleet waterfront, Sir Nikolai is sandwiched between the center of Hamburg's Altstadt and the super-modern HafenCity district to the south. The 94-room property is characterized by twinkling chandeliers, polished marble, and rough wood and brick. Sir Nikolai is also home to IZAKAYA Asian Kitchen & Bar—from the Michelin-starred Nobu restaurant team in London—which serves up Japanese cuisine. After a great meal, guests can retire to the grand Library, replete with terrazzo flooring and an open fireplace.

| | |
|---|---|
| **WHERE** Hamburg Germany | **ROOMS** 94 |
| **MEMBER SINCE** 10/2015 | **RATES** EUR 130–750 |
| **DESIGN** FG Stijl | **MEET THE ORIGINALS** Bram van der Hoek, Liran Wizman |

## Hotel ÜberFluss

Hotel ÜberFluss, Bremen's first member of Design Hotels™, is located on a small, quiet street on the banks of the Weser river above recently unearthed medieval relics. Some of the 51 guestrooms are endowed with baths and showers that open into the rooms themselves, while the suite features a whirlpool and a Finnish sauna from which guests can take in views of the river below. Easily accessible from the city's central railway station, airport, and motorway, Hotel ÜberFluss also provides access to Bremen's charming marketplace and old city center.

| | |
|---|---|
| **WHERE** Bremen Germany | **ROOMS** 51 |
| **MEMBER SINCE** 12/2009 | **RATES** EUR 124–345 |
| **ARCHITECTURE** Kastens + Siemann Architekten | **MEET THE ORIGINALS** Lüder Kastens, Rolf Specht |
| **DESIGN** Concrete | |

# Factory Hotel

The old Germania Brewery in Münster has found a second life as the Factory Hotel, a surprising and successful combination of old and new that fuses urban buzz with quiet serenity. The land-marked brewery building at the complex's center looks out over a relaxing lake and is surrounded by a lively combination of shops, restaurants, and clubs. The modern wing created by architect Andreas Deilmann houses the Factory Hotel, with 128 rooms and 16 luxury suites designed with elements such as wood, concrete, and felt, that reflect the site's industrial origins while fostering a comfy sophistication. Guests can get some personal training or simply relax at the amazing and expansive 3,500-square-meter fitness center, with its swimming pool, spa, and roof terrace, before they re-emerge into Factory life. It's a life that serves up traditional German and Austrian cuisine in the main restaurant and Mediterranean snacks and tapas at the Spanish eatery. Things heat up at night with dancing till dawn in the brewery basement nightclub, Grey, which has won a great reputation in town as an electro and house venue.

Hotel manager David Deilmann was quick to recognize the poten-tial of his native Münster, a city rapidly developing along with its local hotel market. At the heart of this growth is the Factory Hotel. Opened on the former site of the Germania Brewery, the Factory was reconstructed by Deilmann's architect father, Andreas Deilmann. The younger Deilmann has pulled together a team of specialists in all divisions, from event sales to bartenders, united in their goal to help prepare a good time for all guests. Through the development of the Factory, Deilmann has led the renaissance of Münster's most exciting lifestyle district. —

David Deilmann

| WHERE | ROOMS |
|---|---|
| Münster | 144 |
| Germany | |
| | RATES |
| MEMBER SINCE | EUR 89–268 |
| 06/2008 | |
| | MEET THE ORIGINAL |
| ARCHITECTURE / DESIGN | David Deilmann |
| Andreas Deilmann | |

# The Qvest

For Michael Kaune, being editor-in-chief of *Qvest* magazine means a great deal of time on the road. Indeed, he says he's probably stayed in more than 600 hotels in his life. But for the passionate art and design collector and lover of design-driven hotels, that's just fine with him.

His infatuation with hotels started in the early 1990s when he was among the first guests at the Paramount in New York—a city where he spent a great deal of time because of his work. But it has lead someplace far more personal—to a hotel of his own.

"I got offered this great building in the neighborhood where I grew up," says the Cologne native of a neo-Gothic structure from 1897, set on a quiet square between the Cologne Cathedral and the Belgian Quarter. A remarkably stunning hotel, The Qvest is a hidden gem in the center of Cologne, now quietly wearing the mantle of the city's new modern showroom.

One look at The Qvest is all it takes to understand that this is a special property, brought back to life with respect for the past and a love of design, the dramatic, and the wonderful. The heritage-listed building was the former historic archive of Cologne, created after a design by Friedrich Carl Heimann. Following two years of extensive renovation spearheaded by Kaune, the property has become a stunning archive of modern design, featuring cross vault ceilings and Gothic windows.

With a careful eye to restoring the building's historical details, each of the 34 rooms and suites are cut differently and befittingly furnished with individual character. The interiors are a mid-century design and Bauhaus lover's dream. With a large part of the hotel including Kaune's personal collection of furniture and photographs, the spaces form a veritable design museum. Here, one finds a vintage and mid-century design treasure trove, as well as a haven for lovers of contemporary photography and art. Some of the suites feature six-meter high cross vaults, while the Salon Suite boasts a hand-painted medieval wooden ceiling from 1390. The interiors are filled with design classics by the likes of Charles and Ray Eames, Arne Jacobsen, Le Corbusier, Eileen Gray, and Mies van der Rohe. How strong is the love for the creative here? The Qvest offers a record player and a small library of art, design, and fashion literature in every room.

Taking advantage of the space and the scale of the historic building, Verner Panton's playful Living Tower and stool can also be seen in one of the rooms. The bathrooms, meanwhile, are furnished with Parisian Metro tiles featuring quirky details, such as Pailla wall lamps by Eileen Gray or the Circulaire mirror that Jacques Adnet developed in the early 1950s for Hermès Paris. In the lobby, guests are greeted by a striking vintage brass and Belgian bluestone front desk.

For Kaune, it's fitting that the hotel he loves best is in the city that initially shaped him. Cologne, with its narrow alleyways, colorful buildings along the Rhine, and many historic sites, is also home to some trendy neighborhoods where street art, high-end fashion stores, and a multicultural milieu attract the young, the creative, the driven, and the intellectual. Here, directly next to The Qvest, one finds the hotelier's renowned Galerie-Kaune Contemporary, which is housed in a glorious old chapel.

Cologne draws fans of design and art from all over the world. Fortunately, it also attracted a native son who loves hotels—and wasn't afraid to build his own. —

WHERE
Cologne
Germany

MEMBER SINCE
06/2015

DESIGN
Michael Kaune

ROOMS
34

RATES
EUR 140–900

MEET THE ORIGINAL
Michael Kaune

Michael Kaune

# Hotel zum Löwen

**WHERE**
Duderstadt
Germany

**MEMBER SINCE**
12/2012

**DESIGN**
Anja Müller

**ROOMS**
54

**RATES**
EUR 105–170

**MEET THE ORIGINAL**
Prof. Hans Georg
Näder

When you step into Hotel zum Löwen, a timber-framed building in the heart of medieval Duderstadt, it feels like you're entering a close friend's home. Personal touches from owner Hans Georg Näder, a local hero, have enlivened the renovation of this historic and beloved hotel: Original artworks by Andy Warhol hang on the walls; Näder's favorite wines are sipped beneath chandeliers in Chez Otto, one of two restaurants; and eclectic souvenirs from his world travels have been thoughtfully placed throughout the rooms. As you stroll through the building, with the purple-brown interiors conjuring up a sense of drama, you'll see how the best elements of a traditional German guesthouse have been retained and then reinvigorated with modern design and comfort. For starters, the well-known hotel has its own resort-quality spa, complete with a steam room, pool, salt sauna, and fitness equipment by Milon. The newly renovated 17th-century building also has three meeting rooms, a daylight-drenched winter garden, vaulted wine cellars (including tasting rooms), and an in-house microbrewery overseen by an acclaimed local Braumeister. The largest of the 54 rooms and suites have balconies from which you can see Duderstadt's red rooftops and black spires stretching off into the distance. Kunsthalle HGN, the gallery housing Näder's contemporary art collection, is also close by—making this place perfect for a restful getaway. —

# Gerbermühle

Frankfurt's Gerbermühle boasts everything one could desire in the German financial capital. Classical architecture (the building was a flour mill in the 1500s) is interspersed with sleek, modern accoutrements, handsome leather furniture, and a 500-seat summer garden. Luxuriously situated on the banks of the idyllic Main river, the property even offers a sense of historical romance; it was here that Goethe met the love of his life.

**WHERE**
Frankfurt
Germany

**MEMBER SINCE**
06/2007

**ARCHITECTURE**
Jochem Jourdan,
Bernhard Müller
(Jourdan & Müller)

**DESIGN**
Oana Rosen
(Rosen Architekten)

**ROOMS**
18

**RATES**
EUR 110–500

**MEET THE ORIGINALS**
Micky Rosen,
Alex Urseanu

# The Pure

A 19th-century loft in the heart of Frankfurt was completely renovated to create The Pure—a hotel that captures the city's open-minded, cosmopolitan spirit. Guests are invited to relax in a welcoming, homey atmosphere where the works of artist Stefan Strumbel in the lobby, breakfast room, bar, and lounge explore the meaning of the word *heimat* (home). Lighting and music add ambience that changes throughout the day.

**WHERE**
Frankfurt
Germany

**MEMBER SINCE**
09/2005

**ARCHITECTURE**
Scharnberger
Architekten

**DESIGN**
Oana Rosen
(Rosen Architekten)

**ROOMS**
50

**RATES**
EUR 100–460

**MEET THE ORIGINALS**
Micky Rosen,
Alex Urseanu

# Roomers

Classic curves meet progressive design at Roomers, an ambitious venture in Germany's business capital. With its gleaming glass façade set in specially glazed white concrete, Roomers offers a glossy snapshot into the city it inhabits: all timeless charm and modern architecture. Conceptualized by Grübel Architects and designer Oana Rosen (known for her work at The Pure and Gerbermühle), Roomers is an elegantly futuristic six-story hotel full of electrifying design flourishes, such as an illuminated bubble-domed wellness center on the rooftop designed by 3deluxe-Biorhythm. Once a staid office building, Roomers has morphed into the exact opposite: a cozy space full of swirling dark colors. Guests enter the lobby and are transported into a world of luxury. The interior design of the 116 guestrooms is both indulgent and minimalist—the two seemingly contradictory concepts meet here to superb effect. Three conference areas in Roomers' illuminated top level are kitted out with the most modern yet elegant accoutrements, making them the ultimate business experience for up to 25 people. Located just minutes away from the river Main, visitors are hard-pressed to find a better backdrop to relax and indulge in Frankfurt. —

| | |
|---|---|
| **WHERE** Frankfurt Germany | **ROOMS** 116 |
| **MEMBER SINCE** 09/2007 | **RATES** EUR 170–700 |
| **ARCHITECTURE** Norbert Grübel (Grübel Architekten), 3deluxe–Biorhythm | **MEET THE ORIGINALS** Micky Rosen, Alex Urseanu |
| **DESIGN** Dana Rosen (Rosen Architekten) | |

# 25hours Hotel by Levi's

25hours Hotel by Levi's offers 76 unique guestrooms in inviting shades of Levi's blue, along with quirky decorative elements that evoke different decades of the 20th century. As evidenced in its fully equipped Gibson Session Room, spectacular rooftop lounge, iMac workstation, and the relaxed Chez Ima restaurant, 25hours Hotel by Levi's is committed to making urban nomads feel as if they've slipped into the perfect pair of jeans.

WHERE
Frankfurt
Germany

MEMBER SINCE
01/2008

ARCHITECTURE
Karl Dudler

DESIGN
Delphine Buhro,
Michael Dreher

ROOMS
76

RATES
EUR 110–240

MEET THE ORIGINALS
Stephan Gerhard,
Ardi Goldman,
Christoph Hoffmann,
Kai Hollmann

# Roomers Loft

On bustling Kaiserstrasse, a few steps from Frankfurt's main train station, Roomers Loft is an urban oasis. Its 240 square meters of exquisitely appointed space is for guests who want five-star service in a private apartment. An ideal setting as an extended-stay suite, film set, conference venue, or romantic retreat, the loft is wonderfully integrated into the very fabric of Germany's financial capital.

WHERE
Frankfurt
Germany

MEMBER SINCE
09/2010

DESIGN
Kay Mack
(Mack+Co)

ROOMS
1

RATES
EUR 650–7,000

MEET THE ORIGINALS
Micky Rosen,
Alex Urseanu

# 25hours Hotel
# The Goldman

**WHERE**
Frankfurt
Germany

**MEMBER SINCE**
09/2006

**ARCHITECTURE**
Alexander Bernjus,
Hathumar Gisbertz

**DESIGN**
Delphine Buhro,
Michael Dreher

**ROOMS**
97

**RATES**
EUR 100–210

**MEET THE ORIGINALS**
Stephan Gerhard,
Ardi Goldman,
Christoph
Hoffmann,
Kai Hollmann

Both a hideaway and a local hotspot, 25hours Hotel The Goldman was influenced and inspired by the diversity of "Mainhattan" (that's Frankfurt am Main, for the uninitiated) and the aesthetics of the UN Headquarters in New York. With its recent extension, the hotel project initiated by Ardi Goldman—well known for his instrumentality in the revival of Frankfurt's Ostend—has become even more popular as a meeting place for the city's style-conscious urban natives and as a home base for young business travelers who appreciate individuality. Designed by Delphine Buhro and Michael Dreher, the Goldman's 97 individually designed guestrooms tell the stories of local and international celebrities. Guests get a never-ending variety of vintage eclecticism, and the themed rooms—like the Princess, Paris, and Casino rooms—add to the sense of fun. All of them boast the standard 25hours features that urban nomads love: ultra-comfortable beds, air-conditioning, sustainable toiletries, a flat-screen TV, a minibar, UE Boom bluetooth speakers, and free WiFi. Goldman Restaurant boasts a Mediterranean-inspired ambience and ambitious cuisine created by proprietor and chef Thomas Haus, who has put the hotel on the culinary map. Right next to the lobby is the laid-back Oost Bar, a lounge, bar, and venue for local artists. Just a few steps away is the bespoke green living room, with its own little terrace— a space in which to kick back and relax. —

# Die Träumerei

Standing as a landmark site in the pastoral German town of Michelstadt since 1623, Die Träumerei is a brilliantly executed project by German film actress Jessica Schwarz and her sister, Sandra Schwarz, both of whom grew up admiring the historic building from afar. Now converted into five spacious and impeccably designed rooms, the re-imagined timbered house with cozy café fully retains the whimsical charm of its shingled predecessor, with many aesthetic bonuses added to the new incarnation. Quirky design touches abound, such as movie-row seats and individual room themes of hollyhock, ivory, jade, and gold. Die Träumerei (which translates as "The Dreamery") thus wordlessly taps into the attic-dwelling nostalgia of many people in creative professions. The artistic use of the original dark wood beams will make guests feel as if they're stepping into a fantastical haute-design tree house. The guestrooms' intimacy and comfort is a dream-come-true for couples in need of a getaway, while the beautiful natural surroundings of the Odenwald provide many possibilities for outdoor activities. Let your latent childhood desires run rampant for a weekend. —

WHERE
Michelstadt
Germany

MEMBER SINCE
01/2009

ARCHITECTURE
Gesine Stöcker,
Johannes Müller-
Baum

DESIGN
Johannes Müller-
Baum,
Jessica Schwarz,
Sandra Schwarz

ROOMS
5

RATES
EUR 105–160

MEET THE ORIGINAL
Jessica Schwarz

Günter Wagner

# La Maison Hotel

In a century-old mansion in the middle of Saarlouis—a small town just over the French border in Germany—La Maison Hotel wows culinary connoisseurs and contemporary design buffs alike. Originally built as an officers' casino, the vacant property was stumbled upon by a lover of fine food and ambitious would-be hotelier, Günter Wagner. With a penchant for both the old and the contemporary, Wagner commissioned architects Christina Beaumont and Achim Gergen to renovate and extend the existing building to create La Maison Hotel, a hybrid of old aristocratic opulence and an angular ode to contemporary design. The property's new façade of bronze and aluminum melds perfectly with the traditional regal villa amid lush tree-shaded lawns and a cobbled drive. The glassed winter garden plays host to the Pastis bistro and a delicatessen shop, while the hotel park is a regal retreat. As created by Birgit Nicolay, the hotel's interior design comprises glamorous white spiral staircases, herringbone hardwood floors, bespoke leather furnishings, freestanding bathtubs, oak windows, and an artistic documentation of Louis XIV's life throughout. The most notable of these tributes is the Louis restaurant, which offers gourmet cuisine under head chef Martin Stopp, who worked in various Michelin-star restaurants including the much-celebrated GästeHaus Klaus Erfort (three stars) and Saarbrücken's Le Noir (one star).

When you're given the reigns to a company that is credited with introducing frozen pizza to Germany and changing the face of its food market industry, hotels seem a strikingly divergent path. But Günter Wagner's decision to open a hotel seems preordained; his father owned a hotel in the small town of Braunshausen and Wagner even went to culinary school and worked in a Michelin-starred restaurant. When he retired from Wagner Frozen Food Company, the Saarland-native's mind returned to hotels. The result is La Maison, Saarlouis' first upscale hotel—a property that's been missing in this stunning French-German city, and one that is changing the local hospitality scene. —

| WHERE | ROOMS |
|---|---|
| Saarlouis | 38 |
| Germany | |
| | RATES |
| MEMBER SINCE | EUR 85–245 |
| 01/2014 | |
| | MEET THE ORIGINAL |
| ARCHITECTURE | Günter Wagner |
| Achim Gergen, | |
| Christina Beaumont | |
| (CBAG) | |
| | |
| DESIGN | |
| Birgit Nicolay | |
| (Nicolay Design) | |

# Becker's
# Hotel & Restaurant

**WHERE**
Trier
Germany

**MEMBER SINCE**
09/2007

**ARCHITECTURE**
Andreas Bohr,
Hans-Jürgen Stein

**DESIGN**
Ingbert Schilz,
Jutta Schilz

**ROOMS**
32

**RATES**
EUR 110–240

**MEET THE ORIGINAL**
Wolfgang Becker

Nestled amid the vineyards and rolling hills of the ancient German city of Trier, Becker's Hotel & Restaurant has a family tradition of winemaking that proudly dates back five generations, but it is also a tribute to modern style. Becker's self-professed heart is its kitchen, where high quality ingredients are celebrated through minimalist, subtly flavored dishes. Done in black and white, the restaurant suggests a sophistication befitting a black-tie event or a white wedding, while the wine bar's deeper, darker tones evoke a cosmopolitan night out. The serene stone floors of the lobby and restaurant give way to the guestrooms' finely patterned dark wood, combined with the mellow mood of low spot lighting. A simple pane of glass separates the dark tiled shower from the sleeping area, adding airiness to the otherwise earthy elements embodied in the hotel's design. —

Wolfgang Becker

# Cortiina Hotel

Cortiina Hotel is the result of one of Munich's most inspired partnerships—that of gastronome Rudi Kull and architect Albert Weinzierl. Like Kull and Weinzierl's other establishments, the Cortiina is situated in the idyllic heart of the city's old town, neighbored by cultural venues such as Munich's opera house. A sanctuary of refined design, the hotel boasts unparalleled access to the city's creative scene thanks to its well-connected owners. With its feng shui-inspired ambience it exemplifies Kull and Weinzierl's shared philosophy, synthesizing sophisticated design, impeccable service, and a uniquely authentic relationship with the surrounding community. Encompassing 75 rooms spread across the hotel's main building, a rear wing, and a more recently added apartment wing, the Cortiina's aesthetic is one of relaxed elegance and soothing minimalism. Tranquil feng shui aesthetics permeate every aspect of the Cortiina, including the hotel's name itself, which was modified to express harmonious balance. Regional materials such as stone pine, bronze, linen, and bog oak coalesce in each guestroom's arrangement, underscored by warm, mood-enhancing hues of deep crimson and rich earth tones. While the sun terrace offers picturesque views of the city's most historic rooftops, the golden glow of the classic Cortiina Bar & Restaurant invites guests to partake in Munich's well-heeled social scene late into the night. —

WHERE
Munich
Germany

MEMBER SINCE
07/2010

ARCHITECTURE / DESIGN
Albert Weinzierl
(Kull & Weinzierl)

ROOMS
75

RATES
EUR 169–639

MEET THE ORIGINALS
Rudi Kull,
Albert Weinzierl

# Louis Hotel

The first member of Design Hotels™ to grace the streets of Munich, the Louis Hotel is a perfect reflection of the Bavarian capital in which it stands: chic, poised, and full of heart. Located directly on the bustling Viktualienmarkt, the Louis is an ideal starting point for any Munich visitor, a short stroll away from all main sights of the city—Glockenspiel, Hofbräuhaus, and the famed Maximilianstrasse, the neo-Gothic avenue extraordinaire. Its 72 individually designed rooms offer a delightful retreat after a jam-packed day of exploration, its wide range of services ensures the utmost in guest comfort, and its fully equipped gym with sauna and roof terrace provides for all wellness needs. Gastronomy at the Louis is overseen by Tokyo-trained chefs who combine traditional Japanese dining culture with modern international flair, using fresh foods sourced directly from the Viktualienmarkt. At the Emiko Restaurant, guests can dine communally according to the Japanese "sharing principle," and at the Emiko Bar next door, they can enjoy signature cocktails specially mixed to harmonize with the aromas of the Asian kitchen.

Together with partner Albert Weinzierl, Rudi Kull opened Munich's Cortiina Hotel in 2001 and introduced the concept of the modern boutique hotel to the Bavarian capital. Hailing from Ingolstadt, Germany, Kull studied gastronomy in the United States and gathered practical experience working at top restaurants in New York and Los Angeles. Over a decade later, Kull and Weinzierl have become two of the most acclaimed hoteliers and gastronomes in Munich, with two hotels and six restaurants. Determined to make their second hotel a place for world travelers by world travelers, the duo opened the Louis Hotel in 2009. Their collaboration has blossomed into a partnership that pushes boundaries and is consistently stimulating for themselves and Munich's creative classes. —

Albert Weinzierl & Rudi Kull

WHERE
Munich
Germany

MEMBER SINCE
07/2009

ARCHITECTURE / DESIGN
Albert Weinzierl
(Kull & Weinzierl),
Andreas Hild (Hild
und K Architekten)

ROOMS
72

RATES
EUR 179–719

MEET THE ORIGINALS
Rudi Kull,
Albert Weinzierl

# The Flushing Meadows Hotel & Bar

Munich's 16-room The Flushing Meadows Hotel & Bar gets its name from the glorious fields surrounding both it and the scenic Isar river. Situated on the top floors of a former post office and smack in the middle of Munich's most progressive district, Glockenbach, Flushing Meadows' industrial building gives no clue to the gem that lies inside. Munich's patron saints of good taste, owners Sascha Arnold, Niels Jäger, and Steffen Werner, tapped into their creative pool to design the third-floor lofts. And so, eleven studios have been individually designed in collaboration with an equal number of prominent creative types, including Austrian actress and singer Birgit Minichmayr, hip-hop legend Michi Beck, surf maven Quirin Rohleder, Helmut Geier aka DJ Hell, Folk founder Cathal McAteer, and industrial furniture designer Norbert Wangen. The top floor features five penthouse studios as well as The Flushing Meadows Bar—a haven for both guests and locals, with a large terrace overlooking the southern roofs of Munich. The Super Danke! shop on the ground floor, the first green smoothie place in Germany, serves up organic smoothies, cold pressed juices, and cleanse programs that provide a perfect boost to the day. Framed by architects Arnold/Werner's warm yet characteristically raw communal spaces, Flushing Meadows is at once sanctuary and sizzling hot spot for the design-minded visitor and discriminating Münchner alike. What's more, thanks to the many bars that the hoteliers own in the city, guests immediately have access to a number of cool places to hang out. —

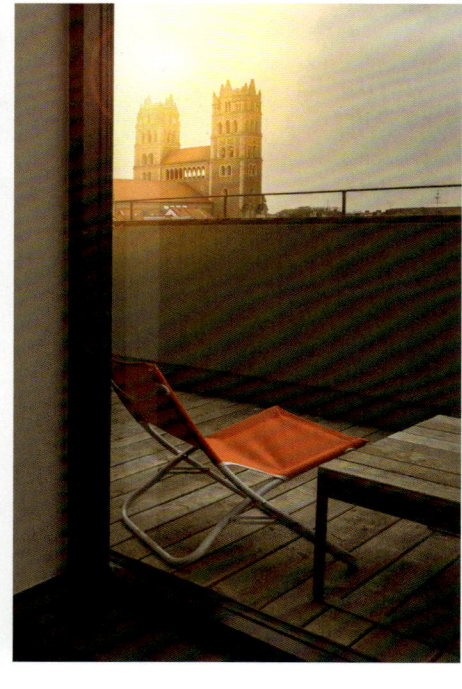

| WHERE | ROOMS |
|---|---|
| Munich Germany | 16 |
| **MEMBER SINCE** 04/2014 | **RATES** EUR 110–310 |
| **ARCHITECTURE** Arnold/Werner | **MEET THE ORIGINALS** Sascha Arnold, Niels Jäger, Steffen Werner |
| **DESIGN** Fantomas Designgesellschaft, PSLAB | |

# Hotel
# Bachmair Weissach

**WHERE**
Rottach-Egern
Germany

**MEMBER SINCE**
12/2011

**ARCHITECTURE**
Ralph Gierlinger
(RGP Architekten)

**DESIGN**
Doris Pesendorfer,
JP Williams
(Design MW)

**ROOMS**
146

**RATES**
EUR 189–1,699

**MEET THE ORIGINAL**
Korbinian Kohler

Majestic Alpine beauty, a warm atmosphere, and expansive estate grounds unite at Hotel Bachmair Weissach. Built in 1862, the hotel, consisting of several buildings surrounded by parkland, has been restored to its former glory. Ideally situated in proximity to Munich, this Bavarian life-style resort combines simple elegance and pastoral cool to convey the feeling of a private country club. Owner Korbinian Kohler's vision to re-establish Hotel Bachmair Weissach as a hive of social activity is illustrated in the intimate fireside Mizu Bar, where Bavarian tradition is given a contemporary spin. Peppered throughout the property are cozy spaces for wining and dining, such as the Gasthof zur Weissach, where sophisticated interpretations of Bavarian cuisine are served. The Mizu Sushi-Bar complements the culinary experience at the hotel by serving innovative dishes in an elegant dining atmosphere. The impressive conference and event spaces range in size and can cater for any occasion, be it an intimate meeting, a celebration, or a gathering of up to 1,100 people. The 1,100-square-meter spa offers unique treatments in sleek surroundings, with an indoor pool that offers views out onto the surrounding parkland. Effortless Bavarian style extends to the 146 rooms and suites, where exposed wooden beams and earthy shades reflect the surrounding landscape. —

# Bergland Hotel Sölden

When local deep-snow and synchronized skiing hero Sigi Grüner turned hotelier, he boldly decided to start from scratch and rebuild Sölden's old Bergland Hotel. The result is a self-contained playground for active travelers and adrenaline-seekers who come here to carve down some of Austria's highest peaks. Crafted by local tradespeople, the 86-room resort has subtle hints of old Austria, such as rocking chairs and oiled oak floors. But the main concept—that all of the ingredients for an active and stress-free holiday should be kept under one roof—aligns with 21st-century values. Next to the main entrance, there's a direct lift to the ski slopes, and an in-house sports shop gives guests the flexibility to turn up empty handed and still enjoy a day of skiing, biking, hiking, or other outdoor activities in Tyrol's Ötztal Valley. Herbs from the hotel's Alpine garden are used at the 1,700-square-meter Sky Spa, high above the rooftops of Sölden, where treatments are based on promoting lasting wellbeing rather than voguish health fads. Massages and beauty therapies are often followed by raw snacks and cups of herbal tea at the poolside Sky Bar, with its clued-in staff and relaxed atmosphere. After an active day, guests can refuel at one of the hotel's three restaurants. —

| WHERE | ROOMS |
| --- | --- |
| Sölden | 86 |
| Austria | |
| | RATES |
| MEMBER SINCE | EUR 258–636 |
| 10/2011 | |
| | MEET THE ORIGINAL |
| ARCHITECTURE | Sigi Grüner |
| Peter Wimreiter | |
| (Wimreiter & | |
| Partner) | |
| | |
| DESIGN | |
| Reinhard Köck | |
| (Köck & Bachler) | |

# Hotel Kitzhof
# Mountain Design Resort

In the chandelier-studded lobby of Hotel Kitzhof Mountain Design Resort, just a five minute walk from the center of Kitzbühel, the beauty of the Austrian Alps is all around you. This elegant retreat combines natural splendor and design, offering its guests a full experience of the region's natural beauty: Glimpses of the snow-laden peaks stream through the hotel's panoramic windows and in the summer, blue skies touch the greenest of nature, while traditional Alpine materials accent the spacious public areas. Rustic wooden beams and floorboards lead the way to the Weißer Hirsch, a Tyrolean-style restaurant, while the 600-square-meter blossom-scented Kitz Spa will draw you deeper into the building. Co-owner Uschi Schelle-Müller has expertly woven the town's spirit of glamour and indulgence through the hotel's 172 rooms, studios, and suites, seamlessly blending contemporary lines with textured, locally sourced materials like leather and loden. Some rooms have inspirational views over the powder-covered slopes, and even the bathrooms, with Raindance showers and luxurious amenities by Just Pure, invite guests to leave their everyday lives behind them. Hotel Kitzhof Mountain Design Resort is a serene wellness destination where guests can experience contemporary Austrian design and hospitality. —

| | |
|---|---|
| **WHERE**<br>Kitzbühel<br>Austria | **ROOMS**<br>172 |
| **MEMBER SINCE**<br>04/2011 | **RATES**<br>EUR 190–2,600 |
| **ARCHITECTURE**<br>Werner Aschaber<br>(Hochbau-Atelier) | **MEET THE ORIGINAL**<br>Uschi<br>Schelle-Müller |
| **DESIGN**<br>Uschi<br>Schelle-Müller | |

# Hotel Zhero – Ischgl / Kappl

Nestled in Austria's Tyrolean Alps, Hotel Zhero – Ischgl/Kappl is a true blend of traditional Alpine hospitality and upscale, innovative design. The hotel boasts walking distance to some of the world's top ski, snowboard, hiking, and climbing locations and even arranges a free shuttle service to the famous ski resort of Ischgl. After a day of activity, guests can retreat to one of 79 luxurious rooms and suites, or dine at the The Zhero Open Grill where executive chef Klaus Brunmayr has created a menu mixing regional and international cuisine.

| | |
|---|---|
| **WHERE** Kappl, Tyrol Austria | **ROOMS** 79 |
| **MEMBER SINCE** 08/2012 | **RATES** EUR 190–5,140 |
| **ARCHITECTURE** Manfred Jäger (Jäger ZT) | **MEET THE ORIGINAL** Jens Liebhauser |
| **DESIGN** Torsten Haardt (Toc Design Studio), EWRE Interior | |

# Loisium Wine & Spa Resort Langenlois

With stunning views of the Austrian wine country and innovative architecture by Steven Holl, the Loisium is a high-concept hotel built upon centuries-old wine cellars. Holl's bespoke furnishings and famous use of space and light give the property a relaxing and airy feeling, while natural materials placed throughout the hotel's public and private spaces amplify the wine lover's experience. The Aveda Wine Spa features specially created wine treatments based on grapes, grape seeds, and grape-seed oil.

| | |
|---|---|
| **WHERE** Langenlois Austria | **ROOMS** 82 |
| **MEMBER SINCE** 09/2006 | **RATES** EUR 94–331 |
| **ARCHITECTURE / DESIGN** Steven Holl Architects | **MEET THE ORIGINAL** Susanne Kraus-Winkler |

# Augarten Art Hotel

**WHERE**
Graz
Austria

**MEMBER SINCE**
03/2001

**ARCHITECTURE**
Günther Domenig

**DESIGN**
Nicole Lam

**ROOMS**
57

**RATES**
EUR 89–305

**MEET THE ORIGINAL**
Dr. Helmut Marko

In this eclectically and strikingly designed glass and metal structure, open communication between the universe within and the environment without is the name of the game. Architect Günter Domenig's Augarten Art Hotel makes a unique statement for modernity in Graz—an Austrian city dominated by Gothic, Renaissance, and Baroque architecture. To Domenig, good architecture is all about capacity, economy, and stature. At the same time, Domenig is the "architect of the game," meaning that Augarten Art Hotel invites its guests to play. In the guestrooms and apartments, straightforward streamlined furnishings and interiors provide striking accents throughout. The hotel also boasts a collection of over 400 original artworks by modern and contemporary masters, which adorn the rooms and public spaces. This fusion of design and art creates spaces that are conducive to work, contemplation, and play. In fact, no space is overlooked as a creative and potentially inspiring venue. Vibrant works by two hundred different contemporary painters and sculptors are displayed in surprising places, such as the courtyard, stairwells, and rooftop terrace—which offers magnificent views of the old city below—as well as Suite 601 overlooking the clock tower. —

# Loisium Wine & Spa Resort Südsteiermark

Rolling vineyards and a mild, Mediterranean-style climate attract nature lovers to Styria in southeastern Austria. Known as the "Tuscany of Austria," the region produces prize winning wine— given a fruity characteristic and dry finish by the clay-heavy soil—that makes them linger even longer. At Loisium Wine & Spa Resort Südsteiermark, only 40 minutes from Graz and 10 minutes from the Slovenian border, these delights blend with a bold, geometrical architectural concept. Unrefined local materials and carefully selected colors harmonize with the surrounding landscape, providing roomy, thought-provoking spaces. With views across the hotel's private vineyard and a well-stocked "Vinothek" offering wine-tasting sessions and seminars, wine is central to the Loisium experience. Sommeliers are present throughout the property to offer personal advice to wine novices and experts, from the Loisium Weinclub Bar to the wine gallery and panoramic terrace restaurant. But wine is not the only thing on the menu. After a day spent hiking and biking along the nearby river Mur, guests can relax in the Loisium Wine Spa, with eight treatment rooms, environmentally friendly Aveda amenities, and a Spa living room, complete with bar and open fireplace. Like the public areas, the 105 rooms and suites are stripped down and spacious, allowing reflections of the landscape to rebound off the glazy-white walls.

Even the meeting rooms are lit by the amber-colored sunshine, and glimpses of nearby Ehrenhausen Castle can be caught around almost every corner.

Susanne Kraus-Winkler is a longstanding and highly recognized tourism and hospitality expert in Austria. After graduating from the Vienna University of Economics and Business Administration, Winkler became the senior partner in the Vienna office of Austria's leading tourism consulting company, Kohl & Partner. With more than 20 years of management in her family's hotels and restaurants, Winkler is the founding partner of the Loisium Wine & Spa resort hotels, uniting the timeless lifestyle trend of wine with her love of modern architecture to create an exceptional experience. Winkler is currently vice president of HOTREC, the European Hotel & Restaurant Association in Brussels, and lectures on tourism and leisure real estate at various academic institutions across Europe. —

More from Loisium:

AUSTRIA
Langenlois, Loisium Wine & Spa Resort Langenlois: → P. 182

| WHERE | ROOMS |
|---|---|
| Southern Styria | 105 |
| Austria | |
| | RATES |
| MEMBER SINCE | EUR 148–349 |
| 11/2011 | |
| | MEET THE ORIGINAL |
| ARCHITECTURE | Susanne |
| Peter Zinganel | Kraus-Winkler |
| (Architektur | |
| Consult) | |
| | |
| DESIGN | |
| Stephan Ferenczy | |
| (BEHF Corporate | |
| Architects) | |

# Monika

## GOGL

WORKING IN A FAMOUS MOUNTAIN REGION THAT IS
OVERLOADED WITH DESIGN CLICHÉS, THIS AUSTRIAN ARCHITECT
USES GLASS WALLS, SUBDUED TONES, LOCAL
MATERIALS, AND STRIKING MINIMALISM TO TRANSFORM THE
VERY VERNACULAR OF ALPINE ARCHITECTURE.

> *"Monika Gogl managed to create a space that allowed guests to understand the architectural history of the region—the many stamps of time that have existed there over the centuries."*
>
> AUSTRIAN STATE PRIZE JURY

The Austrian city of Innsbruck exudes a quintessentially Alpine charm. In addition to world-class ski slopes (which have hosted not one, but three Winter Olympic Games), Innsbruck also boasts a cross-section of historic Austrian architecture, from the Gothic, Renaissance, and Baroque periods, to quaint mountainside cabins and countless rustic lodges. In recent years, Innsbruck architecture has rapidly evolved, adding cutting-edge design to its repertoire. Starchitects such as Zaha Hadid and Dominique Perrault have built breathtaking structures here, as has one prolific, lesser-known star: Monika Gogl. But given the rapidly expanding influence of this Austrian architect's work, that "lesser-known" qualifier is quickly melting away like mountain snow.

Born in St. Johann, in Austria's Tyrol region, and educated at the University of Innsbruck's architecture program, Gogl is fluent in the vernacular of mountain architecture. But her unmistakable style is wholly her own: a clean minimalism of muted tones and panoramic vistas, thanks to a generous use of floor-to-ceiling glass, with acute tailoring to the landscape that maximizes interaction with nature.

After her undergraduate education, Gogl completed a Masters program at London's Bartlett School of Architecture, then returned to Innsbruck and, from 1997 to 2000, was one of the leaders of Ma'nGO, an energetic young design collective founded in collaboration with architect Hans-Peter Machné. They coined their name as a coy reference to both the tropical fruit and the thriving architectural scene in western Austria. "Mangoes grow in a wide variety of

sizes and shapes," reads their initial company brochure. "They have a thin, tough skin and are an excellent source of vitamins A (rchitecture), C (ity Planning) and D (evelopment)."

Ultimately, the group parted ways and Gogl founded Gogl Architekten in 2001. Over the span of a decade, her work spread throughout the region, from ski resorts to retail showrooms to nightlife destinations and community centers. Each is refreshingly modern, with no references to outdated ski lodges in sight. As the Austrian State Prize jury articulated in 2008 of Gogl's adaptation of a 1980s Kitzbüheler ski lodge, which included a strikingly chic rooftop pool, "She managed to create a space that allowed guests to understand the architectural history of the region—the many stamps of time that have existed there over the centuries. And she did it in a confident, natural way without leaning on overused traditional Austrian design tropes."

Naturally, mountainside residences became a staple in Gogl's architectural practice. At Haus Walde, a private residence built in 2012, her client emphasized a desire for living spaces with breathtaking views. That part was no problem; the house was situated on a picturesque slope of the Kitzbühel Alps. The real difficulty, however, was the steepness of this slope and the narrowness of the site. In addition, the team had to work around a home built on the property in 1937 by the homeowner's grandfather, Mr. Walde himself, a famous Austrian painter.

Surmounting these obstacles, Gogl designed an open-plan home that provided a

## SIDE NOTES

NAME *Monika Gogl*

COMPANY NAME *Gogl Architekten*

COMPANY HEADQUARTERS *Lans (Innsbruck)*

NUMBER OF PEOPLE IN COMPANY *9*

WEBSITE *gogl-architekten.at*

SIGNATURE PROJECTS *Hinterglemm, Austria: Hotel Wiesergut Kitzbühel, Austria: Haus Walde; Hotel Schwarzer Adler Lech am Arlberg, Austria: Bar Strolz Bonn: Stadthaus Bonn Munich: Off & Co Showroom*

## SIGNIFICANT AWARDS

2015 *The Best House Architecture Award, Best House in Tyrol for Haus Walde*

2014 *Timber Construction Award for Haus S. and Hotel Wiesergut*

2013 *proHolz Tirol Award for Design & Carpentry for Haus S. and Hotel Wiesergut*

2009 *Mies van der Rohe Award for European Architecture, nomination for Hotel Schwarzer Adler*

2008 *Austrian State Prize for Architecture for Hotel Schwarzer Adler*

*Gogl's artisanship abounds in the Austrian Alps at Wiesergut, where lighting designer and longtime collaborator of Gogl Architekten, Isabel Hamm, was brought in to contribute hand-blown glass chandeliers.*

1

2

contemporary foil to the older house and sat perfectly in sync with the mountainous terrain. Minimizing the need for interior walls, the spaces are divided into three separate levels, and despite the small site, this openness, in tandem with the floor-to-ceiling wraparound windows, creates the illusion of space. Wood and stone recur throughout the house, with oak as the material of choice for the bedrooms' floors and ceilings. On the ground floor, where the exposed concrete ceiling adds a contrasting accent to the structure's natural materials, the centerpiece is an open fireplace that, in turn, sends surplus heat to a geothermal pump. For the exterior, the façade was outfitted with movable wooden panels that can open to reveal the stunning landscape and close again for the residents' privacy. A garden extends to the roof of the carport, which nearly disappears beneath a field of plants.

Not far from here, at Wiesergut—an elegant hotel hideaway retrofitted into a 14th-century estate in Saalbach-Hinterglemm, Austria— Gogl's mastery of the local elements shines brilliantly. Here, she has built a complex of minimalist villas attached to the site's original four-story white house. To harmonize with the vast snowy landscape, seen through expansive swaths of floor-to-ceiling windows,

the interiors are bathed in subdued tones of slates and grays. Their richness was developed not through color, but texture: distressed local woods, natural stone such as gneiss, and exposed concrete abound. Glass passageways create a natural flow of light throughout the property, while bespoke furnishings by Gogl Architekten in linen, loden, and weather-beaten leather add softness and warmth, as do the suites' untreated steel fireplaces. Lighting designer and longtime collaborator of Gogl Architekten, Isabel Hamm, contributed hand-blown glass chandeliers for a slight touch of extravagance.

If there were any lingering questions about whether or not the rustic, log-cabin ski lodge is outdated, Gogl effectively, beautifully, and dramatically answers it, consigning those mountain-dwelling caricatures to the history books.

*Text: Janelle Zara*

3

4

5

6

4 + 5 *For the mountainside residence Haus Walde, Gogl used walls of glass and a movable façade to create the feeling of spatial openness while at the same time safeguarding the privacy of the owner.*

6 *In typical Gogl fashion, exterior elements at this Alpine residence, such as natural wood and glass walls that maximize views, blur the lines between the inside and outside worlds.*

# Wiesergut

The challenge facing those who hope to design a standout mountain hotel is a grand one: How do you compete with the majesty of the mountains themselves?

For Sepp and Martina Kröll the answer lay in creating two things at once. Wiesergut—their 24-suite, four-story house-like structure, set directly on the slopes in Saalbach-Hinterglemm just an hour away from Salzburg—is a sanctuary of light, nature, and fresh air that blends so seamlessly into the landscape it's as if it were a part of the very fabric of the mountains. Yet the hotel is also a testament to modern design. Its architecture showcases an abundant use of glass throughout, with floor-to-ceiling windows and glass passageways literally bringing the outside world in.

The Kröll's desire to integrate their hotel into nature and celebrate the glorious surroundings has deep roots. The plot of land that Wiesergut stands upon has been in Sepp's family since 1350 and has been used for small-scale farming since his great-grandmother Gertrude opened a guesthouse on the property two generations ago. The Kröll family tradition of farm to table continues to this day at Wiesergut—with a twist. In the kitchen, chefs combine Austrian classics with experimental cuisine, all seasoned with fresh herbs from an outdoor garden, grown literally within arm's reach of Wiesergut's state-of-the-art kitchen.

This commitment to preserving artisanal craft extends from the locally sourced foods and fine ingredients that grace the tables of the hotel's restaurant to Wiesergut's 17 manor suites and seven exclusive garden suites. Here, homespun luxury prevails with each suite a study in mindful relaxation, featuring earth-tone decor and bespoke wooden furnishings by Austrian designers commissioned exclusively for Wiesergut. Attention is paid to the smallest detail throughout the hotel's private quarters, from hand-blown glass chandeliers right down to the steel door handles. Beautifully distressed wooden ceilings and floors sourced from local wood contrast with natural stone, granite, glass, and exposed concrete. And, of course, there are those large windows, which blur the boundaries between interior and exterior space. Indeed, every aspect of the hotel's design is intended to cultivate this slippage between inside and outside, between old and new.

For the Krölls, Wiesergut is something they've aspired to ever since they met and dreamed of going back to the land together. Now, from the heights of their exquisite two-story lofted apartment atop the hotel they can survey their creation—and the mountaintop, Zwölferkogel—through their own floor-to-ceiling windows. Indeed, when you enter Wiesergut, you are greeted with a smile and a warm welcome that reflects the sentiments of the hoteliers themselves.

This personalized sense of hospitality not only comes naturally to Sepp Kröll but to his team, which, like the hoteliers here, bring generations of local experience. And this experience is one found not only in the hotel, but in the ideas the hotel stands for. "To me, luxury is a lot of space; it's fresh bread," Sepp Kröll explains, "It's knowing that the chickens in the stall laid the eggs you ate for breakfast. Easy, and still beautiful."

In other words, this is how you compete with the majesty of the mountains—by being, like Wiesergut, as natural and as beautiful as your surroundings. —

Martina & Sepp Kröll

WHERE
Saalbach-
Hinterglemm
Austria

MEMBER SINCE
10/2012

ARCHITECTURE / DESIGN
Monika Gogl
(Gogl Architekten)

ROOMS
24

RATES
EUR 160–250

MEET THE ORIGINALS
Martina Kröll,
Sepp Kröll

"This love of detail is so important to me—that someone made something with love. We've been in hotels where the heart was missing, the soul was missing, and it just was no good. There has to be something more."

MARTINA KRÖLL

# Hotel Lamée

**WHERE**
Vienna
Austria

**MEMBER SINCE**
10/2011

**DESIGN**
BEHF Corporate
Architects

**ROOMS**
32

**RATES**
EUR 218–898

**MEET THE ORIGINAL**
Martin Lenikus

Escape to another era at Hotel Lamée, where a harmonious mix of old and new recalls the glamour of old Hollywood, while maintaining a distinct Viennese charm. Located in Vienna's historic 1st district—surrounded by museums, galleries, luxury shopping, and famous coffeehouses—the original 1930s building offers a modern interpretation of a little grand hotel. Renovated with a strong focus on sustainability, the hotel follows a philosophy of resource conservation. The interiors reflect the dramatic, slim exterior, while light bounces off warm brown marble that covers every surface of the entrance. High-gloss wood, splashes of sassy red, brass detailing, and oversize tassels recreate the private recesses of a graceful movie star. The suites are equipped with terraces, perfect for small events. Another highlight is the food and drink. At Bloom, the hotel's two-story café, bar, and bistro, guests and locals enjoy innovative interpretations of Austrian delicacies. The specialties are prepared using organic products and served alongside owner Martin Lenikus's own brand of eco-friendly wines. The hotel's large glass doors open onto the street, inviting a lively buzz into the richly decorated space. From the breezy rooftop garden, views of the old town and the spires of St. Stephen's Cathedral will bring guests back. —

# Das Triest

**WHERE**
Vienna
Austria

**MEMBER SINCE**
03/2000

**ARCHITECTURE**
Peter Lorenz

**DESIGN**
Sir Terence Conran

**ROOMS**
72

**RATES**
EUR 279–549

**MEET THE ORIGINAL**
Hans Christoph List

One of Vienna's first design hotels was born in 1995 in an old coach station used by travelers en route to the spas of Trieste, formerly part of the Austro-Hungarian Empire. Austrian architect Peter Lorenz and British interior designer Sir Terence Conran preserved parts of the original structure, combining elements of imperial elegance with sober lines, and providing well-heeled guests with a haven of refinement and warm color among the city's 19th-century buildings and Art Nouveau façades. Cross-vaulted rooms give the building a distinctive Viennese flair, while the rooms are casually broken up by solid planes of reds, yellows, and beige in the carpeting and armchairs. Guests can enjoy the subtle luxury of handcrafted upholstered pieces by the Austrian firm Wittmann. Conran's choice of instantly recognizable modern classics includes Artemide light fixtures. The bathrooms have porthole windows, which, along with railings and flag motifs in the rest of the hotel, offer an emotional link to the Adriatic port of Trieste. Specially commissioned photographs of Trieste and Vienna further celebrate a connection to the building's historic role in international travel. Today's travelers yearning for reserved nostalgia combined with modern comforts will have found what they're looking for. —

# Do & Co Hotel Vienna

Do & Co already enjoyed global notoriety as gastronomic genius Attila Dogudan's exclusive catering company. Now, with the brilliant renovation of its flagship property in Vienna's Haas Haus, it has firmly established itself as a purveyor of elite hospitality. Pritzker-prizewinning architect Hans Hollein upgraded his iconic building with the additional design expertise of FG Stijl, creating a futuristic interior that seamlessly blends both high- and low-tech accents. Four floors of the sparkling glass and metal structure have been transformed into 43 cone-shaped, distinct, and spacious guestrooms and suites that offer luxurious comfort as well as unparalleled views of the city's most majestic square. In the rooms, high-quality natural materials underline the hotel's more tech-savvy furnishings, such as generous two-square-meter showers, Bang & Olufsen mega flat-screens, and even Nintendo Wiis. Sophistication is also reflected in the property's culinary offerings, which are given an equally sparkling setting in the hotel's restaurants, the chic, sixth-story Onyx Bar, and the Temple, a twelve-seat private dining pavilion. Adjacent to St. Stephen's Cathedral, Hollein's cantilevered structure, despite its sci-fi style, remains reassuringly anchored in Viennese tradition, giving guests an unrivaled taste of past and future in the Austrian capital. —

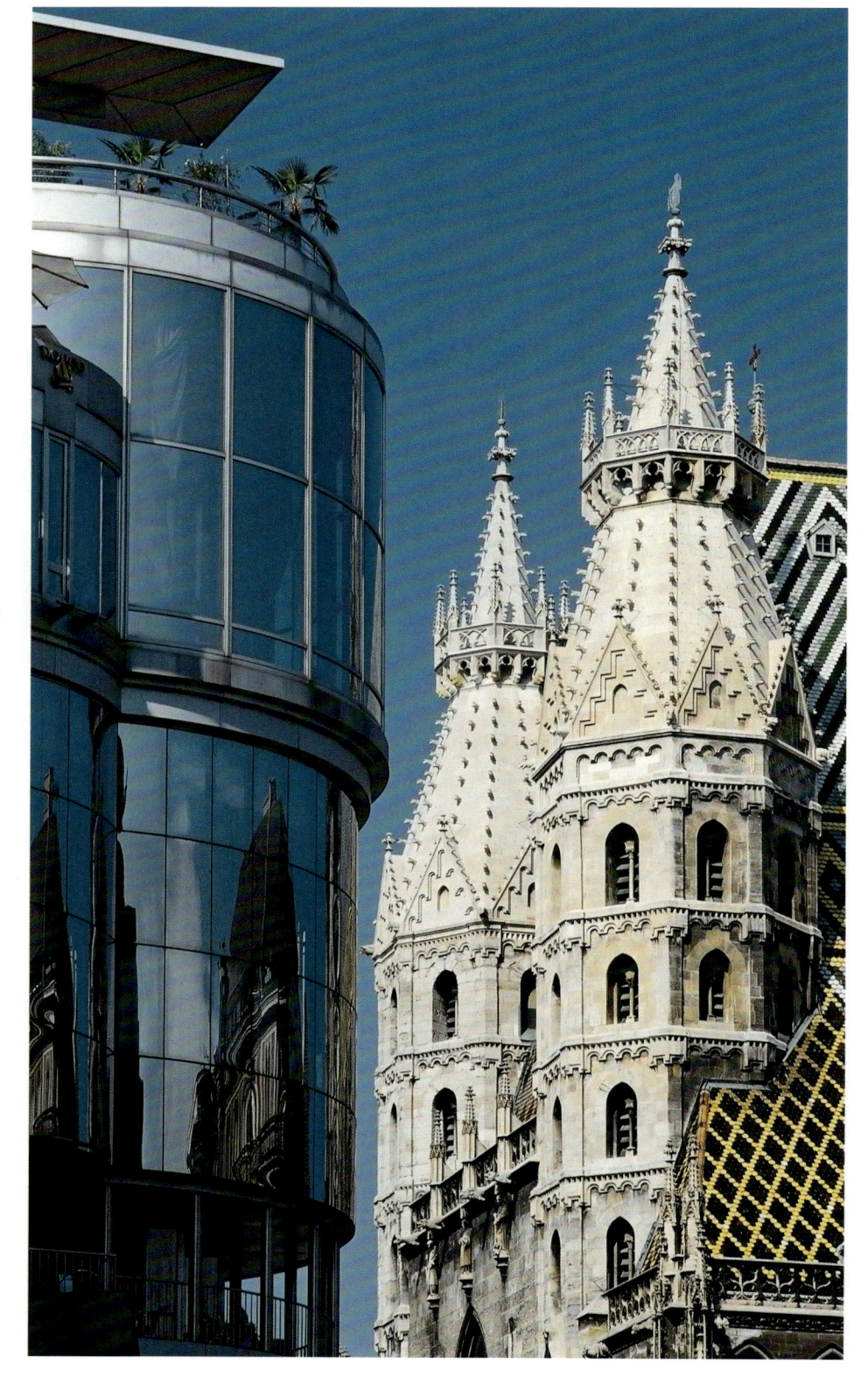

**WHERE**
Vienna
Austria

**MEMBER SINCE**
08/2005

**ARCHITECTURE**
Hans Hollein,
FG Stijl

**DESIGN**
Colin Finnigan
(FG Stijl),
Hans Hollein

**ROOMS**
43

**RATES**
EUR 249–1,550

**MEET THE ORIGINAL**
Attila Doğudan

# Hotel Topazz

Located in the 1st district of Vienna, close to many sought-after attractions, Hotel Topazz honors the city's artistic past while setting a precedent for the future. Vienna's first green upscale hotel combines landmark architecture with a sustainable, resource-saving philosophy. The 32 guestrooms and the penthouse suite draw influence from Vienna's artistic heritage of the late 19th and early 20th centuries, and the hotel's cozy and inspiring Salon recreates the easy-going yet luxurious vibe of a private turn-of-the-century Viennese house.

| | |
|---|---|
| **WHERE** Vienna Austria | **ROOMS** 32 |
| **MEMBER SINCE** 10/2011 | **RATES** EUR 218–598 |
| **ARCHITECTURE** BWM Architekten und Partner | **MEET THE ORIGINAL** Martin Lenikus |
| **DESIGN** Michael Manzenreiter (Manzenreiter) | |

# 25hours Hotel at MuseumsQuartier

Inspired by the early 20th-century's golden age of the circus, 25hours Hotel at MuseumsQuartier's made-to-measure design evokes an authentic atmosphere of stagecraft. Tucked within a mix of Baroque and modern architecture and overlooking Weghuberpark, the hotel features 219 rooms and suites, an American-Italian inspired restaurant, and a breathtaking rooftop bar overlooking Vienna's 7th district.

| | |
|---|---|
| **WHERE** Vienna Austria | **ROOMS** 219 |
| **MEMBER SINCE** 09/2010 | **RATES** EUR 110–240 |
| **ARCHITECTURE** BWM Architekten und Partner | **MEET THE ORIGINALS** Stephan Gerhard, Ardi Goldman, Christoph Hoffmann, Kai Hollmann |
| **DESIGN** Armin Fischer (Dreimeta) | |

# The Guesthouse Vienna

Invigorated by the bold desire to come up with a contemporary interpretation of a classic Viennese coffeehouse, Manfred Stallmajer brought on the godfather of design for The Guesthouse Vienna, British designer Sir Terence Conran. This 39-room standout can be described in three words: home, honesty, and heritage, reflecting the hotel's design, materials, and service. Located in a former 1950s student hostel, the hotel has been transformed into a spacious ode to modern Viennese style. Here, the calm, classic design vocabulary of Conran & Partners is showcased with clean lines and elegant, simple forms. The designer has produced cozy, well-thought-out rooms that are very much grounded in the city's rich culture, featuring modern Viennese classics by Wittmann and Carl Auböck. Throughout the hotel, welcoming window seats provide a calm perch from which to take in the city below. And from that city, one in turn bears witness to the building's brilliant transformation by local architect Arkan Zeytinoglu, who installed pop-out windows on the building's front (his version of the classical decorative feature found on many of the surrounding area's historical façades), attracting the attention of passersby with "floating cubes." Reveling in its brilliant 1st district location (the historic core of the capital), the hotel also taps into the local scene with its Brasserie & Bakery, a popular meeting spot that echoes the city's glorious early 20th century.

Voted Austria's Hotelier of the Year in 2008 by *Hotel & Touristik* magazine, Manfred Stallmajer has a knack for converting hospitality spaces into a melting pot for creative types in the city. He has been running the well-known Café Drechsler for many years as well as award-winning Design Hotels™ member hotel, Das Triest. Interestingly, Stallmajer's collaboration with Sir Terence Conran goes back a long way, with the latter having designed both Das Triest and Café Drechsler. The result of their collaboration is a genuinely warm environment radiating an energetic spirit that looks set to raise the bar even higher in the ever-demanding Austrian capital. —

WHERE
Vienna
Austria

MEMBER SINCE
02/2014

ARCHITECTURE
Arkan Zeytinoglu
(Zeytinoglu
Architects)

DESIGN
Tim Bowder-Ridger,
Sir Terence Conran
(Conran and
Partners),
Katharine Harding

ROOMS
39

RATES
EUR 235–595

MEET THE ORIGINAL
Manfred Stallmajer

# Atlantis
# by Giardino

Close to the heart of Zurich, at the foot of Üetliberg hill, Atlantis by Giardino offers the best of the urban and natural worlds. With views of lush forests and cityscapes, the 95-room hotel presents the ultimate in luxury combined with tranquility and Mediterranean hospitality. Guests can enjoy an indoor or outdoor pool, a sauna area, or Dipiù cosmetics treatments in the spa. The Hide & Seek Restaurant offers fusion dishes with an Ayurvedic twist. The restaurant, Ecco, serves up culinary magic by Rolf Fliegauf, following the concepts of his Michelin-starred restaurants in Ascona and St. Moritz.

The lives of Daniela and Philippe Frutiger have been connected to the Giardino Hotel Group ever since they met at its first property in Ascona in 1994. Together they repositioned and expanded the Swiss hotel brand into a successful business encompassing four hotels, a spa, and cosmetics line, Dipiù, and the restaurant Ecco. Philippe trained as a cook before learning the ropes of hotelery in his native Switzerland and abroad. His wife Daniela, originally from southern Germany, is a trained beautician and pharmacist, and presides over interior design and spa operations. The Frutigers' key values—unconventionality, creativity, charisma—are exhibited throughout their properties in a fresh interpretation of luxury for the modern traveler. —

WHERE
Zurich
Switzerland

MEMBER SINCE
12/2014

ARCHITECTURE
Monoplan

DESIGN
Hirsch Bedner
Associates

ROOMS
95

RATES
CHF 500–3,000

MEET THE ORIGINALS
Daniela Frutiger,
Philippe Frutiger

# 25hours Hotel
# Zurich West

Stephan Gerhard, Ardi Goldman, Christoph Hoffmann, and Kai Hollmann—the creative spirits behind the made-to-measure "budget-de-luxe" 25hours hotels—are surely four of the most uninhibited men in Europe.

How better to explain their one-of-kind 25hours properties than to say that they are creative efforts in storytelling that produce stunningly inventive and fully realized narratives where boundaries don't exist and where the joy comes from posing the question, "We couldn't really do that, could we?" and then responding a moment later: "Oh yes we can!"

As a result, each opening of a 25hours means more than just the debut of an inventive, wholly unique hotel. Rather, fans are so devoted to the 25hours way of looking at the world that each opening is seen as a major creative event—and not just in the hospitality arena.

True to the 25hours motto "you know one, you know none," the newest kid on the block, 25hours Hotel Zurich West, is as uniquely compelling as its siblings and its surroundings. A former industrial neighborhood, Zurich West is now the most important developing area in Zurich, home to independent cultural spaces, eclectic design stores, jazz clubs, and antique bookshops that enliven graffiti-splattered streetscapes. Fueling the creative spirit, the first 25hours in Switzerland greets its guests with flashes of raspberry and fuchsia furnishings that mirror the area's artistic buzz and colorful nightlife.

Like many of the late 19th-century factories nearby, the hotel building looks square-edged, functional, and gritty. But inside, things become more refined, with the spacious ground floor reflecting the city's old-fashioned reputation for sophistication, its cheeky-bright walls and pillars echoing the free and easy vibe of Zurich West's best nightclubs, and its bold stairways hinting at a city in transition.

Alfredo Häberli's unmistakable signature design style—a mixture of innovation and pure joyous energy—leaps out from every corner of the hotel's seven stories. Rooms and suites in the hotel —named after silver, gold, and platinum—feature hand-tufted carpets, bronze fittings, freestanding tubs, and wallpaper with a mother-of-pearl effect.

WHERE
Zurich
Switzerland

MEMBER SINCE
10/2011

ARCHITECTURE
ADP Architekten

DESIGN
Alfredo Häberli
(Alfredo Häberli
Design
Development)

ROOMS
126

RATES
CHF 180–310

MEET THE ORIGINALS
Stephan Gerhard,
Ardi Goldman,
Christoph
Hoffmann,
Kai Hollmann

The designer even reinterprets those graffiti-filled streets by scribbling his personal local recommendations on surfaces and objects throughout the hotel to encourage guests to visit his favorite hotspots. Custom-designed multifunctional furniture abounds, while imaginative clocks ensure that checking the time becomes a thrilling artistic endeavor.

The creative force behind all this wonderful expression, Ardi Goldman, is a born raconteur. But when he is not telling stories visually, he likes to talk about the spirit that drives each hotel's birth. "We try not to answer questions, but to create them," he says. "We aim to give people the possibility to think in a big way, or to think in a small way, but always to think. What is important is how you create and tell a story. We like to tell stories." No wonder the party atmosphere at 25hours Hotel Zurich West—indeed, at all these renegade properties—goes on and on, 25 hours a day. —

More from 25hours Hotels:

AUSTRIA

GERMANY

"We aim to give people the possibility to think in a big way or to think in a small way. What is important is how you create and tell a story. We like to tell stories."

ARDI GOLDMAN

# Chetzeron

Sometimes the middle of nowhere is the middle of somewhere beautiful, and it seems the secluded Swiss Alpine retreat, Chetzeron, has found just that spot. Accessible from Crans-Montana by foot or Snow-Cat only, the former restaurant and gondola station sits at over 2,000 meters above sea level. And with nothing but snow-covered peaks for neighbors, the space gives the concept of rest and retreat a breath of fresh Alpine air.

The 16 rooms and suites have panoramic views of the Rhone Valley and the majestic Alpine peaks, from Matterhorn to Mont Blanc. Generous windows turn the landscape into an integral part of the decor, offering panoramic mountain views throughout the property. There are terraces on three levels, dotted with hammocks, sun loungers, and other plush seating; private or public bars, and the "refined Alpine" restaurant that serves local and seasonal cuisine along with the best selection of Valais wines. Unsurprisingly, the 33-degree-centigrade rooftop pool is a beloved après-ski spot.

Swiss architect and design team, Actescollectifs Architectes, transformed the secluded mountaintop structure with the use of local stone, natural woods, and rich textures. By showcasing this former gondola station's large concrete porticos and original stone walls, this new hotel is awash in old-world charm. The luxe interiors contrast rough materials like stone against plush bedding and furniture, resulting in an Alpine setting that is far from traditional but very much in keeping with the surroundings.

Yet for all the glorious design and welcoming luxury, Chetzeron is perhaps above all an environmentalist's happy place, having reduced its environmental footprint to the minimum. The building benefits from cutting-edge technologies and standards in terms of energy management, including the use of solar panels to heat the water, photovoltaic panels for electricity production, a pellet-fired boiler, heat recovery of the refrigeration system, and Minergie label for insulation.

Though simply enjoying the peace, quiet, and breathtaking sunsets from this inviting and cutting-edge property is high on the regulars' to-do list, Chetzeron is also rich in extraordinary experiences, such as nature walks, moonlight paragliding, and, naturally, top-notch skiing on some of the world's most coveted slopes. Full of sparkling cheer in winter, Crans-Montana, which embraces a string of lakes, is now the much-loved haunt of luminaries like Roger Moore and other boldfaced names. It is renowned for its Alpine ski racing (it was the site of the 1987 World Championships) and is often on the World Cup schedule, frequently for women's events. It hosts the area's only winter mountain pop rock festival, Caprices, during which incredibly cool music echoes through the mountains. And each September, the region welcomes the second largest European golf event, the Omega European Masters (top professional golfers Adam Scott, Edoardo Molinari, and Sergio García all have homes here).

Swiss Lebanese hotelier Sami Lamaa—the driving force behind this one-of-a-kind property—is the third generation in the family business of gastronomy and hospitality. His ingredients for success include the need to both surprise and challenge, while also providing something that is authentic and beautiful. At 2,112 meters above sea level, Chetzeron's biggest surprise is its glorious views. Lamaa, a self-described claustrophobe, has ensured that his hotel's key locations—both the public spaces and private rooms—are spacious and calming. —

WHERE
Crans-Montana
Switzerland

MEMBER SINCE
07/2014

ARCHITECTURE /
DESIGN
Ambroise Bonvin
(Actescollectifs
Architectes)

ROOMS
16

RATES
CHF 255–675

MEET THE ORIGINAL
Sami Lamaa

Chetzeron
Crans-Montana, Switzerland

# Nira Alpina

One of the joys of staying at Nira Alpina, a glass-and-timber mountain sanctuary just five kilometers from the popular resort town of St. Moritz, is being able to ski right up to the entrance. Sitting atop the village of Silvaplana, Nira Alpina is the gateway to some of Switzerland's highest mountains, including Corvatsch, the highest mountain in the Upper Engadine skiing region. The hotel appeals to summer and winter adventurers: 120 kilometers of ski runs rush down the slopes towards Silvaplana Lake at the middle of the mountain range, and the surrounding hills and lakes offer exceptional hiking and biking trails, windsurfing, sailing, and canoeing. But it isn't just the location that makes Nira Alpina special. Throughout all 70 rooms and suites, award-winning hotelier Puri has created a soothing space for travelers to enjoy Swiss Alpine style and unobstructed views of the mountains. Locally sourced materials such as wood and granite are just as likely to be seen as elegant swathes of glass, which let the outside world become a part of the building's interior. Panoramic views illuminate almost every public space, particularly in the top-floor restaurant, which bases its dining concept on fresh, local ingredients. Puri's food and beverage expertise shows in the hotel's culinary offerings, from the classic Italian dishes at the Trattoria to the bread and pastries, baked fresh daily at the hotel's own bakery. The Nira Spa is a haven of calm with colored mood lighting and five large treatment rooms, offering authentic treatments for holisitic, stress-free living. —

**WHERE**
St. Moritz
Switzerland

**MEMBER SINCE**
07/2011

**ARCHITECTURE**
Dolenc Scheiwiller
AG,
Volpe Architecten

**DESIGN**
Puri

**ROOMS**
70

**RATES**
CHF 200–910

**MEET THE ORIGINAL**
Puri

# Giardino Mountain

In the Alpine village of Champfèr, near St. Moritz, Giardino Mountain hoteliers Daniela and Philippe Frutiger have created a fusion of modern and traditional comfort through sensuous interior design and attentive service. Whether guests are being pampered with all-organic products in the hotel's spa or savoring a meal prepared in the two-Michelin-starred restaurant Ecco St. Moritz, staying in this cozy mountain retreat is an experience that nourishes the soul.

WHERE
St. Moritz
Switzerland

MEMBER SINCE
10/2012

ARCHITECTURE
Hinzer Architektur
AG

DESIGN
Francesca
Alder-Schweizer
(Bofor Design),
Gaby Bachhuber
Geissinger
(Bachhuber
Geissinger)

ROOMS
78

RATES
CHF 355–2,020

MEET THE ORIGINALS
Daniela Frutiger,
Philippe Frutiger

# Rocksresort

Eight rough-hewn stone cubes, clustered around a town square and containing 122 two-, three-, and four-bedroom apartments, along with 75 hotel rooms, make up Rocksresort, one of the most unique and spectacular ski resorts in the world. Located at the Laax base station, it is the only fully integrated ski resort in Europe, which makes for an extremely convenient, satisfying, and fuss-free holiday in winter as well as summer.

WHERE
Laax
Switzerland

MEMBER SINCE
07/2008

ARCHITECTURE /
DESIGN
Domenig &
Domenig
Architekten

ROOMS
122

RATES
CHF 250–1,000

MEET THE ORIGINAL
Reto Gurtner

# Cervo Mountain Boutique Resort

Cervo Mountain Boutique Resort is a timber-framed sanctuary built into the slopes above Zermatt, Switzerland's most iconic Alpine resort. Guests can ski right up to the entrance where, with the majestic Matterhorn looming large on the horizon, they're greeted by a small, almost private doorway that oozes exclusivity. When they step inside, the soothing smell of warm wood and a smiling face greets them. Wandering further into the building gives guests the comforting sensation of being immersed in a contemporary Alpine wonderland. Local materials like felt, loden, and stone converge with vintage curios in the main building, a converted 1950s chalet that still has its original wooden floor. Young visionaries Daniel and Seraina Lauber merge contemporary lines and homey colors throughout the property, from the Provençal-inspired restaurant to the peaceful chalets that house Cervo Mountain Boutique Resort's 36 rooms and suites. With help from local architect Roman Mooser, they've even incorporated seductive spas into each of the sunlit chalets. This dedication to accentuating life's comforts, combined with an enviable location next to some of Europe's best ski slopes, makes Cervo Mountain Boutique Resort the ideal place to savor the tranquility of the Alps.

Daniel Lauber wanted to be a hotelier since childhood. For him, the right hotel can feel like home. After studying at the Swiss Hotel Management School Lucerne, and training at international five-stars in both the United States and Switzerland, Lauber broke ground in 2009 with Cervo Mountain Boutique Resort— his family-owned ski chalet that he converted into a the 36-room hotel with his wife and chef Seraina. The Laubers calls it "Alpine chic," combining the roots of the Zermatt region with the vitality of modern style. In keeping with local tradition, Daniel Lauber has also made a name for himself as the president of the hunting association in Upper Valais. —

Seraina & Daniel Lauber

| WHERE | ROOMS |
|---|---|
| Zermatt | 36 |
| Switzerland | |
| | RATES |
| MEMBER SINCE | CHF 240–5,000 |
| 04/2011 | |
| | MEET THE ORIGINALS |
| ARCHITECTURE | Daniel Lauber, |
| Roman Mooser | Seraina Lauber |
| (Mooser Lauber | |
| Stucky Architekten) | |
| | |
| DESIGN | |
| Roger Bächthold | |
| (P. 5) | |

"When I was about six or seven years old, someone asked me what I wanted to do. I remember it clearly: I said I wanted to own a hotel. Maybe it was in my bones—not my family's, who are in a different trade altogether—but to me, being in a hotel feels right somehow. Like home, I suppose."

DANIEL LAUBER

# The Omnia

In the Swiss Alps, high above the snow-laden roofs of Zermatt, a conifer-studded mountainside is bisected by the sharp lines of a modern alpine hideaway. Here at The Omnia, which sits serenely in the shadow of the Matterhorn, New York-based architect Ali Tayar has fused elements of the traditional American mountain lodge with functional, modernist furnishings, creating a high-altitude space for reflection and rejuvenation. The word omnia, which means "all-encompassing" in Latin, gives clues to Tayar's inclusive design philosophy. Inside his 30 individual rooms and suites, which have been left unnumbered to enhance the homey mountain lodge feel, primal elements come together as a harmonious whole. Fires crackle in black, egg-shaped stoves, while shades of dark granite and white oak accent furnishings that have been custom-made by local cabinetmakers. Private balconies offer spectacular views of the saw-toothed peaks that surround the car-free town of Zermatt. But it's inside the mountain itself that you'll see the most spectacular manifestation to help guests forget where they came from and where they are going. The multifunctional space called The Cavern is a club, conference center, and cinema floating over a sea of water in a man-made cave. Deep underground, and yet close to the epic sky, it's the perfect place for guests to reconnect with the wider world. —

| | |
|---|---|
| WHERE | ROOMS |
| Zermatt | 30 |
| Switzerland | |
| | RATES |
| MEMBER SINCE | CHF 350–3,500 |
| 01/2005 | |
| | MEET THE ORIGINAL |
| ARCHITECTURE / DESIGN | Alexander Schärer |
| Parallel Design | |
| Partnership | |

# Giardino Lago

When Daniela and Philippe Frutiger started to design a property in Minusio, in the district of Locarno, on the northern shore of Lake Maggiore, they knew they had to do something exceptional to complement the setting. The solution was simple: rip up the rulebook of predictability and create a retreat that is understated yet indulgent. Clever design features, such as the 400-square-meter roof terrace, allow guests to make the most of the region's Mediterranean climate, which is warmed by 2,300 hours of sunshine a year. With only fourteen rooms and one suite, the guest experience at Giardino Lago is engineered to offer maximum comfort and service. Originality is also pulled off with élan in the kitchen, where signature dishes like Canadian bison and Angus beef are cooked in an infrared oven that heats up to 800°C. Whether visitors are breathing in pure air on the sun terrace, or appreciating the views from the sensuously curved exterior staircase, they'll find that the built elements of the hotel frame and celebrate the natural surroundings. —

WHERE
Minusio
Switzerland

MEMBER SINCE
10/2012

ARCHITECTURE
Rolf Balmer
(Raumforum
Balmer + Krieg)

DESIGN
Francesca
Alder-Schweizer
(Bofor Design)

ROOMS
15

RATES
CHF 200–760

MEET THE ORIGINALS
Daniela Frutiger,
Philippe Frutiger

# The Cambrian

In the heart of the idylic Swiss Alpine village of Adelboden, The Cambrian looks out onto one of the world's most spectacular landscapes. Combining sleek, modern design with innovative use of natural, local materials, The Cambrian's exquisite interior effortlessly reflects its exterior, adding to the purifying immensity of the mountains. The central lobby's open fireplace and incredible mountain views set the tone right away. Each piece in the puzzle, from the outstanding service to the equally wonderful spa and recreational facilities, is part of the experience of staying at The Cambrian: unforgettable. The indoor pool and waterfall, the outdoor thermal infinity pool that actually seems as though it is flowing right into the mountains, the Finnish sauna with Bisazza mosaics, and the various treatment and fitness areas all maximize relaxation. The restaurant provides an authentic culinary experience, while the Bar, lobby/winter garden, and the two spacious terraces are also beautiful spaces to relax. All offer exceptional mountain views and the perfect place for an après-ski drink, or simply an opportunity to enjoy the crisp Alpine air and comfortable, warm decor. The Cambrian is known for its astounding location and superb design, but it is the hotel's fabulous service above all else that makes it truly exceptional.

Hotelier Grant Maunder brings a touch of Wales to the Swiss Alps. The Welshman bucked the trend of the cozy Swiss chalet in favor of a contemporary, character-filled retreat brimming with subtle, personal references to Cambrian culture, like portraits made by Welsh painters. —

WHERE
Adelboden
Switzerland

MEMBER SINCE
10/2009

DESIGN
Nicole Daniels,
Grant Maunder

ROOMS
71

RATES
CHF 190–1,700

MEET THE ORIGINAL
Grant Maunder

Grant Maunder

*The Cambrian*
*Adelboden, Switzerland*

**WHERE**
Rougemont
Switzerland

**MEMBER SINCE**
01/2015

**ARCHITECTURE**
Christian Sieber
(Sieber
Architecture)

**DESIGN**
Claudia Sigismondi
(PlusDesign),
Alessandro Galloni,
Andrea Proto

**ROOMS**
33

**RATES**
CHF 275–1,260

**MEET THE ORIGINALS**
Alexander Perper,
Christine Perper

# Hotel de Rougemont

Set in the fairytale landscape of Pays-d'Enhaut, 1,007 meters above sea level, Hotel de Rougemont is surrounded by majestic pine trees and boasts breathtaking views of the Gstaad Dolomites. Perched above the picturesque Rougemont, the hotel's architecture echoes the village's chalet-only style (the hotel is made up of a cluster of five interconnected chalets). Planning and construction placed great emphasis on the surroundings and the landscape—every window affords stunning views. The rooms and suites use clean lines and handpicked natural materials, giving each room its own character; wool, linen, leather, and sumptuous pelts form a cohesive play of colors and textures that are inspired by nature. Intricate pieces of oxidized steel art by artist Paolo Albertelli in the suites echo the surrounding landscape and reflect the region's craft tradition of paper cutting. The bathrooms are uncharacteristically encased in glass, showcasing both contemporary and traditional design. The hotel's Alpine brasserie, Le Roc Restaurant, serves dishes that are innovative as well as traditional and in tune with nature, meaning fresh seasonal ingredients. A cozy lounge with a fireplace, a wine bar with the best Swiss varietals, and a gold-onyx-and-wood-accented bar provide plenty of spaces to relax. The luxurious spa, illuminated by candles and black mosaic (in the pool area), offers treatments using Pure Altitude products made from organic Alpine plants. A private cinema with plush burgundy seating brings to mind cinema of yore.

You could call them the hospitality family—Christine and Alexander Perper and their one-year old daughter, Chloé. The hospitality management graduates have spent years in New York working for top hotel brands and also providing consultancy. Christine, who was born in Interlaken, says, "It's great to come back home after spending exciting years abroad." Alexander chimes in, "The quality of life, the fresh, clean air, and friendly and approachable people captivated me the very first time I visited the region." The couple took over the management of Hotel Rougemont, determined to give it a *chez nous, chez vous* feel—and thanks to their passion they have made it "home." —

Christine & Alexander Perper

# Hotel Nevaï

Situated at an altitude of 1,500 meters, Verbier is surrounded by more than 400 kilometers of slopes for skiers of all levels. Its boutiques, restaurants, and world-famous après-ski nightlife make this gorgeous village one of the most exclusive and exciting European ski destinations, with Hotel Nevaï as one of its most important trendsetters. The stylish Alpine resort's 33 rooms, with south-facing balconies and two spectacular Penthouse Suites, are equipped with luxurious amenities, such as Egyptian cotton bedding, Elemis bath products, and magnificent views of the Swiss Alps. Without leaving the grounds, guests can enjoy the perfect evening: dinner at the Nomad Restaurant & Bar—featuring stunning views, an open kitchen, a sumibiyaki grill, a flawless bar, and a live DJ—before heading to the dance floor at the famous Farm Club, the place to see and be seen in Verbier for over 40 years. —

| WHERE | ROOMS |
|---|---|
| Verbier | 35 |
| Switzerland | |
| | RATES |
| MEMBER SINCE | CHF 159–1,695 |
| 09/2009 | |
| | MEET THE ORIGINAL |
| ARCHITECTURE | Marcus Bratter |
| Grégoire Comina | |

DESIGN
Christina van Baal
(C+C Interiors),
Yasmine
Mahmoudieh

## La Réserve Genève Hotel and Spa

In a park on the shores of Lake Geneva, La Réserve takes you on a global safari and invites you into a realm of playful indulgence. Parisian designer Jacques Garcia transformed the 1970s hotel into an explosion of extravagant color, sumptuous fabrics, and exotic touches. A gold leaf trim courses the lobby's upper wall, below which a frieze quotes philosopher Jean-Jacques Rousseau, a native son of the city, with "Back to Nature."

| | |
|---|---|
| **WHERE** Geneva Switzerland | **ROOMS** 102 |
| **MEMBER SINCE** 01/2005 | **RATES** CHF 550–8,600 |
| **ARCHITECTURE** Patrice Reynaud | **MEET THE ORIGINALS** Raouf Finan, Michel Reybier |
| **DESIGN** Jacques Garcia | |

## La Réserve Paris

Nestled within the Place du Trocadero, with panoramic views of the Eiffel Tower and an array of five-star services, La Réserve Paris offers travelers a sophisticated experience in the City of Lights. Rémi Tessier's warm-toned, airy interiors exude subtle luxury and feature modernist design by the likes of Andrée Putman, Maxalto, Flos, and Vitra. The Varenna kitchens are equipped with Gaggenau appliances. Discreet, private, and exclusive, this is a place to work, relax, or simply live in absolute comfort.

| | |
|---|---|
| **WHERE** Paris France | **ROOMS** 10 |
| **MEMBER SINCE** 01/2006 | **RATES** EUR 1,400–3,800 |
| **ARCHITECTURE / DESIGN** Rémi Tessier | **MEET THE ORIGINAL** Michael Reybier, Raouf Finan |

# Le Roch Hotel & Spa

Location, as they say, is everything—and the elegant 37-room Le Roch, nestled between Place Vendôme, the Opéra Garnier, and the Louvre, undoubtedly boasts one of the best in the City of Light. As soon as you step into the lobby, the unique design scheme soothes and invites with soft light, clean lines, and a balanced pastel palette of sage, chartreuse, and milky green. Plush, expansive sofas are an invitation to relax, while the lounge and library area is ideal for a pleasant moment of reading by the fireplace. The hotel's guestrooms and suites all feature unique decor by French designer Sarah Lavoine, including Carrara marble, solid walnut wood flooring, Kaldewei bathtubs and basins, Cassina furniture, and Ressource paint. You may prefer to spend time in the hotel's superb courtyard garden, basked in natural light that changes with the seasons, or to wind down from the Parisian pace of life in the hotel's state-of-the-art fitness and spa area, featuring a private pool and hammam. Top that off with world-class gastronomy by rising-star chef Arnaud Faye, whose work from the Ritz to the Mandarin Oriental to Le Relais Bernard Loiseau has earned him two Michelin stars, and it's clear: Le Roch is your perfect Paris *pied-à-terre*.

The work of French interior designer Sarah Lavoine is imbued with the spirit of Paris. Having previously designed the restaurant Le Victoria 1836 and the Place Saint-Sulpice flagship store of the Comptoir des Cotonniers, her inspiration for Le Roch was fed by both the love she has for her city and by her passion for color, design, travel, and authentic objects. A long-time resident and avid connoisseur of the Saint-Honoré district, Lavoine considers Le Roch her second home, and the design of its interiors, a labor of love. —

| WHERE | ROOMS |
|---|---|
| Paris | 37 |
| France | |
| | RATES |
| MEMBER SINCE | EUR from 400 |
| 11/2015 | |
| | MEET THE ORIGINAL |
| ARCHITECTURE | Sarah Lavoine |
| Vincent Bastie | |
| DESIGN | |
| Sarah Lavoine | |

# Les Bains

Few places come with the heritage that Les Bains in Paris has, nor the roster of regulars that have called it home. Perhaps most well-known as the nightclub Les Bains Douches that was home to Yves Saint Laurent, Andy Warhol, and Prince, with David Guetta blossoming as an undercover resident DJ, this cultural institution has had many lives.

The building itself—a Haussmannian masterpiece—is an architectural gem marked by a glorious, rich, and diverse legacy. First created in 1885, Les Bains Guerbois soon became the most famous and prestigious private bathhouse in Paris, the place where Proust regularly bathed. Its owner and conceiver, François Auguste Guerbois, had already founded with his son Albert, the Café Guerbois, which established itself as a top venue for artists and intellectuals. From Zola to Manet, from talented Bohemians to elite members, it long attracted the most influential and special people of the Belle Époque.

In 1978, this monument was transformed into a mythical nightclub, the legendary Les Bains Douches, ushering in a new golden age for the property. Here, top models such as Kate Moss and Naomi Campbell hobnobbed with A-list artists such as David Bowie, Jack Nicholson, and Mick Jagger. It's the place that launched the career of star designer Philippe Starck. And it even inspired Ian Schrager to create the first boutique hotel in New York.

In 2011, in order to reinvent and save this icon of Paris, "La Société des Bains" was born thanks to filmmaker Jean-Pierre Marois, whose family has owned the building since the late 1960s, and who breathed new life into this old treasure. Architect Vincent Bastie painstakingly restructured the building, adding light-filled courtyards, terraces, and balconies, while at the same time staying true to its illustrious, almost mythical, past.

"The building has a powerful aura, a mix of glamour and raw spirit," Marois explains. "L'Hotel des Bains pays tribute to the heritage of a Parisian icon while projecting it into the future. It is a hotel unlike any other, and much more."

That "more" here includes an international clubhouse, which features a restaurant, a bar, a private lounge, and a club. The hotel's 39 rooms and suites, meanwhile, present spaces that create vastly different moods and are the result of the bold visions of designer Tristan Auer, who was recently named "one of the ten best contemporary interior designers, stars of tomorrow" by *Architectural Digest*. Denis Montel, who is responsible for the chic French look found in Hermès boutiques around the world, is the man behind Les Bains' ground-floor restaurant/salon. Indeed, public spaces here inspire rousing conversation, even new romance. And the spa is an ethereal experience of relaxation and wonder.

Les Bains is much more than a luxury hotel. Set at 7 Rue du Bourg L'Abbé, a jewel of the historic third arrondissement, the property is ideally ensconced in Paris' old aristocratic district, a trove of atmospheric streets and architectural splendors. Just a short walk away, along tree-lined boulevards, past galleries and cafés, one finds several outstanding museums, including the Pompidou Center. The new Les Bains offers a rare experience that speaks to the art of living, a meeting point for all the trendsetters and creative people in search of the ultimate lifestyle. —

"The building has a powerful aura,
a mix of glamour and raw spirit.
So it had to be a hotel unlike any
other, and much more."

JEAN-PIERRE MAROIS

Jean-Pierre Marois

WHERE
Paris
France

MEMBER SINCE
01/2013

ARCHITECTURE
Vincent Bastie

DESIGN
Tristan Auer,
Denis Montel

ROOMS
39

RATES
EUR 392–2,900

MEET THE ORIGINAL
Jean-Pierre Marois

# Jean-Michel

## WILMOTTE

ARCHITECT, DESIGNER, TOWN PLANNER, AND MORE,
WILMOTTE NOT ONLY RISES TO THE MANY DIVERSE CHALLENGES
PUT BEFORE HIM, BUT HE USES HIS MODERNIST TOUCH,
HIS RESPECT FOR HISTORY, AND HIS FLAIR FOR SOPHISTICATED
SHOWMANSHIP TO CREATE ONE-OF-A-KIND WONDERS.

> *"Giving [historic buildings] a second life
> is an exciting challenge. They are
> the projects that are the most poetic."*
>
> JEAN-MICHEL WILMOTTE

Whether he's updating the Baroque interiors of the Louvre for the 21st century or reincarnating a 16th-century salt storage facility as an auction house, French architect Jean-Michel Wilmotte has come to specialize in the transformation of historic buildings into first-class, modern-day luxury spaces. "Giving them a second life is an exciting challenge," he said recently. "They are the projects that are the most poetic."

Wilmotte's repertoire extends to undertakings of vastly different scales in both directions. Since founding Wilmotte & Associés in 1975, he has established himself as a polymath in all things design—architecture, urban planning, *objets d'art*, and more—and consequently his firm can have up to 150 simultaneous projects going at any given time. The best known have been his collaborations with Pritzker Prize-winning architect I.M. Pei, first at the Louvre, for the 20-year overhaul and modernization of the exhibition spaces, including the Richelieu wing, Primitive Arts department. In 2008, the two opened their grandest collaboration yet: Doha's Museum of Islamic Art, where Wilmotte's gallery design has been lauded not only for contemporizing the sacred traditions of Islamic geometry, but the seeming weightlessness and drama of the exhibition displays.

On the significantly smaller end of the scale, Wilmotte approaches industrial design with equal showmanship, crafting everything from architectural lighting fixtures to utilitarian pocket knives with his signature elegance and precision. On the larger end, Wilmotte has completed projects that dwarf even the Louvre: urban masterplanning. In 2012, alongside architects and urban planners Antoine Grumbach and Sergey Tkachenko, he was selected to develop

Greater Moscow, an intensive restructuring and expansion of the Russian city in anticipation of a skyrocketing of its population. Wilmotte's ethos of urban regeneration is of "contemporary grafting," introducing modern features while respecting the heritage of the past. In an early example from 1991, Wilmotte treated the renewal of Cap d'Agde's Mediterranean port as "urban interior design," adding site-specific furniture to Belle Agathoise Square so that the town's residents could enjoy the outdoors as comfortably as their living rooms.

These big-picture undertakings are just a part of Wilmotte's majesty. Take, for example, his transformative work on a quiet street in Paris's 9th arrondissement, not far from the ornate splendor of Palais Garnier. Here, he worked his renovation expertise to convert a 19th-century Haussmanian apartment building into what is now Hotel de Nell. While the exterior remains true to its original architectural glory, Wilmotte fully transformed the interiors with a modernist touch, opting for structured, straightforward lines in the 33 guestrooms—this stark minimalism combined with rich natural materials breeds elegance. The windows, some of which frame views of the nearby gorgeous Paroisse Saint Eugène, are dressed in taupe linen, while organic Swedish wool covers the floors. Deep brown wooden panels recur throughout, while Oregon myrtle wood is an accessory to what is arguably the room's main attraction: the right-angled, Japanese-style soaking tubs, many of which were carved from single blocks of stone.

In a transformation of a decidedly different tone, on top of a serene hill slightly removed from the extravagance of Saint Tropez, Wilmotte transformed a series of 1950s buildings into the La Réserve Ramatuelle

### SIDE NOTES

NAME *Jean-Michel Wilmotte*

COMPANY NAME *Wilmotte & Associés*

COMPANY HEADQUARTERS *Paris*

NUMBER OF PEOPLE IN COMPANY *More than 220*

WEBSITE *wilmotte.com*

SIGNATURE PROJECTS *Paris: The Louvre Richelieu wing; Musée d'Orsay exhibition space; The National Assembly; Collège des Bernardins refurbishment Lyon: Museum of Fine Arts Clichy, France: L'Oréal Group headquaters Nîmes, France: Hôtel de Ville Amsterdam: Rijksmuseum Lisbon: Chiado Museum Doha, Qatar: Museum of Islamic Art; Guy Savoy Restaurant*

### SIGNIFICANT AWARDS

2015 *Grand Prix du Rayonnement Français, Cultural Influence*

2015 *Induction to the Academy of Fine Arts*

2015 *Best European Museum for The Rijksmuseum*

2014 *International Architecture Award for the Allianz Riviera stadium*

2011 *Wallpaper\* Design Awards, Best New Hotel for La Réserve Ramatuelle*

2010 *Europa Nostra Awards EU Prize for Cultural Heritage, Grand Prix Conservation Category for Collège des Bernardins*

1999 *Knight of the Order of the Legion of Honour*

*Wilmotte's design evokes a full palette of emotions at Hotel de Nell: one of mystery, sensuality, and order.*

1

Hotel, Spa and Villas. Rather than compete with the beauty of the site's natural Mediterranean surroundings, Wilmotte surrendered to them, filling the interiors with a subdued palette of whites and taupes that play well with the natural light, raw wooden flourishes, and natural stones in shades of ochre. His emphasis was on bringing the outdoors in, building terraces and incorporating floor-to-ceiling windows to frame the vastness of the seaside views. And as for furnishings, they're top of the line: woven rugs by Paola Lenti and Tai Ping; linen and cotton drapes by Marc Geisen and Kieffer; Finn Juhl's Poet sofa and Hans Wegner's Papa Bear armchairs.

Now, as his company embarks on its 41st year, Wilmotte & Associés still shows no signs of slowing down. "Architecture is one of those professions you don't bring to a halt," Wilmotte concluded in a 2014 interview. "When you stop after having been used to such an intense pace, you're done for."

*Text: Janelle Zara*

1 *For the Louvre Museum's Department of Tribal and Aboriginal Arts, Wilmotte's challenge, masterfully achieved with a pared-down harmony of materials (bronze, stone, and glass), was to give life back to the space and to adapt it to the works, while respecting the historical dimension of the building.*

2 *Designed for the French Embassy in Washington D.C., Wilmotte's Washington Lamp captures a sense of institutional elegance through chromed metal and high quality light that is on a spectrum similar to natural light.*

2

3

4

5

3 *Wilmotte's cauldron-shaped Allianz Riviera Stadium, in Nice, France, utilizes an undulating form that evokes the flight of a bird.*

4 *Using noble materials such as Bourgogne stone, glass, and timber, the architectural language of Wilmotte's Russian Orthodox Spiritual and Cultural Center in Paris, seeks to establish diversity and radiance.*

5 *Through a masterful use of brick, plaster, and pure lines, Wilmotte transformed a 1970s building into the 21st century La Réserve Ramatuelle Hotel, Spa and Villas, in Ramatuelle, France.*

# Hotel de Nell

**WHERE**
Paris
France

**MEMBER SINCE**
08/2012

**ARCHITECTURE /
DESIGN**
Jean-Michel
Wilmotte (Wilmotte
& Associés)

**ROOMS**
33

**RATES**
EUR 250–1,200

**MEET THE ORIGINAL**
Jacques Konckier,
Lisa Konckier-Abrat

Ideally located in a quiet street in the diverse and intellectual 9th arrondissement, Hotel de Nell blends comfort and exceptional service with an innovative trend in French cuisine—bistronomie. La Régalade, the hotel's bistro, serves honest yet sophisticated dishes from Bruno Doucet, one of France's leading chefs, and the decor follows the same school of thought: Clean lines and minimal furnishings create an atmosphere that is polished and elegant, without being too formal. Guests will also marvel at the restored façade of the 19th-century building, which is stark white and flawless. The interiors showcase design by acclaimed architect Jean-Michel Wilmotte. Through the use of natural wood paneling, under-floor heating, fireplaces, retro lighting, and pure white marble in the Japanese-style bathrooms, Wilmotte created a warm atmosphere in the 33 rooms and suites. The excellent location offers numerous restaurants, bars, and theaters, as well as an easy walk to the Grands Boulevards shopping area and the Palais Garnier Opera House. A passion for design, hospitality, and culture is evident throughout the property, where authentic surroundings turn the simple into the unforgettable. —

# La Maison Champs Élysées

Set in the heart of Paris's Golden Triangle, Maison Martin Margiela's first hotel interior uses dramatic illusions and ironic interiors. All 57 rooms offer state-of-the-art bedding, high-quality linen sheets, duvets in pure goose down, and generous amenities. Seventeen of the rooms and suites belong to the Couture Collection and are decorated with a touch of whimsy that plays with proportion and perception. The lighthearted, attentive service can be experienced throughout at La Table du 8 Restaurant, the bLind Bar, and The Cigar Bar.

| | |
|---|---|
| **WHERE** Paris France | **ROOMS** 57 |
| **MEMBER SINCE** 12/2011 | **RATES** EUR 250–1,250 |
| **ARCHITECTURE** Danièle Damon | **MEET THE ORIGINAL** Bernadette Chevallier |
| **DESIGN** Maison Martin Margiela | |

# Hôtel Sezz Paris

Hidden behind a classical façade in a building dating back to 1913 is interior designer Christophe Pillet's modern masterpiece. Textured Portuguese Cascais stone walls, dark wood detailing, funky furnishings, and soft lighting make the Hôtel Sezz Paris a secret high-style gem in Paris' usually quiet 16th arrondissement. All of it is topped off with the City of Light's first Veuve Clicquot champagne bar, La Grande Dame.

| | |
|---|---|
| **WHERE** Paris France | **ROOMS** 26 |
| **MEMBER SINCE** 06/2007 | **RATES** EUR 290–1,200 |
| **ARCHITECTURE / DESIGN** Christophe Pillet | **MEET THE ORIGINALS** Shahé Kalaidjian, Christophe Pillet |

# Hotel Vernet

**WHERE**
Paris
France

**MEMBER SINCE**
11/2013

**ARCHITECTURE**
Albert Joseph
Sélonier

**DESIGN**
François
Champsaur

**ROOMS**
50

**RATES**
EUR 290–2,200

**MEET THE ORIGINAL**
Anne Jousse

Located a few steps from Paris's celebrated Arc de Triomph, within the city's Golden Triangle, the once traditional Hotel Vernet has been transformed by Paris-based architect François Champsaur into a sleek new 50-room boutique hotel. Housed in a post-Haussmann building that dates from 1913, the exterior is the embodiment of Parisian charm, which complements the fresh modernity that lies within. Among the facilities is an avant-garde restaurant that is housed under an ornate glass dome, designed by legendary civil engineer Gustave Eiffel, while the hotel's in-house concierge service can provide guidance on the ideal Parisian experience. —

# Hotel Bel Ami

**WHERE**
Paris
France

**MEMBER SINCE**
03/2000

**ARCHITECTURE**
Christian Lalande,
Philippe
Maidenberg

**DESIGN**
Pascal Allaman,
Nathalie Battesti,
Marino Bessé,
Véronique Terreaux

**ROOMS**
108

**RATES**
EUR 270–1,190

**MEET THE ORIGINALS**
Anne Jousse,
Philippe
Maidenberg

In the heart of Saint-Germain-des-Prés in Paris, which has attracted Parisian intellectuals since the 18th century, you can enjoy the beautiful Rive Gauche, find some of the most complete and interesting bookshops in Paris, stop by one of the historical cafés, or simply get lost in the enchanting streets around the church of Saint-Sulpice and find hidden restaurants and young designers' stores. The café Procope, for instance, which still exists, was the meeting point for the *encyclopédistes*, and also for the future revolutionists Danton, Marat, and Guillotin. More recently, the quartier became the intellectual center of the city, where it is common to find artists, writers, and philosophers.

This setting is home to Hotel Bel Ami, which brings together in its concept and design the most interesting characteristics of its setting: history, cultural life, and sophisticated choices for relaxing, shopping, and eating. Bel Ami is located in a renovated, former 19th-century printing works, in which the first copy of Guy de Maupassant's novel *Bel Ami* was printed, and it has been recently redesigned by architect and designer Philippe Maidenberg. Inspired by its literary background, Maidenberg conceived the newly refurbished bedrooms as elegant and minimal environments in which one can easily settle. —

# Le Pigalle

"We didn't want to make a hotel that simply reflected what Pigalle is becoming, but what it was and still is."

So says Valéry Grégo, the man behind the shining new beacon in Paris's Pigalle district. This sentiment seems the perfect place to start if one is to truly understand Le Pigalle—not only the look and feel of this 40-room stylish, bawdy, and oh-so-musical hotel, but the very ethos of the high-minded yet all-inclusive property.

Grégo gets at it best: "When I buy a property, the first thing I want to know is its history," he says. "The place must fit the purpose." And few places have as rich a history or are as story-filled as the Pigalle district, the once-seedy, now neon-lit neighborhood that was the Paris of Alexandre Dumas, Victor Hugo, and Edith Piaf. So to hear Grégo speak—and more, to see the hotel for yourself—is to understand that while Paris's golden age is respected and honored at Le Pigalle, it is only part of the story here, a launching point for new narratives that must be created by the Pigalle of today.

To capture this sense of "now," Grégo has put into motion the same artistic and collaborative spirit that has always reigned in this quarter. For Le Pigalle, he has turned to the district's residents to create what is a monumentally inspired, brazen, and energetic focal point. This authentic neighborhood hotel introduces you to the people and stories that make Pigalle so vibrant at every step. This means photographs and illustrations by local artists, curated music by a neighborhood DJ, delicious baked goods delivered by a nearby bakery, and touches brillantes throughout the property by local flower shop Muse. It means special access to shopkeepers and other residents who will enthrall you with tales of the neighborhood's gritty, provocative, functioning red light district that defied definition. And it means the best place to spend a Thursday night in all of Paris—each week the hotel hosts "Black Music Thursday," which features a collective of top DJs who come to spin rare, soulful sounds that are about one million miles from the soporific muzak piped into conventional hotels.

With this community-first approach firmly in mind, architects Charlotte de Tonnac and Hugo Sauzay have used the history of Pigalle as a blueprint for their redesign of this former hotel. "A project's starting point is always the context, the history of a place," they say. "We love it when periods confront one another, and we like mixing up genres, allowing the space to breathe and letting the light shine in."

The building's location on Rue Frochot in the heart of "Nouvelle Athènes" (new Athens) means that it rubs shoulders with both the neo-classical flourishes of its neighbors and with the colorful façades of Place Pigalle. Using simple volumes and materials, such as marble, granite, and plaster in the lobby and the rooms, has allowed the architects more room for combinations of design.

Inside, the hotel's ground floor is the vibrant heart of Le Pigalle, pulsing with creative Parisians and guests day and night, while also opening up to the neighborhood. The glorious mix of vintage and contemporary design embodies the spirit of collaboration that underlines the hotel. The space is divided into a café, bar, restaurant, a vinyl library, and a newspaper and book kiosk, all run by colorful local characters who make Pigalle what it is. A local musicologist has even created an iconoclastic Pigalle soundtrack that guests can listen to throughout the hotel.

When it comes to Le Pigalle, Grégo adds, "We want people to discover the neighborhood in the hotel, its past and its present." Indeed, as if preordaining Grégo's thought, Dumas himself had said, "All human wisdom is summed up in two words: wait and hope." For lovers of one-of-a-kind hotels that are as much about place and experience as they are about comfort and design, the wait in Pigalle is over. —

More from Perseus:

FRANCE
Courchevel, Hôtel des Trois Vallées → P. 250
Val Thorens, Le Val Thorens → P. 248
Val Thorens, Le Fitz Roy → P. 249

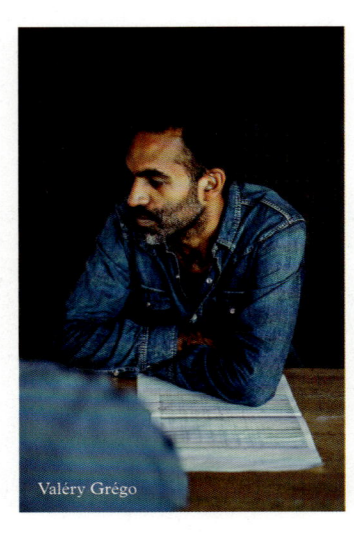

Valéry Grégo

| | |
|---|---|
| **WHERE** | **ROOMS** |
| Paris | 40 |
| France | |
| | **RATES** |
| **MEMBER SINCE** | EUR 140–485 |
| 07/2015 | |
| | **MEET THE ORIGINAL** |
| **ARCHITECTURE** | Valéry Grégo |
| Charlotte de Tonnac, | |
| Hugo Sauzay | |
| (Festen Architecture) | |
| | |
| **DESIGN** | |
| Antoine Ricardou | |
| (Be-poles) | |

# Hôtel Sezz
# Saint-Tropez

Saint-Tropez has seen it all. In the heart of the French Riviera, the beautiful town has come to be known for the row of private yachts lining the quay and the stream of movie stars that file through during peak season. It is the region's natural beauty that attracts them, of course. But the modish lifestyle doesn't hurt much either. It is here, in Saint-Tropez, that we encounter Shahé Kalaidjian and Christophe Pillet's beautiful second collaboration. With their first successful joint endeavor, Hôtel Sezz Paris in the city's 16th arrondissement, they developed a language of their own. In Saint-Tropez, they translate it from an urban lexicon into one that exudes the ultimate in luxury vacation. Situated on the town's Route des Salins, the hotel is built of light and air—guests can smell and feel saltwater and warm breezes from their beds and baths. With 37 elegantly appointed guestrooms and villas engulfed by a lush wooded park and a swimming pool at its hub, Sezz Saint-Tropez is as warm and inviting as it is fresh and full of creative vision. The Personal Assistant Program devised at Sezz Paris has been carried over to Hôtel Saint-Tropez, but the new collaborations—the Dom Pérignon bar and the spa developed in partnership with Payot—are unique to Sezz Saint-Tropez. Each of the hotel's guestrooms, suites, and villas is individualized and has its own private balcony leading out to the central pool or into a private garden. In an exceptional setting surrounded by olive and palm trees, the hotel's restaurant, Colette, serves fresh, flavorsome Mediterranean dishes.

Beirut-born, British-educated Shahé Kalaidjian launched Hôtel Sezz in Paris in 2005 with French designer Christophe Pillet. In 2010, they opened a second installment in Saint-Tropez. A mix of brains and brawn, Kalaidjian is an avid polo player and a classically trained hotelier. In 1994, he opened the Holiday Inn at Marne La Vallée, and followed up in 1999 with the Pavillon de Paris. Pillet received his masters in Design from the prestigious Domus School in Milan and made a name for himself working with powerhouse designers while running his own studio out of Paris. With Hôtel Sezz, Kalaidjian and Pillet express their eclectic approach to the hotel business: A place where elegance and sophistication are the rule, and space and service are incomparable. —

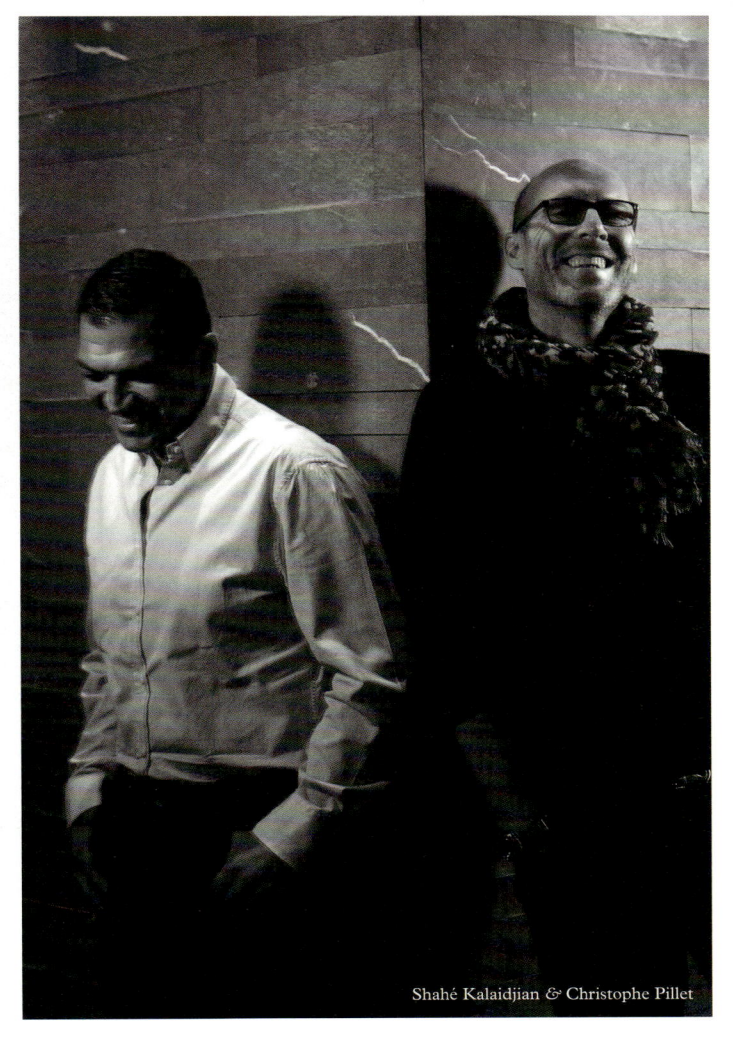

Shahé Kalaidjian & Christophe Pillet

| | |
|---|---|
| **WHERE** Saint-Tropez France | **ROOMS** 35 |
| **MEMBER SINCE** 09/2009 | **VILLAS** 2 |
| **ARCHITECTURE** Jean-Jacques Ory (Studio Ory) | **ROOM RATES** EUR 270–980 |
| **DESIGN** Christophe Pillet | **VILLA RATES** EUR 1,130–2,300 |
| | **MEET THE ORIGINALS** Shahé Kalaidjian, Christophe Pillet |

# Domaine des Andéols

A thick buzz of crickets and cicadas, of wood crackling in the heat, and of bushes bristling—this is the sound of Provence. Rows of fragrant lavender and fields of gnarled olive trees set this landscape apart, as does the occasional town wedged into the side of a steep hill. A morning farmers' market full of fresh herbs, dried fruits, and cheese, is an indispensable part of the experience here, along with an evening glass of a young rosé. But at Domaine des Andéols, located just one hour from Avignon, clean lines, bold geometric spaces, and an evocative art collection reframe Provence. Domaine des Andéols' owners, Olivier and Patricia Massart, spent the last 20 years collecting paintings, photographs, furniture, and objects. Seeing no point in keeping the collection private, they set out to create a place where they could share it with artists and designers, and guests from around the world. Today, Domaine des Andéols is home to more than 250 pieces from the Massarts' personal collection, and each of its ten villas is inspired by an artwork, color, or theme. Outside, flat concrete surfaces, the sharp horizon of a turquoise pool, and sculptures that play with scale, continually push the eye to see the landscape from

a fresh perspective. Just as the art, interior architecture, and design cast the surrounding area in a slightly different light, so too does the exquisite cuisine of the hotel's restaurant, La Maison des Saveurs. A Provençal garden of apricots, plums, figs, and cherries; seven types of mint; and more than 50 varieties of tomato, plays muse to the kitchen. Lamb from the Luberon, herbs from the Garrigue, and Domaine des Andéols' own olive oil are part of the palate here, where Provence comes to life in the modern compositions.

In 2003, Olivier Massart and his wife Patricia transformed 59 acres and 10 stone farm buildings into a vivacious collection of villas. Domaine des Andéols is a fulfillment of the two designers' long-standing dream to create a property reminiscent of the stone cabins their grandfathers used to build. The Massarts also turned the property into a living museum, housing paintings, photographs, furniture, and *objects d'art* they have collected over the last 20 years. It's easy to see why some might call the Massarts the design ambassadors of the Provençal landscape. —

WHERE
Luberon
France

MEMBER SINCE
03/2012

DESIGN
Olivier Massart,
Patricia Massart

VILLAS
10

RATES
EUR 230–1,200

MEET THE ORIGINALS
Olivier Massart,
Patricia Massart

Patricia & Olivier Massart

# Hôtel de Tourrel

Birthplace of the prophetic seer Nostradamus, muse to Van Gogh's iconic "The Starry Night" among countless other paintings, and home to an unparalleled gourmand scene, Saint-Rémy-de-Provence is an intoxicating presence in southern France. Still a favorite with artists, this once-sleepy place has become quite cosmopolitan with its world-class boutiques and design shops. Emblematic of this historic-meets-modern wave is Hôtel de Tourrel. Set in a 17th-century *palais* in the center of the old village, the hotel and its seven spacious suites are a mid-century design odyssey. Architect Margot Stängle, who is also one of Hôtel de Tourrel's owners, had the pleasurably complex task of converting this 17th-century manor into the all-suites property it now is. Stängle and fellow owner Ralph Hüsgen's careful restoration of this building, named after the noble de Tourrel d'Almeran family that once lived here, paid heed to its rich history. A beautiful salon, where Charles Gounod's opera Mireille was first performed in 1864, was converted into a suite. Carefully bridging the historic heart of Saint-Rémy to modern times, Stängle's new extension to the building sits elegantly between its ancient neighbors and presents the city center's first modern façade. The extension, with its striking brass doorways and windows, houses two "contemporary" suites as well as Saint-Rémy's new favorite wine boutique and bar. Two rooftop terraces were added as well: one with views over Saint-Rémy and environs, and the other with a private pool, the only such luxury in town. Despite the pair's love for the modern, they spent extensive time researching historic techniques to restore the original manor. After having accidentally discovered stucco under peels of paint, they hired a professional team of conservators who took 13 weeks to uncover it. The hotel interiors charmingly mix original features, such as herringbone parquet, with custom-ordered modern furniture by ClassiCon designers Eileen Gray and Konstantin Grcic, as well as the olive and taupe colors seen throughout. Some of the furniture was designed by Stängle and Hüsgen themselves, inspired by little details such as the ancient doors in Saint-Rémy. The hotel is also home to an innovative nouveau Mediterranean restaurant. With pristine natural surroundings and an address close to 34 wine appellations and important historical sites, such as the ancient hilltop village of Les Baux-de-Provence, Arles, and Avignon, Hôtel de Tourrel adds a new layer of luxury to the heart of an already refined and stunning Saint-Rémy. —

WHERE
Saint-Rémy-
de-Provence
France

MEMBER SINCE
11/2014

ARCHITECTURE
Margot Stängle

DESIGN
Ralph Hüsgen,
Margot Stängle

ROOMS
7

RATES
EUR 250–690

MEET THE ORIGINALS
Ralph Hüsgen,
Margot Stängle

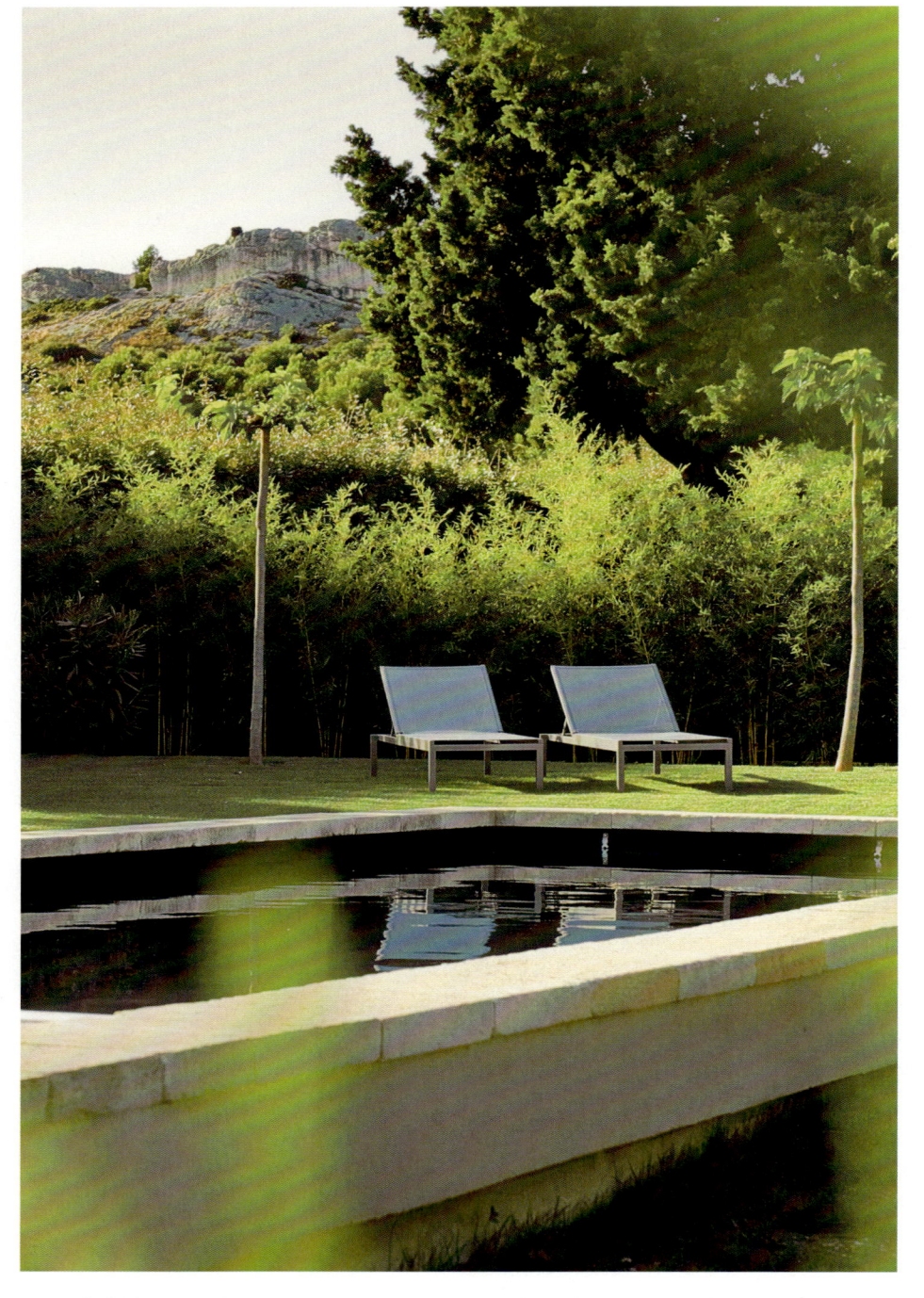

## Hotel B
## Design & Spa

A newly built two-story retreat, Hotel B Design & Spa does a marvelous job of fitting in with the rustic farmhouses and sweet-smelling lavender fields of rural Provence. Wrapped by a fragrant grove of olive trees and with craggy limestone karst providing a dreamlike backdrop, this spa hotel is a calming, isolated sanctuary. Here, guests can recharge and indulge in the serenity of French country life. With its pale white façade and sloping, tiled roof, Hotel B Design & Spa has all of the external architectural charm of a traditional pastoral residence. But inside, designer Christophe Pillet (who has already made his mark on Design Hotels™ properties in Paris and Saint-Tropez) has emphasized swooping modern contours and broad open spaces. Mineral shades of white, brown, black, and gray pervade each of the 14 airy suites. Each room has access to a cerulean private pool, while the outdoor terrace rewards with energizing views over the rolling green-and-purple countryside. In the spacious 250-square- meter spa, delicately fragranced products by Carita and Decléor help guests unwind in their own private treatment rooms. Here in southern France, gastronomy is central to the *joie de vivre*, so guests are wowed nightly with simple, seasonal dishes infused with locally produced herbs and oils. There aren't any menus, but with the markets of Provence providing an endless variety of fresh, flavorsome ingredients, there's always something new to try. —

| | |
|---|---|
| **WHERE** | **ROOMS** |
| Paradou | 14 |
| France | |
| | **RATES** |
| **MEMBER SINCE** | EUR 390–650 |
| 11/2010 | |
| | **MEET THE ORIGINALS** |
| **ARCHITECTURE** | André Bourguignon, |
| André Bourguignon | Nancy Bourguignon |
| **DESIGN** | |
| Christophe Pillet | |

# Le Val Thorens

In keeping with its pioneering spirit, Le Val Thorens was recently transformed into a present-day version of a high altitude chalet. Vintage furniture and muted textures complement eye-catching works of modern art by the likes of Martin Richman, Gerhard Richter, and Sigmar Polke. With the slopes a clean carve away, the property serves as both a convenient kickoff and a welcoming retreat, which boasts a multi-room spa area, a panoramic swimming pool, and a fireplace cocktail lounge that's a work of art in itself, with an anthracite waxed concrete floor and a burnt-pine ceiling.

**WHERE**
Val Thorens
France

**MEMBER SINCE**
05/2014

**ARCHITECTURE /
DESIGN**
Gilles Leborgne,
ID Associés

**ROOMS**
83

**RATES**
EUR 165–760

**MEET THE ORIGINAL**
Valéry Grégo

# Le Fitz Roy

Perched high on a Val Thorens mountain-top and nestled between the three valleys of the world's largest ski resort, Le Fitz Roy is quintessential modern luxury in the shape of a chalet. Reviving an iconic hillside landmark, Le Fitz Roy now stands for cozy seclusion, homey comfort, and top-notch cuisine. Hotel guests also find an elaborate spa area, which includes a Turkish bath, mountain pool, and massage treatments. With an expertly staffed Ski Shop on-site, Le Fitz Roy serves as a luxurious launching pad for beginner skiers and Val-veterans alike.

**WHERE**
Val Thorens
France

**MEMBER SINCE**
05/2014

**ARCHITECTURE /
DESIGN**
Gilles Leborgne

**ROOMS**
58

**RATES**
EUR 275–3,355

**MEET THE ORIGINAL**
Valéry Grégo

WHERE
Courchevel
France

MEMBER SINCE
05/2014

ARCHITECTURE /
DESIGN
Gilles Leborgne

ROOMS
31

RATES
EUR 350–2,350

MEET THE ORIGINAL
Valéry Grégo

# Hôtel des Trois Vallées

The first post-war hotel on Courchevel, Hotel des Trois Vallées (meaning three valleys hotel) is situated at the foot of the resort's world-class ski slopes. At the time of its construction in the 1950s, post-war modernists contemplated a new way of mountain living—this landmark hotel came to epitomize just that. Over half a century after the inn became an international reference point for resort-style construction, Hôtel des Trois Vallées has returned to its original 1950s layout, creating an inspired mid-century modern twist on today's ski resort retreat. From the focal-point lobby fireplace to the spa area, and throughout the 31 spacious rooms and suites, muted colors, natural textures, and original mid-century furniture craft an antique, yet chic environment that is consistently and authentically vintage. Pieces by such iconic designers as Charlotte Perriand, Pierre Paulin, and Pierre Guariche take center stage. "L'Auberge de Luxe," as the hotel likes to call itself, has many spots for warming up, be it the fireside restaurant or a terrace lunch in the sun. Guests on the go have the welcome option of taking away some nibbles from The Épicerie shop. And with the slopes but a snowball-throw away, skiers of all levels can easily take advantage of the in-house ski service, complete with on-site locker room, ski rental, lessons, and even helicopter bookings for the most daring of guests. The holistic spa, set in the midst of nostalgic modern mountain design, is a warm wooden cocoon to rejuvenate those post-ski muscles.

Valéry Grégo's job as Managing Partner at Perseus Capital Partners requires him to be a bit of a soothsayer. After all, the private investment firm excels at identifying the right opportunities and capitalizing on them. This, mixed with the Paris-educated Grégo's study in business and humanities, and his keen interest in design and architecture, has led him to open three very interesting resorts in the French alps —Le Fitz Roy, Le Val Thorens, and Hôtel des Trois Valées. One might even call them the mountain resorts of the future and past. For him, "A hotel is an experience first, based on its unique history, background, personality, and location. Our goal was to allow for a modern feel in a vastly old-fashioned environment. We chose some hotels with very strong personalities and history and we went under heavy renovation programs to reveal them." Now all that's left is for guests to explore this grand new history. —

# La Réserve Ramatuelle Hotel, Spa and Villas

"I do exactly what I want to do," Michel Reybier says of his working style. "But, *bien sur,* I am not able to do it all by myself."

Enter Raouf Finan, a mastermind of hotel management, who perfectly complements the visionary genius of Reybier. Together, they are the team behind the standout La Réserve hotels in Paris, Geneva, and the Côte d'Azur—the latter, of course, being that stunning Provençal property La Réserve Ramatuelle Hotel, Spa and Villas.

Perched on a quiet hill by the Mediterranean Sea and just minutes outside legendary Saint-Tropez, this temple of wellbeing is part spa, part hotel, and all serenity. Its 9 guestrooms, 19 suites, and 1,000 square meter spa are seamlessly integrated into La Réserve's private domain: a gorgeous pine-covered expanse, also home to 12 private villas that can be rented on a short- or long-term basis. The property's luxuriously spacious bedrooms range from 50 to 100 square meters, and each is equipped with a private terrace or scented garden offering unrestricted views over the Mediterranean Sea below. The rooms themselves offer a feast of subtle design touches. Stone floors are bedecked with woven rugs by Paola Lenti and Tai Ping; giant windows are hung with linen and cotton drapes by Marc Geisen and Kieffer; and contemporary furniture by Hans J. Wegner, Finn Juhl, Moroso, Flexform, Poltrona Frau, B&B Italia, and Roda abound.

Outside, architect Jean-Michel Wilmotte had a problem to overcome. How do you compete with the stunning natural beauty of Provence, especially in Ramatuelle, which sits amid pine-topped hills above sparkling Mediterranean waters? So rather than compete, Wilmotte chose to embrace the landscape, creating spaces that pay reverence to the environment that surrounds them. In a complete transformation of the 1950's buildings, in which La Réserve Ramatuelle Hotel, Spa and Villas now stands, Wilmotte chose natural materials and a soft color palette of ochre, white, and sandy beige. The result is a fresh and relaxing space that gracefully mirrors its serene seaside setting.

Why take on a mid-20th-century structure? Reybier explains: "I look for places that feel extraordinary—a certain light, a certain energy, a certain esprit. I look for qualities we can't find anywhere else."

Two spots where that energy and those qualities converge are in the hotel's lounge bar and restaurant, La Voile (which recently earned one Michelin star for its stellar Mediterranean cuisine), and its spa. The heart of La Réserve, this enormous wellness area includes 10 treatment cabins, indoor pool, fitness studio, steam bath, and solarium.

So how exactly did the dynamic team of Reybier and Finan come together? Already a magnate in the chocolate, delicatessen, and supermarket industries, Reybier was on vacation in Bali when he met Finan, who at the time was a resourceful general manager of an exclusive resort. After working at New York's illustrious Drake Hotel and studying at Switzerland's top-ranked Glion Institute, Finan had been developing and running luxury hotels in Asia for almost a decade. The two felt an instant affinity. With La Réserve, the pair has struck a balance between, as they see it, "Someplace inviting but otherworldly, too."

In Ramatuelle, Finan oversaw the transformation of that once-forgotten 1950s-era property, which has now become a must-stay, even for those who already own a vacation house in the area. "We have become like a family home," says Reybier.

But a family home needs to stay fresh and exciting, too, which is why Reybier and Finan are always seeking that new, rare, and almost indefinable element to present to their guests. "There's a saying in the hotel industry," says Reybier, with a wave of his hand. "You need to bring something different to the job, or you simply don't belong in this business." —

More from La Réserve:

FRANCE
Paris, La Réserve Paris → P. 223

SWITZERLAND
Geneva, La Réserve Genève Hotel and Spa → P. 223

| | |
|---|---|
| WHERE | ROOMS |
| Ramatuelle | 28 |
| France | |
| | VILLAS |
| MEMBER SINCE | 12 |
| 05/2009 | |
| | ROOM RATES |
| ARCHITECTURE / | EUR 780–4,500 |
| DESIGN | |
| Jean-Michel | VILLA RATES |
| Wilmotte (Wilmotte | EUR 3,600–8,400 |
| & Associés) | |
| | MEET THE ORIGINALS |
| | Raouf Finan, |
| | Michel Reybier |

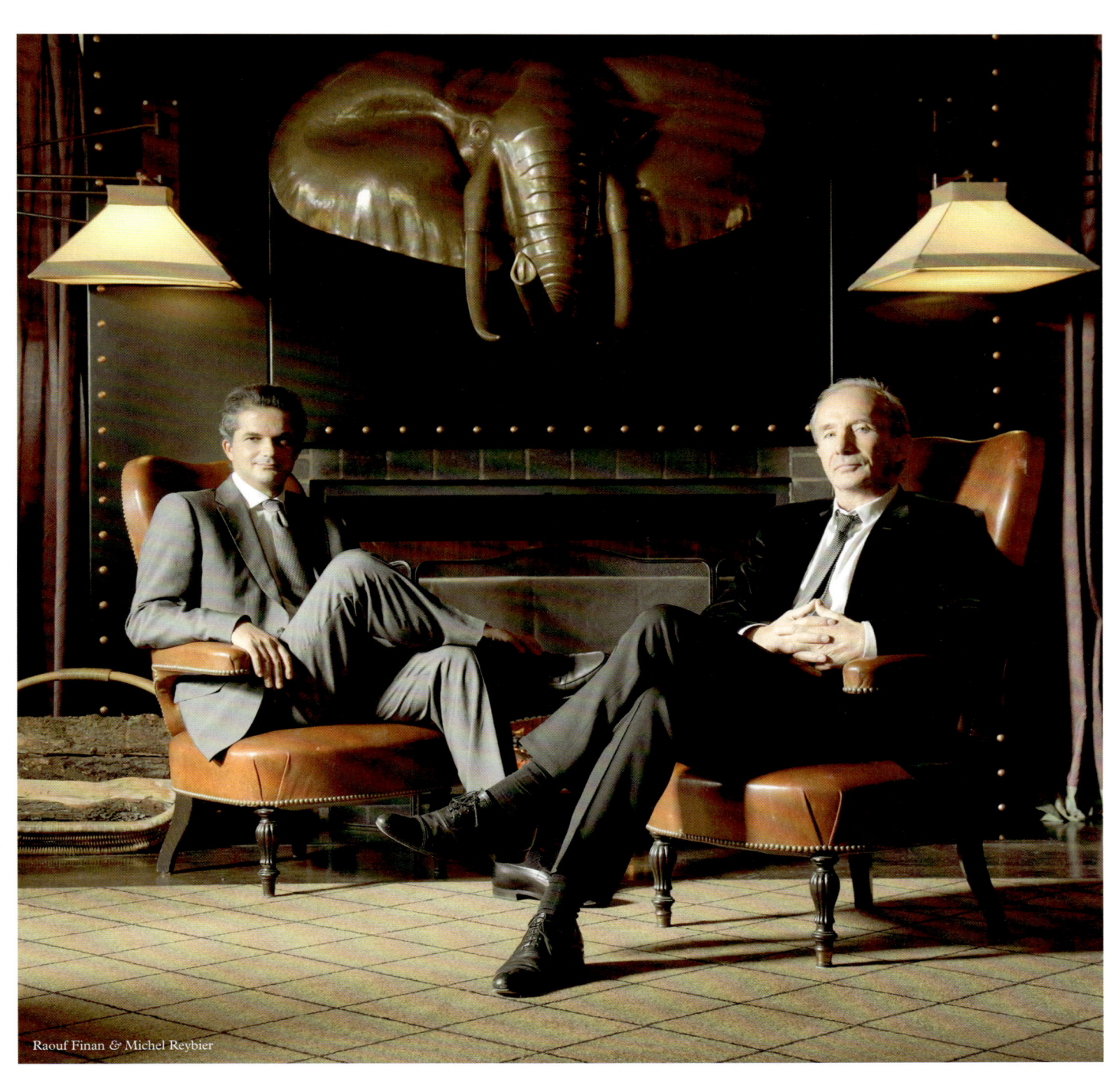

Raouf Finan & Michel Reybier

"I look for places that feel
extraordinary—a certain light,
a certain energy, a certain esprit.
I look for qualities we can't find
anywhere else."

MICHEL REYBIER

## La Plage Casadelmar

Natural materials and a sandy, beach-inspired color scheme have been used to create a hotel that is in perfect harmony with its seaside surroundings. La Plage Casadelmar is set on a private, sandy beach in Porto-Vecchio on the island of Corsica, famed for its colorful nightlife and laid-back elegance. Award-winning French architect Jean-François Bodin has used oak wood, volcanic rock, old stone, cement, resin, and glass to create a pure, clean design that is flooded with light. With only 15 rooms and suites, and the same management as sister property Casadelmar, guests can enjoy a genuine experience and warm hospitality.

**WHERE**
Corsica
France

**MEMBER SINCE**
03/2012

**ARCHITECTURE /
DESIGN**
Jean-François Bodin
(Bodin & Associés
Architectes)

**ROOMS**
15

**RATES**
EUR 500–2,000

**MEET THE ORIGINALS**
Jean-François
Bodin,
Gianluca Bertilaccio

## Five Seas Hotel Cannes

Guests are treated to a visual journey around the world at the Five Seas Hotel Cannes, where fine handcrafted furnishings and adornments excite the senses. With its 45 rooms and suites, the hotel is located near all of the best that Cannes has to offer. Wining, dining, and luxury are top priorities here, from the menu curated by 1-Michelin Star chef Arnaud Tabarec at SeaSens restaurant and the sweet creations by World Pastry Champion Jérôme de Oliveira, to the Spa by Cinq Mondes and Carita, and a cruise on the hotel's private yacht.

**WHERE**
Cannes
France

**MEMBER SINCE**
11/2011

**ARCHITECTURE /
DESIGN**
Marc Hertrich,
Nicolas Adnet
(Studio MHNA)

**ROOMS**
45

**RATES**
EUR 200–4,540

**MEET THE ORIGINAL**
Dona Bertarelli

# La Monnaie Art & Spa Hotel

WHERE
La Rochelle
France

MEMBER SINCE
12/2011

ARCHITECTURE /
DESIGN
Philippe Lucazeau
(Atelier Solo)

ROOMS
36

RATES
EUR 159–319

MEET THE ORIGINAL
Sylvette Lebeau

Sylvette and Pascal Lebeau have long been admirers and collectors of contemporary art, and now, within the 17th-century walls of La Monnaie Art & Spa Hotel, they have found a historic space in which to display part of their modern collection. The hallways, lounges, and 36 rooms and suites act as a transient gallery, offering changing exhibitions in conjunction with the nearby Galerie Albane. Original paintings, photographs, and sculptures from renowned international artists offer visitors a place to absorb culture. While surrounded by France's largest yacht marina, guests can amble through the Old Town, feast on the freshest seafood, or sail and surf in the Atlantic Ocean. The historic building has been given a makeover with decor that is audacious and lively. Patterned wallpaper, iconic furniture, and a color palette of smooth whites and soft grays are kept fresh with bright accents. Relax by the roaring fire in the bar and tearoom—serving creations by Pascal Caffet, French World Pastry Champion and chocolatier—or indulge at the ultramodern Spa. Within easy reach of La Rochelle's convention centers, and boasting a state-of-the-art meeting room for up to 40 people, La Monnaie Art & Spa Hotel is an inspiring destination that is simultaneously soothing and stimulating. —

# Vertigo Hotel

The name Dijon usually calls to mind, well, mustard. But the quaint French town in the northeast of France has a lot more going for it than just seasoning. The capital of Burgundy has a rich cultural heritage, beautiful vineyards, is one of four official French cities of gastronomy, and now has its first Design Hotels™ member—Vertigo Hotel. Set in a Haussmann-style building— more Paris than Côte d'Or—Vertigo's interiors are a black-and- white contrast to the exterior. The interior's modern color scheme is aided by Ligne Roset design pieces, suspended beds, mirror- cum-media-entertainment-system, photograph-bedecked ceilings, and many other little surprises. With a focus on service, the hotel welcomes guests as soon as they enter the driveway. A black retro bar, meanwhile, offers vintage burgundy wines, Champagne, and cocktails. And lastly, an indoor swimming pool, hammam, and sauna ensure the ultimate holiday repose.

Local heroes in Dijon, twin brothers Bruno and Christophe Massucco have opened a series of successful hotels and restau- rants in the area. The hoteliers of Italian-origin began their careers in the hospitality institutes in Dijon and Grenoble. Given that their parents also owned hotels, one could say that hospitality is in their blood. Purveyors of upcoming trends, their specialty is taking over old properties and creating exciting new identities. The Massucco brothers currently own four hotels in Dijon, each with an individual identity. When they're not working, they spend time pursuing two of their biggest passions: cars and Juventus Football Club out of Turin, Italy. —

| | |
|---|---|
| WHERE | ROOMS |
| Dijon | 42 |
| France | |
| | RATES |
| MEMBER SINCE | EUR 127–399 |
| 04/2014 | |
| | MEET THE ORIGINALS |
| ARCHITECTURE | Bruno Massucco, |
| Yvon Carminati | Christophe |
| | Massucco |
| DESIGN | |
| Ludivine De Brito | |

Bruno & Christophe Massucco

# Château de la Resle

Should you be traveling through France's winemaking region of Burgundy and come across an ivy-wrapped manor house with the charm of a well-loved private home, you will understand the spell that mesmerized Dutchmen Johan Bouman and Pieter Franssens. The two businessmen had come to France to set up a subsidiary of the food company they ran in The Netherlands, but after being entranced by the area's vineyards and *châteaux* they bought a *château* of their own. Today, that property has been transformed into Château de la Resle, a six-room testament to the very best the region has to offer.

Set atop a hill, Château de la Resle has the charm and personality of a home that belongs to a good friend. Those six elegant rooms and suites, like the house itself, have been painstakingly restored by Bouman and Franssens. Adding to the feeling of romance and exclusivity, the duo has also assembled and displayed throughout the manor their personal collection of contemporary art and design, which attracts fellow connoisseurs from around the world.

From the château, which sits on the edge of an 800-hectare hunting forest, there are bucolic views down the valley of Montigny la Resle. The wine village of Chablis, which gives its name to one of the most famous white wines in France, is also just a short drive away. Exploring the area is a delight, but guests are equally happy to unwind at the château's spa, soak in the azure pool, or relax by a sizzling open fire with a glass of the château's own Chablis.

With two hectares of landscaped gardens, complete with glasshouses, that inviting swimming pool, and orchards to meander through, there's really no need to leave. Indeed, to stroll the grounds here is to walk into Burgundy's—and the property's—

rich past. Originally built in the 17th century, Château de la Resle was torn apart by fire and rebuilt in the 19th century. Looking better than ever, it now retains many of its original architectural features, including sweeping staircases and a fort-like round tower with a conical roof. Throughout, windows with wooden louvers let natural light flood into the rooms and public spaces, providing glimpses of the wine country outside.

Inside, the same detailed attention to aesthetics reigns supreme. Using standout furnishings by some of their favorite design brands, Bouman and Franssens added modern simplicity to the iconic building. When the pair developed the interior design concept, they focused on creating spaces that would quench their thirst for contemporary art and make the most of the mansion's original features, such as open fireplaces and delicate plasterwork details.

The result of these labored efforts of love is a hotel that twinkles with personality and invites guests in to share Bouman and Franssens' wonderful collection of artwork. In fact, this expert eye for design has recently led the duo to launch their own Château de la Resle label, which features exclusive, one-off limited-edition pieces created by the very designers whom the pair collaborated with when creating the furniture for the hotel. The label will allow guests to recreate in their own homes the charm and majesty that so beguiled Bouman and Franssens—and which, today, comes alive in every corner of Château de la Resle. —

| WHERE | ROOMS |
|---|---|
| Montigny la Resle | 6 |
| Burgundy | |
| France | RATES |
| | EUR 225–475 |
| MEMBER SINCE | |
| 10/2013 | MEET THE ORIGINALS |
| | Johan Bouman, |
| DESIGN | Pieter Franssens |
| Johan Bouman, | |
| Pieter Franssens | |

Johan Bouman & Pieter Franssens

# Hotel Claris

WHERE
Barcelona
Spain

MEMBER SINCE
10/1994

ARCHITECTURE
MBM Architects

DESIGN
Derby Hotels
Collection Design
Team

ROOMS
124

RATES
EUR 235–1,500

MEET THE ORIGINALS
Joaquim Clos,
Jordi Clos

Part of Barcelona's renaissance as a center for commerce and the arts, the Claris has been a beacon for outstanding design and luxury since 1992. Built 100 years earlier as the exterior of the neoclassical Vedruna Palace, the façade was reworked by MBM Architects and incorporated into the hotel space. The lobby's alcove lighting and copper accents segue into elegant stair rails that lead to a retro-cool rooftop pool with a view. In the 124 recently renovated guestrooms, modern, elegant lines soothe, while steel and copper details subtly stimulate. No two rooms are alike: From furniture construction to the choice of marble and wood, everything has been traditionally handcrafted, and combinations of old and new come into their own. More than 400 *objets d'art* are scattered throughout, including Indian and Burmese sculptures from the 5th to the 13th centuries, more than 100 engravings commissioned by Napoleon in 1812, Turkish kilims, Roman mosaics, and engravings by the Catalan artist Guinovart. It's all a feast for the eyes as well as food for the soul at one of the best addresses in this Catalan city. —

# Hotel Granados 83

A unique experience in remixed neoclassicism, built on the site of Barcelona's venerable Pujol i Brull clinic, the Hotel Granados 83 brings an entirely modern concept of luxury to a notable Old City location. Constructed around a luminous central courtyard crowned by a glass ceiling, the building looks just as good in real life as it does in pictures. Original colonnades are enhanced by steel, red marble, glass, and iron, but the lobby is also dotted with antiques and art objects. The soothing atmosphere and low, social buzz give guests a sense of constant, languid movement; friendly, generous service ensures that they are absolutely comfortable not only in public spaces but also in the 77 loft-style guestrooms. Here, Asian pieces of art soften the high-tech facilities and ultramodern materials, while there is a literal Asian flavor in the restaurant, "3." With its "8 Terrace Bar" located on the rooftop, the hotel offers the perfect place for pre-dinner cocktails and snacks. Extensive use of white Thassos marble and zebrawood as well as phosphorescent iron pieces adds chic throughout; raw leather inserts on headboards and chairs lend a wonderful warmth. It's a textural mix that is as inspiring and soothing as everything else in this smart urban getaway. —

WHERE
Barcelona
Spain

MEMBER SINCE
08/2005

ARCHITECTURE
Carles Bassó

DESIGN
Jordi Cuenca
(Triade Studio),
Montse Casellas
(Derby Hotels
Collection Design
Team)

ROOMS
77

RATES
EUR 190–630

MEET THE ORIGINALS
Joaquím Clos,
Jordi Clos

# Tarruella Trenchs

## STUDIO

THROUGH THEIR INNATE UNDERSTANDING OF SPACE, COLOR, AND THE POWER OF THESE ELEMENTS TO STIMULATE CREATIVITY AND A SENSE OF COMMUNITY, THIS BARCELONA TEAM CRAFTS INTERIORS THAT ATTRACT ARTISTS AND FELLOW DESIGNERS WHO COME TO BE INSPIRED.

*Tarruella designed a fine-dining experience at El Celler de Can Roca based on generous amounts of natural light and a recurring motif of triangles— a reflection of the three brothers who founded it.*

In 1987, designer Sandra Tarruella began her career when two restaurateurs, Grupo Tragaluz founders Rosa Maria Esteva and Tomás Tarruella, opened a simple snack counter in Barcelona called El Mordisco; while they oversaw the kitchen and the finances, Sandra designed the interior. The recipe created an instant legend. El Mordisco quickly became the gathering place of Barcelona's creative elite—drawing artists, designers, and models to its long, communal table with fresh modern dishes and a casual, convivial atmosphere. It was an undeniable success, followed by many others.

Sandra Tarruella remained the company's mainstay designer as it expanded with more than a dozen acclaimed restaurants in Barcelona, Madrid, and, ultimately, Mexico City, but her success outside of Grupo Tragaluz has taken her even farther afield— to London, Toulouse, Dubai, and beyond.

Tarruella studied interior design at Barcelona's Escuela DIAC and Escola de la Llotja, as well as fashion design at Escuela IDEP. She apprenticed for two years under the formidable Pepe Cortés, and from 1992 to 2009 ran the firm Tarruella-López with architect Isabel López Vilalta.

In 2009, Tarruella and partner Ricard Trenchs founded Tarruella Trenchs Studio, which has since created the interiors of countless residences, shops, offices, and exhibitions, but it is best known as the go-to firm for the world's most prestigious chefs, Nandu Jubany, Carles Abellan, and Luis Baena among them. Perhaps most notable of these culinary maestros are the formidable Roca brothers, founders of the number one spot on The World's 50 Best Restaurants list of 2015, El Celler de Can Roca, located in Girona, Spain.

With former business partner López Vilalta, Tarruella designed a fine-dining experience at El Celler de Can Roca based on generous amounts of natural light and a recurring motif of triangles—a reflection of the three brothers who founded it. In contrast to the dramatic presentations of the avant-garde dishes—caramelized olives served hanging from a miniature tree, for example, or ice cream that dances, thanks to a concealed motor—the interiors are understated. In the dining room, the prevailing color is white, accented by the blonde woods that comprise the seating and the exposed beams running parallel to each other along the ceiling and vertically along the walls, while three glass walls surround the triangular courtyard in the center of the restaurant to ensure that every guest has a scenic view. In the more playful cellar, the wine selection is divided into box-like compartments decorated with the ink-stamped labels of wooden wine crates.

Also in Girona is Rocambolesc, a nearby ice cream bar offering Jordi Roca's desserts in a masterwork by Tarruella Trenchs. Where El Celler is defined by its understated elegance, Rocambolesc is defined by whimsy. The interior is a veritable candyland, with powder-blue walls, a counter with wheels that resemble those of an ice cream cart, and pipes on the walls and ceiling painted with the spiraling red-and-white stripes of a candy cane. For its charm and levity, Rocambolesc was named Best Bar in Europe by the 2013 Restaurant & Bar Design Awards.

For Tarruella, professional partnerships run deep, and once established, they lead to endless possibilities. The aforementioned colleagues—Rosa Maria Esteva; López Vilalta; and the three Roca brothers—along with Barcelona architect Juli Capella, came

## SIDE NOTES

**NAMES** *Sandra Tarruella & Ricard Trenchs*
**COMPANY NAME** *Tarruella Trenchs Studio*
**COMPANY HEADQUARTERS** *Barcelona*
**NUMBER OF PEOPLE IN COMPANY** *12*
**WEBSITE** *tarruellatrenchs.com*
**SIGNATURE PROJECTS** *Barcelona: El Mordisco; Hotel Omm; Metropolitan; Woki Organic Market; Céleri **Girona, Spain:** El Celler de Can Roca; Rocambolesc Gelateria **Madrid:** Bar Tomate; Bosco de Lobos; La Bien Aparecida **La Rioja, Spain:** Bodegas Marqués de Murrieta **Milan:** Panino Giusto **Mexico City:** Bar Tomate*

## SIGNIFICANT AWARDS

**2015** *Architectural Digest Designer of the Year*
**2013** *Restaurant & Bar Design Awards, Best Bar in Europe for Rocambolesc Gelateria*
**2010** *La Luna de Metrópoli, Best Interior Design for Bar Tomate, Madrid*
**2009** *Interiorismo Plus Awards, Best Hotel for Hotel Eme*
**2008** *Interior Design Magazine Best of Year, Best Hotel for Hotel Eme*
**2005** *Condé Nast Awards Europe, Best Hotel for Hotel Omm*

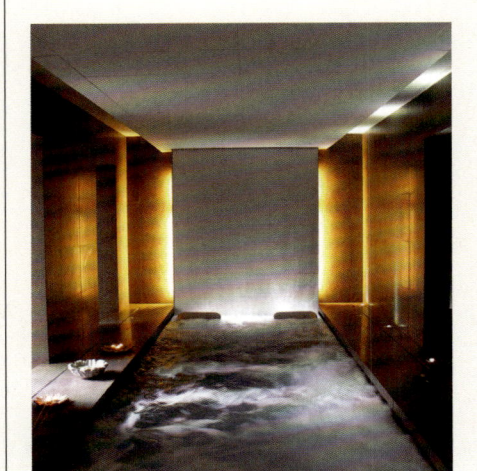

*The masterful design of Hotel Omm's spa creates a sense of relaxation while referencing the architectural feel of Barcelona.*

together in 2003 for an unprecedented venture by Esteva: Hotel Omm, in Barcelona's L'Eixample quarter, Esteva's first foray beyond the restaurant business. Tarruella's sleek interiors, with their straightforward procession of right angles and subtle palettes, are punctuated by the occasional punch of color. The white minimalist rectangular fireplace in the lobby, for example, plays nicely with the soft curves of the banana-yellow Arne Jacobsen armchair stationed next to it. The dark corridors, cinematically lit by long stretches of sci-fi floor lights, open directly into the contrastingly light and airy guestrooms. And those rooms have been hewed down to the essentials, unencumbered by the superfluous entryway found in most hotels, and furnished with maximal modernity: The contemporary take on the four-poster bed is framed by the straight lines of a minimalist canopy, and a white, illuminated bedside cube doubles as both nightstand and nightlight.

At Hotel Omm, the two restaurants—the cozy and well-appointed Roca Moo and Roca Bar, both works by Tarruella Trenchs Studio—bustle with fashionable guests. Like El Mordisco, Hotel Omm has established itself as a gathering place, putting forth the novel idea that a hotel can also be a comfortable destination for locals. As such, Tarruella has done then what she and Trenchs continue to do today—inject a sense of the household into the hospitality business, one that gives visitors the feeling that they're among friends.

*Text: Janelle Zara*

1

1 *For the Marqués de Murrieta Cellar, in the Spanish town of La Rioja, Tarruella and Trenchs perfectly captured the elegance and history of the region.*

2 *Parallel lines and warm lighting at Hotel Omm's restaurant create an embracing but relaxed sense of grandeur.*

3 *For Taberna wabi-sabi, in Valladolid, Spain, Tarruella and Trenchs evoked a Japanese philosophy built around the ephemeral and the beautiful.*

2

3

**4** Set on the mezzanine of the W hotel in Barcelona, Bravo 24 Restaurant has a resolutely contemporary feel thanks to Tarruella and Trenchs' use of light and dark woods.

**5** Tarruella and Trenchs created a social gathering spot at Barcelona's Metropolitan Iradier health club that celebrates the young, fresh vibe of the setting but without sacrificing elegance.

**6** For the Instituto Javier de Benito, the design team acknowledged the refinement of Barcelona's Eixample district by keeping the space's existing ceilings, cornices, and decorative elements in their original state.

5

4

6

# Hotel Omm

In Barcelona's elegant Passeig de Gràcia district, Hotel Omm at first looks like the ultimate meeting place for international movers and shakers. But behind the captivating appearance is also a kind of smooth, effortless usability. Sections of the unusual limestone façade teasingly peel back like pages of a book, about to reveal the rooms inside. Yet what seems like decorative fantasy is actually functional: The angled windows shield guests from outside views and street noise, but allow direct sunlight to flood in. The spacious lobby cleverly flows into a sleek bar, and then into the restaurant, Roca Moo, with furnishings kept at a low, uniform height to allow guests to glide through just as freely; a full-service spa in an adjacent wing echoes the hotel's jet-set elegance. Interior designers Sandra Tarruella and Isabel López based their concept on simple lines, a balance of colors and volumes, and the use of natural materials, but chic surprises abound. Yes, the black rubber-lined corridors absorb sound, but with two tubes of light spanning their length, they also create a fantastically futuristic atmosphere. Guests pass through, enter their wide-open light-filled rooms, and immediately feel the perfect marriage of form and function.

From her restaurant empire Grupo Tragaluz—a joint venture with her son that includes 16 restaurants—to her exquisite taste and inherent sense for hospitality, Rosa Maria Esteva has become the empress of authentic hotel and dining experiences in Barcelona and Madrid. In 2003, Esteva opened Hotel Omm, designed by architect Juli Capella, in the landmark-laden neighborhood of Eixample in Barcelona. Since then, the hotel has become a place to "live with the locals" as Esteva puts it. To ensure everything runs smoothly, Esteva has made her home above the hotel, dines in the Michelin-starred Moo Restaurant, and even occasionally spends a day in the spa. For Rosa Maria Esteva, quality control is the key to success. —

WHERE
Barcelona
Spain

MEMBER SINCE
09/2003

ARCHITECTURE
Juli Capella
(Capella Garcia
Arquitectura)

DESIGN
Sandra Tarruella
(Tarruella Trenchs
Studio)

ROOMS
91

RATES
EUR 220–1,500

MEET THE ORIGINAL
Rosa Maria Esteva

Rosa Maria Esteva

# Grand Hotel Central

The recently renovated Grand Hotel Central is a discreet and luxurious hideaway amid the bustle of Barcelona's fashionable El Born district. Established in the 1920s by architect Adolf Florensa, the building was inspired by the newly created skyscrapers of Chicago and New York. Eighty-five years later, owner Pau Guardans has completely reworked the building to create a hotel that evokes the splendor of Barcelona's high society in the early part of the 20th century. The result is a tranquil property infused with timeless elegance and urban soul. Guardans offers guests an insider view with his very own city guide "Barcelona Around" and even a free city guide, app *Guías Punto,* featuring major events, trends, and new places in town. Inside, 1920s-style grandeur is everywhere you look, starting with the original bronze doors of the impressive structure's elegant entrance. This motif continues in the oversize rooms, which feature stone cornicing and flooring and preserved wrought iron lamps. The dark oak floors and clean lines of the 147 rooms and suites ooze urban modernity through smooth materials such as glass and wood. Within the bedrooms, transparent panels and semi-opaque materials are used as dividers, so that sleeping spaces, bathrooms, and even the wardrobes all merge seamlessly. Enjoy dinner or a cocktail at City Restaurant, a modern space with timber flooring, industrial lamps, and huge windows, offering fresh Mediterranean meals to be shared. Book a massage in the seventh-floor Wellness Suite, enjoy the private hammam and sauna area, or relax in the library. With the rooftop Sky Bar, infinity pool, and panoramic views, guests will feel completely immersed in the buzz of the city without leaving the comfort of their chaise longue. One brand-new addition to the hotel is the downstairs City Bar, offering a delectable menu of sandwiches, tapas, salads, coffee, and cocktails, as well as a gallery featuring work by local artists.

There are entrepreneurs who ride trends and there are those who drive them. Pau Guardans, a Barcelona native and veteran hotelier, is decidedly of the latter kind. As co-founder and director of the successful chain AC Hotels, he helped introduce design into the Spanish hospitality sector. Then in 2006, he struck out on his own with Barcelona's Grand Hotel Central, which reinterprets the grand hotels of the 1920s. Hotels, says Guardans, should function as "engines of local communities," a principle that governed his second and third properties: the Único in Madrid and most recently The Principal Madrid, which opened in 2011 and in 2015, respectively. It has also led him to just launch his own free app, *Guías Punto,* with personal tips for Madrid and Barcelona. —

Pau Guardans

WHERE
Barcelona
Spain

MEMBER SINCE
06/2011

ARCHITECTURE
Oriol Tintoré

DESIGN
Sandra Tarruella
(Tarruella Trenchs
Studio),
Isabel López

ROOMS
147

RATES
EUR 240–1,450

MEET THE ORIGINAL
Pau Guardans

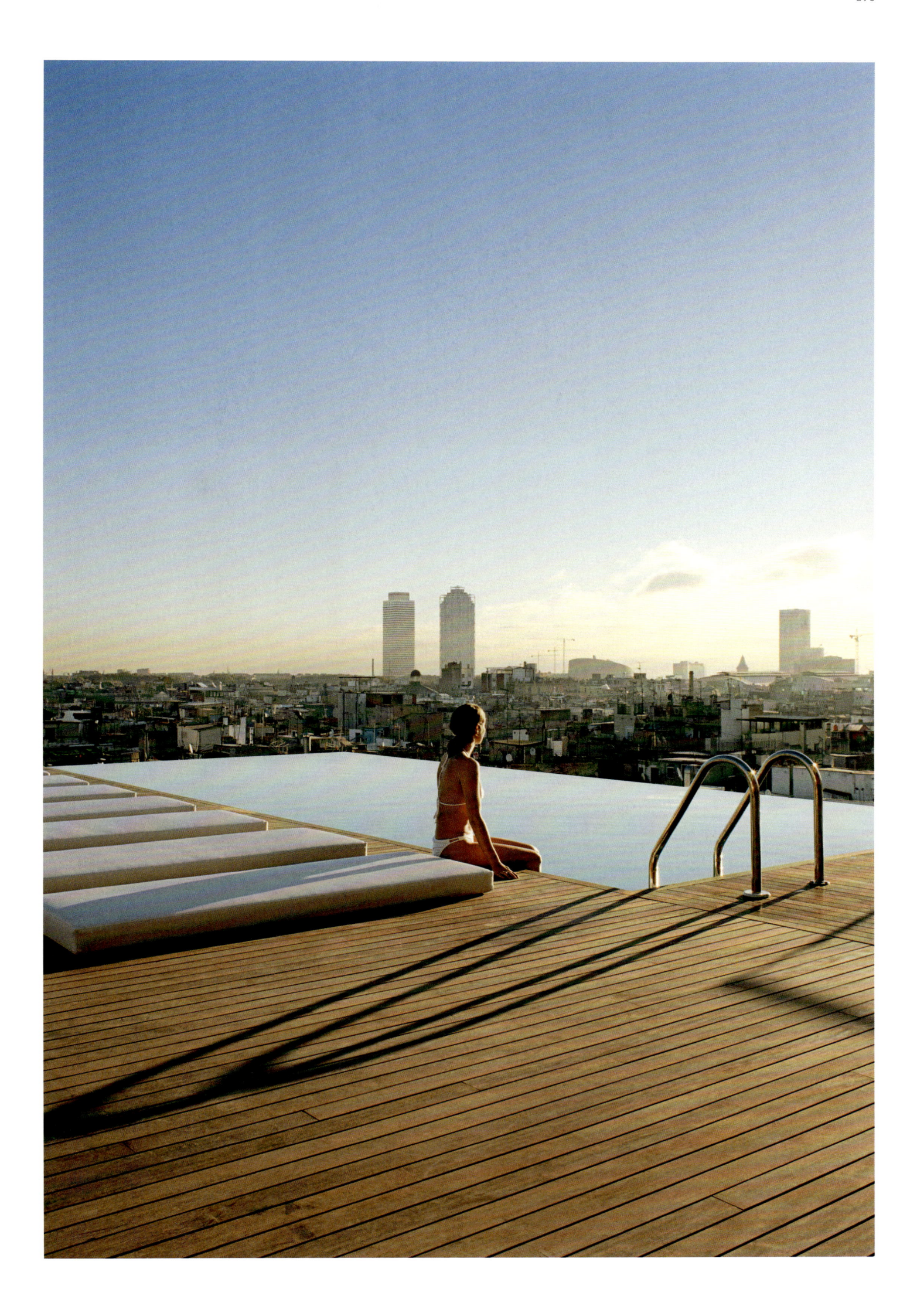

# The Serras

History, art, and pure sensual delights come together majestically at The Serras on Barcelona's celebrated Passeig de Colom. Here, breezes blow off the Mediterranean into large rooms with balconies that offer a front row seat to this trendy Barcelona neighborhood. Here, too, one finds a top Catalan chef and the site of Pablo Picasso's first studio where he painted Ciencia y Caridad in 1897 (celebrated with a Picasso Suite). Today, a new masterpiece is being created in the form of a stylish rooftop terrace, oversized rooms with tiles echoing the classic Barcelona style, a historic façade by a famous 19th-century architect, and all set amid the latest technology presented in a hassle-free environment. Though a fashionable world lies just outside its front door, inside, a soothing color palette of gray, silver, sand, mustard, and green echoes the sea, painting a portrait of calm that Picasso himself would have admired. —

WHERE
Barcelona
Spain

MEMBER SINCE
08/2014

ARCHITECTURE
Ferran Gelabert
(Arq)

DESIGN
Eva Martinez Torres
(Kasamar)

ROOMS
29

RATES
EUR 198–3,800

MEET THE ORIGINAL
Jordi Serra

# Ocean Drive Hotel

With its classic Art Deco design, Ocean Drive Hotel is a 40-room architectural icon situated on Ibiza's Marina Botafoch. Mies van der Rohe and Le Corbusier furniture in the lobby and bar exudes vintage glamour, while the rooftop bar and terrace is a favorite local attraction, beloved for its world-famous DJs and spectacular views. Established among island residents, Ocean Drive offers guests unparalleled access to Ibiza's notorious nightlife, while providing a scenic and stylish spot to relax before and after late nights in the town.

| WHERE | ROOMS |
|---|---|
| Ibiza | 40 |
| Spain | |
| | RATES |
| MEMBER SINCE | EUR 100–600 |
| 04/1998 | |
| | MEET THE ORIGINAL |
| DESIGN | Marc Rahola |
| Mayte Matutes | Matutes |
| (Estudi Pam 2) | |

# Aguas de Ibiza Lifestyle & Spa

Anchored in Santa Eulalia Bay Marina, Aguas de Ibiza Lifestyle & Spa offers a peaceful, central setting ideal for exploring the island. With interiors by Barcelona-based Triade Studio, Aguas blends the charming character of a rural finca with the high-end services and savvy style of a contemporary hotel. The 112 rooms and suites have private terraces and floor-to-ceiling windows as well as quirky extras like an energy-saving domotics system. The hotel also has three outdoor pools with lush gardens and terraces where guests can sunbathe, relax, and enjoy stunning views.

| WHERE | ROOMS |
|---|---|
| Ibiza | 112 |
| Spain | |
| | RATES |
| MEMBER SINCE | EUR 190–2,500 |
| 05/2008 | |
| | MEET THE ORIGINAL |
| ARCHITECTURE | Alberto Torres |
| Jordi Cuenca | |
| (Triade Studio), | |
| Juan De Los Rios | |
| | |
| DESIGN | |
| Jordi Cuenca | |
| (Triade Studio) | |

# OD Port Portals

WHERE
Mallorca
Spain

MEMBER SINCE
11/2013

ARCHITECTURE
Victor Rahola
Aguadé (Rahola
Vidal Arquitectes)

DESIGN
Mayte Matutes
(Estudi Pam 2)

ROOMS
77

RATES
EUR 80–450

MEET THE ORIGINAL
Marc Rahola
Matutes

As the most exclusive port on the island of Mallorca, Puerto Portals serves as a meeting point for the international jet set, with its celebrated bars and restaurants, such as the Moorish-style Karma bar, as well as a diverse range of lifestyle boutiques. A sensational landing spot for island hoppers, the sleek OD Port Portals offers 365 days of exclusivity perfectly situated near the luxurious yacht harbor. Transmitting the same exuberant energy as its sister property and member hotel Ocean Drive in Ibiza, OD Port Portals has become the hot hangout space. The interiors take their cue from the Ibizan property, with a retro glamour conveyed through design classics, colors, and patterns. Luxury at the resort includes not only the private chauffeur service (or a complimentary car with every Junior Suite) to visit the nearby beaches, but also health-conscious crossover cuisine with Asian, Latin American, and European influences. —

# Puro Oasis Urbano

The relaxed, cosmopolitan spirit of Puro Oasis Urbano also defines the hotel's owner, Mats Wahlström, the Puro Group's Swedish-born, adventure-loving founder. In 1998, he acquired the 18th-century town palace and began to transform it into a singular gathering place on Mallorca. The hotel opened in 2004 and underwent a complete refurbishment in 2010. Wahlström continues to push the boundaries with his vision for the hotel, and the result is a 21st-century style hotel with 51 rooms, including 11 suites in a new private wing, and three fully equipped meeting and event spaces for up to 40 people. With the redesign, the hotel's original boho-ethnic aesthetic has morphed into a more affirmatively urban look created by Swedish designer Gabrielle Jangeby. Smart leather furniture, earth-tone fabrics, and modern art (including key pieces by Peter Gröndahl) reject the trappings of traditional prestige and embrace the new luxuries of time and ease. Public spaces are filled with chill-out music, there are numerous light-soaked lounge areas, and the rooftop terrace has a plunge pool and canopied daybeds. The light, Asian-influenced cuisine at Opio Bar & Restaurant is a perennial favorite. Opio Bar has a VIP area and a music studio opened in early 2011. In-room details include flat-screen Bose televisions, spa-like bathrooms, free WiFi, and iPod docking stations on which to listen to the latest "Puro Music" releases. At PuroBeach, the nearby beach club, there is a spa, pool, and restaurant lounge situated on a peninsula overlooking the bay of Palma. —

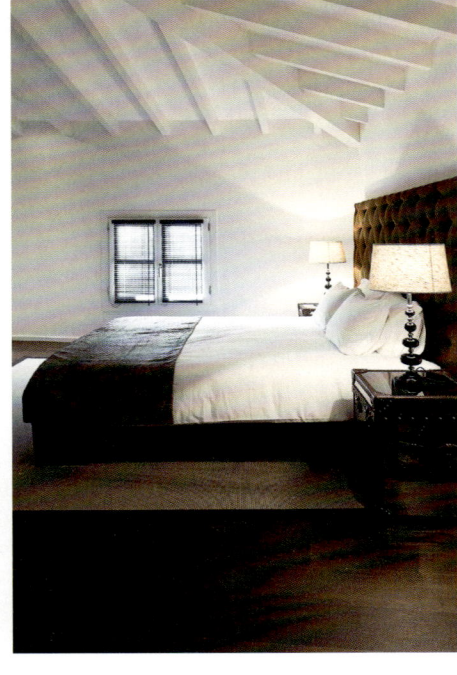

**WHERE**
Mallorca
Spain

**MEMBER SINCE**
11/2003

**ARCHITECTURE**
Alvaro Planchuelo

**DESIGN**
Gabrielle Jangeby
(DIS Inredning AB)

**ROOMS**
51

**RATES**
EUR 150–515

**MEET THE ORIGINAL**
Mats Wahlström

# Hotel Cort

Amid the narrow streets that crisscross Palma de Mallorca's old town is a hotel with serene, spacious suites and a rippling rooftop pool. Like an island within an island, Hotel Cort sits at the epicenter of this historic and increasingly cosmopolitan city. Guests will find quiet inspiration in the 14 suites and 2 rooms designed by self-styled "urban archeologist" Lázaro Rosa-Violán, whose framed maps and cool splashes of ultramarine color hint at the hotel's proximity to the sea (the nearest beach is just a 15-minute walk away). It's equally easy for guests to mingle with locals in the hotel's bars and Mallorquin restaurant, which spills onto the sun-drenched cobbles of Plaça de Cort. This central plaza is home to Palma's Baroque-era town hall and a centuries-old olive tree that acts as a natural meeting place for locals, making it the ideal base for weekending visitors who want to uncover the real Mallorca, far from the usual "fun in the sun" beach resorts.

Spanish style hunter Lázaro Rosa-Violán, renowned for his work at restaurants, bars, hotels, and shops around the world, knows how to get results. "The interior designer is an actor," he says. "He must dress up and change roles, understand new identities and integrate them with his own." At Hotel Cort (and Hotel Pulitzer, a member hotel in Buenos Aires) this saw him going beyond the usual remit of an interior designer, taking charge of how the lighting, ambiance, sleeping areas, and food worked together to make a complete experience. "We wanted to create in the guest's mind a memory of wellbeing and warmth that they could take away with them after their stay at Hotel Cort," he says. —

**WHERE**
Mallorca
Spain

**MEMBER SINCE**
06/2013

**ARCHITECTURE**
Vicente Alcover
Ripoll

**DESIGN**
Lázaro Rosa-Violán
(Contemporain
Studio)

**ROOMS**
16

**RATES**
EUR 165–1,190

**MEET THE ORIGINAL**
Lázaro Rosa-Violán

# Hospes Maricel

Formerly a notorious haunt of the old-school jet set, this proud and palatial building once hosted parties that kept the paparazzi snapping. The atmosphere now is more stylishly leisurely, but today's international travelers can still savor a hint of those decadent days in the retained details—a neoclassical entrance, large windows, neo-Gothic pillars—of a 1949 building. Otherwise the Hospes Design Team revamp has returned traditional Balearic elements of the original structure—archways and arcades, columns in marble and local stone—while modern accents supply a beautifully contemporary flair. The palatial structure houses 29 cozy, light-filled rooms with sea or mountain views while the adjoining eco-building has 22 avant-garde rooms. The seafront arcade and grand terraces send guests straight to another era—or to a state of relaxed bliss. So does the refined, subtle service. Whether they arrive by private yacht or just drive in, visitors can sample an array of open-air spa treatments in the grotto-like alcoves above the waves, savor local seafood in the Maricel restaurant, or float in the stunning infinity pool, which seems to dissolve into the … yes … infinite blue of the sea. —

## More from Hospes Infinite Places:

SPAIN
Alicante, Hospes Amérigo → P. 282
Córdoba, Hospes Palacio del Bailío → P. 284
Granada, Hospes Palacio de los Patos → P. 283
Madrid, Hospes Puerta de Alcalá → P. 290
Salamanca, Hospes Palacio de San Esteban → P. 286
Seville, Hospes Las Casas del Rey de Baeza → P. 285
Valencia, Hospes Palau de La Mar → P. 282

| WHERE | ROOMS |
|---|---|
| Mallorca | 51 |
| Spain | |
| | RATES |
| MEMBER SINCE | EUR 150–1,700 |
| 10/2002 | |

ARCHITECTURE /
DESIGN
Hospes Design
Team

# Hospes
# Palau De La Mar

Flying on the high honors bestowed upon them for some of the hottest restaurant and hotel interiors in Spain, the Hospes Design Team remodeled two adjacent 19th-century palaces in the center of Valencia. In the interior, modernist principles reign. Carefully coordinated design elements, mainly using Wenge wood, have been chosen for the guestrooms.

| WHERE | ROOMS |
|---|---|
| Valencia | 66 |
| Spain | |
| | RATES |
| MEMBER SINCE | EUR 125–700 |
| 12/2003 | |

ARCHITECTURE /
DESIGN
Hospes Design
Team

# Hospes
# Amérigo

Neo-Gothic arched windows and Juliet balconies are the first impression made by this Alicante property. What began as a Dominican convent, and once housed the local prosperous bourgeoisie, is now a hotel filled with modern creature comforts. A light-filled lobby welcomes with polished white marble and glass surfaces, but the past is present again in the wrought iron work that surrounds the balcony above it. Head up to the roof terrace for stunning views of the city's castle.

| WHERE | ROOMS |
|---|---|
| Alicante | 81 |
| Spain | |
| | RATES |
| MEMBER SINCE | EUR 135–795 |
| 01/2004 | |

ARCHITECTURE /
DESIGN
Hospes Design
Team

# Hospes
# Palacio de los Patos

At the foot of the awe-inspiring Sierra Nevada in Andalucia, Granada is a city known for its fervour and fire. The interfusion of Arabic influence and native Iberian tradition brands the atmosphere of the place, made visible at locations such as the Alhambra. A stay at the Hospes Palacio de los Patos is sure to bring one closer to this authentic Granada. Situated almost adjacent to the Puerta Real, Hospes Palacio de los Patos is housed in a reconstructed 19th-century town palace. Use this retreat as your springboard into the city and Andalucia, and enter an enchanted world under snow-capped peaks. Hospes Palacio de los Patos is an urban oasis combining dramatic classical design with equally stunning modern architecture. The Hospes Design Team has retained the splendor of such original elements as the grand staircase, while 42 well-appointed guestrooms and suites ensure that guests feel at home within an environment of vivid, sultry contrasts that fuse the city's Moorish influence with a Spanish-Iberian flavor. Guests can settle into modern comfort in two buildings—a classical section in the palace's heart and a new construction housing 22 rooms, plus a restaurant, spa, and parking. —

WHERE
Granada
Spain

MEMBER SINCE
07/2004

ARCHITECTURE /
DESIGN
Hospes Design
Team

ROOMS
42

RATES
EUR 215–2,444

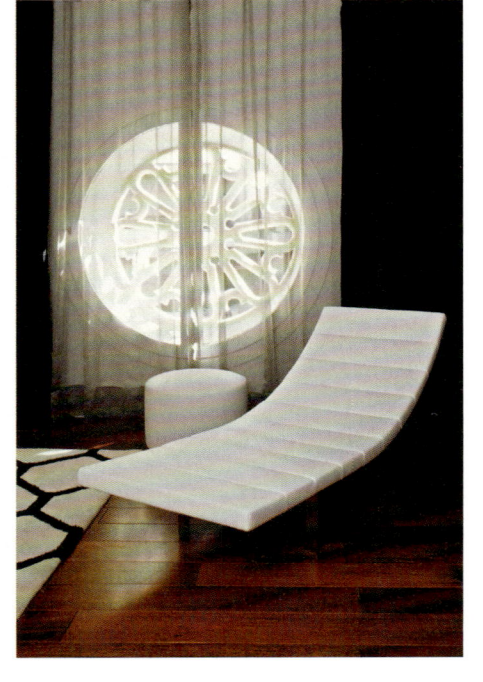

# Hospes
# Palacio del Bailío

Built between the 16th and 18th centuries, this traditional Andalusian estate, now in the historical heart of Córdoba, has been meticulously restored and finely balanced with contemporary design. Guests move among original detailing, such as wrought-iron railings, cool terracotta tiles, Moorish embellishments, and a lavishly painted ceiling—all artfully enhanced with understated modern touches. Rich fabrics and textures in shades of champagne and copper are offset by dark walnut and light polished marble floors. Solid slabs of black local stone lure guests to the lush, flowery gardens outside, the perfect place to linger over a drink, a book, or a loved one. The estate is composed of several buildings— the palace itself, designated a "place of cultural interest," along with its coach houses, stables, and granaries—arranged around a mosaic of five patios. In the spectacular main patio, traditional paving has been replaced with a dramatic glass floor to reveal Roman ruins 4½ meters below. The restored frescoes further reflect a care for artistic detail, while a sense of serene luxury invites guests to be revitalized by history. —

WHERE
Córdoba
Spain

MEMBER SINCE
10/2005

ARCHITECTURE /
DESIGN
Hospes Design
Team

ROOMS
53

RATES
EUR 225–1,600

# Hospes Las Casas del Rey de Baeza

Mingling elements of Moorish and European design from the two cultures that have shaped the Andalusian capital over centuries, the Hospes Las Casas del Rey de Baeza is a relaxed, sophisticated fusion of past and present. In the hotel's courtyards, bright, whitewashed walls are embellished with the ochers and reds of southern Spain's bullrings. The courtyards are shaded by arcaded walkways that tempt those who wander them into conspiratorial moments amid a forest of salvaged wooden posts and stone columns. Ah, the passion of Seville. Once inside, cool terracotta flooring and natural tones lead guests to the 41 guestrooms, where a gracious modernity takes over. Dark chocolate-colored furnishings, sisal mats, wooden beds from Indonesia, extravagant floor cushions, and soft lighting set the scene for a retreat from the sultry city outside into interiors that are surprisingly reminiscent of urban apartments. Natural light shines through slim passages formed by columns, and bounces off freestanding bowl sinks, water jugs, and other ornaments from bygone eras that are ready to be enjoyed in all their glory today. —

**WHERE**
Seville
Spain

**MEMBER SINCE**
10/2002

**ARCHITECTURE /
DESIGN**
Hospes Design
Team

**ROOMS**
41

**RATES**
EUR 140–500

# Hospes Palacio de San Esteban

In Salamanca's Old City—a UNESCO World Heritage Site—Hospes Palacio de San Esteban is a contemporary-cool historic hideaway built by Dominican Friars in the 16th century. After the meticulous restoration of one of Spain's most significant Dominican convents, the property now boasts 51 outward-facing "chambers," in a structure defined by solid Villamayor stone walls; elegantly modern furnishings and fabrics; dark-wood beams and high-vaulted ceilings; and to-the-minute technology, as conjured by architecture team Fernando Población Íscar and Grupo Veintidós. The hotel's anachronistic spirit is expressed in its purest form at El Monje restaurant: Set in the convent's original kitchen, the restaurant serves traditional-meets-progressive Castilian cuisine and fresh local delicacies—such as chorizo sausage made from acorn-fed ham, and hearty *guisos* (stews) and *asados* (grills)—in a setting that reflects on its original purpose while welcoming world cosmopolites and connoisseurs. The terrace, El Patio de los Olivos, overlooks the Old City's cathedrals and the Dominican Gardens—allowing guests to contemplate the stunning location with a cocktail in hand—and the Turkish bath offers a rejuvenating respite should one need a moment of monastic headspace with a dash of contemporary indulgence. Hospes Palacio de San Esteban is also just a few steps from the neighborhood's main square amid many of the city's most awe-inspiring sights, such as the fiesta-frequented streets and architectural gems that earned Salamanca its World Heritage Site status. —

More from Hospes Infinite Places:

| WHERE | ROOMS |
|---|---|
| Salamanca Spain | 51 |
| **MEMBER SINCE** 03/2015 | **RATES** EUR 100–270 |

**ARCHITECTURE**
Fernando Población Íscar, Groupo Veintidós

**DESIGN**
Hospes Design Team

*Hospes Palacio de San Esteban*
*Salamanca, Spain*

# Hospes
# Puerta de Alcalá

Originally an affluent apartment house designed in 1883 by architect José María de Aguilar, the handsome red-brick Hospes Puerta de Alcalá with its wrought-iron balconies is an icon of Bourbon Restoration period architecture. Therefore, the Hospes Design Team needed to take special care that their modern additions were in harmony with the building's historic elements. Guests eager to experience the landmark in its original glory will be relieved that despite a dominant minimalist style, the original moldings, columns, wrought iron, and woodwork remain intact. The lobby's high ceiling and magnificently restored wooden door offer a grand welcome through the former carriage entrance. This gracious sense of hospitality extends throughout the hotel, where a tranquil, opulent ambience emanates through white marble and gold details offset by dark fine wood. The Bodyna Spa is ensconced in the former stables; the Independencia restaurant offers a formal dining room with an oak-coffered ceiling and stucco work—in contrast to the luminous interior patio, where guests can relax on comfortable sofas and listen to whispering water as they enjoy a drink at the hotel bar. Hospes Puerta de Alcalá's imaginative array of modern additions accentuates an overall sense of permanent privilege and eternal elegance. —

**WHERE**
Madrid
Spain

**MEMBER SINCE**
01/2008

**ARCHITECTURE**
José María de
Aguilar

**DESIGN**
Elvira Blanco,
(Elvira Blanco
Montenegro)

**ROOMS**
41

**RATES**
EUR 170–1,600

# Hotel
# Único Madrid

Leaving behind the bustle of Madrid's Golden Mile and entering the tranquil 19th-century palace which houses Hotel Único, you're immediately filled with a sense of peace. Behind the elegant white façade of the hotel, a majestic staircase, marble mosaic floors, high ceilings, and huge windows perfectly preserve the ambience of the former private patrician residence. Ideally positioned in Madrid's center, this indulgent city retreat is surrounded by boutique shops, museums, lush parks, and endless options for eating and drinking. The beating heart of Hotel Único is its tranquil garden, where guests come to relax and enjoy a drink after a busy day of shopping, sightseeing, or meetings. Alternatively, there's the option to enjoy a massage in the hotel's dedicated therapy room; train at the recently refurbished fitness center; browse the magazines, guidebooks, or city tips by the hotel in the well-stocked library; or sample complimentary marshmallows and chocolates (made by the hotel's own award-winning chef, Ramón Freixa) while watching a film. The hotel's restaurant Ramón Freixa Madrid has quickly become a "must" among Madrid's food buffs, having earned two Michelin stars and a reputation for fresh, avant-garde Mediterranean and Spanish food. Creative entrepreneur Pau Guardans oversaw the hotel's entire re-invention. The result is 44 ultra-comfortable guestrooms and exceptional hospitality for every guest, complemented by all of the five-star services of a luxury hotel. With two meeting rooms and space for 80 people in the garden, Hotel Único is well equipped to host all manner of events. Meanwhile, the spa-like bathrooms are stocked with sumptuous robes and hydro-massage jets in the showers. Here, nothing will stand between you and total relaxation. —

WHERE
Madrid
Spain

MEMBER SINCE
06/2011

ARCHITECTURE
Aurelio Rubio

DESIGN
Maria José Cabré

ROOMS
44

RATES
EUR 260–1,200

MEET THE ORIGINAL
Pau Guardans

# The Principal Madrid

WHERE
Madrid
Spain

MEMBER SINCE
11/2014

DESIGN
Pilar García-Nieto,
Luzio

ROOMS
76

RATES
EUR 220–1,200

MEET THE ORIGINAL
Pau Guardans

The empress of avenues in the Spanish capital, Gran Vía is lined with the city's finest Art Nouveau and Art Deco buildings. It is also possibly the most well situated street in Madrid, close to such well-loved places as Puerta del Sol, the Círculo de Bellas Artes, Cibeles, and Puerta de Alcalá, as well as renowned museums and parks. And now the street is home to one of Spain's most exciting hotels—The Principal Madrid. Housed in a 1917 Spanish Renaissance building, the hotel features interiors that celebrate the grand scale of this historic building with high ceilings, iron railings, large windows, and columns, while mixing in eclectic furniture that embodies a New York loft aesthetic. The Único Hotels design team, led by Pilar García-Nieto in collaboration with María José Gómez and Maximiliano Zigart from the Barcelona studio Luzio, are responsible for the luxuriously exclusive vibe that feels more like a private home than a hotel. Ático, spread over the top two floors, is a sublime sanctuary that's perfect for tea or delicious cocktails, for leisure or business, and where the gastronomy is overseen by the renowned chef Ramón Freixa. Gran Vía is famous for being home to great cocktail bars that are frequented by famous writers, artists, and celebrities. The year-round La Terraza garden conservatory, with a pool on the rooftop, is a rare inner-city perk. —

# Hotel Urban

Taking the notions of reason and passion as a source of inspiration, Derby Hotels Collection has created a hotel in the cultural center of Madrid that blends intimacy and community, function and fantasy, art and design. Hotel Urban brings new space to the cultural axis of the Spanish capital.

**WHERE**
Madrid
Spain

**MEMBER SINCE**
11/2003

**ARCHITECTURE**
Carles Bassó,
Mariano Martitegui

**DESIGN**
Jordi Clos (Derby
Hotels Collection
Design Team)

**ROOMS**
96

**RATES**
EUR 235–1,500

**MEET THE ORIGINALS**
Joaquim Clos,
Jordi Clos

# Hotel Miró

Stimulated by the nearby Museum of Fine Arts and the Guggenheim Museum, fashion designer Antonio Miró has turned this ten-story hotel into a place of rest with the sober, simple style that has made him a favorite on Barcelona's runways. Markina black marble and pale beige tones are the pleasant backdrop to designer furnishings and a private photography collection. Indulge in wellbeing treatments and the exclusive Courtesy Bar when you're feeling social or simply use your room as a cocoon—draw the curtains to open or enclose the space around you.

**WHERE**
Bilbao
Spain

**MEMBER SINCE**
01/2001

**ARCHITECTURE**
Carmen Abad
Ibáñez de Matauco

**DESIGN**
Antonio Miró,
Pilar Libano

**ROOMS**
50

**RATES**
EUR 85–342

# Seaside Palm Beach

Alberto Pinto's redesign of the classic 1970s Seaside Palm Beach is much more than the usual superimposition of a new identity on an old structure. Pinto clarified original design elements, creating an award-winning late-modernist statement that appeals to savvy world travelers and design aficionados alike. Located in an ancient palm grove, the Miami Beach-inspired façade curves into a flowing sense of interior and exterior space. Turquoise mosaic pools and public spaces in a muted palette enhance the primal experience of sun and shade. Bold Pucci-style patterns are reinterpreted in an array of textures, and materials such as chrome, mirrored glass, travertine, and marble add a touch of old-school elegance throughout. The 328 rooms offer guests a deliciously decadent slice of seaside glamour. Walls are bathed in warm tones while floors come alive in cool colors. The overall effect is less retro than contemporary, something that shows just how forward-looking the original design was. Guests can dive into fully indulgent modernity in an extensive state-of-the-art wellness and spa area, where guests are offered a wide range of massage treatments, Thalasso and aromatherapy, oriental Rasul baths, and other specialty spa packages. —

| | |
|---|---|
| WHERE | ROOMS |
| Gran Canaria | 328 |
| Spain | |
| | RATES |
| MEMBER SINCE | EUR 225–1,345 |
| 09/2002 | |
| | MEET THE ORIGINAL |
| DESIGN | Theo Gerlach |
| Alberto Pinto | |

# Bohemia Suites & Spa

**WHERE**
Gran Canaria
Spain

**MEMBER SINCE**
10/2010

**ROOMS**
67

**RATES**
EUR 200–1,060

**MEET THE ORIGINALS**
Imen Euling,
Rembert Euling

The Bohemia Suites & Spa is a sophisticated oasis surrounded by the volcanic beauty of Gran Canaria. Combining luxury with tropical gardens and beautiful landscapes, the hotel offers a secluded setting for guests to indulge themselves in total peace and privacy. At this unique hotel, guests find themselves immersed in any one of its multiple surroundings, such as the Siam Spa with the best Thai massages in Mandala-inspired marquees and rooms; or the mesmerizing 360° restaurant and lounge, on the top floor, with breathtaking panoramic views over the Atlantic Ocean, the Dunes of Maspalomas, and the mountains. Beyond all of this beauty, it is the Bohemia Suites & Spa team who makes this hotel unique. The vitality and attention of the team ensures a special experience for every guest, as if they were staying with friends. By reducing the hotel rooms from 115 to 67, owners Rembert and Imen Euling have been able to create secluded living spaces that stretch effortlessly from inside to outside. Rich mahogany floors, native olive-wood furnishings, and shades of yellow, purple, and terracotta harmonize with the natural environment, rooting guests firmly in the heart of this sun-scorched volcanic island. —

# Memmo Alfama

The circuitous, narrow streets of the picturesque Alfama district brim with the sights and sounds of old-world Lisbon. Here, visitors will find traditional shops and classic restaurants along roads lined with gently weathered colored houses, between which lines laden with linens slightly sway in the breeze. This is Lisbon's historic heart—steeped in ancient traditions and steps away from the Cathedral and Sao Jorge Castle. As you round the corner onto Travessa das Merceeiras, a slight urban intervention meanders into view. In perfect harmony with the traditional houses that surround it stands a mural by the young Portuguese street artist Alexandre Farto (aka Vhils): a relief of a former resident's face marks the façade of a building that otherwise blends into its surroundings. Behind this wall lies the Memmo Alfama. Upon entering, a cozy living room greets guests in lieu of a traditional front desk and they can check in from anywhere in this adults-only hotel. Memmo Alfama's laid-back ambience implores its visitors to feel at home, welcoming them not only to borrow a book from the living room library or grab a fresh snack or slice of homemade cake from the 24-hour loyalty fridge, but also to integrate themselves into the vibrant culture of the Alfama district and the city of Lisbon. Memmo Alfama has dedicated an intimate area of the hotel to its signature Lisbon Story, which provides guests with all the relevant information they need to navigate this rich and dynamic city, and Living Alfama, an inventive approach to local integration, pairs staff suggestions for neighborhood delights with inside tips from locals themselves. Memmo Alfama offers countless avenues to take in the allure of Lisbon from the authentic Portuguese gastronomy and wines in the wine bar to the stunning terrace, bar, and pool, which offers a sublime vantage point to take in the sights and sounds of the city and the Tagus River.

Rodrigo Machaz is as comfortable with his surfboard tucked under his arm as he is walking the corridors of his hotel, Memmo Baleeira, situated in Sagres on the southernmost tip of Portugal. His hotel staff is family—local ambassadors for the region—and his guests are friends. A born and bred hotelier, Machaz returned to the location of his childhood summer holidays to reinvent the town's former Hotel da Baleeira, maximizing the foundation's spectacular sea views and the abundance of natural sunlight. For Machaz, business is all about focusing on what is beautiful. Machaz's talent for highlighting what is beautiful and distinctive about a place also distinguishes his second venture—Memmo Alfama. Here, Machaz has curated an exceptional blend of local cusine, design, history, and culture for his guests from tips on where to hear Fado to the selection of fine Portuguese wines on the hotel's rooftop bar. —

Rodrigo Machaz

WHERE
Lisbon
Portugal

MEMBER SINCE
12/2012

ARCHITECTURE / DESIGN
Samuel Torres de
Carvalho (Memmo
Design Team)

ROOMS
42

RATES
EUR 140–400

MEET THE ORIGINAL
Rodrigo Machaz

More from Memmo Hotels:

PORTUGAL
Sagres, Memmo Baleeira → P. 302

# Hotel Teatro

In the center of the beautiful and historic Portuguese city of Porto, declared a UNESCO World Heritage Site, Hotel Teatro is an elegant innovation set in shades of bronze and gold. Drawing connections to the former site of the revered 1859 Teatro Baquet, which was destroyed by a fire in 1888, the internationally celebrated designer Nini Andrade Silva reflects the spirit of the hotel's theatrical and spectacular roots, while conveying an ultimately stylish and contemporary urbanity.

**WHERE**
Porto
Portugal

**MEMBER SINCE**
03/2010

**ARCHITECTURE**
Eduardo Miguel
Brito Nogueira
(NN Arquitetura
e Planeamento)

**DESIGN**
Nini Andrade Silva

**ROOMS**
74

**RATES**
EUR 94–321

**MEET THE ORIGINAL**
Nini Andrade Silva

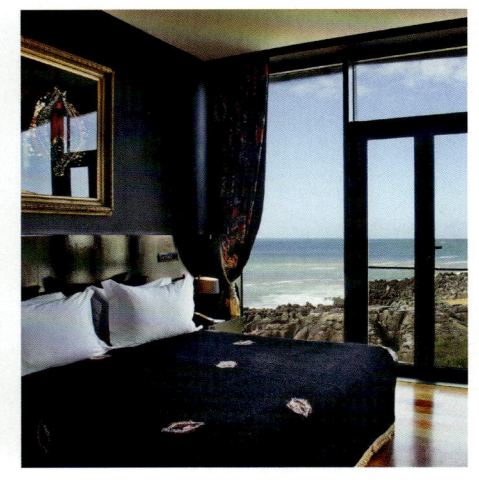

# Farol Design Hotel

This luxurious seaside retreat on the beautiful Portuguese Riviera is nestled between the powdered sands of Guincho beach and the picturesque fishing village of Cascais. Guestrooms in this modern transformation of the Count of Cabral's 19th-century mansion were "dressed" by Portugal's fashion elite. The excellent culinary offerings include sensational Mediterranean signature cuisine as well as the mind-blowing Sushi Design, creating an unforgettable sensorial experience with an enviable ocean view. The bliss of the saltwater swimming pool and a delightful cocktail at sunset provide a magical rest by the Atlantic.

**WHERE**
Cascais
Portugal

**MEMBER SINCE**
08/2001

**ARCHITECTURE**
Carlos Miguel Dias

**DESIGN**
Filosofia do Espaço

**ROOMS**
33

**RATES**
EUR 156–608

**MEET THE ORIGINAL**
Mark Leivikov

# Vila Monte

WHERE
Moncarapacho
Algarve
Portugal

MEMBER SINCE
12/2015

ARCHITECTURE
Jorge Guimarães

DESIGN
Teresa Barão,
Vera Iachia

ROOMS
55

RATES
EUR 247–823

MEET THE ORIGINAL
Miguel Guedes
De Sousa

Vila Monte's vision of luxury is expansive, and not just because the property spans over nine hectares of orange and olive groves, gardens, and ponds. Situated in Moncarapacho—in Portugal's Olhão municipality—the farmhouse-style property offers two swimming pools and a tennis court, and its 55 rooms and suites are shared among four cool white buildings that dot the verdant landscape. In keeping with the traditional design and architecture of the Algarve, while adding a dash of the contemporary, Vila Monte is characterized by whitewashed walls, natural woods, and terraces, that combine to create bright, airy spaces such as the soaring lobby complete with chimney centerpiece. While the elegant interiors by Vera Iachia—noted for working with Andy Warhol and Jacques

Grange—are enough to make guests want to stay indoors and luxuriate, the diverse activities on offer will tempt guests to set out and explore, with fishing in the Ria Formosa, seafood tasting, boat trips, and desert island sunbathing on the agenda. A trip to the Olhão market with the hotel chef is a highlight, allowing guests to witness the care and passion that goes into the strictly traditional cuisine served at the À Terra restaurant, which sticks to wood oven and Josper grill cooking methods. When the weather agrees, guests are invited to wind down in front of a movie in the great outdoors or discover the Algarve's natural beauty on foot. —

# Praia Verde Boutique Hotel

**WHERE**
Castro Marim
Portugal

**MEMBER SINCE**
04/2014

**ARCHITECTURE**
Miguel Saraiva

**DESIGN**
Pureza Magalhães
(Pureza
Decorações)

**ROOMS**
65

**RATES**
EUR 120–300

**MEET THE ORIGINAL**
Miguel Guedes
de Sousa

On the tip of southernmost Portugal, where an expansive pine forest meets the deep blue of the Atlantic, one discovers the Praia Verde Boutique Hotel. Located in the untouched eastern part of the Algarve, the area is known for white sandy beaches as far as the eye can see, its salt flats, and the natural park of Ria Formosa. The 65 expansive rooms and suites at the Praia Verde, meanwhile, offer uninterrupted views of the beautiful sea and landscape. The hotel's 40 suites come equipped with a separate living room and a kitchenette. The restaurant, À Terra, serves delicious homey country food made with fresh seasonal ingredients. Inspired by Mediterranean gastronomy, the food is presented family-style for a table to share and is ever flowing. The pool bar, with a wooden terrace under a canopy of green, is another place to relax and soak in the surroundings over light meals and chilled cocktails. Praia Verde's commitment to all-things-local extends beyond its kitchen to a grocery store where salt from the region is available along with wines and more. —

# Pedras Salgadas
# Spa & Nature Park

**WHERE**
Bornes de Aguiar
Portugal

**MEMBER SINCE**
12/2013

**ARCHITECTURE /
DESIGN**
Luís Rebelo
de Andrade
(Rebelo de
Andrade Studio)

**ROOMS**
15

**RATES**
EUR 140–320

**MEET THE ORIGINAL**
Rui Lopes Ferreira

In the municipality of Vila Pouca de Aguiar, Pedras Salgadas Spa & Nature Park perfectly demonstrates how innovative, sustainable architecture can wrap itself around a centuries-old park. Scattered throughout are 12 modular ecohouses, two tree-houses, and one cottage, designed by architect Luís Rebelo de Andrade, that flawlessly blend in with the lush environment, conspicuous only for their pitched roofs. Three identical prefabrication modules allowed the construction of each house to fit into its environment yet retain its individual feel. The interiors create a true sense of serenity. Here, clean lines, natural light, and a neutral palette are all emblematic of a look the designers masterfully strived for.

Matching the simplicity of their modular setups, the eco-houses are notable for their unadorned living spaces: The white-on-white interiors are only occasionally interrupted by the appearance of wooden flooring and furniture, or a natural-colored textile. Here, nature is literally a step away, with all eco-houses featuring outdoor decks and vast floor-to ceiling windows in unexpected corners. Central to the hotel is a 19th-century thermal spa renovated by Pritzker Prize winner Álvaro Siza Vieira. Encompassing a pool, hammam, sauna, and Vichy shower, the spa takes full advantage of Pedras Salgadas' historic mineral water springs and their reputed health benefits. —

# Memmo Baleeira

With its comfortable, minimalist design, Rodrigo Machaz's 144-room hotel and spa on Portugal's Sagres peninsula meets the needs of travelers in search of individual or family-friendly recreation and relaxation. An extensive and well-equipped business area ensures that work can certainly be mixed with pleasure. Memmo Baleeira is a way of life. Here, guests' slates are wiped clean in order to be filled with local flavors and memories to last a lifetime.

WHERE
Sagres
Portugal

MEMBER SINCE
06/2008

ARCHITECTURE
PPST Arquitectos

DESIGN
Memmo Design
Team

ROOMS
144

RATES
EUR 80–400

MEET THE ORIGINAL
Rodrigo Machaz

# Design & Wine Hotel

Perched on the banks of the Minho Estuary in Caminha, a historic port town on the Spanish border, Design & Wine Hotel is an ecologically sustainable hide-away that blends local heritage, art, technology, and distinctive regional wines. The hotel's architecture is a striking mix of old and new, housed in a refurbished 18th-century manor and a rotating, solar-powered steel structure that offers everchanging views of the River. Each of the hotel's rooms and suites features a design concept influenced by a painting, street art, fashion, or graphic design.

WHERE
Caminha
Portugal

MEMBER SINCE
03/2012

ARCHITECTURE
Pedro Guimarães

DESIGN
Feedback Studio

ROOMS
23

RATES
EUR 80–200

MEET THE ORIGINAL
José Carlos Pereira

# Estalagem
# da Ponta do Sol

WHERE
Madeira
Portugal

MEMBER SINCE
08/2001

ARCHITECTURE
Tiago Oliveira

DESIGN
Carvalho Araújo

ROOMS
54

RATES
EUR 90–132

MEET THE ORIGINAL
André Diogo

This stark white getaway is all simplicity and straight edges, framing the raw magnificence of its clifftop setting high above the Portuguese village of Ponta do Sol. Layering itself down a slate cliff, the hotel is cut into the rocky landscape in a series of thick stone wall terraces. Here, walkways let visitors explore the meticulously manicured grounds and drink in the endless blue of the breathtaking ocean views—which they can also enjoy from private balconies. Inside, interior designer Carvalho Araújo created a monochrome look using white walls adorned with classic black-and-white photography, black stone floors strewn with gray rugs, and minimalist furnishings in light wood. Outside, the swimming pool's infinity edge makes the vast Atlantic seem just a dive away. The restaurant is completely stripped of any superfluous decor, emphasizing the vista across the coastline of Madeira, extensive banana plantations, and the village below. It all adds up to an utterly relaxing retreat in a sophisticated atmosphere … perfect for couples looking to connect, singles looking to recharge, or anyone looking for all-round beauty. —

# Furnas Boutique Hotel, Thermal & Spa

"I love all things gastronomic. I love to visit places where things originate. I go to Italy to see the white truffles. I go to Galicia, Spain, to see the best cows for T-bone steak. I travel the world to taste many wines."

If the author of this quote, Miguel Guedes de Sousa, sounds like someone you'd like to travel with, then you are in luck. As the CEO of DHM—Discovery Hotel Management, Guedes de Sousa is the heart and soul behind the stunning new Furnas Boutique Hotel, Thermal & Spa in the Azores archipelago off the coast of Portugal. Which means his spirit for adventure and his quest for original experiences translates into the adventures and experiences that his guests have.

And the hotel's setting couldn't be more advantageous for experiencing the unique. The Azores archipelago, in the middle of the Atlantic Ocean, is one of the last truly untouched places in Europe, with nine pristine volcanic islands, vast verdant canopies featuring every type of flora and fauna imaginable, thermal water springs, lagoons, and prismatic marine life. And here on São Miguel, the largest and lushest of these islands, one finds Furnas, which serves as both a gateway to the island's many wonders and a reinvigorating retreat.

And wondrous it is. São Miguel—or, as locals have coined it, "The Green Island"—offers stunning hiking and mountain biking, as well as whale watching tours for the aquatically inclined. Nearby Furnas Lagoon and Poca da Dona Beija hot springs boast the region's most sought-after attractions: warm waters and vapors said to hold healing properties.

Indeed, you might just say that the healing is in the air here. Before Furnas Boutique Hotel, Thermal & Spa came to be, it was a thermal center. Today, this salubrious spirit lives on at the hotel with its luxurious on-site thermal circuit spa, complete with sauna, hammam, outdoor and indoor swimming pool, and deliciously relaxing treatments.

Restoring the old thermal center of the Furnas municipality and expanding it for the hotel was a challenging task that Saraiva + Associados, one of the world's largest architectural practices, was thrilled to have. The simple but arresting solution was to add a neutral metal structure in anthracite gray to the existing edifice and then fill it in with glass panels, thereby maintaining the building's original character and providing the glorious scenery outside center stage. The natural heritage of São Miguel is reflected in the materials chosen for the project, such as basalt stone on the exterior walls and interior flooring.

Miguel Guedes de Sousa

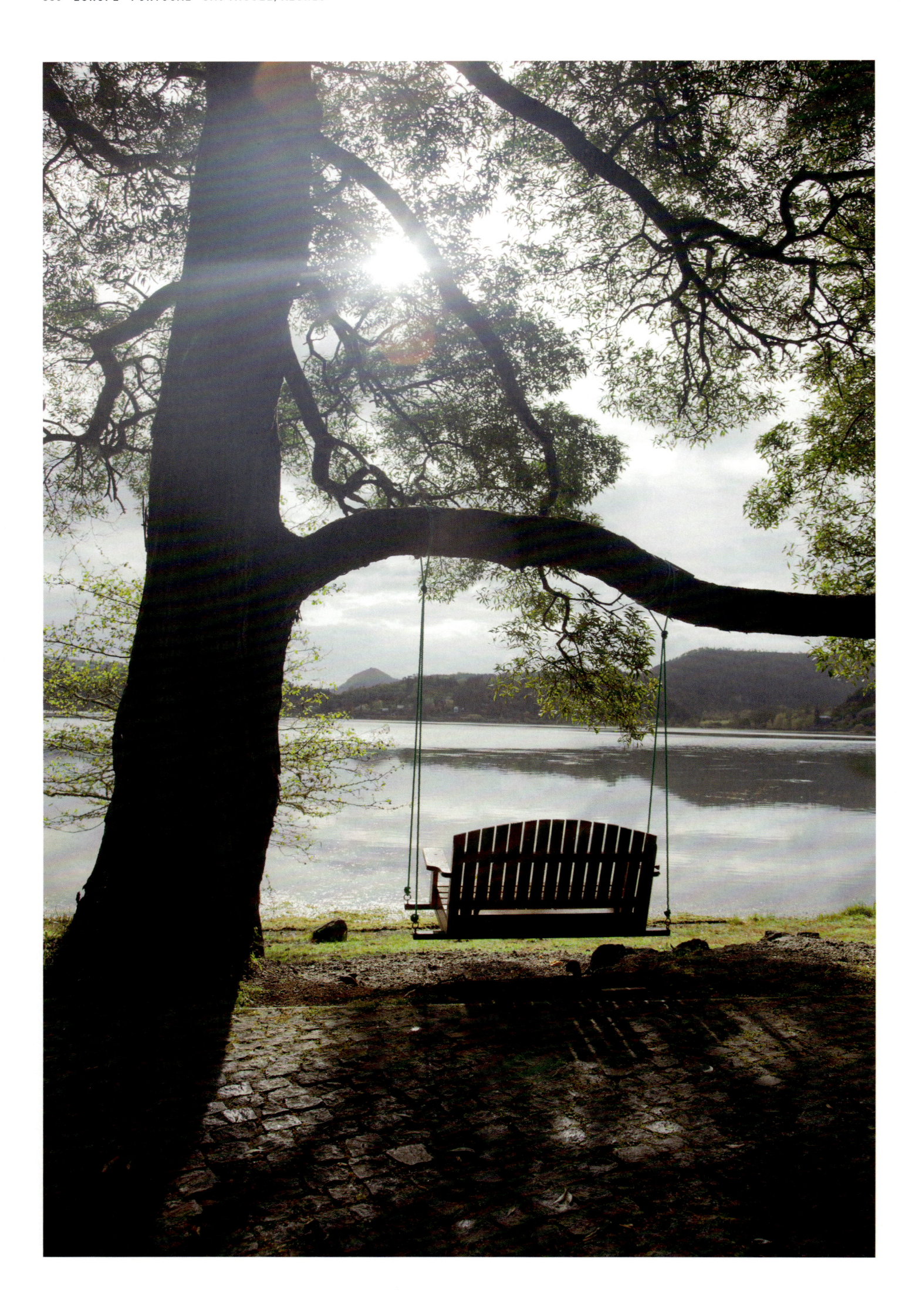

Celebrated Portuguese designer Nini Andrade Silva, meanwhile, works her magic in the hotel's nature-inspired interiors with whimsical touches, such as huge photographs used as wallpaper that create dramatic realism and echo the region's natural bounty. The lobby market is the soul of the hotel with a reception, lounge, restaurant, and grocery store featuring local products. And in the À Terra restaurant, large communal tables perfectly capture the social concept here of food sharing.

And at Furnas, social is key. There is as much a sense of friendship as there is hospitality. Perhaps Guedes de Sousa's attitude sums up that feeling best. "I receive guests in my hotels in the same way as I receive friends into my house," he says. "We think of our guests as family. For example, in our hotels breakfast never closes. We serve what you want any time you want it." Or put another way, at Furnas Boutique Hotel, Thermal & Spa the spirit of adventure, wellness, and welcome lives on. —

More from DHM - Discovery Hotel Management:

PORTUGAL
Castro Marim, Praia Verde Boutique Hotel → P. 300
Moncarapacho, Algarve, Vila Monte → P. 299

# Straf

The Straf began its life as a 19th-century palazzo a few steps from Milan's Duomo cathedral and La Scala opera house before it spent years as a "normal" hotel. Now the hotel has become a mesmerizing monument to the deconstructivist design aesthetic of Milanese architect/artist/fashion designer Vincenzo de Cotiis. With bare cement floors and stairs, rooms featuring oxidized brass and split slate, scratched mirrors, burnished iron, and torn, aged gauze captured between sheets of glass, de Cotiis summons an atmosphere of warmth and well-being from scrappy, hard-edged materials. The 64 guestrooms come in either a light or dark color palette and exude intimacy despite (or perhaps because of) the hints of industrial design. Guests can bask under color-therapy light panels in some rooms; all offer tactile pleasures in fine textiles, decadent bathrooms, and mirrored surfaces. Public areas offer slightly unfinished odes to fashion and relaxation: A reading area invites guests to a couch formation in a glass-roofed courtyard, and the slick Straf Bar has become a magnet for fashion mavens from around the world. "The hotel is almost like an installation," says de Cotiis. An experience here is indeed nothing less than artistry.

Since 1969, Daniela Bertazzoni, daughter of hotel giant Manlio Bertazzoni, has been managing with great passion her father's Grand Hotel et de Milan, the downtown home of high society since 1863. More recently, she has involved her daughter, Sarah Mancino, in the family business to help run Straf, an ultra-modern Milanese hotel opened in 2004. For mother and daughter, passion is a key element that quickly turns into a deep dedication to an unconventional property. What the pair has learned most from experience, another vital element behind extraordinary hotels, is a genuine approach to managing that comes with a mix of familial instincts and a strong feminine intuition. —

**WHERE**
Milan
Italy

**MEMBER SINCE**
09/2003

**ARCHITECTURE /
DESIGN**
Vincenzo de Cotiis

**ROOMS**
64

**RATES**
EUR 200–1,109

**MEET THE ORIGINALS**
Daniela Bertazzoni,
Sarah Mancino

# Filario
# Hotel & Residences

It takes many things to open a hotel on the shores of Lake Como. An understanding for this Italian region's grand history and its stunning natural beauty are critical. But even more, one has to have patience—a lot of patience. A rigorous permit process meant to safeguard that history and beauty meant that the Filario Hotel & Residences, which is perched directly on the lake, took more than 10 years to go from an idea to a finished product.

And what a product! Filario offers generous spaces where one can unwind and take in this stunning location. The hotel carefully blends into its surroundings while showcasing them at the same time thanks to terraces in each of the guestrooms and apartments that offer up glorious lake views. Filario also has its own private beach and an infinity pool that stretches deep into the glimmering blue of the wishbone-shaped lake. The hotel bistro, meanwhile, offers the best the region has to offer—authentic, fresh Italian dishes and wine.

While Filario is firmly rooted in Italian heritage and craftsmanship, its modern aesthetic and amenities cater to young, discerning travelers. The building, once the site of a small wire factory, incorporates local stone typical of the Lombardy region to ensure that the façade blends nicely into the mountainside that serves as its backdrop. Given limited lakefront space, the wise decision was made here to create fewer and thus larger rooms, and each offers stunning views of Bellagio, Villa Balbianello, and Comacina Island.

Crafted by famed Italian designer Alessandro Agrati, the rooms are a study in natural, subtle elegance. Agrati has implemented his signature style of "dressing" interiors with textiles, light, and strong-tempered objects. Italian heritage and artisanship are also a strong focal point at the hotel, which is why its furniture was created by local craftsmen in the neighboring town of Cantù, a world-class hub for high-end Italian design.

Naturally then, once you step inside Filario, it's easy to forget about the years of patience and the respect for local history that brought it to life. But, "One must really credit Nessi & Majocchi," says Alessandro Sironi, the general manager at Filario Hotel & Residences. "They are local developers from Como and it was their dedication and patience that brought the hotel about. Their company has been here for almost a century and built many of the constructions that shape modern Como."

For Sironi, as for his guests, the wait has been well worth it. "Here, hospitality is very traditional, especially in Italy where things are family run," he notes. "We don't have many of the new boutique contemporary hotels. And yet guests who come here are looking for something contemporary, modern, fresh. There was nothing like that in Lake Como."

Until Filario came along, that is. "Our property is very simple. As is the color scheme. The stone and wood are all local materials. And the balconies are all glass and crystal, so they connect you to the lake and you think you are part of the water. Taken together, they make the place serene and peaceful." Or put another way, they make Filario Hotel & Residences well worth the wait. —

WHERE
Lezzeno
Lake Como
Italy

MEMBER SINCE
03/2015

ARCHITECTURE
Nessi & Majocchi

DESIGN
Alessandro Agrati

ROOMS
21

RATES
EUR 340–650

MEET THE ORIGINAL
Alessandro Sironi

Alessandro Sironi

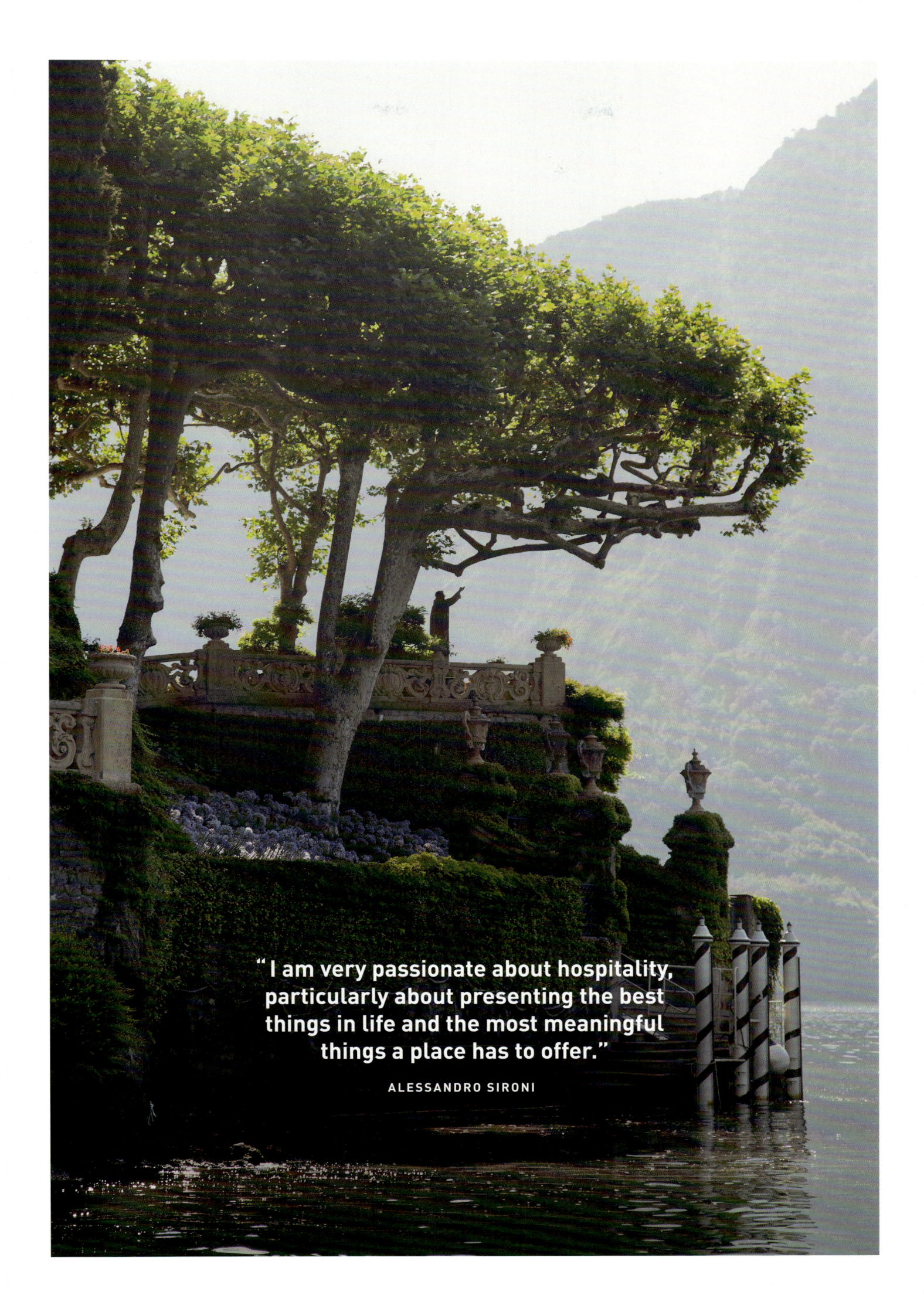

"I am very passionate about hospitality, particularly about presenting the best things in life and the most meaningful things a place has to offer."

ALESSANDRO SIRONI

# C-Hotel & Spa

Stepping into the stone-clad lobby of C-Hotel & Spa, around 20 kilometers from the shores of Lake Como, you know you're in for a sensory experience. First, you'll be hit by the warm, chocolaty smell of freshly ground coffee beans, which lures you deeper into the building. Then, you'll notice the stretched teak reception desk sandwiched between a bustling Italian bar and a family-run confectionary shop that's been baking mouthwatering delicacies on this site for more than 30 years. Although the shop has been completely rebuilt as a minimalist enoteca, complete with a wine cellar that fuels legendary tasting sessions, the locals still love it. At Materia Prima Restaurant, Chef Fabrizio Colzani creates fine Italian cuisine, using fresh regional ingredients from nearby farms. The hotel also boasts a concept store, C-Colzani, and the award-winning C-Caffè. Andrea Colzani, the young entrepreneur who built C-Hotel & Spa around his family's existing businesses, hasn't relied on former glories. Instead, he has used his self-taught architectural skills to create a forward-thinking minimalist retreat among the hills of the Lake Como region. By cleverly threading locally quarried limestone through the naturally lit hallways of the glass-fronted building, he's created a blank canvas for artists to enliven during the exhibitions that are often held here. And as if to make the building immune to the effects of time, all 18 suites have been stripped back to a functional minimum. —

WHERE
Cassago Brianza
Italy

MEMBER SINCE
11/2010

ARCHITECTURE
Andrea Colzani,
Emilio Trabella

DESIGN
Andrea Colzani,
Mario Nanni

ROOMS
18

RATES
EUR 155–455

MEET THE ORIGINAL
Andrea Colzani

# GombitHotel

Situated at the intersection of two ancient Roman roads in the charming Città Alta of Bergamo, a medieval walled city close to both the Alps and Milan, the GombitHotel has turned a historic crossroads into contemporary luxury. The hotel is adjoined by a monumental 13th-century watchtower that rises above the old town's clustered rooftops. "The entire historical building comes back to live a new life in the service of art, and therefore of continuity," according to owner and Bergamo native Nadia Galeotti. Having chosen this symbolic address as a physical link to the city's remarkable past, Galeotti envisions the hotel as a setting for creative exchange, a platform for local artists, and, above all, a space for cultural discovery. The GombitHotel's interiors lighten the austerity of its stonewall aesthetic with hints of surreal artistry. Bright red books adorn the ceiling leading to the library nook, while sculptures, such as bundles of rolled manuscripts, are nestled within the ancient walls' crevices. Original wooden ceilings aged hundreds of years create a monastic ambience that interior designer Giò Pozzi complemented with her choice of textiles, primarily handmade lightweight linens in unostentatious earth tones. With 13 distinctive guestrooms and a daily regional breakfast, the GombitHotel is an intimate sanctuary that promises an exceptional experience in hospitality: It is an enchanting point of departure for cultural and epicurean exploration, bridging the ancient and the contemporary. —

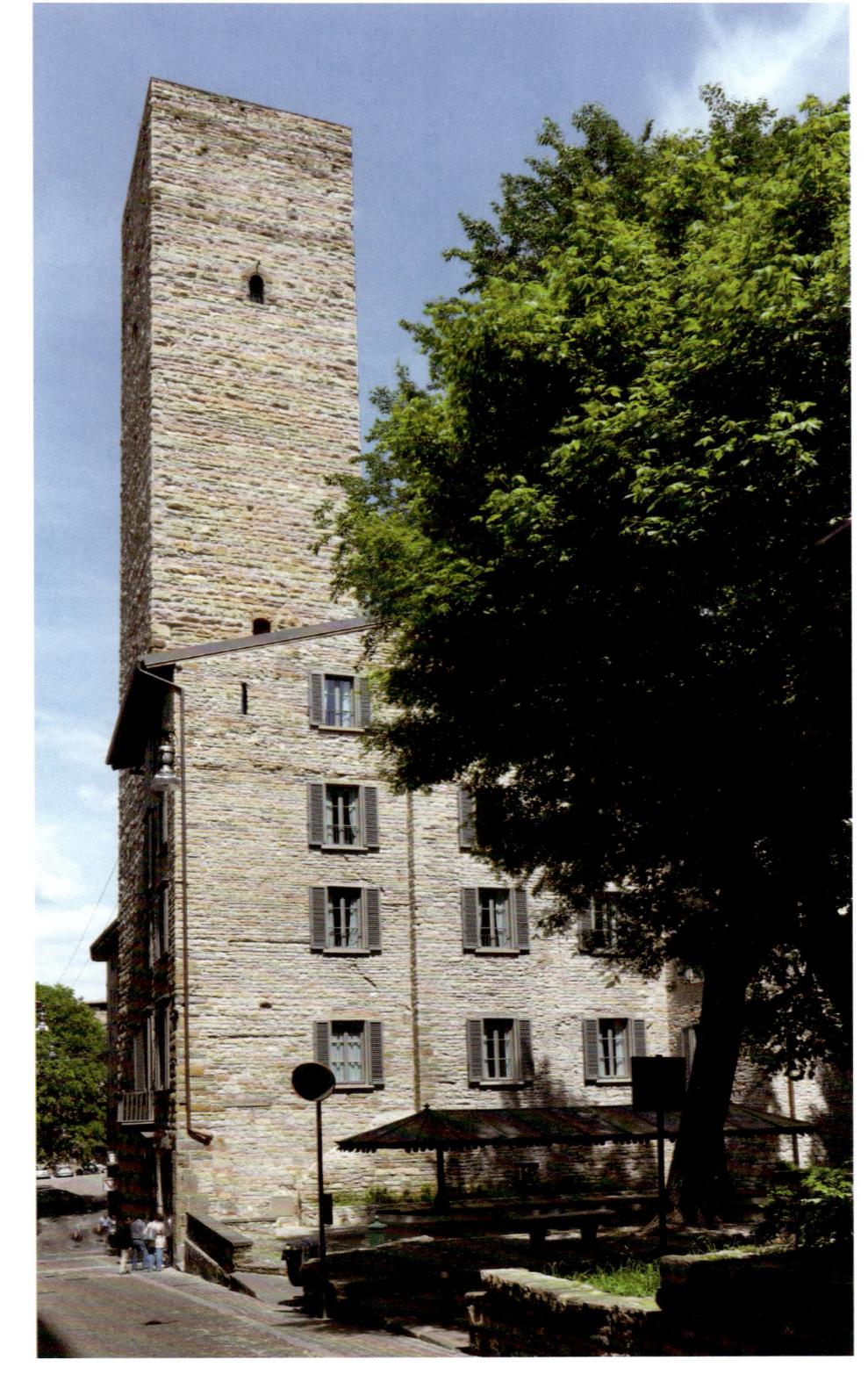

WHERE
Bergamo
Italy

MEMBER SINCE
06/2010

ARCHITECTURE
Dedalo Srl

DESIGN
Giò Pozzi

ROOMS
13

RATES
EUR 160–450

MEET THE ORIGINAL
Nadia Galeotti

# Hotel Greif

**WHERE**
Bolzano
Italy

**MEMBER SINCE**
12/2002

**ARCHITECTURE /
DESIGN**
Boris Podrecca
(Studio Boris
Podrecca)

**ROOMS**
33

**RATES**
EUR 130–420

**MEET THE ORIGINAL**
Franz Staffler

The family-owned Hotel Greif exudes a rare mixture of honored tradition, modernity, and passionate creativity. Perched at the base of Italy's epic Dolomite mountain range, now a UNESCO World Heritage Site, South Tyrol's Bolzano blends Austrian and Italian cultures, resulting in a charming Alpine lifestyle. Owner Franz Staffler elegantly redesigned the centuries-old guesthouse with lauded Viennese architect Boris Podrecca. The new design carefully preserved much of the original structure's integrity. Spaces were then sparingly appointed with antique furniture from the original hotel and custom-designed pieces built from local maple or knotted walnut. Each of the 33 rooms has a very special touch: some feature terrace views of the Dolomites or bay windows looking onto Bolzano's ancient square, while others boast steam saunas or marble whirlpool baths. Gracious details such as custom-made textiles, raw silk curtains, and dark brown African Wenge wood floors topped with Persian carpets elicit an air of refined comfort. Staffler commissioned local artists—painters, sculptors, photographers, and installation artists—to create unique artwork for each of the Hotel Greif's suites, making the hotel a focal point of local creative activity. Its bar, Grifoncino, lures guests and locals with its clever lighting, projections, and signature cocktails. —

# Eden Hotel

For thousands of years, Bormio has been a vacation hot spot—literally. Ancient Roman aristocrats flocked to the Italian mountain town's thermal spas for relaxation and rejuvenation. Today, people travel to Bormio to ski, skate, shop, dine, and explore … and then visit those same spas, soaking in the history as well as the natural beauty of the Valtellina Valley and the Italian Alps. Even with its illustrious past, the town still has room for something new: Eden Hotel, a stylish and elegant destination that works in concert with its mountain setting, conceived and executed by Antonio Citterio Patricia Viel and Partners. Together, the hotel's four buildings and enclosing chestnut fence form a graceful single structure that harmonizes with its environment. The buildings are connected with staircases and transparent catwalks to give visitors the best possible access to Bormio's panoramic mountain views. Wood, glass, and stone come together in simple shapes, embedded in the gentle slope of the mountains, blending with the colors and features of the landscape. Further emphasizing this dialogue with nature is the lush, sustainable garden surrounding the hotel—it's nearly as enchanting as the one that gives Eden its name. Altogether, Eden. —

WHERE
Bormio
Italy

MEMBER SINCE
10/2012

ARCHITECTURE /
DESIGN
Antonio Citterio,
Patricia Viel
(Studio Antonio
Citterio Patricia
Viel & Partners)

ROOMS
27

RATES
EUR 150–700

MEET THE ORIGINAL
Antonio Citterio

# Matteo

## THUN

ITALY MAY HAVE PRODUCED THIS PROLIFIC ARCHITECT AND
DESIGNER, BUT IT CERTAINLY COULDN'T CONTAIN HIM.
TODAY, HIS HOLISTIC APPROACH AND INNATE BRILLIANCE FOR
CONVERTING SIMPLE FORMS INTO WORKS OF ART MEAN
AN INFLUENCE THAT SPANS THE GLOBE.

*"Geographical, geological, meteorological, historical, and cultural characteristics—the whole context of a project—need to be taken into account to create a building or interior design scheme that respects the genius loci, the soul of the place."*

MATTEO THUN

It's rare that one encounters a modern-day Renaissance Man, yet Matteo Thun proves that they most certainly do exist. The multi-award-winning architect and designer has spread his talents across a remarkably diverse range of projects, from hotels and restaurants to bathrooms, kitchens, furniture, lighting, ceramics, glassware, and watches, working with top manufacturers and gaining numerous accolades along the way, including the prestigious Compasso d'Oro. Yet his prolific and varied portfolio is united by a common thread: a thorough understanding of materials and technologies, an ability to simplify forms and functionality, and a deeply held belief in the importance of sustainability.

Looking at Thun's recent designs, it's a surprise to realize that their eloquent simplicity comes from a man so closely connected to the Memphis Group—the colorfully daring movement that defined Italian design during the 1980s. Having gained an architecture degree in Florence in 1975, Thun moved to Milan and co-founded Memphis with Ettore Sottsass, becoming a partner at Sottsass Associati from 1980 until he founded his own studio in 1984. Collaborations with key manufacturers followed, including Artemide, Driade, Flos, Campari, Bulgari, Zwilling, Illy, Philips Electronics, Porsche Design, Swarovski, Villeroy & Boch, Zucchetti, and many others. Yet the broad scope of Thun's activities doesn't end there. From 1983 to 2000 he held the chair of Product Design and Ceramics at the University of Applied Arts in Vienna and was creative director at Swatch between 1990 and 1993.

With so many projects running concurrently, Thun's company is now streamlined into several divisions. MTLC—run by Thun and Luca Colombo—focuses on architectural and interior design projects in Italy, with an

emphasis on hotel work. MTD-R—an acronym for Matteo Thun Design Rodriguez—is a product design team led by Thun and Antonio Rodriguez. A Shanghai-based office, MTD-R China, which opened in June 2015, handles architecture, interior design, exhibition styling, and product design. Its team of architects and designers are native Chinese speakers trained in Milan who ensure that projects developed in Italy's design capital are correctly carried out in Asia. Atelier Matteo Thun—the most recent division—focuses on handcrafted furniture and lighting, presenting its initial series of limited edition glass and ceramics during Milan's Salone Internazionale del Mobile in 2015.

It all adds up to a huge responsibility whose cohesion relies on Thun's holistic approach. "Buildings need interiors, interiors need products, products need designers, manufacturers, and users," he notes. His passionate belief in sustainability runs through every project, with energy efficiency, noise-reduction, and environmentally friendly materials as defining characteristics. "Our architectural and interior design projects follow the principles of sustainability through the three zeros—zero $CO_2$, zero kilometers (for transportation of materials), and zero waste," he explains.

Thun's hotel projects offer clear evidence of this approach. Take Vigilius Mountain Resort in South Tyrol, which won *Wallpaper\** magazine's Design Award 2004. This eco-friendly retreat is accessible only by cable car, offering inspirational views of the surrounding Dolomites. Using natural larch wood throughout—as well as a grass-covered roof—the hotel's architecture blends seamlessly with the landscape. The 41 guestrooms face either east or west, offering uninterrupted views of the sunset or sunrise. Internally

## SIDE NOTES

**NAME** *Matteo Thun*

**COMPANY NAME** *Matteo Thun & Partners; MTLC; MTD-R; MTD-R China; Matteo Thun Atelier*

**COMPANY HEADQUARTERS** *Milan*

**NUMBER OF PEOPLE IN COMPANY** *60*

**WEBSITE** *matteothun.com*

**SIGNATURE PROJECTS** *Hamburg: Side hotel South Tyrol, Italy: Vigilius Mountain Resort Milan: Tortona 37 Multi-Purpose Complex Coldrerio, Switzerland: Hugo Boss Business Unit Worldwide: Vapiano restaurants (interiors)*

## SIGNIFICANT AWARDS

**2015** *Red Dot Award for Axent "One"*

**2014** *Good Design Award for Antrax "Serie T" radiator shelves and towel rails*

**2010** *Green Good Design Award for Rapsel "Ofurò" bathtub; Belux "Arba" lighting; Biomass Power Station, Schwendi*

**2010** *Wallpaper\* Design Award for TVS "Terra" cookware*

**2006** *Red Dot Award for Porsche Design Store*

**2004** *Compasso d'Oro award for Catalano "Girly System"*

*At Vigilius Mountain Resort, in South Tyrol, Thun beautifully united muted browns and dark tones with a world of box-shaped elements.*

1

heated clay walls in each room are highly energy efficient, while warm colors and natural materials foster a soothing ambience. It's an exemplary demonstration of sensitivity to the environment.

Even with city-center projects, Thun maintains the same principles. The public spaces in Hamburg's urban-chic Side hotel are characterized by voluptuously rounded furniture and a warm orange/yellow palette, while a dramatically dark bar is offset by a calm oasis of creamy, buttery tones in each guestroom. "Geographical, geological, meteorological, historical, and cultural characteristics—the whole context of a project—need to be taken into account to create a building or interior design scheme that respects the genius loci, the soul of the place," Thun says. "Only by respecting this can you create a building of long-lasting aesthetic value.

Sustainability also guides my choice of construction materials; I prefer local materials that help limit $CO_2$ emissions in transportation."

A similar approach is taken with products, furniture, lighting, and interior fittings. "Product design starts from simplification and reduction to the essential, striving towards an iconic form," Thun has said. The same considerations apply whether the project is a sleek wooden bathtub for Rapsel, globe-like Laguna lamps for Artemide, artistic Alla Morandi glass vessels for Venini, or the clean lines and minimal volumes of Baxter's Godard upholstered furniture. Thun believes in sticking to his principles. Yet it takes a truly Renaissance spirit to turn cerebral theories into such a beautiful aesthetic.

*Text: Nicole Swengley*

2

3

4

5

1 *For Baxter's Godard collection, Thun masterfully married a bourgeois luxury concept with fine materials, essential shapes, reduced volumes, and a carefully selected range of colors.*

2 *A truly sensory experience, Thun's Alla Morandi collection of bottles in blown handmade glass for Venini references the majesty created in still life paintings by Giorgio Morandi.*

3 *For the Hugo Boss Business Unit, in Coldrerio, Switzerland, Thun created a glazed volume wrapped with a wooden latticework, symbolizing the company's products and mitigating the relationship between the landscape and the building.*

4 *Inspired by the misty lagoon of Venice, Thun, along with designer Antonio Rodriguez, created this singular collection of spherical glass lamps for Artemide.*

5 *Using energy-regulating clay walls, a green roof, and a glazed façade, Thun crafted the sustainability-minded Vigilius Mountain Resort. To ensure that the hotel was in full harmony with its surroundings, he designed a structure that followed the outline of the mountains and the integrity of the landscape.*

# Vigilius
# Mountain Resort

"Geographical, geological, meteorological, historical, and cultural characteristics—the whole context of a project—need to be taken into account to create a building or interior design scheme that respects the soul of a place."

So says Italian architectural and design legend Matteo Thun. And when it comes to Vigilius Mountain Resort—his stunning creation nestled harmoniously in the midst of Mount Vigiljoch among the soaring peaks and crisp Alpine air of Italy's South Tyrol—truer words could not be spoken. For few respect the soul of a place better than Vigilius.

An eco-inclined mountain hideaway where awareness coexists with aesthetics, and everything revolves around nature and landscape, Vigilius is accessible only by cable car and almost invisible to the outside world. Here is a resort that offers tranquility and panoramic views over the Dolomites and a larch forest.

The principle of "organic architecture"—an architecture that seamlessly blends into its surroundings—is expressed through Thun's use of wood and glass in a way that shrinks the difference between architecture and nature to a near imperceptible nuance. Here, a grass-covered roof, the use of natural larch wood throughout, and internally heated clay walls in the 41 rooms and suites all support Thun's organic approach. It's around these rooms and public spaces that guests can meet and mingle in a kind of high-altitude private community. These spaces include the reception area, with its gentle orange glow; the Stuba ida, which features a cozy tiled stove from the 19th century (part of the original dilapidated mountain hotel that Thun transformed into Vigilius); and Restaurant 1500, with its 300-year-old timbers.

In the rooms, clear design, warm colors, and natural materials linked to South Tyrolean history are employed, achieving a simplicity that frees the mind and opens the senses. All guestrooms face either east or west, but always to the outside, with nothing in the rooms distracting from one's personal dialogue with nature. What's more, that abundance of larch creates a unique sensory experience throughout the resort: The floors here are covered in the roughly patterned wood with a fine grain used for paneling and finishes and a fluted look for the doors.

Perhaps German proprietor Ulrich Ladurner who, together with Thun, brought the resort to life best sums up the experience one has here. "Being a guest at Vigilius is more than just spending a few beautiful days," he says. "It's about gaining new experiences and discovering new values." In short, nature sets the tone at Vigilius, determining the path of daily life and facilitating easy reflection and rediscovery of oneself. Says Thun, "Only by respecting [nature] can you create a building of long-lasting aesthetic value."

Ladurner couldn't agree more. After all, this was a spot that first fascinated him when he was a child. "It wasn't just being immersed in nature that put me under the spell of the place," he explains, "but also the views into the distance you had from above. It was only much later, though, that an idea and a dream grew within me to build a very different sort of hotel up here one day, where guests could share in the extraordinary feeling that emanates from this place. Matteo Thun drafted a design and then planned this modern wood-built structure down to the very last detail. It is a far cry from the ordinary, and exactly as I had imagined it."

After construction was complete, the challenge was to imbue the hotel with a sensuous feel. Ladurner explains that many locals thought he was crazy, as he puts it. "They said, 'It'll never work!'" But he listened to the land, not the people. "The mountain is honest and simple, we wanted to emulate it," he says.

Which is exactly what he and Thun have done here. In their eyes—and in the eyes of Vigilius' many loyal guests—the resort is as natural, simple, and spontaneous as the beauty that surrounds it. —

WHERE
Lana, South Tyrol
Italy

MEMBER SINCE
01/2003

ARCHITECTURE /
DESIGN
Matteo Thun

ROOMS
41

RATES
EUR 230–490

MEET THE ORIGINAL
Ulrich Ladurner

WHERE
Saint-Vincent
Italy

MEMBER SINCE
12/2013

ARCHITECTURE /
DESIGN
Piero Lissoni
(Lissoni Associati)

ROOMS
119

RATES
EUR 119–837

MEET THE ORIGINALS
Luca Frigerio,
Piero Lissoni

# Parc Hotel Billia

Despite its super-modern façade, or perhaps thanks to it, the Parc Hotel Billia looks like a page out of an historic book. The book in this case is a town called Saint-Vincent, an ancient settlement (with archaeological findings from pre-Roman times) in a natural basin in northwestern Italy, surrounded by the highest peaks in Europe—The Matterhorn, Mont Rose, Mont Blanc, and The Gran Paradiso. And the story, thanks to starchitect Piero Lissoni's signature minimalist style, is one told with local wood and stone that blends seamlessly into the surroundings. The hotel's facilities have now become integral parts of the new Saint-Vincent Resort & Casino, one of Europe's largest leisure centers, enhanced by a reconstructed spa that offers traditional cures alongside modern wellness treatments. The excellence of the local wine, the sweet flavor of Fontina cheese, and the subtle softness of Lardo d'Arnad enjoyed over views of an age-old park are all extra reasons to delve into the spirit of the Parc Hotel Billia.

A proud local, Luca Frigerio has sought to retain the unique charm of the magical, unpolluted natural world of the Aosta Valley. The director of Casino de la Vallée, the company behind the colossal Saint-Vincent Resort & Casino project (two hotels, a casino, wellness center, restaurants, and bars), Frigerio is a well-known figure in the casino scene. And yet, despite this connection to a fast-paced glitter-filled world, when he decided to add a new addition—the Parc Hotel Billia—to the historic Grand Hotel Billia, he knew that maintaining tradition was critical. Thus, his decision to use architect Piero Lissoni enabled him to marry the use of age-old building materials with the demand for luxury from today's guest. "Wood and stone have always been typical of the architecture of these places and today, technology allows us to use traditional materials, maintaining their appeal, but also guaranteeing performance that meets the most modern of needs," says Lissoni. —

Piero Lissoni

# Continentale

**WHERE**
Florence
Italy

**MEMBER SINCE**
09/2002

**ARCHITECTURE /
DESIGN**
Michele Bönan

**ROOMS**
43

**RATES**
EUR 300–3,200

**MEET THE ORIGINAL**
Leonardo
Ferragamo

Part of the fashion design family Ferragamo's small chain of hotels, the Continentale in Florence pays tribute to the retro spirit of the 1950s and 1960s with a candy-colored mix of both vintage and contemporary style, offset by just the right amount of playful kitsch. Pink-upholstered chairs greet guests in the reception, a mellow space second only to the fabulous Relax Room on the second floor, overlooking the Ponte Vecchio, the Arno river, and the Corridoio Vasariano. The view from La Terrazza, the hotel's rooftop terrace and bar, is even more breathtaking—an unrivaled perch from which to sip the typical *aperitivo*. Nods to glamorous vintage design are scattered throughout the hotel, but evenly balanced out by the color composition's happy-go-lucky charm, as intended by interior designer Michele Bönan. For those looking to unwind in style, the White Iris Beauty Spa by Comfort Zone offers a wide range of signature treatments inspired by the seductive simplicity of Florentine elegance and informed by the expertise of a renowned international brand. The hotel's 43 guestrooms are appointed with sheer-draped beds and flowing curtains that catch the Tuscan light. Reassuringly retro black-and-white photomontages complete the glorious modern look that goes hand in hand with a positive mid-century feel in the heart of this romantic Italian city. —

# Argentario Golf Resort & Spa

**WHERE**
Porto Ercole
Tuscany
Italy

**MEMBER SINCE**
03/2010

**ARCHITECTURE**
Alessandro
Casciotti,
Massimo
Mastromatteo

**DESIGN**
Andrea Fogli

**ROOMS**
73

**VILLAS**
1

**ROOM RATES**
EUR 250–1,500

**VILLA RATES**
EUR 1,800–2,900

**MEET THE ORIGINAL**
Augusto Orsini

In a verdant valley in Tuscany's Monte Argentario Peninsula, Augusto Orsini has created a masterpiece in contemporary design. Instead of a traditionally rustic Tuscan resort adorned in the typical terracotta and wrought iron, the Argentario Golf Resort & Spa offers an alternative vision—one that looks forward not only aesthetically and architecturally, but also ecologically. Its 18-hole golf course is BioAgriCert accredited for its minimal environmental impact; its Dama Dama Restaurant and The Bar specialize in locally inspired cuisine made from indigenous, regional ingredients; even the hotel's luxurious Espace Spa treatments are based largely on organic products. Argentario Golf Resort & Spa, the only golf resort in the Design Hotels™ collection, has 73 guestrooms and suites throughout its dragonfly-shaped structure with flaxen limestone façade. Its seven suites are all different, offering guests the option of a new experience with every stay. The Locker cottage, surrounded by an olive-tree garden, has all the glamour of a Tuscan country house updated to modern times. The junior suites, 3-bedroom villa, and superior rooms all have terraces overlooking the beautiful, eco-conscious golf course. Just steps away from the beautiful sandy beaches of Feniglia and Giannella, this resort and golf haven breathe new life into Tuscan luxury service and recreation. —

# G-Rough

The explanation of the name of G-Rough hotel gives you a peak at the personality of this hotel. "The 'G' is from our other property PalazzinaG in Venice," explained Emanuele Garosci, the man responsible for bringing about much of the brilliance that abounds here. "We're presenting a very Italian sense of luxury— one with history, design, and a touch of whimsy," adds entrepreneur Gabriele Salini, the other bold visionary at work here. Like its sister property in Venice, G-Rough will offer guests an insider slice of a city, in this case Rome. The building of G-Rough, like the ancient city it resides in, has seen much history. Built in the 1600s and renovated in the late 1800s, its architecture showcases the typical Roman bourgeois style of the 17th century. The façade even has an original Latin inscription, *Satis Ampla Qvae Secvritate Rideat,* meaning big enough to give one a feeling of security. More than just comfort, G-Rough is a pastiche with original wooden ceilings, patina walls, and meandering floor plans typical of Roman apartments. The hotel's unconventional "Made in Italy" concept of luxury in the Piazza Navona showcases iconic Italian designers and brands from the 1930s to the 1950s, such as Ico Parisi, Giò Ponti, Venini, and Seguso. As such, the rooms at G-Rough will be worthy of a veritable design museum. And with the help of a lifestyle manager or virtual butler, one easily finds the Rome of Romans.

A true visionary, Emanuele Garosci lived his life doing only what he was passionate about. His business partner Gabriele Salini, an authentic ninth generation Roman with a passion for art and vintage design, hails from one of the most important families in Rome. The two came together—friends, business partners, and bon vivants—thanks to a shared vision of redefining luxury and an unconventional approach to hospitality. The result is a contemporary nostalgia unique to G-Rough, a poetic mix of high- and low-brow luxury. —

Gabriele Salini

| | |
|---|---|
| **WHERE**<br>Rome<br>Italy | **ROOMS**<br>10 |
| **MEMBER SINCE**<br>10/2014 | **RATES**<br>EUR 450–3,500 |
| **DESIGN**<br>Emanuele Garosci | **MEET THE ORIGINALS**<br>Emanuele Garosci,<br>Gabriele Salini |

# Sextantio
# Albergo Diffuso

One and a half hours northeast of Rome, Santo Stefano di Sessanio nestles in the middle of Abruzzo, between the 2,912-meter peak of the Corno Grande and the sandy beaches of the Adriatic. It is one of the region's most striking hilltop towns and the home of the 27-room Sextantio Albergo Diffuso. Named after some of the area's first settlers, Sextantio's gorgeous series of buildings spreads throughout the handsome village, which was purchased and then meticulously revived by Swedish-Italian entrepreneur, philanthropist, and hotelier Daniele Kihlgren. Kihlgren committed himself entirely to the restoration, using strictly local materials—primarily terracotta tiles, wood, and limestone—and striving for historical accuracy. Sextantio is not part of the hip Italian hotel route of idealized glamour and luxury. It attracts people with a strong sense of adventure, a passion for history and authenticity, and a thirst for new experiences. But Sextantio equally draws those who value a beautiful local meal and cozy, elegant accommodation. While not a traditional hotel, tradition is deeply ingrained in Sextantio's foundations.

Daniele Kihlgren breathes life into Italy's past. His Sextantio villa is comprised of six medieval structures in the village Santo Stefano di Sessanio, which he restored with local architects and archeologists. His second project, Sextantio Le Grotte Della Civita, opened in 2009. Kihlgren is a conservationist and philosopher at heart, striving to preserve his nation's natural beauty and local heritage. —

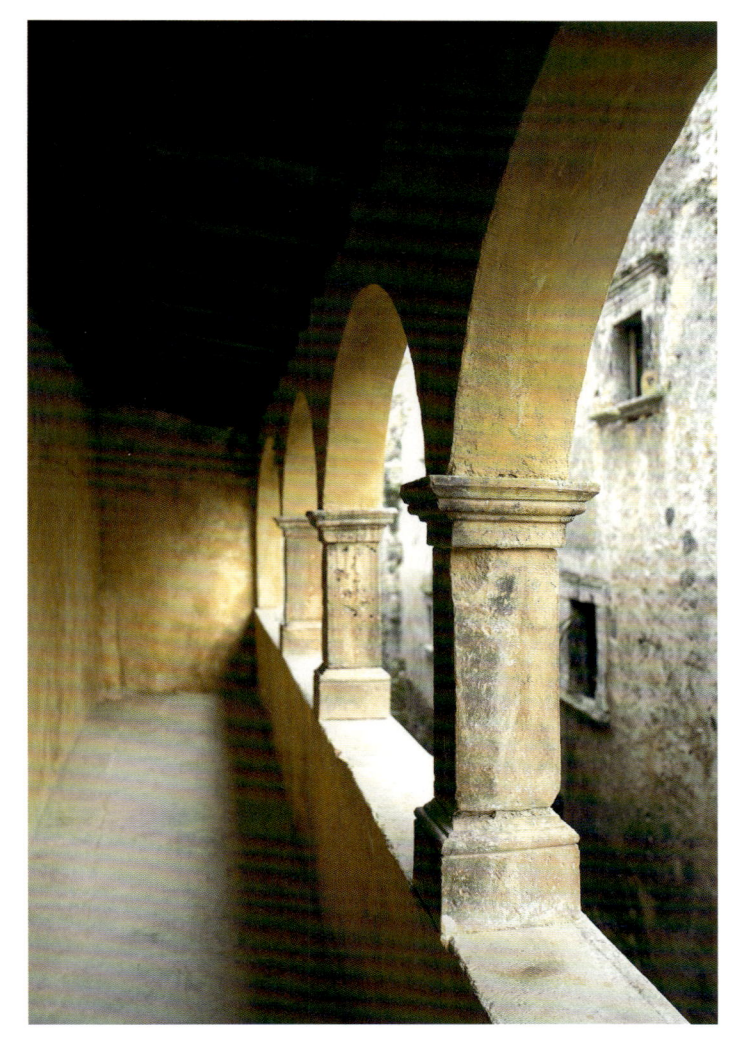

WHERE
Santo Stefano di
Sessanio
Italy

MEMBER SINCE
01/2010

ARCHITECTURE
Lelio Oriano Di Zio

ROOMS
27

RATES
EUR 75–1,000

MEET THE ORIGINAL
Daniele Kihlgren

# Casa Angelina

Perched on a cliff edge with stunning views of Italy's Amalfi Coast, Casa Angelina is a welcoming retreat awash in Mediterranean minimalism and contemporary art—think pure white interiors, floor-to-ceiling windows overlooking the Gulf of Salerno coast, Murano glass sculptures, and paintings by Patricia Valencia Carstens. Here, the notion of "barefoot luxury" flies in the face of the prevailing tradition and opulence of the hospitality scene. Casa Angelina anticipates guests' needs, yet it's all done in a luxurious but informal manner that creates the "down to earth" feeling of staying at, say, a wealthy friend's home. In short, at Casa Angelina one finds freedom and simplicity, not bling or old-world formal luxury—and it's presented in a way that doesn't sacrifice the very high standards you would expect from a 5-star property. Here, too, you will discover private access to a section of La Gavitella beach, one of the coastline's finest, and trips to the nearby Isle of Capri (as well as less accessible destinations such as the Baia di Recommone) on the hotel's boat, Master Angelina. The property is one of the only contemporary boutique hotels in the area, situated in the seaside village of Praiano, just 10 minutes from the town of Positano, and many of the hotel's windows boast sweeping views of the Sorrento Peninsula. Clean, contemporary design and attentive service spell out a serene and stylish retreat, topped off by Vincenzo Vanacore's Un Piano nel Cielo rooftop restaurant that serves up gourmet Mediterranean dishes, and the Marrakech Bar with terrace, offering an irresistible seaside aperitivo with a view.

Antonino Cappiello was brought up in Sorrento, Italy, and has climbed his way up in the hospitality industry to become a Design Hotels™ Original. After a lucrative stint in the toy and gadget retail business, Cappiello bought the property that now houses Casa Angelina, which was formerly a *Pensione* built in the 1970s. Named after Cappiello's mother, the boutique hotel is pioneering chic and artistic luxury in an otherwise more tradition-minded scene. —

WHERE
Amalfi Coast
Italy

MEMBER SINCE
10/2015

ARCHITECTURE
Gennaro Fusco,
Filippo Cannata,
Francesco Savarese

DESIGN
Marco De Luca,
Edward Tancredi

ROOMS
39

RATES
EUR 285–1,800

MEET THE ORIGINAL
Antonino Cappiello

# Zash Country Boutique Hotel

In eastern Sicily, amid rambling citrus groves, sublime views over Mount Etna, and exquisite wines, you'll find Zash: A country hideaway, a former winery, and a Mediterranean garden all rolled into one. Spend the night here and you'll not just be close to Sicily's best scenery, you'll be part of it. All of the rooms find a unique way to immerse you in nature, with expansive views that overlook the evocative Sicilian landscape. For a tantalizing taste of Sicily, retire to the hotel's lounge located at the entrance of the old winery—the perfect stop for an aperitif or an earthy local wine. Just outside the doors, specially designed trails let you get even closer to the sounds and smells of Sicily. So hike, walk, or cycle, and let the countryside take care of the rest.

Architect Antonio Iraci and his partner, designer Carla Maugeri, joined forces to create Zash—a place that is refined in its design, rural in its context, and vital for the soul. Iraci hails from Misterbianco (Catania) and graduated from the Architecture Faculty of Reggio Calabria in 1988 with honors. He launched the Archiline studio in January 1989, as an architectural lab for experimental projects and research. For his work on Zash Country Boutique Hotel, he was awarded the Ischia International Architecture Award (PIDA) for excellence in architecture. Designer Carla Maugeri, a member of the family that originally owned the manor house and surrounding property of Zash, studied architecture at the Architecture Faculty of Siracusa. Maugeri has worked at the Archiline studio since 2008, where she actively customizes design architecture. —

WHERE
Sicily
Italy

MEMBER SINCE
11/2013

ARCHITECTURE /
DESIGN
Antonio Iraci,
Carla Maugeri

ROOMS
10

VILLAS
1

ROOM RATES
EUR 170–650

VILLA RATES
EUR 11,000–27,000

MEET THE ORIGINAL
Antonio Iraci

# Sextantio
# Le Grotte della Civita

Restored from decaying, abandoned ancient caves in the Basilicata village of Matera in southern Italy, Sextantio Le Grotte della Civita offers guests a new take on authenticity. Daniele Kihlgren spearheaded the campaign to resuscitate the caves. The Swedish-Italian entrepreneur, hotelier, and philanthropist breathed new life into the caves while honoring and highlighting the lives spent dwelling in their depths. Situated in the arch of the proverbial Italian boot, Matera is not widely known by foreigners: Historically impoverished, it fell into local seclusion. The importance of maintaining the traditional local aesthetic and preserving the existing architecture is thus intensified in this UNESCO World Heritage Site. Kihlgren has created eighteen impeccable rooms in Sextantio Le Grotte della Civita, the oldest part of the ancient cave dwellings, or *Sassi*. In order to provide guests with proper standards of luxury, Kihlgren composed a synthesis that integrates traditional design made from local materials with a minimum of contemporary amenities. The site was meticulously taken apart, entirely wired and piped, and finally reassembled, with each stone returned to its original location. The result is an architectural masterpiece that provides a truly once-in-a-lifetime experience.

Where others see decay, philosopher and renegade hotelier Daniele Kihlgren sees opportunity, creating hotels that breathe life into the fading communities of Italy's past. His Sextantio villa, which he discovered in ruins back in 1999, is comprised of six different medieval structures located in the village Santo Stefano di Sessanio, which he restored with local architects and archaeologists. His second project, opened in 2009, is a UNESCO World Heritage Site and authentic collection of 18 simple rooms called Sextantio Le Grotte Della Civita. With no conventional training as a hotelier, Kihlgren is a conservationist and philosopher at heart, striving to preserve his nation's natural beauty and local heritage. —

Daniele Kihlgren

**WHERE**
Matera
Italy

**MEMBER SINCE**
02/2010

**ARCHITECTURE**
Enrico Ducrot,
Daniele Kihlgren

**DESIGN**
Margareta Berg,
Laura Einaudi

**ROOMS**
18

**RATES**
EUR 275–600

**MEET THE ORIGINAL**
Daniele Kihlgren

# Ca' Pisani

A revived merchant's townhouse owned by the Serandrei family, Venice's noble Ca' Pisani hotel is more than 500 years old, but has been brilliantly modernized by architects Roberto Luigi Canovaro and Gianluigi Pescolderung into an experience that's nothing less than inspiring. The pair blended elements of the Italian Futurist movement with original architectural features such as exposed wooden beams. Each of the 29 guestrooms boasts original furniture from the middle of the last century, collected from across Italy by the Serandrei family. Posters from the same period inspire one-of-a-kind guestroom doors. Bathrooms feature a special masonry technique that gives the effect of sparkling stars. The hotel's wine and cheese bar, La Rivista, also echoes the Art Deco and Futurist motifs at the Ca' Pisani creating a unique, sophisticated dining environment in Venice. Located in a quiet, picturesque part of the city, the hotel has a calming effect through Canovaro and Pescolderung's clean, sharp lines. The hotel cooperates with two Venetian galleries, and periodically holds exhibitions in Salone Nobile on the first floor, enhancing its status as an exclusive Venetian spot. At Ca' Pisani, guests enjoy the successful melding of two contrasting design eras in a setting that is both relaxing and elegant. —

**WHERE**
Venice
Italy

**MEMBER SINCE**
02/1999

**ARCHITECTURE**
Alberto Rasa

**DESIGN**
Roberto Luigi
Canovaro
(Studio Canovaro),
Gianluigi
Pescolderung

**ROOMS**
29

**RATES**
EUR 174–540

**MEET THE ORIGINAL**
Marianna Serandrei

# Palazzina G

WHERE
Venice
Italy

MEMBER SINCE
05/2009

ARCHITECTURE /
DESIGN
Philippe Starck

ROOMS
22

RATES
EUR 319–4,400

MEET THE ORIGINAL
Emanuele Garosci

Situated on the Grand Canal, the atmosphere of PalazzinaG is that of a home full of charm and vitality, where guests can experience the melancholic grandeur of Venice like true Venetians. Privacy, flexibility, luxury, and elegance are the fundamental elements of this exclusive property, designed by French architect and design trailblazer Philippe Starck. With no reception desk at the entrance area, a personalized check-in marks the beginning of the tailor-made service guests can expect throughout their stay. The façade of the three-story hotel is a classical 16th-century shell, behind which generations of noble and haute-bourgeois families lived; several centuries earlier, the site served as a Roman spa. Classical references abound,

including a restored central colonnade and modern columns. The 15 rooms and seven suite apartments are characterized by a marriage of contemporary and romantic design, highlighted by unique furnishings, glass works by the French artist Aristide Najean, and sophisticated collector's items, with some rooms offering glimpses of the lagoon landscape. The PG's Restaurant reflects the philosophy of PalazzinaG: A warm, informal, yet decadent atmosphere, where chef Paolo Businaro interacts with diners from a show-cooking counter. Continuing inside to the 16th-century wing of the *palazzo*, guests can enjoy the Krug Lounge, the second in the world. —

# Eremito

"I saw so many places that I began to think that I wanted to create a type of place that doesn't exist."

The man who spoke these words, Marcello Murzilli, has seen more of the world than many of us could ever imagine. After creating a wildly successful business in his home country of Italy, he spent two years sailing to the four corners of the planet in a restored wooden boat, seeing everything there was to see. Which leads now to that "place that doesn't exist"—or, rather, didn't until Murzilli had the courage to build it.

Located in the center of Italy, halfway between Rome and Florence, Eremito hotel is surrounded by 3,000 hectares of protected natural reserve in Umbria. Considered the spiritual focal point of the country thanks to the wonderful monasteries in the area, this is the perfect spot for what Murzilli had in mind—a hotel that presented a simpler, old-world way of being. Thus, rooms at this innovative sustainable structure invoke the cells of monasteries *(celluzze)* and are crafted only for people traveling solo, enabling them to fully retreat into a setting that is perfect for contemplation.

"It was not important to me to make a 'nice hotel,'" Murzilli explains. "Lots of people know how to make nice hotels. There are many wonderful hotels in the world." Instead, his idea was to imagine a new concept of luxury, and to imagine a new format for the luxury hotel shaped by that concept.

Built from a mix of the latest biotechnology and old materials from the region, this Italian eco-resort offers an austere aesthetic that aims to provide guests with an "old luxury"—plenty of

quiet and space to reflect and rejuvenate, sans WiFi, phone, and television. The kitchen serves up a vegetarian menu, also inspired by ancient monastic traditions, with ingredients sourced from local organic farms. The spa area features a heated pool dug from the rock and a stone steam room. It's the perfect place to unwind while listening to Gregorian chants.

Though the hotel is new, guests who see it for the first time often need convincing that it isn't a fully refurbished antique. Erected stone by stone upon a derelict house, Eremito hotel took four years to create. Adhering to the ancient art of Italian masonry from the 13th century, some 130,000 stones were used in its construction. And yet, despite its traditional appearance, Eremito is environmentally conscious and sustainably up-to-date. The electricity, for example, is generated by a photovoltaic system, but of course the main source of lighting, by choice, is still candlelight in keeping with the retrospective spirit of the hotel.

As for the hotel's interior and those single bed *celluzze*, the design style can be described as "Franciscan minimalism," meaning time, peace, and contemplative spaces. Natural materials take precedence, and furnishings are few but comfortable, with a clear inspirational design nod to Umbrian monasteries.

Indeed, Murzilli seems to perfectly capture the soulful air of Umbria. But how did he come to choose it as a setting for his unique hotel? "I fell in love with the place," he says, "The colors, the light, the sparkling river, and the hills completely covered with trees." And upon those hills sits a place that doesn't exist. Until now, that is. —

WHERE
Parrano, Umbria
Italy

MEMBER SINCE
04/2014

ARCHITECTURE
Nino Nenna

DESIGN
Marcello Murzilli

ROOMS
14

RATES
EUR 120–390

MEET THE ORIGINAL
Marcello Murzilli

Marcello Murzilli

# Nira Montana

**WHERE**
La Thuile
Aosta Valley
Italy

**MEMBER SINCE**
07/2014

**ARCHITECTURE /
DESIGN**
Architects Tomasi
and Gallo,
Studio del Portico

**ROOMS**
55

**RATES**
EUR 275–840

**MEET THE ORIGINAL**
Puri

Set against the majestic grandeur of Mont Blanc in the Italian ski resort of La Thuile, a laid-back area in the northwestern part of the breathtaking Aosta Valley, Nira Montana is bringing magic to the mountains. The exterior presents a modern façade in the ancient valley, while its rich interiors offer a twist: think "wooded" wallpaper, Italian high-end furniture, and the most splendid spa in the region. Yes, it is luxury in all its glory, but with a nonconformist's bent. The structure of Nira Montana is at once surprising and apt. Built using new construction techniques and local materials, such as stone and wood, it blends seamlessly with La Thuile's historic surroundings. Yet, at the same time, the façade stands out next to its ancient neighbors. Inside, the surprises continue. Designed to have the most spacious rooms in the area, the property offers its guests endless views of the breathtaking mountains. Mixing Alpine charm with Italian high-design, the Milan-based Studio Del Portico combines steel designer pieces and warm woods into one luxurious 55-room space. The fresh, gourmet-style menu at the hotel's crisp yet casual Stars Restaurant, which contrasts wooden paneling with custom-designed steel furniture, is perhaps rivaled only by the offerings at the hotel's Nira Spa, which boasts everything from indoor swimming pool to steam room to deliciously luxurious chocolate interiors. —

# Vander Urbani Resort

Within the walls of what is now the Vander Urbani Resort, owners Amanda and Aleksander Vujandinovič met, got to know each other, and started to share their life. Situated on the river bank of Ljubljana, the surrounding area combines creativity and culture. You can stroll through the medieval streets, visit urban hot spots, and admire the river from romantic bridges. While the façade maintains its historical appearance, the interiors offer something fresh and new. The 16 rooms feature high-end materials, one-of-a-kind design pieces, and plush amenities that all add to the sophisticated yet homey comfort. Continuous forms, such as patterned stone and curved walls and doors, create a feeling of openness between the different levels. Intimate spaces to reflect and rest abound, from the wine cellar in the basement to the restaurant and rooftop terrace where guests can take a sunset swim or enjoy the glassed-in yoga studio with views over the city. —

**WHERE**
Ljubljana
Slovenia

**MEMBER SINCE**
12/2011

**ARCHITECTURE /
DESIGN**
Jurij Sadar,
Boštjan Vuga
(Sadar + Vuga)

**ROOMS**
16

**RATES**
EUR 120–250

**MEET THE ORIGINALS**
Aleksander
Vujandinovič,
Amanda
Vujandinovič

# Hotel Lone

There is something larger than life about a cruise ship—and not just because it's, well, enormous. Spot one close to shore and it's almost like having an alien encounter—you are in the presence of something whose architecture, engineering, scope, and mere ability to float is almost beyond comprehension. The fact that it takes up such a large chunk of the horizon certainly adds to its mythology.

Power, scope, and architectural mythology were certainly in the minds of renowned Croatian architects Silvije Novak, Saša Begović, Marko Dabrović, and Tatjana Grozdanić Begović when they conceived Hotel Lone. Founders of the architectural studio 3LHD in Zagreb in 1994, this internationally recognized and award-winning design team set out to do something special with the property, which is set in the picturesque coastal Croatian town of Rovinj. Inspired by the hotels that dotted the Adriatic Sea in the 1970s, 3LHD has created the perfect symbiosis of work and play. Even more, they have crafted something that resembles a luxury cruise liner nestled on the hillside amid ancient woodlands above wave-lapped coves. Here, the minimalist curves of Hotel Lone's design are at one with the area's unique natural landscape.

Situated only a 10-minute walk from Rovinj's central town square, the hotel's 236 rooms and 12 suites gracefully bend away from the coastline in a distinctive Y-shape, with many offering views of the island-speckled sea. Thanks to the unconventional shape of the hotel, each of the bedrooms offers an invigorating water or park view. Self-assured contrasts are a major component here, such as the alternate black-and-silver stripes of that curved exterior. From the stark white stairways to the lobby's rich and leafy painted mural, contrast is a theme that runs throughout the building. Although it might not be apparent at first glance, the lush natural landscape here has influenced the entire design concept at Hotel Lone. The tall and airy main lobby is dressed in white-beige stone—the color of the region's beaches—and set off by soft, sandy-yellow furnishings.

For the ultimate hideaway, those in need of solace should head to the indulgent spa, where natural tones of wood, stone, water, and gold create an atmosphere of timeless tranquility. Here, delicate strains of locally grown rosemary, lavender, and olive oil tempt guests. In the rooms and suites, meanwhile, large mirrors cling to the walls at seemingly random intervals, letting reflections of the external environment, including forest greenery and ambient light, seep in through sweeping glass panes. Guestrooms, such as the Jazz rooms and the Deluxe Lone Suite, also feature Jacuzzis on the terrace for the ultimate views while relaxing.

Hotel Lone is also the first design-conscious hotel in the Adriatic region that caters to business travelers, with a conference center that includes a 650-seat auditorium. The impressive business facilities combine minimalism, elegance, and state-of-the-art technology. With four large auditoriums and three large meeting rooms featuring high ceilings and wide, generous spaces, the hotel offers guests the freedom and room to brainstorm and ruminate.

Taken together, Hotel Lone is almost beyond comprehension, something both larger than life and at one within the landscape—a mythological god of the Adriatic. —

WHERE
Rovinj
Croatia

MEMBER SINCE
09/2009

ARCHITECTURE
3LHD

DESIGN
Nikola Radeljković
(Numen/For Use)

ROOMS
248

RATES
EUR 250–2,200

MEET THE ORIGINAL
Silvije Novak

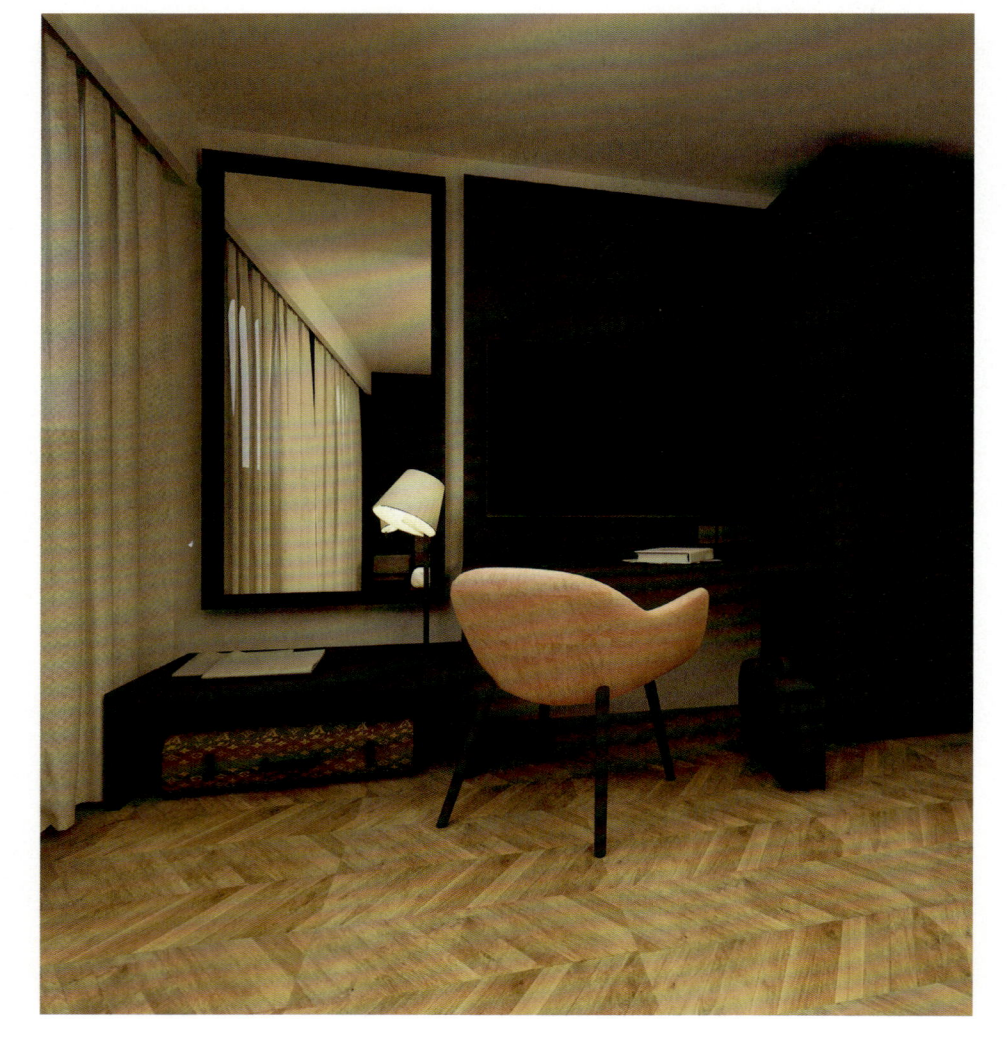

# Bête Noir

The name of the hotel echoes the history and heritage of the 17th century palazzo in the very center of Valletta. Once home to noble members of the Sovereign Military Order of Malta, an international elite of mounted knights, the modern design draws from the elegance and mystery of the building's past. The boutique hotel is set to attract the well-travelled, art loving, and educated visitor who wants to be immersed in the culture and history of Valletta, a UNESCO World Heritage Site. Daaa Haus, the interior designers, blend the historical Baroque architecture with the modern starkness of designer furniture in each of the guestrooms. The branding for Bête Noir, by Logix Creative, recalls the noir ambience of a mysterious city of past chivalry in an elegant and sophisticated way. It is matched by a decor which provides the guest with a boutique experience, surrounded by dark sensuality and an invitation to explore the unknown. The city, "built for gentlemen by gentlemen," is European Capital of Culture in 2018. The hotel is a beacon of design, while still paying homage to the historical setting. The noble façade and the interior architecture were enough for the design team to capture the true essence of the story using only subtle luxury, elegant textures, and clean and sophisticated design. —

| WHERE | ROOMS |
|---|---|
| Valletta | 28 |
| Malta | |
| | RATES |
| MEMBER SINCE | EUR 150–350 |
| 09/2015 | |
| | MEET THE ORIGINAL |
| ARCHITECTURE / DESIGN | Ian Fitzpatrick |
| Daaa Haus | |

# Fresh Hotel

Set in a historical backdrop in central Athens, Fresh Hotel offers an electrifying medley of sleek formality and ancient splendor, where bold design fuses with a traditional location. This urban resort, a creation by owner Ada Yfanti, remains true to its name with a fresh palette of striking tones such as lime, fuchsia, and tangerine set against a simple white backdrop. The design and architecture, courtesy of local studio Zeppos-Georgiadi + Associates, uses natural materials that seamlessly merge with bursts of intense color. The choice of materials was intended to simultaneously contrast and enhance Fresh's surroundings. Peppered with an impressive selection of design furniture handpicked by Yfanti, pieces by Charles Eames, Philippe Starck, and Zaha Hadid inject Fresh with a thoroughly distinctive interior. Each of the 133 rooms is a clean, modern space; every one interspersed with the hotel's signature bold colors, with several accommodations featuring their own calm and concealed private gardens. The relaxed atmosphere that permeates the hotel extends to the popular Air Bar Lounge and the rooftop swimming pool surrounded by olive trees and furniture by Paola Navone, which offers unbeatable views of the Acropolis. For even more low-key moments, Fresh's sauna is on hand, while the hotel's location in the hub of Athens allows guests to take in the city at their own pace. A new addition to the city center, Fresh Hotel's ArtWall brings together contemporary artists who are part of the creative force of Athens, producing new ideas and documenting often contradictory conceptions of the ever-changing city. —

WHERE
Athens
Greece

MEMBER SINCE
11/2004

ARCHITECTURE /
DESIGN
Tasos Zeppos,
Eleni Georgiadi
(Zege: Zeppos–
Georgiadi +
Associates)

ROOMS
133

RATES
EUR 90–400

MEET THE ORIGINAL
Ada Yfanti

# New Hotel

For Greek Cypriot art collector Dakis Joannou, New Hotel has been a true labor of love. After picking apart the tired Olympic Palace Hotel, which was built in the heart of modern Athens in 1958, he set about restructuring it, piece by piece, without discarding anything. The result is an astonishing *Gesamtkunstwerk*, in which all of the senses are brought together in an intensified form of visual, tactile, and somatic interaction. Throughout the chunky modernist building, chairs and doors salvaged from the old property reappear as artworks that awaken guests' senses. Thanks to interiors by Brazilian visionaries Humberto and Fernando Campana, who have earned a reputation for creating living art from castoffs, key elements of design and culture collide on every floor. From the spa and fitness area to the top-floor terrace, which affords one of the best views in Athens, the designs are consistently intense. Each of the hotel's 79 rooms and suites lets guests feel like they're a part of the vivid in-room installations. There are three separate interior design concepts, each inspired by Greek culture, floating above the walls, challenging perceptions of depth and space. And in the public lounges, there are incredible treelike sculptures lovingly made from a jumble of different-colored woods. Both physically and mentally, New Hotel provides endless possibilities for exploration.

Dakis Joannou founded Yes! Hotels back in 2004. Working alongside innovative interior designers such as Brazil's Campana brothers, he has left his cool-as-ice hallmark on three Athens icons—Periscope Hotel, Semiramis, and New Hotel. One of the foremost collectors of contemporary art in Greece, Joannou's personal collection has featured in many leading museums all over the world. As a member of the Board of Trustees at the New Museum of Contemporary Art in New York, a member of the International Directors Council of the Solomon R. Guggenheim Foundation, and cofounder of DESTE Foundation for Contemporary Arts, Dakis Joannou has strived to share subjects that inspire him: art, design, and architecture. —

More from Yes! Hotels:

GREECE
Athens, Periscope → P. 360
Athens, Semiramis → P. 361

| WHERE | ROOMS |
|---|---|
| Athens | 79 |
| Greece | |
| | RATES |
| MEMBER SINCE | EUR 175–2,500 |
| 12/2010 | |
| | MEET THE ORIGINAL |
| ARCHITECTURE / | Dakis Joannou |
| DESIGN | |
| Fernando Campana, | |
| Humberto Campana | |
| (Estudio Campana) | |

# AthensWas

The latest addition to the Athens hospitality scene is a glossy, marbled ode to one of the city's famed architectural highlights: classic modernism. The frenzied glory of a movement that thrived from the 1950s to the 1970s has been re-energized at the AthensWas hotel in a fresh, modern way thanks to celebrated Greek design practice Stage Design Office. Iconic furniture by modern masters such as Le Corbusier, Ettore Sottsass, Michael Graves, and Konstantin Grcic place the hotel right up there with other sites of import in the city. Steps from the Acropolis, Syntagma, and other historical gems, the hotel also masterfully incorporates the timeworn city's rich past with elements that reference ancient Greek forms and architecture. Modernity, however, reigns in the restaurant and rooftop bar where quality and simplicity are valued, and the best views of Athens relished.

Like his work, nothing about Stavros Papayannis is straightforward. Having initially studied Anatomic Pathology, the Greek maverick did a complete about-turn in 1988. Co-founding the multifaceted design studio DeArte, the completely self-taught designer took on interior design, graphic design, and art commissions before establishing his current company, Stage Design Office, where Anemi, and now AthensWas, add to his stunning hotel portfolio. Renowned in Athens—where he still lives and works—he's distinguished by his unique approach to design, likening the designer/client relationship to that of a patient and a doctor, no doubt a lingering hangover of his medical training. —

More from Anemi Hotels:

GREECE
Folegandros Island, Cyclades, Anemi Hotel → P. 366

WHERE
Athens
Greece

MEMBER SINCE
03/2015

ARCHITECTURE
Epilogi Ktirion—
K. Benakopoulos

DESIGN
Stavros Papayannis
(Stage Design
Office),
George Kyriazis

ROOMS
21

RATES
EUR 160–1,320

MEET THE ORIGINAL
Stavros Papayannis

# Periscope

High above the glittering jewelry stores and sweet-smelling chocolate boutiques of Kolonaki, the Greek capital's most opulent shopping district, a periscope keeps watch. Not over individual streets, like the CCTV cameras you'll see bolted to the city's steel lampposts, but over the entire Athenian skyline. Controlling its movements, several stories below, are guests at the aptly named Periscope hotel—an intimate urban hub created by industrialist and contemporary-art connoisseur Dakis Joannou. Here, surveying the city and its people is just part of the guest experience. In the hotel's public areas, which are delineated by chunky concrete supports, interactive art installations invite guests to question their preconceived ideas about surveillance. Huge screens show dystopian images of an Athens stalked by giant three-dimensional animals, while on the main staircase trunk, a kind of primitive altimeter tracks your journey to bed, showing you how high you are above sea level with every step. All 21 bedrooms and suites are a study in pared-down style, with celluloid cityscapes and splashes of blue, red, and black adding warmth to the functional decor. But the views of Athens, including the classical pillars of the Parthenon, will tempt you into a day of city-center exploration. —

**WHERE**
Athens
Greece

**MEMBER SINCE**
01/2011

**ARCHITECTURE / DESIGN**
Alexandros Vaitsos
(Deca Architecture)

**ROOMS**
21

**RATES**
EUR 135–850

**MEET THE ORIGINAL**
Dakis Joannou

# Semiramis

WHERE
Athens
Greece

MEMBER SINCE
11/2003

ARCHITECTURE /
DESIGN
Karim Rashid

ROOMS
51

RATES
EUR 165–465

MEET THE ORIGINAL
Dakis Joannou

Semiramis is what happens when you give a hot designer control over every aspect of a building and its interior. Design star Karim Rashid's dazzling display of lollipop colors and organically shaped furniture plays happily alongside a rotating collection of contemporary fine art, hand picked by owner and art collector Dakis Joannou. Situated in the leafy, upscale Kifissia district of Athens, Semiramis is a feast for the eyes for any guest. While works by Tim Noble, Sue Webster, or Jeff Koons may adorn the walls, representing the best of contemporary art, Rashid's juicy pinks, oranges, greens, and yellows bathe lobby couches, transparent glass partitions, and other surfaces. With an extra element of cheekiness, guests are encouraged to play with Rashid's device for communicating with the outside world. Instead of the boring "Do Not Disturb" signs, he offers electronic message boards, which guests can personalize from their in-room keyboards. He describes his overall view of Semiramis as "an intimate hotel that focuses on positive energy, heightened experiences, culture, design, and art. Semiramis is a place for new, contemporary experiences—to enjoy, relax, work, and engage a new memorable experience unlike any other anywhere else in the world." —

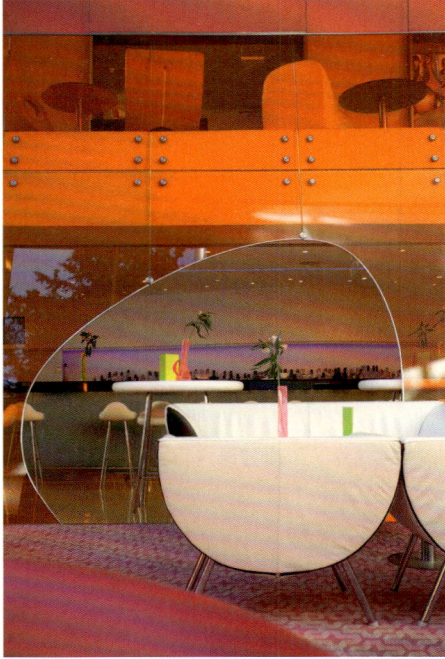

# San Giorgio Mykonos

Melding the carefree finesse of 1960s bohemian life with a down-to-earth "gypset" approach, at San Giorgio Mykonos, everything is about ease and enjoyment. Leisure is writ large and guests are encouraged to store or spend energy as they please. It's like visiting the summer home of your coolest friend, who whips together a feast for the eyes and palate with as much ease and grace as he throws the island's most talked-about fete. And you're along for the ride. The hotel started its humble beginnings in the 1990s thanks to a successful local fisherman who laid claim to a piece of Paraga Beach. Step into 2012 and the 33-room property has changed hands to proprietors Thomas Heyne and Mario Hertel. Long-time friends of Design Hotels™, the duo approached the brand to design a new hospitality experience. San Giorgio is designed for those who seek simple pleasures like waking up to views of the sea, sharing good food prepared with love and care, or even just lounging around the pool and soaking up the Mediterranean sun. Expanding on the vision that started with the hotel, the two entrepreneurs brought their take on modern bohemian style to a new shore-side venue, Scorpios Beach Club at Paraga Beach Mykonos, in May 2015. San Giorgio is situated on one of the most scenic areas of the island between Paradise and Paraga beaches. Not only is Mykonos famed for its nightlife, the picturesque white houses, dazzling blue waters, and quaint alleys are the picture of a Grecian paradise.

With a vision to connect free-thinking, free-spirited individuals from all over the globe, Design Hotels'™ collaboration with the owners of Paradise Club offers another dimension to the brand experience. Mario and Thomas bring special treats to residents of San Giorgio. Not least of which is complimentary access to the VIP area of Paradise Club. As personal friends and part of the San Giorgo family, world-renowned DJs like Martin Garrix, Avicii, and Bob Sinclar will not only have an island home, but have also become integral contributors to the project. Impromptu chilled-house sets and spectacular White Parties are an exclusive highlight for the temporary community. These monthly events take place in the hotel's open-air lounge, perfectly placed to soak up the last rays of sun setting into the Aegean Sea. —

WHERE
Mykonos
Greece

MEMBER SINCE
04/2012

DESIGN
Annabell Kutucu,
Michael
Schickinger

ROOMS
33

RATES
EUR 170–820

MEET THE ORIGINALS
Mario Hertel,
Thomas Heyne

Thomas Heyne
& Mario Hertel

# Mykonos Theoxenia

WHERE
Mykonos
Greece

MEMBER SINCE
11/2004

ARCHITECTURE
Aris Konstantinidis

DESIGN
Angelos
Angelopoulos

ROOMS
52

RATES
EUR 190–975

MEET THE ORIGINAL
Marissa Loizou-
Middleton

A legendary classic of 1960s hotel architecture, the Mykonos Theoxenia hotel has made a glamorous comeback. The lowrise structure occupies a prime location right next to the white windmills that are the island's trademark and offers stunning views of the Aegean Sea below. Revamped in 2004, the 52-room property weds a fresh modern aesthetic with classic 1960s glamour, managing to harmoniously meld with Mykonos' radiant seascape as well as perfectly suit the Greek island's dynamic local nightlife culture. At Theoxenia, privacy and tranquility are of utmost importance. During the day, sun-worshippers can soak up golden rays on white Moroso beach chairs or luxuriate within curtained four-poster beds facing out to the Aegean. Later, they can chill out among the cool

stone details and crisp turquoise, lime, orange, and bright white decor emblazoned in the interior of Aris Kostantinidis' iconic structure by designer Angelos Angelopoulos. His novel use of energetic colors renders the design experience as exciting and joyful as a bowl of ripe fruit; the rest of any guest's experience is in the expert hands of the relaxed spa, restaurant, and service staff who understand the importance of discreet personal service. The voluptuous curves of Patricia Urquiola's deep-blue Fjord bar stools, the organic sensibility of stone pillars, and the clean feel of beech period furniture evoke the relaxed elegance of mod-era jet-setter luxury. It's something the Mykonos Theoxenia exemplified in its first heyday and that it now embodies once again. —

# The Met Hotel

The ancient coastal city of Thessaloniki is speckled with fascinating art galleries, but just one of them, The Met Hotel, doubles as an extravagant luxury hotel. Wandering through its roomy, avant-garde hallways, it's hard to believe people are actually allowed to sleep here. On the piano-black walls, there are bold shots by famous fine-art photographers such as Andreas Gursky and Thomas Struth. And in the generous public spaces between the lobby and the spa, you'll find sculptures and video works by some of the world's most revered contemporary artists. Of course, it's not down here but upstairs, in the 212 seductively simple rooms and suites, that guests really lay their heads. By decking the floors in dark tropical timber, and allowing sea views to flood in through huge glazed panes, the designers have managed to soften and smooth the overwhelmingly sharp contours of the furniture. Art still plays an important role, however, with stark black-and-white photos by German visual artist Ralph Baiker hanging from the walls. Even in the spa—which features an indoor heated pool—edgy lamps and glass partitions blur the lines between form and function. At The Met Hotel, situated in the heart of Thessaloniki's happening new harbor area, hospitality and contemporary art really do exist side by side. —

WHERE
Thessaloniki
Greece

MEMBER SINCE
11/2010

ARCHITECTURE /
DESIGN
Tasos Zeppos
(Zege:Zeppos –
Georgiadi +
Associates),
Andy Martin (Andy
Martin Architects)

ROOMS
212

RATES
EUR 126–2,000

MEET THE ORIGINAL
Christina Chandris

**WHERE**
Folegandros Island
Cyclades
Greece

**MEMBER SINCE**
11/2013

**ARCHITECTURE**
Alexandros Samaras
(Alexandros C.
Samaras &
Associates)

**DESIGN**
Stavros
Papayannis (Stage
Design Office)

**ROOMS**
44

**RATES**
EUR 190–720

**MEET THE ORIGINAL**
Stavros Papayannis

# Anemi Hotel

The Cycladic island of Folegandros plays host to Anemi Hotel with all the drama of a Greek myth. Against the rocky terrain of the village of Karavostasi, the hotel makes a memorable impression with a dozen two-floor whitewashed buildings, unique in their delicate combination of Cycladic architecture and contemporary Greek lines. Inside, 44 rooms and three suites are peppered with furniture by the likes of Charles and Ray Eames, B&B Italia, and Vitra, brought together by designer Stavros Papayannis who has successfully injected Anemi's interiors with an underlying mood of simplicity and modernity. Every guestroom has been designed individually, emphasized by one-of-a-kind photos by Margarita Nikitaki capturing the summer life of Folegandros, which frame each bed. Augmenting this mood of local spirit are traditional Greek elements, seen through numerous decorative objects, and rustic wooden ceilings.

Like his work, nothing about Stavros Papayannis is straightforward. Having initially studied Anatomic Pathology, the Greek maverick did a complete about-turn when he forayed into the world of design in 1988. Co-founding the multifaceted design studio DeArte, the completely self-taught designer took on interior design, graphic design, and art commissions before establishing his current company, Stage Design Office, where Anemi is only his third hotel project. Renowned in Athens—where he still lives and works— he's distinguished by his unique approach to design, likening the designer/client relationship to that of a patient and a doctor, no doubt a lingering hangover of his medical training. —

More from Anemi Hotels:

GREECE
Athens, AthensWas → P. 358

368

*Anemi Hotel*
*Folegandros Island, Greece*

# Ekies
# All Senses Resort

Kick off your shoes, wiggle your toes in the sand, and slip into the languid pace of Ekies All Senses Resort, a pared-down retreat that takes a barefoot approach to holiday relaxation. Celebrating its Greek roots and stunning natural location, the simple design lets the pristine surroundings shine and embraces the notion that luxury should be measured by one's ecological footprint. On an unspoiled beach in Vourvourou on the eastern side of Sithonia— one of three peninsulas in Halkidiki—the resort is surrounded by small rocky islands, caves, crystal-clear waters, sandy beaches, and pine tree forests. With respect for these idyllic surroundings, the design blends harmoniously with the landscape through the use of natural, unrefined materials, such as solid wood and Greek gray marble. The 69 rooms and suites weave elements of Greek tradition with distinctive and original designs, while organic forms, sustainability, metal-free Coco-Mat mattresses, and an ethos of minimal waste complete the resort's eco-philosophy. Diners can enjoy a fresh take on Greek food, made using local products and recipes, wherever and whenever they please, be it by the pool, on the beach, or at one of the three restaurants. This ease of indoor/ outdoor living continues at the Spa Studio, where treatments are accompanied by the sights and sounds of nature in the "Spa cabanas." For further relaxation, guests only have to look to the surrounding landscape, where the azure, tepid waters and rugged coastline provide endless activities to fill the days.

From a young age, Alexandra Efstathiadou's life has been deeply influenced by design. She says renovating Ekies All Senses Resort— the hotel she used to visit with her parents—was a childhood dream that she has finally been able to realize. She spent nine years working with different architects and interior designers to transform the resort into a showpiece for her own culture, "I want to present Greece through design and fabric. I want a history behind it, but in a modern way," she says. Efstathiadou is married to Vangelis Liakos, art director and co-founder of award-winning design agency Beetroot. Based in Thessaloniki the firm was awarded the Red Dot: Agency of the Year 2011 award and was responsible for the resort's visual identity. Efstathiadou's mother's family co-own Coco Mat, a leader for natural sleep products, bed linen, towels and furniture, which are used throughout the hotel. —

**WHERE**
Halkidiki
Greece

**MEMBER SINCE**
11/2011

**ARCHITECTURE**
Agarch Architects,
Ark Team,
Sparch Architects,
Stamataki-Taliadoros
& MP Architects,
T-Square Architects

**DESIGN**
157 + 173 Designers

**ROOMS**
69

**RATES**
EUR 110–900

**MEET THE ORIGINALS**
Alexandra
Efstathiadou,
Vangelis Liakos

Alexandra Efstathiadou

Vangelis Liakos

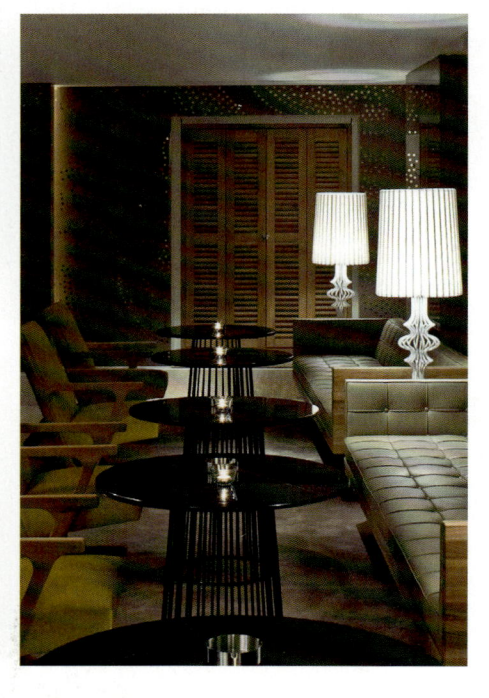

## Witt
## Istanbul Hotel

Located on Istanbul's European side, in a chic bohemian neighborhood of eclectic antique shops, cafés, and designer boutiques, the Witt Istanbul Hotel occupies an unassuming corner building on a residential street. Owner and Istanbul native Tuncel Toprak chose the Witt's location in Cihangir for its connection to a charmingly authentic local community. The Witt's stylish yet domestic atmosphere, exceptionally personalized service, and Toprak's extensive network afford guests an intimate glimpse of everyday life in the thriving metropolis, without sacrificing style or comfort. Autoban, the award-winning Istanbul-based architecture and design firm, outfitted the hotel with an array of distinctly modern furnishings. The interior's monochromatic mix of natural, earthy tones and black and white accentuates each room's sculptural elements and spacious design. Istanbul's rich history is reflected in the designers' use of materials, such as the Marmara marble of classic Ottoman architecture. Each suite is equipped with a kitchenette, bar, lounge area, and private balcony. The latter offers captivating views over Istanbul's picturesque skyline of handsome mosques and ramshackle rooftops, as well as the glistening topaz waters of the Bosporus. —

**WHERE**
Istanbul
Turkey

**MEMBER SINCE**
06/2010

**ARCHITECTURE /
DESIGN**
Sefer Çağlar,
Seyhan Özdemir
(Autoban)

**ROOMS**
18

**RATES**
EUR 185–450

**MEET THE ORIGINAL**
Tuncel Toprak

# The House Hotel
# Nişantaşı

**WHERE**
Istanbul
Turkey

**MEMBER SINCE**
12/2012

**ARCHITECTURE / DESIGN**
Sefer Çağlar,
Seyhan Özdemir
(Autoban)

**ROOMS**
44

**RATES**
EUR 160–349

**MEET THE ORIGINALS**
Ferit Baltacıoğlu,
Canan Özdemir

Perfectly suited to its location above a Prada store on Abdi İpekçi Caddesi, Istanbul's answer to Madison Avenue, The House Hotel Nişantaşı is the second property by café chain pioneers Canan Özdemir and Ferit Baltacıoğlu. With five floors of lavish forms by Turkish design duo Autoban, the hotel successfully connects fashionistas with the city's vibrant, East-meets-West shopping scene. Nişantaşı, the area immediately around the hotel, is Istanbul's most stylish district. Guests can easily spend the day exploring with a personal shopper who has insider knowledge on local fashion and couture. Those who want to unearth cultural treasures can follow a guide from Locally Istanbul, an exclusive service that connects visitors with experts on art, design, and the latest culinary trends. Guests can also enjoy personal Pilates sessions in the hotel's serene studio, housed on the top floor and offering direct sea views. International and Turkish flavors combine at the restaurant's alfresco tables, which attract well-to-do locals and lead into a charming, bistro-like lobby lounge. A true boutique hotel, this cozy city hideaway has just 34 elegantly paneled rooms, plus 10 suites offering views across Nişantaşı's chic cafés and bars. Organic amenities and attentive service add the finishing touches to a hotel that has, understandably, been ranked among the best in the world. In 2011, it was included on *Condé Nast Traveler's* prestigious Hot List. —

WHERE
Istanbul
Turkey

MEMBER SINCE
12/2012

ARCHITECTURE /
DESIGN
Sefer Çağlar,
Seyhan Özdemir
(Autoban)

ROOMS
20

RATES
EUR 119–249

MEET THE ORIGINALS
Ferit Baltacıoğlu,
Canan Özdemir

# The House Hotel Galatasaray

Just like the successful cafés that Canan Özdemir and Ferit Baltacioglu have opened across Istanbul, The House Hotel Galatasaray (their first foray into the hotel business) commands a privileged location. Tucked away among the antique stores of Çukurcuma, the bohemian neighborhood that has inspired countless artists, this 19th-century mansion has been painstakingly restored to offer guests total inner-city tranquility. Acclaimed Turkish design studio Autoban won several awards for its work in restoring the five-story Zenovitch building and bringing out its original details. The sensitive makeover means older features, such as the solid marble staircase that stretches through the lobby, sit comfortably among contemporary wall moldings and polished parquet floors. A gray stone fireplace warms diners in the all-day roof lounge, which has views over downtown Istanbul, while the twenty crisp white rooms, and suites with their high ceilings and marble bathrooms, are an ideal base for exploring the winding streets of Çukurcuma and the rest of Beyoglu. Guests looking for an inside track on the latest food, design, and art can follow an expert from the exclusive guiding service Locally Istanbul, or spend a day with their own personal shopper.

It was the runaway success of their café brand—The House Café—that inspired Canan Özdemir and Ferit Baltacioglu to enter the hotel business. Since the niche-carving House Hotel Galatasaray launched in April 2010, the business partners have gone on to open four more hotels: The House Hotel Nişantaşı, The House Hotel Bosphorus, Vault Karaköy, The House Hotel and The House Hotel Cappadocia. All five have outstanding city-center locations. Although Canan's background is in auditing and Ferit's is in mechanical engineering, they found a shared love of launching new cafés in exciting places. In addition to the five hotels, Canan and Ferit now operate 12 cafés across Istanbul, plus franchised cafés in Baku, Izmir, Antalya and Ankara. —

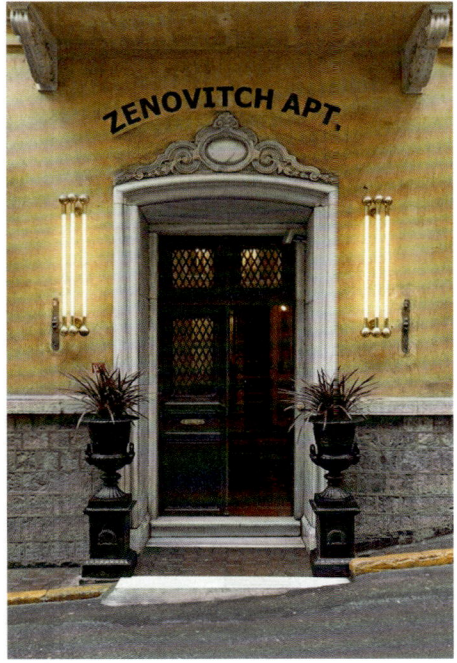

# Gezi Hotel Bosphorus

**WHERE**
Istanbul
Turkey

**MEMBER SINCE**
08/2012

**ARCHITECTURE / DESIGN**
Sinan Kafadar
(Metex Design
Group)

**ROOMS**
67

**RATES**
EUR 220–1,500

**MEET THE ORIGINAL**
Can Atay

Gezi Hotel Bosphorus, the oldest name at Taksim Square, is located in Istanbul's modern, high-rise center; just steps away from the magnificent Bosphorus, the historical old town, and the buzz of the city. The hotel offers business and leisure travelers alike a retreat right in the heart of Istanbul. Located directly across from Taksim Gezi Park, Gezi Hotel Bosphorus' gently curved façade seems to hold the city in a tender embrace. The hotel's 67 rooms, divided into nine different categories, are all designed to woo with sumptuous interiors and spectacular views of the river or the peaceful park. The green certified Gezi Hotel Bosphorus combines luxe materials like high-quality wood and leather with a contemporary design ethos that fuses the color-blocking of Piet Mondrian with high-tech flourishes. First-class conference facilities and in-room business centers provide ideal in-house working conditions. Guests have four meeting rooms of varying sizes at their disposal, as well as a foyer with secretarial desks and state-of-the-art equipment. After a long day of meetings or sight-seeing, guests can unwind at the hotel's Fiamma Restaurant & Bar while enjoying exceptional views of the Bosphorus and indulging in flavorful Mediterranean cuisine. The Silver Spa offers luxurious treatments such as Far East rituals, a modern Turkish bath, steam rooms, sauna, ice fountain, and hot tub. —

# The Sofa Hotel & Residences

Oriental indulgence meets hip Occidental design at The Sofa Hotel & Residences, a chic luxury hotel in the city's upscale Nisantasi quarter. Personalized service and spa options make The Sofa part of the new generation of upscale Istanbul—a reflection of the city's appealing spirit and a prime choice for contemporary travelers looking for urban comfort.

**WHERE**
Istanbul
Turkey

**MEMBER SINCE**
01/2009

**ARCHITECTURE /
DESIGN**
Sinan Kafadar
(Metex Design
Group)

**ROOMS**
82

**RATES**
EUR 180–4,500

**MEET THE ORIGINAL**
Ali Güreli

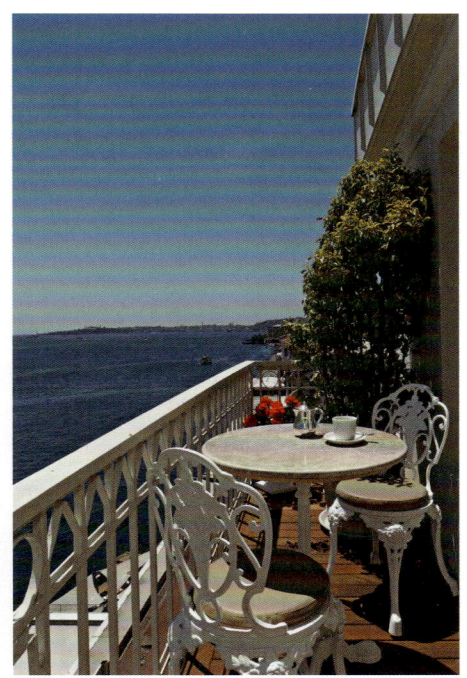

# The House Hotel Bosphorus

With 26 guestrooms and an unbeatable waterfront location near Ortakoy Mosque, The House Hotel Bosphorus is the third property by Turkish entrepreneurs Canan Özdemir and Ferit Baltacıoğlu. Designed by the same dynasty of architects that created Istanbul's finest Ottoman landmarks, this palatial retreat now has interiors by local design group Autoban. Along with a fitness area and meeting space, the hotel offers three panoramic penthouse suites with vitalizing views over the Bosphorus, the strait that separates Europe from Asia.

**WHERE**
Istanbul
Turkey

**MEMBER SINCE**
12/2012

**ARCHITECTURE /
DESIGN**
Sefer Çağlar,
Seyhan Özdemir
(Autoban)

**ROOMS**
26

**RATES**
EUR 180–900

**MEET THE ORIGINALS**
Ferit Baltacıoğlu,
Canan Özdemir

# Maçakizi

Home to a host of designer boutiques, trendy bars, and beach clubs, Turkbuku is often referred to as the St. Tropez of Turkey, and now thanks to Maçakizi Restaurant, which has become a mecca for the jet-set, the Maçakizi hotel is putting the coastal town on the international map. Topping a hill strewn with olive groves, the 74-room hotel—most with panoramic views of the Aegean Sea and beyond—is an exercise in understated luxury with travertine floors, open plan bathrooms, and rain showers. The restaurant, located in an open-air dining room serves up a sumptuous Mediterranean menu, while the private beach provides an intimate place to relax and soak up the surrounding scenery. Other facilities include a swimming pool, fitness center, and the Nuxe Spa, that has a traditional Turkish hammam. The Mediterraneo pavilion offers a dramatic, glass-enclosed area, making it possible to enjoy gourmet dinners by the fireplace overlooking the bay during the cooler months of the season. Thanks to Maçakizi's new yacht, Vanilla, and speedboat, the stunning Greek islands closeby are just a ride away.

Entrepreneur Ayla Emiroğlu left the bright lights of Istanbul in 1977 and established a 19-room pension—which quickly became a popular hangout for writers, artists, and intellectuals alike—in the then quiet town of Bodrum. As the port city evolved as a destination, Emiroğlu headed a few miles away and launched an intimate 7-room boutique hotel in Gumbet, followed by the first beach club in the nearby region of Torba. Emiroğlu's son, Sahir Erozan, meanwhile, was running his own hotspot, a restaurant and lounge in Washington D.C. However in 2000, he returned to his native Turkey and joined forces with his mother to launch the successful Maçakizi hotel in the isolated fishing village of Turkbuku. —

| WHERE | ROOMS |
|---|---|
| Turkbuku, Bodrum Turkey | 74 |
| | VILLAS |
| MEMBER SINCE | 6 |
| 12/2013 | |
| | ROOM RATES |
| ARCHITECTURE | EUR 425–2,950 |
| Ahmet Alataş | |
| (Alataş Architcture | VILLA RATES |
| & Consulting) | EUR 1,495–2,950 |
| | MEET THE ORIGINALS |
| | Ayla Emiroğlu, |
| | Sahir Erozan |

# The House Hotel Cappadocia

Set in a complex of adjoining ancient caves and traditional homes, The House Hotel Cappadocia offers guests a luxurious update on life in the 5th century. Here one is immersed in a world of carved stones that not only shed light on how folks lived long ago, but that also make for the ultimate design feature. The 29 rooms currently bookable (plans call for 45 when the hotel is complete) are carved from several buildings built in the 5th century, as well as the 1800s and late 1900s. Each are uniquely designed in a freshly understated way for the region and feature frescoes, crown moldings, and other original elements that speak to Cappadocia's rich heritage. The hotel's locally inspired restaurant and spa with Turkish hammam, sauna, and steam, help to provide a truly authentic experience. Indeed, the House Hotel Cappadocia offers one full immersion into the local scene, as guests are encouraged to engage with and become part of the community here in the town of Ortahisar. And those same community members also flow into the hotel, thanks to its lofty underground chapel for weddings, concerts, and creative workshops.

It was the runaway success of their café brand—The House Café—that inspired Canan Özdemir and Ferit Baltacıoğlu to enter the hotel business. Since the niche-carving House Hotel Galatasaray launched in April 2010, the business partners have gone on to open three more hotels: The House Hotel Nişantaşi, The House Hotel Bosphorus, and now, The House Hotel Cappadocia. All three have outstanding central locations. Although Özdemir's background is in auditing and Baltacıoğlu's is in mechanical engineering, they found a shared love in launching new cafés in exciting places. In addition to their hotels, Canan and Ferit now operate 12 cafés across Istanbul, plus franchised cafés in Antalya and Ankara. —

| WHERE | ROOMS |
|---|---|
| Ortahisar | 29 |
| Turkey | |
| | RATES |
| MEMBER SINCE | EUR 149–600 |
| 07/2015 | |
| | MEET THE ORIGINALS |
| DESIGN | Ferit Baltacıoğlu, |
| Şekibe Aslan | Canan Özdemir |

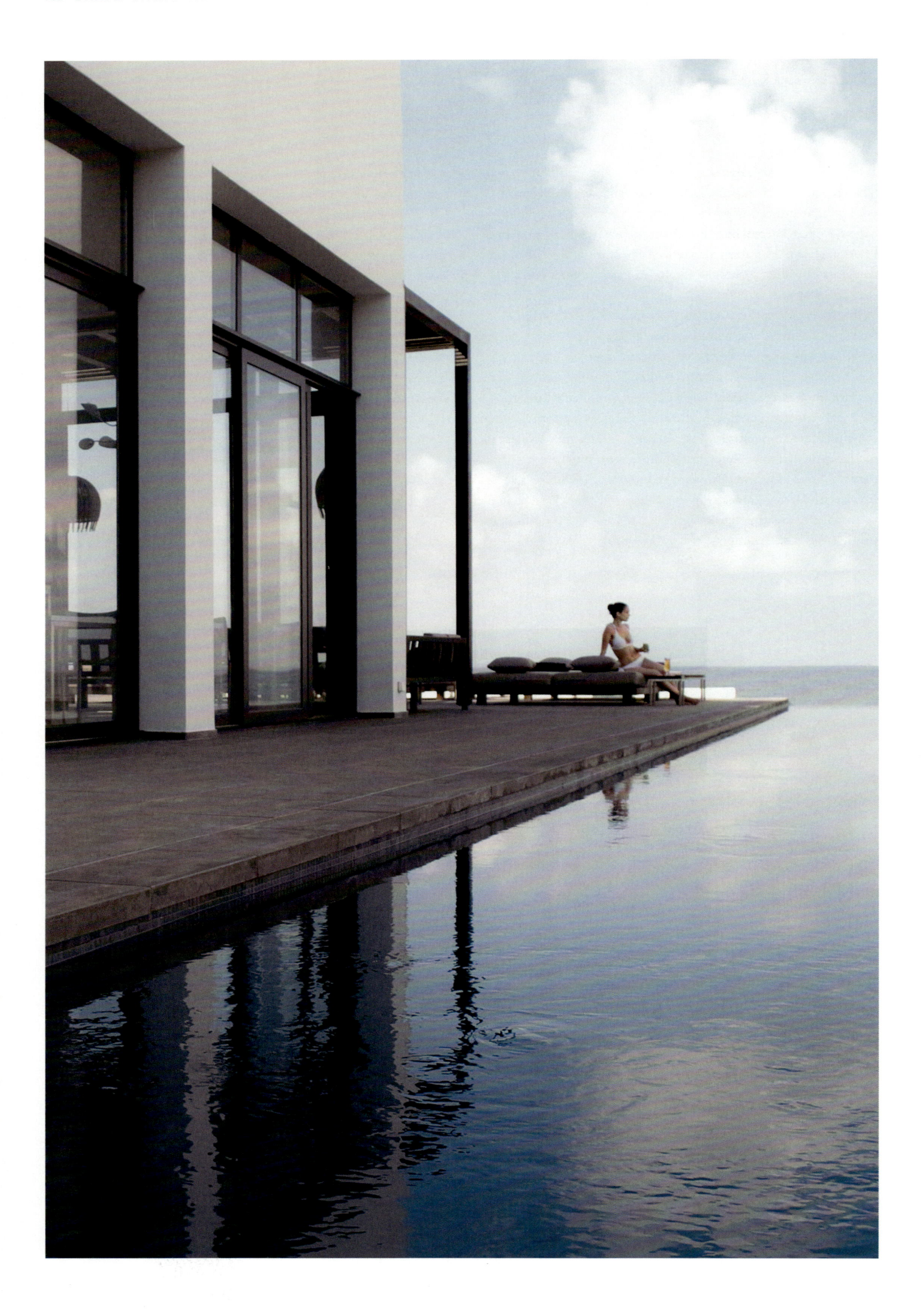

# Almyra

Situated amid eight acres of gardens overlooking the Mediterranean Sea in the coastal city of Paphos, Almyra's enviable location is only the beginning of its story. Under the direction of Thanos Michaelides, the hotel has been family-run and -operated since 1974, relaunching as Almyra in 2003 with diverse contemporary touches. The focus here is on what Michaelides refers to as "modern hospitality," with equal consideration paid to the needs of those traveling with young families and those without. The result is a unique space where simplicity reigns: as inclusive as it is exclusive. With pure, crisp design courtesy of Parisian designer Joelle Pléot, the 189-room hotel is a first on the island; its uncomplicated ease merges seamlessly with the historic surroundings of Paphos. Views of Paphos Castle from Helios Lounge Bar compete with the beachfront Ouzeri, one of four restaurants, where diners are served traditional Greek fare accompanied by sunsets and the sound of crashing waves. The expansive grounds offer families, couples, and singles an assortment of diverse leisure facilities. For solace and well-being, the Almyraspa is home to an extensive menu of organic treatments. Alternatively, two heated freshwater pools and a tennis court cater to more active visitors. Since March 2013, a kids' club offers indoor and outdoor activities in the Explorers program, managed by leading professional UK childcare specialists. Almyra allows all guests the opportunity to create their own, truly personal experience in surroundings that are smooth, fresh, and thoroughly modern.

Thanos Michaelides and his two sisters have been running the family business, Thanos Hotels, with their father since the 1980s. Almyra is one of three hotels in the group, and the only hotel catering to both design aficionados and families. Despite the demands of overseeing three hotels, the father of two still finds time to indulge his passions, such as his impressive collection of classic cars. Capitalizing on a dearth of family-oriented boutique resorts in Cyprus and across the continent, Thanos Michaelides set out to combine high-end design aesthetics with family-friendly features. The result is a resounding, ever-surprising success. —

Thanos Michaelides

**WHERE**
Paphos
Cyprus

**MEMBER SINCE**
01/2004

**ARCHITECTURE**
J+A Philippou

**DESIGN**
Joelle Pléot

**ROOMS**
189

**RATES**
EUR 100–880

**MEET THE ORIGINAL**
Thanos Michaelides

# Rooms Hotel
# Kazbegi

With peaks reaching a formidable 5,000 metres, the dramatic Caucasus Mountain range delivers a spectacular backdrop for this retreat, the first of its kind in northern Georgia. Comprising 156 guestrooms—each with breathtaking vistas—the warm structure of wood, glass, and steel has been designed by young Tbilisi-based duo Nata Janberidze and Keti Toloraia. A restaurant serving traditional Georgian fare interspersed with a host of international dishes is accompanied by a cozy bar with its own fireplace and cigar menu. Meanwhile, a sweeping sun terrace provides a place to relax and soak in the rugged surroundings. Other facilities comprise a spacious lobby lounge, library, casino, gym, sauna, and indoor swimming pool, also with spectacular views of the mountains. For the more adventurous, a range of outdoor activities from quad-bike tours to heliskiing is on offer, while culture enthusiasts can explore the nearby landmark Gergeti Trinity Church.

Inspired by hoteliers in New York, forward-thinking entrepreneur Temur Ugulava is forging a new future for hospitality in Georgia. With a unique, avant-garde approach to design—combining traditional with a contemporary—each property by the Rooms Hotel Group is a proud showcase of a new Georgia. With his first, wildly successful Rooms Hotel Kazbegi still luring guests to the Caucasus Mountain range, Ugulava has now created with Rooms Hotel Tbilisi a focal point for a new wave of thinkers, artists, and designers who are slowly reclaiming the capital's Vera district as a local cultural hub for the 21st century. —

More from Rooms Hotels:

GEORGIA
Tbilisi, Rooms Hotel Tbilisi → P. 386

| WHERE | ROOMS |
|---|---|
| Stepantsminda Georgia | 156 |
| **MEMBER SINCE** 10/2013 | **RATES** USD 125–250 |
| **ARCHITECTURE / DESIGN** Adjara Arch Group | **MEET THE ORIGINAL** Temur Ugulava |

# Rooms Hotel Tbilisi

Rooms Hotel Tbilisi is located in the intellectual neighborhood of Vera, in Georgia's capital, and cleverly incorporates the building's history as a publishing house into its design elements, while also honoring its cultural past with many art and music events. Young local architecture firm Adjara Arch Group is responsible for the brilliantly sensitive restoration. Salvaged wood along with post-industrial window frames-typical to the city-create an eye-catching façade. Sections of the hotel, showcasing original Georgian art, have been given gallery-like treatment featuring atrium-style walls that allow for plenty of daylight. Rooms Hotel Tbilisi's "feel like a local" mantra ensures the presence of many such glass façades, including in the restaurant, so that guests can interact with the buzzing local scene outside. Rife with regal sophistication, the 8-floor property boasts 137 rooms and suites, combining distinct 1930s New York vibes with old-world Tbilisi charm. Each room features bespoke furniture and handmade wallpaper showcasing painted textures and silkscreened graphic patterns. Rich, fragrant leather, mood lighting, velvety textures, and carefully selected sounds fill the spacious fireplace lounge and cocktail bar-home to international guests and fashionable Georgians alike. An enchanting garden takes guests away from the stresses of urban living and the nouveau American restaurant, The Kitchen, with its rough-but-sophisticated artisanal interior and long communal tables encourages diners to sit for hours and socialize over delectable dishes.

Inspired by hoteliers in New York, forward-thinking entrepreneur Temur Ugulava is forging a new future for hospitality in Georgia. With a unique, avant-garde approach to design—combining traditional with a contemporary style—each property by the Rooms Hotel Group is a proud showcase of a new Georgia. With his first, wildly successful Rooms Hotel Kazbegi still luring guests to the Caucasus Mountain range, Ugulava has now created Rooms Hotel Tbilisi. This bold property is a focal point for a new wave of thinkers, artists, and designers who are slowly reclaiming the capital's Vera district as a local cultural hub for the 21st century. —

More from Rooms Hotels:

GEORGIA
Stepantsminda, Rooms Hotel Kazbegi → P. 384

| WHERE | ROOMS |
|---|---|
| Tbilisi | 137 |
| Georgia | |
| | RATES |
| MEMBER SINCE | USD 160–700 |
| 08/2014 | |
| | MEET THE ORIGINAL |
| ARCHITECTURE / | Temur Ugulava |
| DESIGN | |
| Adjara Arch | |
| Group | |

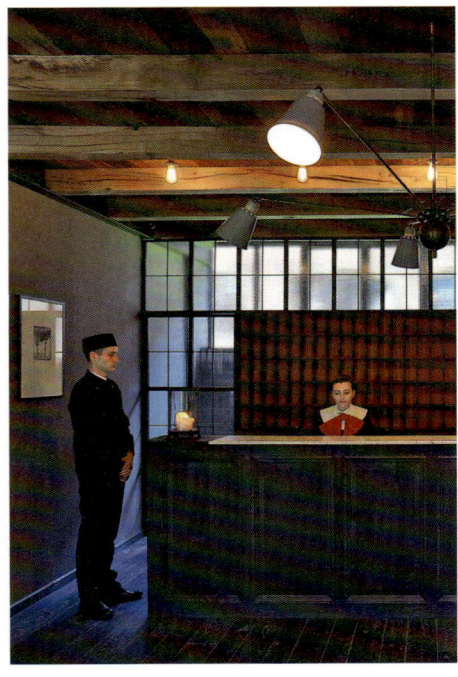

# 11 Mirrors

**WHERE**
Kiev
Ukraine

**MEMBER SINCE**
11/2012

**ARCHITECTURE /
DESIGN**
Anatoliy Kirik,
Marina Leo

**ROOMS**
49

**RATES**
EUR 230–765

**MEET THE ORIGINALS**
Wladimir Klitschko,
Ruslan Oleksenko

One mirror by itself is just a single reflection. But bring many mirrors together and the result is a multifaceted, seemingly infinite series of images that changes every time you look. A visit to Kiev today might be a similar experience. The bustling Ukrainian capital is a fairytale city of onion domes and frescoes, a progressive center of science and education, a hub of business and economics, and a highly desirable culture and leisure destination. Experience every facet of modern Kiev at the city's first and only design hotel, 11 Mirrors. Wladimir Klitschko worked with a team of Ukrainian and international professionals to realize his vision of a hotel that would reflect the many different aspects of Kiev, as well as his own experience as a world traveler. The theme of reflection carries throughout the entire 11-story hotel. The lobby features a stainless steel ceiling designed by Anatoliy Kirik, as well as mirrored wall decor by the Fomichev Brothers Creative Studio. Panoramic windows offer dramatic views of the city, while LCD televisions provide a mirror of the world. The hotel's elegant minimalism is itself a reflection of contemporary Ukraine: sophisticated and simple, with no need for heavy embellishments. Forty-nine rooms and suites offer space for self-reflection as well, from the Incognito Superior Rooms to the exclusive Lifestyle Executive Suite. —

# Sense Hotel Sofia

Flip open the brass shutters and let light flood into your room right above Sofia's yellow paved main boulevard Tzar Osvoboditel. Your bed faces a vertical wall of glass, with views stretching well beyond the neighboring National Assembly and St. Alexander Nevski Cathedral. This is Sense Hotel Sofia, the first upscale design hotel in Bulgaria's capital. Some of the city's most significant architecture can be found nearby, but rather than simply making the building fit in with its neighbors, owners George Chopev, Tatyana Stoilova, and Ivo Hristov deliberately challenged the status quo. With the help of Lazzarini Pickering Architetti, he created a building that is sensitive to its surroundings, but whose innovative glass façade literally reflects Sofia's past, present, and future. Chopev, Stoilova, and Hristov also called upon designers at Architectural Group Tzonkov, who created sophisticated spaces that are loved by locals and guests. Stay in one of the 71 rooms and suites, eat on the terrace of the Mediterranean fusion restaurant, relax in the lobby lounge, sip champagne in the panoramic rooftop bar, or swim in the health center's stainless-steel swimming pool, and you'll discover that Sense Sofia is a new classic that stands out from the crowd. By meeting the changing needs of its guests, and acting as an architectural landmark in its own right, the hotel is sure to stand the test of time. —

| | |
|---|---|
| **WHERE** | **ROOMS** |
| Sofia | 71 |
| Bulgaria | |
| | **RATES** |
| **MEMBER SINCE** | EUR 110–290 |
| 12/2012 | |
| | **MEET THE ORIGINALS** |
| **ARCHITECTURE** | George Chopev, |
| Lazzarini Pickering | Ivo Hristov, |
| Architetti | Tatyana Stoilova |
| | |
| **DESIGN** | |
| Architectural | |
| Group Tzonkov | |

# Lánchíd 19

Lánchíd 19 provides a beautiful view of the UNESCO World Heritage Sites of Budapest and is situated on the Danube riverbank at the feet of the Buda Royal Castle, just a few minutes walk from the city center. Named after Budapest's famed "Chain Bridge," spanning the Danube, the hotel is a contemporary highlight in a neighborhood of predominately 19th-century architecture. A beacon of innovation while still paying homage to its historical settings, Lánchíd 19 is a perfect point of departure for discovering the wonders of Budapest.

**WHERE**
Budapest
Hungary

**MEMBER SINCE**
10/2005

**ARCHITECTURE /
DESIGN**
László Benczúr,
Péter Sugár

**ROOMS**
48

**RATES**
EUR 70–353

**MEET THE ORIGINAL**
Edit Rozsos

# H15
# Boutique Hotel

To check into H15 Boutique Hotel, located on one of the oldest streets in central Warsaw, is to stay at the epicenter of European history. The 19th-century building, originally constructed as a grand private residence, has hosted secret meetings for Polish independence prior to WWI, been home to a Soviet embassy, a headquarters for the Nazi party, and a prize possession of the People's Republic of Poland. Today, following a recent five-year gut renovation, this impressive 46-room gem celebrates its storied past while also emerging as a glorious example of contemporary luxury.

**WHERE**
Warsaw
Poland

**MEMBER SINCE**
04/2014

**ARCHITECTURE /
DESIGN**
Mariola Tomczak

**ROOMS**
46

**RATES**
EUR 150–300

**MEET THE ORIGINAL**
Grzegorz Rygiel

# Hotel Galery69

Frozen over or bathed in warm sun, the lakes of northeastern Poland are consistent in their splendor. Visit during the winter and you can ice skate as snow falls gently onto the red roofs of lakeside cottages. Make the same trip in the summer and it's easy to spend lazy days fishing, swimming, or kayaking as warm breezes ripple across the surface. Artists Małgosia and Wojtek Żółtowscy knew that one of this region's lakes—Wulpińskie—would provide the perfect setting for a new kind of hotel, one which effortlessly melds art with unspoiled nature and an exhilarating mix of outdoor activities. Part showroom, part creative hangout, Hotel Galery69 is a place for dreamers, trend spotters, and conscientious travelers. Aesthetically, emotionally, and gastronomically, the 21-room lodge, which has its own spa and restaurant, takes inspiration from the surrounding environment. All of the furnishings are designed and carefully assembled by Małgosia and Wojtek. The couple handpicked everything, including the floors, walls, windows, and fabrics, conjuring up inspirational spaces that attract creative minds. —

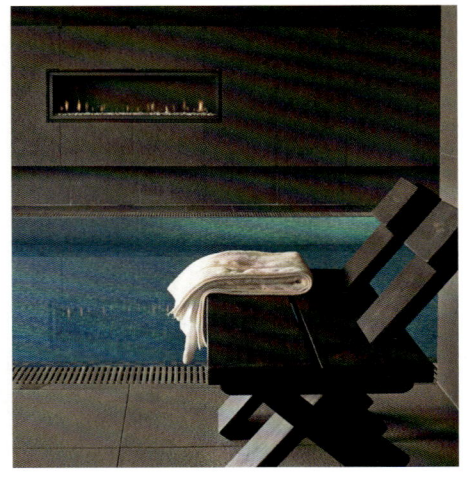

WHERE
Dorotowo, Masuria
Poland

MEMBER SINCE
10/2013

ARCHITECTURE /
DESIGN
Małgosia Żółtowska,
Wojtek Żółtowski
(Manufaktura69)

ROOMS
21

RATES
EUR 130–280

MEET THE ORIGINALS
Małgosia Żółtowska,
Wojtek Żółtowski

# Miura Hotel

The Czech village of Celadna sits among the Beskydy Mountains, where misty peaks and ridges give way to crumbling castles and soft-flowing streams. Framing this pastoral scene is forward-looking Miura Hotel, a sharp-sided steel building that lets guests enjoy high-tech spa treatments and world-class art (original works by Andy Warhol and Damien Hirst are among those adorning the walls). Indeed, a rather special surprise in this untouched paradise where contemporary masters such as Jean-Michael Basquiat, Anish Kapoor, Tony Cragg, Henry Moore, and David Černý sit serendipitously indoors and outdoors for guests to enjoy. A 36-hole golf course extends away from the restaurant's glass-edged terrace, which has views of the forest-covered mountains. The subterranean spa also provides sweeping views of the rugged landscape from the swimming pool. To complement the giant-like statues by Czech sculptor David Černý, which seem to crawl along the hotel's walls, the masters at Prague-based architectural practice Labor 13 commissioned special pieces of furniture from European and Czech designers. Their slick and unexpected forms appear in the hotel's public spaces as well as the 44 rooms and suites.

The driving force behind Miura Hotel is the art collector Richard Kučík. Working with his father, an experienced hotelier who shares the same name, he set about creating an adventurous new hotel that would allow guests not just to see art, but actually live around it. "We wanted to build something timeless and original," says the younger Richard. Teaming up with Czech architectural studio Labor 13, he and his father managed exactly that, launching a hotel that success-fully fuses world class art with bold modern design, unforgettably good spa treatments, and views of the forested hills. —

Richard & Richard Kučík

WHERE
Celadna
Czech Republic

MEMBER SINCE
07/2013

ARCHITECTURE
Albert Pražák,
Martin Vomastek
(Labor 13)

DESIGN
Labor 13

ROOMS
44

RATES
EUR 114–471

MEET THE ORIGINALS
Richard &
Richard Kučík

# Hotel Josef

**WHERE**
Prague
Czech Republic

**MEMBER SINCE**
11/2001

**ARCHITECTURE /
DESIGN**
Eva Jiricna
(Eva Jiricna
Architects)

**ROOMS**
109

**RATES**
EUR 119–299

**MEET THE ORIGINAL**
Rudolf Ploberger

In the heart of one of Europe's most beautiful cities, Eva Jiricna's award-winning design for Hotel Josef is a masterpiece of contemporary cool, building on a great 20th-century tradition of modern Czech design. The 109-room Hotel Josef comprises two buildings centered on a peaceful, landscaped courtyard that create a chilled-out counterpoint to the active, urban lifestyle of Prague's old town. Abandoning conventional hotel interiors, Hotel Josef boldly embraces minimalist, comfort-bidding features. Evoking a stark white modernist utopia, the reception and bar area features clear lines, glossy surfaces, and a magnificent example of Jiricna's signature high-tech steel and glass staircase, which connects the conference area with the lobby, and its floor-to-ceiling windows leading out to the Zen-inspired courtyard. A mix of efficiency and luxury pervades the rest of the hotel, and guest-rooms are equipped with the latest communications technology. A business center and gymnasium, along with a sauna, complete the sophisticated environment of Hotel Josef, which has already become a favorite destination in Prague's growing tourist economy. —

# StandArt
# Hotel Moscow

The country's first Design Hotels™ member, StandArt, has put Moscow firmly on the hospitality map—especially for those who value top-of-the-line gastronomy, luxurious amenities, and a cosmopolitan ambience right on Pushkin Square. Housed behind a monumental Art Nouveau façade and designed by architect Pavel Andreev—known for the internationally acclaimed redesign of the Bolshoi Theater in 2011—StandArt surprises with unexpected modernism and sleek lines, boasting 105 carefully designed rooms and suites, some offering breathtaking views of the square. Spacious yet welcoming gathering spots offer rest and retreat after a good day's exploration of neighborhood hot spots, such as the famous restaurant and café Pushkin and the luxury shopping lanes of Stoleshnikov and Stratsnoy. Guests and locals mingle in the lobby and the ninth-floor lounge bars, or recharge with a city view and hearty meal at the in-house restaurant, courtesy of the Michelin-starred executive chef. Also a first for the city's luxury lifestyle landscape, StandArt's exceptional spa includes a full thermal zone—complete with a fully equipped gym, a traditional Russian steam room, and the country's first Dr. Barbara Sturm Molecular Cosmetics studio. Taken together, it makes StandArt an exciting new melting pot for the city's creatives in the bustling capital. —

| WHERE | ROOMS |
|---|---|
| Moscow | 105 |
| Russia | |
| | RATES |
| MEMBER SINCE | RUB 18,000– |
| 10/2014 | 210,000 |
| ARCHITECTURE | MEET THE ORIGINAL |
| Pavel Andreev | Stanislav Tratsevskiy |
| DESIGN | |
| Piotr Bragovskiy | |

PAGE 396–407

# Africa & Near East

HOTELS

# 7

COUNTRIES

**Israel, Kenya, Morocco, Oman, South Africa, Tanzania** »

MOROCCO

# AnaYela

AnaYela, a gorgeous 300-year-old palace transformed into an opulent boutique hotel, is the jewel of Marrakech's Medina, or ancient quarter. This four-time winner of the World Hotel Awards "Soul Experience" prize also garnered a special award for outstanding service and has been selected for the Condé Nast Hot List. AnaYela is like a passionate affair: The luminous three-room and two-suite city palace will leave lucky guests breathlessly drunk on the thrill of new discovery. More exciting than its mesmerizing appearance, however, is the love story that took place behind AnaYela's closed doors: A 16-year-old girl and her beau once had clandestine nighttime meetings in the palace's Tapis Volant, or "flying carpet" tower. During the hotel's full-scale renovation in 2007, a handwritten manuscript was discovered in a hidden room behind a wall. The lovers' tale has now been engraved in Arabic calligraphy onto every door in the property. The silver characters can be viewed chronologically while ambling through the roofless indoor courtyard, which features a heated limestone pool, and up to the beguiling rooftop terrace with its extraordinary panoramic views of Marrakech. With so much mystique, it's no wonder that guests report feeling as if they've stepped into a captivating and indulgent mirage. —

| | |
|---|---|
| **WHERE** | **ROOMS** |
| Marrakech | 5 |
| Morocco | |
| | **RATES** |
| **MEMBER SINCE** | EUR 190–490 |
| 11/2008 | |
| | **MEET THE ORIGINALS** |
| **ARCHITECTURE /** | Andrea Kolb, |
| **DESIGN** | Bernd Kolb |
| Bernd Kolb, | |
| Yannick Hervy | |

# Tribe Hotel

**WHERE**
Nairobi
Kenya

**MEMBER SINCE**
09/2011

**ARCHITECTURE**
Mehraz Ehsani

**DESIGN**
Les Harbottle

**ROOMS**
137

**RATES**
USD 245–1,350

**MEET THE ORIGINAL**
Shamim Ehsani

Urban, loft-like style blends effortlessly with warm African colors at Nairobi's Tribe Hotel, a pioneering lifestyle property that sets itself apart with atypical angles and an unrivalled appreciation for tribal crafts. Some nine hundred hand-sculpted artifacts from throughout Africa have been gathered here, capturing the diversity of the continent and evoking a sense of splendor that is raising the luxury hotel stakes in the continent. Spread across three wings in the heart of Nairobi's diplomatic district, home to the United Nations and many other institutions, a soaring sunlit atrium links the Tribe's 137 guestrooms and suites. Inside, cool granite and stretches of dark Indian slate temper earthy combinations of cumin, sandstone, and brown-sugar hues. Architect Mehraz Ehsani continues this balance by using authentic and tactile Kenyan materials in the public spaces. These include the curvy Kaya Spa, which takes its inspiration from the country's sacred forests; the well-stocked library, home to almost 3,000 books; the rooftop bar; and the heated pool, surrounded by waterfalls and gardens. At the sophisticated Jiko restaurant, diners can enjoy melt-in-the-mouth grilled meats with fresh, seasonal vegetables and pasta, gelato, and pastries all made in-house. Adjacent to the hotel is the Village Market, a shopping and entertainment complex that is also home to a weekly Maasai market. —

# Zuri Zanzibar

WHERE
Zanzibar
Tanzania

MEMBER SINCE
12/2015

ARCHITECTURE
Jestico + Whiles

DESIGN
Jestico + Whiles,
Le Patio Lifestyle

ROOMS
65

RATES
USD 250–2,500

MEET THE ORIGINAL
Vaclav Decjmar

Zuri Zanzibar is the perfect base from which to take in the natural beauty of a stunning archipelago: The hotel boasts a 300-meter stretch of private and pristine beach, a verdant spice garden of exotic flora, and west-facing views of the African sunsets over the azure Indian Ocean. Situated on the northern coast of Zanzibar's main island of Unguja, the property immerses guests in gorgeous natural surroundings amid a captivating setting of traditional African design and cool modernism. The internationally renowned Prague-based studio Jestico + Whiles has created a garden-like landscape shaded by palm trees and cooled by the sea breeze. Here, bungalows and villas—many with private terraces, hammocks, and thatched roofs that typify the design of traditional African villages—offer the perfect tropical hideaway for guests. Natural materials are ubiquitous, from the raw beams used in the structures, to the polished furniture pieces in the rooms and communal areas, resulting in an overall "African chic" character. While remaining ecologically and socially sensitive, the property uses local materials and fair-trade organizations to create a luxurious retreat that is topped off with a swimming pool bar and grill; a waterfront cocktail bar, offering the perfect spot for a sundown tipple; and an intimate—and inimitable—"dinner on the beach" service that's sure to be an unforgettable experience. —

# Ten Bompas

A suite-only hotel, Johannesburg's Ten Bompas maximizes design diversity. Its public spaces, featuring graceful curves and neutral walls set off by lively prints on custom-built furniture, provide relief from the bustle of the business district. The Winehouse restaurant serves simple, delicious French fare from the hotel's own garden. The striking architecture of Space, the hotel's function and events center, adds a new dimension to Ten Bompas. Proprietor Christoff van Staden charged a different top designer with creating a home away from home in each of the 10 suites.

WHERE
Johannesburg
South Africa

MEMBER SINCE
09/1999

ARCHITECTURE
Luc Zeghers
(Luc Zeghers and
Associates),
Enrico Daffonchio
(Enrico Daffonchio
and Associates)

DESIGN
Paul Mrkusic
(Spark Interiors)

ROOMS
10

RATES
ZAR 3,250–3,500

MEET THE ORIGINALS
Peter Aucamp,
Christoff van Staden

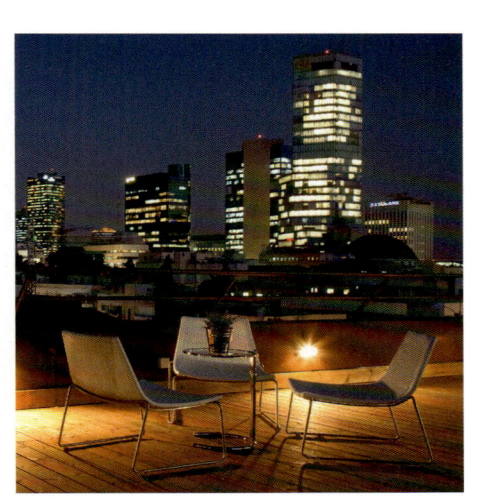

# Brown TLV

Behind the façade of a former bank in the Neve Tzedek district, is the Brown TLV—a hotel defined by its rich, chocolate-colored walls, dark wood floors, and vintage-inspired furniture. The 30 rooms invite an intimate, personal experience, in contrast to the restless city of Tel Aviv outside. Here, guests find cocktail-hour lighting, leather couches, and low-slung chairs, while warmly-lit hallways and the occasional piece of provocative art lead into perfectly tailored rooms. On the rooftop, guests can lounge under the Mediterranean sun or take a refreshing open-air shower overlooking the vibrant city.

WHERE
Tel Aviv
Israel

MEMBER SINCE
03/2012

ARCHITECTURE
Dario Grunzweig

DESIGN
Rubi Israeli
(Gavriel)

ROOMS
30

RATES
USD 135–415

MEET THE ORIGINAL
Leon Avigad

# Elma Arts
# Complex Luxury Hotel

When you have devoted much of your life to community work in two areas—the absorption of immigrants and the promotion of culture—then breathing new life into an iconic structure that celebrates both the community and the arts is an opportunity to be grasped with both hands.

That's just what Lily Elstein has done with the Elma Arts Complex Luxury Hotel, in Zichron Ya'akov, some 70 kilometers up the coastline from Tel Aviv. After a meticulous eight-year restoration, the Mivtachim Sanitarium, Yaakov Rechter's award-winning masterwork of postwar Brutalism, is now an innovative boutique property set on the rim of Israel's Mount Carmel overlooking vast sloping forests and the deep blue Mediterranean Sea.

And thanks to Elstein, this stunning and inviting beacon is many things to many people. Yes, it's a hotel, with 95 spacious and opulently outfitted guestrooms, but it also offers up a world of culture. There are 750 square meters of gallery space devoted to Israeli and international artists, as well as not one, but two state-of-the-art performance halls. Acoustic engineering specialists Arup/Artec designed the 450-seat Elma Hall, which houses two Steinway grand pianos and a 1,414-pipe organ, created by the acclaimed German manufacturer Orgelbau Klais, the most advanced of its kind to be built in Israel. There's also the smaller, more intimate Cube Hall, which seats 150. And these spaces get plenty of use as monthly concert programs at Elma feature a wide-range of acclaimed orchestras, chamber choirs, jazz ensembles, and world-music artists from Israel and around the globe.

"Elma is a place where those who enter its doors can find art in every corner and at every moment," explains Elstein of the abundance of cultural riches here. Indeed, upon entering, guests are immediately greeted by the largest work that artist Sigalit Landau has ever created—Thirst, a monumental 26-ton depiction of a man and a woman pushing a boulder over a well. This imposing sculpture—its figures are eight times life-size—represents nine months of labor in an Italian quarry, where Landau and a team of craftsmen worked two giant slabs of marble, one Calcutta gold and the other Portuguese pink, into the shape of a kneeling couple.

Such a laborious endeavor makes perfect sense to Elstein, who is committed to just one thing: getting it right. And for her, "right" meant saving the very building that houses Elma from demolition. "I could not allow them to pull down such an iconic structure," she says. "I felt I had to preserve it and the mountain it stands on."

A descendant of the founders of Zichron Ya'akov—the seaside village where Elma (an acronym for Elstein Music and Art) is located—Elstein has also added the flavor of the neighborhood to the hotel with the locally sourced Oratorio restaurant. And, of course, downtime is given center stage as well, with the hotel's indoor/outdoor pools and a sumptuous spa.

But even before taking one step inside, guests are confronted by the specter of grandeur—Rechter's architectural wonder, a serpentine-shaped Brutalist marvel that earned him the prestigious Israel Award for Architecture in 1973. The building's masterful renovation some 40 years later echoes the restraint of the original design. Constructed of modular concrete units that seem to hug the curves of Mount Carmel, the building was lovingly updated by a vanguard team selected by Elstein. Architects Ranni Ziss and Amnon Rechter (Yaakov's son) took on the challenge, boldly reimagining the structure as a new kind of utopia: a hybrid of hospitality and high art.

The interiors of Elma, meanwhile, exude the signatures of high modernism—exposed cement, clean white lines, and natural walnut furnishings. Senior interior designer Lea Mahler, whose past accomplishments include work on the King David Hotel in Jerusalem, together with architectural firm Baranowitz + Kronenberg, took care that the interiors would echo the undulating subtlety of the structure's façade. Terrazzo floor tiles, cement surfaces, and oak highlights exude restrained elegance, while the careful selection of furniture—sofas and benches of white leather, oak and walnut stools, and black, minimalist patio furniture—harmonizes with the building's clean design.

Elma's 95 spacious rooms, suites, and freestanding cottages are opulently outfitted with a carefully curated selection of fabrics and other materials. Kilim rugs, original artworks, and all that natural oak furnishings are complemented by cutting-edge amenities, such as LED "smart" televisions and espresso machines. And the placement of the furniture invites guests to immerse themselves in the breathtaking views from each balcony and terrace of the surrounding forests and the vast sea beyond, perfectly framed by Yaakov Rechter's original room partitions.

Though you'll quickly settle into the luxurious surroundings of your room, you can take heart in the fact that your neighbors—Mr. Mozart, Mr. Bach, and many of their musical pals—are just down the hall, a short walk away. Lily Elstein would have it no other way. —

WHERE
Zichron Ya'akov
Israel

MEMBER SINCE
08/2015

ARCHITECTURE
Amnon Rechter,
Yaakov Rechter,
Ranni Ziss

DESIGN
Baranowitz +
Kronenberg
Architecture,
Lea Mahler,
United

ROOMS
95

RATES
USD 208–455

MEET THE ORIGINAL
Lily Elstein

Lily Elstein

*Elma Arts Complex Luxury Hotel*
*Zichron Ya'akov, Israel*

# Alila
# Jabal Akhdar

Comprising 78 suites and two Jabal Villas with private pools, Alila's first property in Oman is a solitary vision that provides a true escape from urban life. Designed by UK-based architecture firm Atkins with interiors by Thailand's P49 Deesign, the LEED-designed building was constructed using local building materials and traditional techniques, resulting in an alluring blend that reflects the Omani history, with a contemporary flavor. Food and beverage options are available from Juniper Restaurant and Rose Lounge, while other facilities include an infinity and indoor pool, gym, meeting venues, and Spa Alila featuring treatments inspired by age-old regional and Asian traditions.

Mark Edleson believes in offering his customers the same luxury, beauty and earthy aesthetic that he enjoys in his own life. A graduate of Stanford University and formerly a Vice President of Citibank, Edleson is a founder of the Nusa Pacific Group that owns several well-regarded upscale hotel properties in Indonesia. Edleson is also a founding partner of Mandara Spa Asia, the leading global operator of resort spas. With over thirty years in finance, real estate development and the leisure industry in Southeast Asia, Edleson is the driving force behind Alila's green initiatives and community involvement projects, while presiding over Alila's new developments and corporate strategy. His latest initiative is to co-found the Bali Institute for Sustainable Agriculture (BISA) to raise the living standards of Bali's farmers which will have the further effect of preserving the Balinese agrarian based culture and landscape. —

More from Alila Hotels & Resorts:

| | |
|---|---|
| **WHERE** | **ROOMS** |
| Jabal Akhdar | 78 |
| Oman | |
| | **VILLAS** |
| **MEMBER SINCE** | 2 |
| 12/2013 | |
| | **ROOM RATES** |
| **ARCHITECTURE** | USD 325–860 |
| Atkins | |
| | **VILLA RATES** |
| **DESIGN** | USD 1,805–3,235 |
| P49 Deesign | |
| | **MEET THE ORIGINAL** |
| | Mark Edleson |

# Asia-Pacific

HOTELS

# 41

COUNTRIES

**Cambodia, China, Hong Kong, India, Indonesia, Japan, Malaysia, Singapore, South Korea, Taiwan, Thailand** »

JAPAN

# The Park Kolkata

After an extensive reinvention, The Park Kolkata opened in 1967, the same year that the Beatles came to India to learn transcendental meditation. Today, the 149-room hotel has a completely new look thanks to the hands-on involvement of design gurus Conran & Partners. The current interiors are influenced by Indian psychedelia from the 1960s and Hindu meditation, which links the seven bodily chakras to the seven colors of the human body. Against a dramatic background of black and white, colors pop and inspire an electric state of mind.

WHERE
Kolkata
India

MEMBER SINCE
12/2002

ARCHITECTURE
Conran & Partners

DESIGN
Sir Terence Conran,
Pradeep Khosla,
Prakash Mankar

ROOMS
149

RATES
INR 12,000–20,000

MEET THE ORIGINAL
Priya Paul

# The Park New Delhi

The Park New Delhi features a stunning interior concept by British designers Conran & Partners, playing upon modern concepts of movement and transparency. Originally opened in 1987 and recently updated, the 220-room hotel offers a mix of Eastern hospitality and Western chic. The richness of the Indian visual tradition and globally inspired minimalist design span the hotel's public and private spaces.

WHERE
New Delhi
India

MEMBER SINCE
09/2005

ARCHITECTURE /
DESIGN
Conran & Partners

ROOMS
220

RATES
INR 12,000–50,000

MEET THE ORIGINAL
Priya Paul

# Anya Hotel

Meaning "different" in Sanskrit, Anya is the perfect name for this hotel, which presents worldly sophistication with a splash of Indian panache and contemporary cool in the soaring commercial hub of Gurgaon. Located on the prestigious Golf Course Road, the hotel has a fitting mantra—"luxury with an undercurrent of minimalism"—and it comes alive everywhere, from the spacious suites to the Amaltas Spa by L'Occitane, which presents wellness with an Indian soul. Renowned architect Alfaz Miller was enlisted to create a unique kind of DNA for Anya's façade—one that incorporates hotelier Marcel Vadera's desire for a structure that is crescent-shaped rather than linear. Since the building lot was long and narrow, Miller's idea for an eye-shaped design stood out from other proposals. Thanks to its sleek, curvy shape, each room differs in size and form. The rooms mix Italian marble, warm wooden floors, and accents of plush silk for a contemporary look with local influences. Rani pink, indigo blue, marigold orange, eggplant purple—all strong colors associated with Indian culture—are found on the bedspreads and mixed harmoniously with modern elements such as artichoke-shaped chandeliers and Flos lamps. Anya also features multiple international music zones, from jazz and electronic to Indian classical concerts. Thanks to owner Misha Vadera's passion for art—he's an avid collector for the past 30 years—Anya is adorned with works by such contemporary Indian masters as Bose Krishnamachari and Chittrovanu Mazumdar, and commissioned work by Remen Chopra. —

WHERE
Gurgaon
India

MEMBER SINCE
09/2014

ARCHITECTURE
ABM Architects
Pvt Ltd

DESIGN
Carl Ettensperger
(C&C Studio),
Sandeep Khosla
(Khosla Associates)

ROOMS
117

RATES
INR 5,500–16,000

MEET THE ORIGINALS
Marcel Vadera,
Misha Vadera

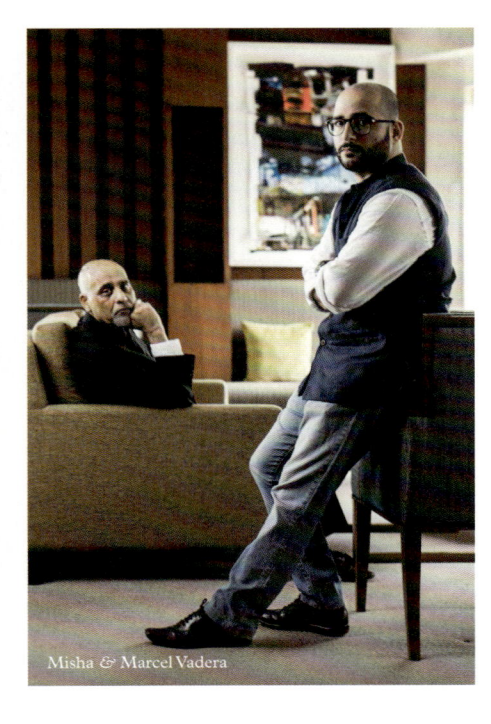

Misha & Marcel Vadera

# The Park
# Hyderabad

India's pioneering boutique hotel group, The Park Hotels, has a precious gem in its crown. The Park Hyderabad continues Priya Paul's practice of integrating traditional aesthetics and local craftsmanship into contemporary, international design themes. Hyderabad's proud heritage as a center for design and the production of precious stones and gems greatly influenced the hotel's development. The building's façade is meticulously designed to emulate the metalwork found in the Nizam jewelry collection, one of the most valuable and precious in the world. The building offers 268 exquisitely designed guestrooms, executive and presidential suites, a variety of restaurants and lounges, entertainment spaces and banquet halls, retail facilities, and art galleries. The centerpiece is its three-dimensional horizon pool in which swimmers can enjoy elegant and relaxing surroundings while diners and club-goers beneath can peek into its watery depths through fragmented windows. The Park Hyderabad is an unparalleled luxury destination, gold certified by LEED (Leadership in Energy and Environmental Design), remaining consistent with Priya Paul's commitment to holding her company's place as one of India's ecological frontrunners.

Art collector and design aficionado Priya Paul has been revolutionizing the hotel industry in India for the last 25 years. As a Chairperson of Apeejay Surrendra Park Hotels in India, Priya Paul repositioned The Park Hotels as India's first and only collection of contemporary luxury boutique hotels. Paul holds a BA in Economics from Wellesley College in the United States and completed the Owner President Management Program at Harvard Business School. She is a founding member of the World Travel and Tourism Council, and has been internationally awarded numerous times—including the Aatithya Ratna Award by Hotel Investment Forum India, 2011—for seamlessly combining contemporary art and high-function design with an extraordinary spirit of hospitality. —

WHERE
Hyderabad
India

MEMBER SINCE
09/2009

ARCHITECTURE
SOM Skidmore
Owings & Merrill
LLP

DESIGN
SOM Skidmore
Owings & Merrill
LLP, Conran &
Partners

ROOMS
268

RATES
INR 15,000–
100,000

MEET THE ORIGINAL
Priya Paul

Priya Paul

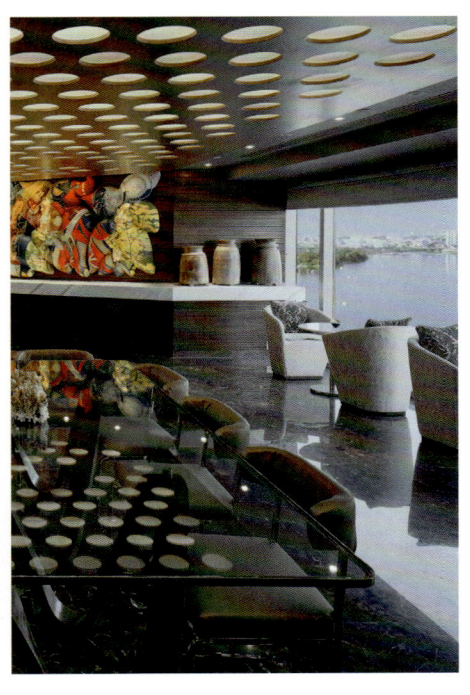

# The Park
# Chennai

Built on the former site of one of India's largest film studios, The Park Chennai was designed to blend the site's cinematic past with its new incarnation as one of India's most design-forward hotels. An oversize movie screen greets guests in the light-filled lobby, dramatic curtains veil poolside beds on the rooftop, and the 214 guest-rooms are enveloped with sensual muted tones of silver and gold.

WHERE
Chennai
India

MEMBER SINCE
12/2002

ARCHITECTURE / DESIGN
Hirsch Bedner
Associates

ROOMS
214

RATES
INR 10,500–40,000

MEET THE ORIGINAL
Priya Paul

# The Park Pod,
# Chennai

The intimate 20-room The Park Pod, Chennai is located right on Khader Nawaz Khan Road, the electric center of Chennai's fashion and design scene. The bi-level glass and concrete building allows dappled light to flood into its public spaces. The hotel's nightlife attracts a fashion-forward crowd, drawn to The Park Pod for its trendy Italian restaurant, Italia, the Absolute Bar, and Absolute Dec, the hotel's sleek outdoor pool, lined with blood-red tiles and a DJ station.

WHERE
Chennai
India

MEMBER SINCE
07/2010

ARCHITECTURE / DESIGN
Atul Malhotra
(Evoluzione),
Vikram Phadke

ROOMS
20

RATES
INR 8,000–15,000

MEET THE ORIGINAL
Priya Paul

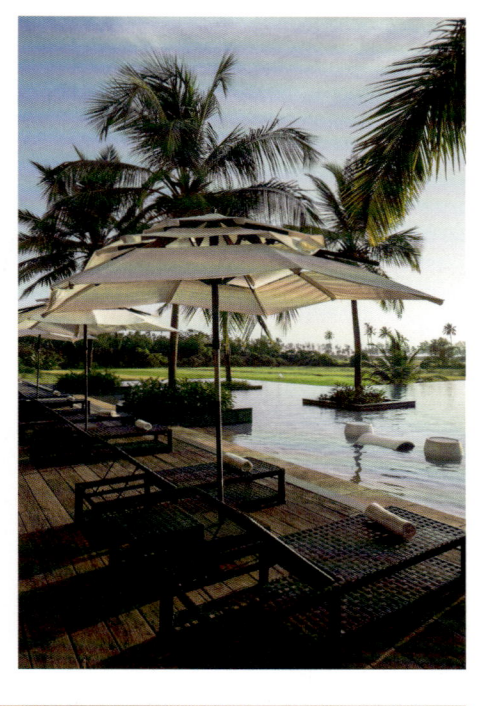

# Alila
# Diwa Goa

Looking out onto the Arabian Sea from the coast of Gonsua Beach in South Goa, also known as "the pearl of the East," Alila Diwa Goa brings an unmatched level of luxury to this exotic beach destination. Set amid lush paddy fields, Alila Diwa Goa has blended the best of contemporary Goan architecture with rich cultural traditions to fashion an extraordinary experience in high-end destination travel. Each of the 153 guestrooms and suites are designed for relaxation, enhanced by the beauty of the vibrant natural surroundings. For a more intimate experience, the crescent-shaped Diwa Club—with 27 rooms and eight suites—offers pure luxury, with in-room check-in, personal hosts, all-day breakfast, and its own lap pool with an open-air Jacuzzi. Extending outward from the heart of the hotel is the infinity pool, which invites guests to gaze out at the verdant landscape. There are several options for wining and dining: Spice Studio, an award-winning Indian specialty restaurant; Vivo, with live cooking stations; Edge Bar and Lounge; and Bistro, attached to the Diwa Club, featuring Mediterranean and European influenced cuisine, and a "Chai Paani" hour in the evenings with traditional Indian snacks. At the signature Spa Alila, treatments, which include detox programs, combine organic nutrition and health knowledge with ancient Asian healing techniques using natural, fresh ingredients. This laid-back atmosphere is perfectly enhanced by the resort's excellent service. The Leisure Concierge Team can coordinate customized activities and sightseeing attractions designed to give guests the opportunity to experience local community and culture. —

| | |
|---|---|
| **WHERE**<br>Goa<br>India | **ROOMS**<br>153 |
| **MEMBER SINCE**<br>01/2010 | **RATES**<br>INR 11,000–23,000 |
| **ARCHITECTURE**<br>Tony Joseph<br>(Stapati) | **MEET THE ORIGINAL**<br>Mark Edleson |
| **DESIGN**<br>Lisa Garriss<br>(Plum Design) | |

# The Park
# Calangute Goa

Pristine beach views, lush tropical rain forests, and a laid-back bohemian vibe await guests at The Park Calangute Goa. The pool deck, bar, and restaurant extend to the unspoiled beach, where guests have exclusive beach access and can take in the magnificent sunsets accompanied by resident DJs. Here, or in-suite, guests can take advantage of on-site ayurvedic treatments from the Aura Spa. The primarily white decor of the 30 rooms acts as a blank canvas that is accented by bright splashes of neon pink and deep purple and decorated with contemporary works of art.

| WHERE | ROOMS |
|---|---|
| Goa | 30 |
| India | |
| | RATES |
| MEMBER SINCE | INR 12,500–40,000 |
| 01/2012 | |
| | MEET THE ORIGINAL |
| ARCHITECTURE | Priya Paul |
| Kundan Prabhu | |
| | |
| DESIGN | |
| Pierre Maciag | |

# The Park
# Bangalore

India's first contemporary boutique hotel, The Park Bangalore is still a dynamic hub and meeting place in this fast growing, high-tech city. A clever mix of modern design with Indian accents, the hotel is a reflection of its location in the city's most exciting upscale retail district. Each of the four floors showcases a different design and color scheme, crowned by the top-floor luxury residential area and private lounge—The Residence—which rewards its guests with sumptuous style and what Priya Paul calls "white glove service without the gloves."

| WHERE | ROOMS |
|---|---|
| Bangalore | 109 |
| India | |
| | RATES |
| MEMBER SINCE | INR 15,000–28,000 |
| 12/2002 | |
| | MEET THE ORIGINAL |
| ARCHITECTURE / | Priya Paul |
| DESIGN | |
| Conran & Partners | |

# The Beach Samui

WHERE
Koh Samui
Thailand

MEMBER SINCE
11/2012

ARCHITECTURE
David Archer

DESIGN
David Archer
(Archer Humphreys
Architects),
Charlotte Rose
Melsom

ROOMS
21

RATES
THB 8,000–28,000

MEET THE ORIGINALS
Bryan Lunt,
Charlotte Rose
Melsom

Among the palms on a beautiful stretch of sandy beach by the sleepy, traditional Thai fishing village of Thong Krut, lies The Beach Samui—a consciously developed retreat with just 21 suites and penthouses offering uninterrupted views across the archipelago. Each oceanfront suite boasts open-plan interiors with washed oak walls, handcrafted teak and marble furnishings, terrace and private outdoor tub, a palette of muted sea tones, polished terrazzo floors, and handpicked trimmings. Inside, you will find 300-thread count Egyptian cotton linens, cool waffle robes, the latest organic toiletries, and relaxed yet fully attentive service. Within this small but perfectly formed boutique hotel you will

discover Thailand's age-old relaxation traditions. Float in the panoramic infinity pool, dine on organic island produce in the Beach Samui Restaurant and Bar, enjoy a holistic treatment in the spa, re-energize in the Amethyst steam room, catch a movie screening under the stars, or simply snooze in a beachfront cabana. There are even yoga and meditation classes to leave you physically and spiritually prepared to explore Koh Samui's natural wonders; or you can choose to go island hopping in the marine park on the resort's private boat. You will also enjoy a personal mobile phone for use during your stay with complimentary international dialing.  —

# The Library

Against the seductive backdrop of Koh Samui's Chaweng Beach, The Library reads like an elegant monograph. Owned by Samui native Kasemtham Sornsong and created with designer Tirawan Songsawat, the beachfront hotel is a refreshing and subtle play on the notion of the book. The expansive grounds provide ample space for guests to flourish, each area representing a blank page on which to write their story. With its restrained yet sophisticated design, the conceptual resort is unique to the island; understated and peaceful, The Library narrates a story in which genuine harmony with the neighboring landscape is a tangible achievement. The hotel's library binds the property; its collection of over 1,300 books, available to borrow or purchase, provides a satisfying alternative to modern distractions. Indeed, the 26 suites and studios are interlaced with a reassuring assortment of entertainment technology, such as iMacs and plasma televisions, and one of The Library's suites has been transformed into The Bookmark, which provides more space and more intimate amenities. The 2-Bedroom suite is the largest, at 158 square meters, and accommodates an entire family of six! From The Page restaurant holding fort on the beachfront, to the 270-degree sea views from the glass-enclosed gym, The Library bridges the chasm between nature and modern life. The Library's brand-new second restaurant outlet, the Drink Gallery, whips together music, art, and design, while serving up the most unique cocktails on the island. Like a good book, The Library contains an assortment of interesting chapters, enticing guests to learn to live harmoniously with nature.

Kasemtham Sornsong and Tirawan Songsawat's vision for The Library was of a hotel that invites one to sit with a book in quiet contemplation while also weaving its own story of natural beauty and unmatched luxury. Set in the heart of Chaweng Beach on Thailand's island of Koh Samui, the result is a seamless example of how design can tastefully merge with comfort, quality, and the timeless power of nature. Just 26 years old when The Library was launched, Sornsong realized his dream with the help of partner Tirawan Songsawat. The Library is a testament to the couple's adoration of the island. Fittingly, each page of the hotel's story is deeply rooted in their reverence for Samui life and landscape. —

| | |
|---|---|
| **WHERE** <br> Koh Samui <br> Thailand | **ROOMS** <br> 26 |
| **MEMBER SINCE** <br> 08/2006 | **RATES** <br> THB 16,618–33,236 |
| **ARCHITECTURE / DESIGN** <br> Tirawan Songsawat | **MEET THE ORIGINALS** <br> Tirawan Songsawat, <br> Kasemtham <br> Sornsong |

# Casa de la Flora

An example of urban design quietly nestled among an oasis of natural serenity, Casa de La Flora sits in Khao Lak, on the shore of the Andaman Sea. The brainchild of businessman Sompong Dowpiset, this 36-villa resort is an ode to the angular geometries of Brutalist architecture, while simultaneously paying tribute to the surrounding environment. Evincing a distinct sensitivity to the adjacent landscape and achieving harmony with the local flora, the hotel by VasLab Architecture is Khao Lak's only resort offering cutting-edge architecture with minimalist design. Guests are invited to experience this exceptional retreat with its pioneering interiors, personalized services, and discreet yet sincere eco-credentials. With each low-rise villa, guests are introduced to arresting sea views, private pools, and welcome quirks such as in-room entertainment technology provided by Apple and a complimentary mini-bar replenished daily. Beyond the secluded solace of each glass-fronted villa, Casa de La Flora's public spaces include an infinity-edge pool and Spa La Casa featuring exclusive treatment courses. Among the contemporary highlights is a library where visitors can unwind while enjoying an assortment of books and connect to the world outside from the iMac offered. And La Aranya restaurant lures guests with veritable feasts of Thai and international cuisine.

As a chairman of Haco Group, Sompong Dowpiset is a man whose foresight and vision have taken him from door-to-door sales to becoming Thailand's top importer of European bathroom ergonomics. Dowpiset now spends his time at the company's various offices dotted around the country, sometimes managing to squeeze in a round of golf with Thailand's elite. In the sector of hospitality, Dowpiset applies a similar strategy to success. His fourth hotel, Casa de La Flora is a beachfront resort in Khao Lak, designed by ultramodern Bangkok-based VasLab Architecture. Along with celebrated Thai hospitality, Casa de La Flora provides a private sanctuary where the pervading philosophy is rest and relaxation. —

WHERE
Khao Lak
Thailand

MEMBER SINCE
08/2010

ARCHITECTURE
Vasu Virajsilp,
Boonlert Deeyuen
(VasLab Architecture)

DESIGN
Thawatchai
Klongwatthanakith
(VasLab Architecture)

VILLAS
36

RATES
THB 10,530–65,260

MEET THE ORIGINAL
Sompong Dowpiset

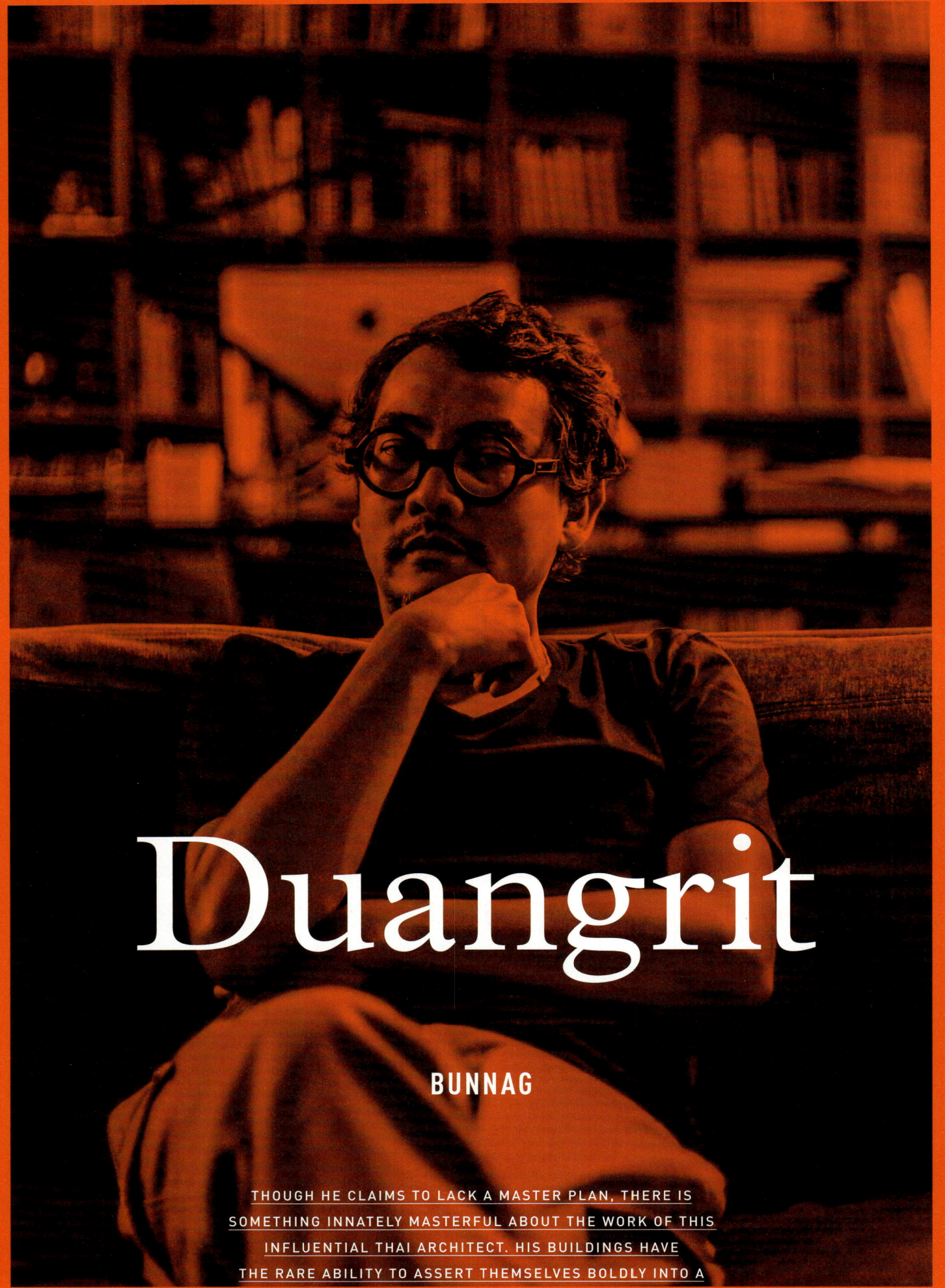

# Duangrit

## BUNNAG

THOUGH HE CLAIMS TO LACK A MASTER PLAN, THERE IS SOMETHING INNATELY MASTERFUL ABOUT THE WORK OF THIS INFLUENTIAL THAI ARCHITECT. HIS BUILDINGS HAVE THE RARE ABILITY TO ASSERT THEMSELVES BOLDLY INTO A LANDSCAPE YET ALSO SEEM ORGANICALLY AT ONE WITH THEIR SETTING.

*"I've never had a concrete plan
about what is going to happen.
We made it up as we went along."*

DUANGRIT BUNNAG

Duangrit Bunnag does not believe in Feng Shui. "I think it's ridiculous," he told *The Wall Street Journal* in a 2014 interview, as he praised the logical brain above an ethereal one, yet also admitted that "Feng Shui consultants have told me that most of my projects are perfectly aligned with their principles."

It's no surprise. Although he's said that he relies solely on his intuition, Bunnag's work matches up well with this ancient Chinese philosophy of balancing underlying spatial energies. Since founding Duangrit Bunnag Architect Ltd., or DBALP, in 1998, the Thai architect has carved out a distinctive style for himself, characterized by the harmonious unity of seemingly opposing forces: the assertive geometry of his structures alongside the organic elements that occur in nature. The result is an irreverent air of cool.

Bunnag is an influential, visionary force throughout Thailand and beyond, from the many tropical resorts he's designed (including the award-winning Hotel de la Paix, located in a Laotian UNESCO World Heritage Site in Luang Prabang) to his creation of Thailand Creative & Design Center to his participation in the 2012 Venice Architecture Biennale's Thailand Pavilion presentation. Bunnag's firm is set in Bangkok, his favorite city, and where he was born in 1966. After earning his undergraduate degree in 1989 from Chulalongkorn University's architecture program, he worked for Thai firm Architects 49 Limited on and off for a total of nine years. For his graduate studies, he attended the Architectural Association in London before ultimately returning to Bangkok to start his own firm.

Since 2013, DBALP has occupied The Jam Factory, a hybrid hipster destination that combines an art gallery, restaurant, coffee shop, and furniture showroom, with space for his office tucked somewhere in between. Bunnag found this setting of formerly abandoned warehouses during his search for a larger office space as he was eager to move his growing firm away from its previous home on the 28th floor of the corporate Siam Discovery Complex. The sprawling complex in the Thonburi neighborhood offered a decidedly calmer atmosphere, as well as plenty of room for experimentation.

And the uncertainty that comes with experimentation is at the heart of Bunnag's magic. "I've never had a concrete plan about what is going to happen," he explained to *The Wall Street Journal*. "We made it up as we went along."

Take, for example, that new headquarters of his. There, Bunnag left the industrial aesthetic in tact, incorporating the exposed brick walls and wooden rafters into the interior design and painting the walls uneven shades of gray. Meanwhile, in the complex's 50-seat restaurant, The Never Ending Summer, where Bunnag himself designed the menu, he made stunning use of utilitarian stainless steel lamps, which hang from the ceiling, and potted plants that appear to sprout from the walls. With the abundance of natural light streaming through and ceilings so high they're nearly nonexistent, the interior gives an air of a secret garden nestled in urban decay. Meanwhile, Anyroom, the shop that carries work by Bunnag's industrial design company Ministry of Space, is much less rustic with its floor-to-ceiling glass—a smart choice that encourages window-shopping.

Far from his headquarters and the bustle of Bangkok, The Naka Phuket, a remote hilltop paradise located above Thailand's idyllic Kamala Bay, epitomizes Bunnag's dual reverence for both nature and structure—

## SIDE NOTES

NAME *Duangrit Bunnag*

COMPANY NAME *Duangrit Bunnag Architect Ltd. (DBALP)*

COMPANY HEADQUARTERS *Bangkok*

NUMBER OF PEOPLE IN COMPANY *52*

WEBSITE *duangritbunnag.com & dbalp.com*

SIGNATURE PROJECTS *Bangkok: The Jam Factory; Thailand Creative & Design Center; The Issara Ladprao; Millennium 292; The Only Son Phuket: The Naka Phuket Phang-nga, Thailand: Villa Noi Phang Nga*

## SIGNIFICANT AWARDS

2015 *ARCASIA Awards for Architecture, Best Building for The Naka Phuket*

2014 *Wallpaper\* Design Awards, Best New Hotel for The Naka Phuket*

2014 *ASA Architectural Award for The Jam Factory*

2013 *ARCASIA Awards, Gold Medal for X2 Kui Buri*

2005 *ARCASIA Awards, Gold Medal for Costa Lanta Resort*

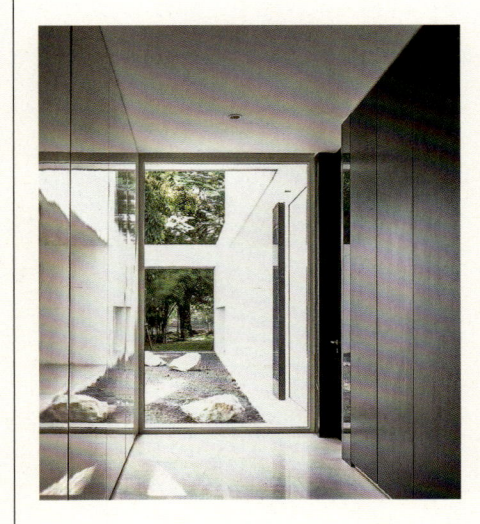

*For the discreet, arresting, and oh-so-private Naka Phuket, in Thailand, Bunnag was inspired by the "honest personality" of his client.*

not to mention the ultimate in luxury retreats. The design of the 94-room resort is site-specific, directly addressing the nuances of the terrain as nearly 100 rectangular villas composed of floor-to-ceiling glass walls protrude from the lush hillside. From the rectangular swimming pools appointed to each of the villa's gardens, to the sharply cut white stone walls that allow each guest total privacy, all that is built adheres to a recurring theme of right angles, and yet somehow the estate fits marvelously well into the surrounding landscape. Bunnag not only shrouded each villa in greenery, which included installing grass lawns on their roofs, he used the existing topography as his guide, staggering the villas on the hill according to the landscape's natural curves. Consequently, they appear to be floating as they cantilever six meters beyond where the land ends. For the interiors, dually geometric furniture in muted, natural colors encourage guests to turn their gaze to the outdoors.

Bunnag has demonstrated a refined skill for creating spaces of leisure, whether this means monastic getaways on the coast or casual gathering places in the middle of a city. The site makes little difference to him.

"They all feel like home to me," he said. "You love all of them differently, but you love them all." Still, he attributes his design ethos and choices not to any personal or spiritual philosophies, but simply to intuitive logic. "When I walk into one of my projects, it feels familiar. They make sense."

*Text: Janelle Zara*

1 *Bunnag's Serenity House, a private residence in Phuket, is a three-story testament to a seamless integration with nature and to what the architect describes as the "realness" of material.*

2 *The 48-story Issara Ladprao, in Bangkok, speaks to Bunnag's desire to represent the pattern of space and mass in an urban fabric.*

3 *Bunnag's Millennium Residence, in Bangkok, offers contrasting colors and textures that take on new emotions as light moves through the residence.*

4 *For The Jam Factory, Bunnag's all-in-one office, café, bookstore, and showroom, the architect transformed an abandoned warehouse into a community-defining hub.*

5 *For the Naka Phuket, Bunnag did one of things he most loves: He used natural materials to authentically express a oneness between a structure and its environment.*

1

2

3

4

5

# The Naka Phuket

**WHERE**
Phuket
Thailand

**MEMBER SINCE**
08/2012

**ARCHITECTURE /
DESIGN**
Duangrit Bunnag,
Saranya
Srisakulchairak
(DBALP)

**ROOMS**
3

**VILLAS**
91

**ROOM RATES**
THB 12,020–
23,890

**VILLA RATES**
THB 19,650–
83,400

**MEET THE ORIGINALS**
Duangrit Bunnag,
Sompong Dowpiset,
Thaveesakdi
Phucharoen

Hidden in an ancient valley on the western edge of Phuket, The Naka Phuket is Duangrit Bunnag's most daring hotel to date. Not only because the Bangkok-based architect set out to redefine the idea of an indulgent island escape, but also because he single-mindedly followed a dream: one that would allow the hotel's guests to float among the trees. The unique result is a discreet, tropical hideout, with the glass-built villas cantilevering out from the mountainside to give endless panoramas of the sparkling Andaman Sea. With an outdoor pool attached to each of the secluded living spaces, guests have all the privacy they need to find their natural equilibrium. At the rooftop spa, which overlooks the forest and the ocean, cicadas provide the spellbinding soundtrack to soothing body scrubs and massages. Guests can also unwind in the hotel's Olympic-sized infinity pool, or feel the powder-fine sand between their toes on the wave-lapped private beach. Tantalizing fresh market produce is served at the hotel's three restaurants, including The Nava, which sits along a natural watercourse that Bunnag ingeniously integrated into his final design. Here, as in the rest of the hotel, there's a sense of being cocooned in a secret valley. Privacy and serenity are guaranteed, but for those seeking adventure, Phuket city is only a 20-minute ride away. —

# Indigo Pearl

One doesn't often associate industrial design with an unspoiled beach. But in Thailand, at the Indigo Pearl resort, nestled on the lush Nai Yang beach on the north-west coast of Phuket, metal is alluringly mixed with traditional Thai decor and cutting edge art. What it spells for design conscious travelers is a new kind of tropical island retreat to swoon over. For owner Wichit Na-Ranong, and daughter Prakaikaew Na-Ranong, the hotel is a tribute to Phuket's tin-mining history and his family's role in that once-flourishing trade. And both the island and his family have reason to be proud: Complementing its unusual style, the Indigo Pearl offers up the perfect recipe for relaxation, with three restaurants and bars, a café, three swimming pools, and an award-winning spa. —

| | |
|---|---|
| **WHERE** Phuket Thailand | **ROOMS** 177 |
| **MEMBER SINCE** 02/2014 | **VILLAS** 7 |
| **ARCHITECTURE** Bill Bensley (Bensley Design Studios) | **ROOM RATES** THB 6,900–23,000 |
| **DESIGN** Bill Bensley (Bensley Design Studios), John Underwood (Underwood Art Factory) | **VILLA RATES** THB 44,000–92,000 |
| | **MEET THE ORIGINALS** Prakaikaew Na-Ranong, Wichit Na-Ranong |

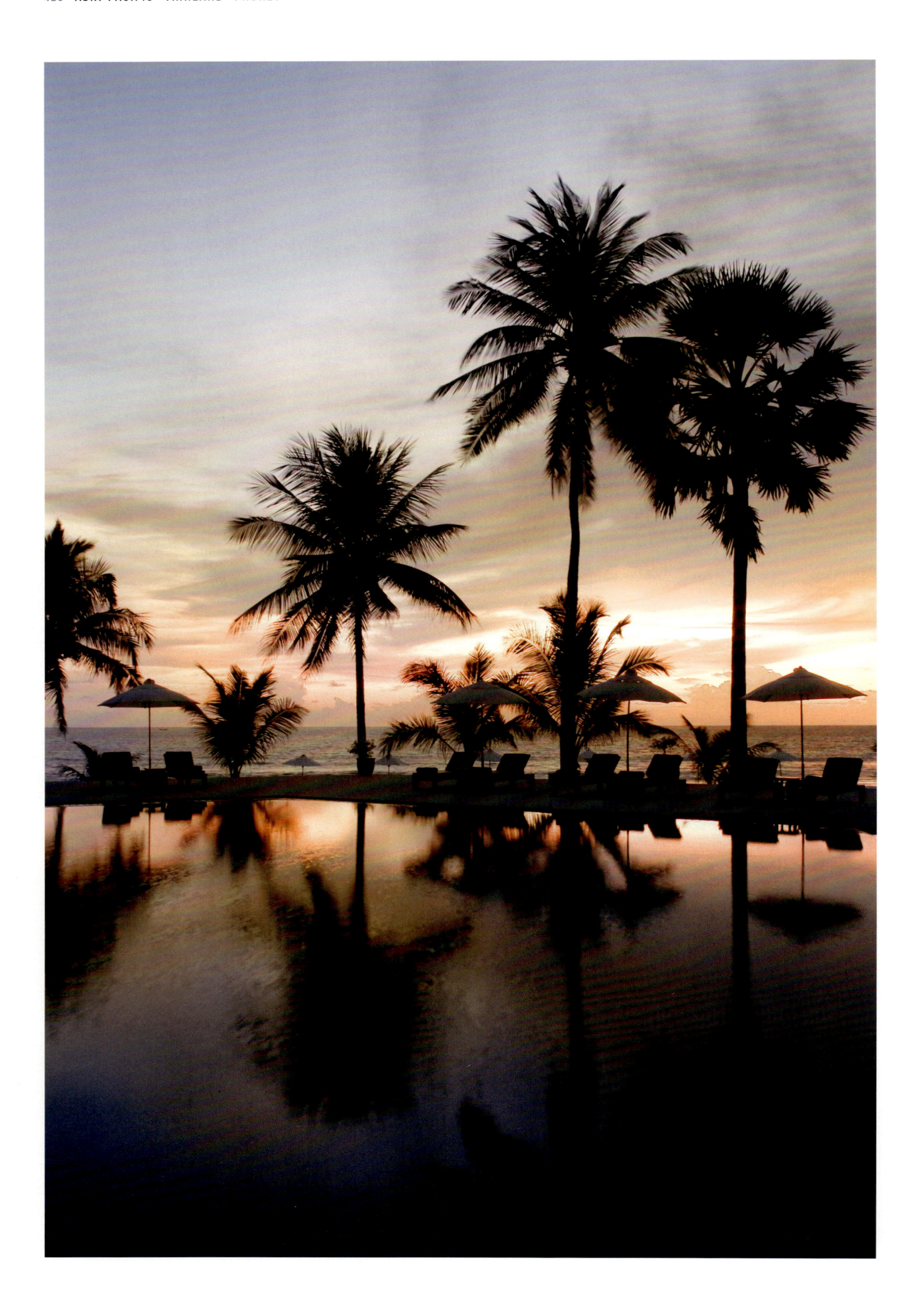

# The Surin Phuket

Amid coconut palms and gently rolling slopes, The Surin Phuket elegantly punctuates the tropical landscape along the island's finest white sand beach at Pansea Bay. Paris-based architect and designer Ed Tuttle, who originally designed The Surin (formerly known as The Chedi), has recently rejuvenated its 103 cottages and suites set within a beachfront coconut grove. Jungle walkways link the lobby-level Superior Cottages, which offer guests unobstructed views of the ocean, as well as the idyllic Beach Suites and Studios, which offer direct walk-on access to the beach. The Lomtalay Restaurant serves delectable Thai specialties, while the Sunset Café offers a casual all-day menu of Asian and international fare. The Beach Restaurant offers a menu inspired by seaside dining, with flavors from Asia and fresh fish, shellfish, and prime-cut meat served from the charcoal BBQ. The Sunset Bar and the Beach Bar are meeting points for an aperitif before dinner and are the best venues to witness the spectacular sunset. The peaceful setting of the Spa has been created with thoughtful intention, in harmony with the natural beauty of the surroundings, while those looking for more active diversion can utilize the dramatic black-tiled pool, fitness center, and two tennis courts, as well as three nearby golf courses: Blue Canyon, Red Mountain, and Laguna Phuket. The Surin povides the idyllic experience you have always dreamed of, set in a truly remarkable location—the ultimate in Southeast Asian seaside serenity.

Ed Tuttle is one of America's most renowned architects. Although he has undertaken numerous residential projects, hotels make up the major part of his portfolio, with properties in Thailand, Indonesia, France, and the United States. A native of Seattle, Tuttle gained much of his early experience in Asia, where he spent seven years working on hotels across the region. The list of distinguished names includes Park Hyatt, Hilton, Sheraton, and Inter-Continental. Tuttle settled in Paris where, in 1977, he set up his own firm, Designrealization, situated on Rue des Saints-Peres. Maintaining respect both for the local culture and for his own architectural philosophy, Tuttle ensures that wherever one looks, an interesting perspective can be seen. —

WHERE
Phuket
Thailand

MEMBER SINCE
09/1999

ARCHITECTURE /
DESIGN
Ed Tuttle

ROOMS
103

RATES
THB 20,000–
50,000

MEET THE ORIGINAL
Ed Tuttle

# Phum Baitang

"Innovation, integrity, simplicity, and the pursuit of excellence. Our hotels have neither trend nor strategy—what they offer is a way of living that is free of pretension."

So says Arnaud Zannier, whose second hotel in Cambodia, Phum Baitang, is a study in purity of form and authenticity. The owner and founder of Zannier Hotels creates hotel projects that are driven by his personal values. This is, indeed, a good thing as those values of his are inspired by da Vinci's adage "simplicity is the ultimate sophistication."

And sophistication is certainly on display at Phum Baitang (Khmer for "green village"), an elegant hideaway wrapped in eight acres of lush gardens and paddy fields near Siem Reap—rural Cambodia at its most beautiful. The 45 spacious villas with thatched roofs, form a village-like cluster inspired by traditional design and are complemented by local modes of transportation, such as tuk-tuks.

Speaking of local, here too one finds an ancient farmhouse on-property that has been converted into a lounge and furnished with rattan wing chairs and plush oriental carpets, reminiscent of Cambodia's colonial days. The hotel's Bay Phsar restaurant, meanwhile, has a local market feel where guests can pick their own fresh ingredients and spices, and where the rice comes from the surrounding paddy fields. An outdoor pool with a bar and cigar lounge invites guests to unwind after exploring the wonders of the surrounding ancient culture. Indeed, that cigar lounge is a popular retreat at Phum Baitang, one where a sense of simplicity-meets-sophistication is created thanks to a relaxed colonial setting defined by solid wooden tables and those delightful rattan chairs— it's an ideal setting to enjoy vintage liqueurs, fine wines, and a wide variety of cocktails. Seven treatment rooms, a relaxation area, sauna, and yoga pavilion, meanwhile, are laced with green spaces and open areas. There's even a tranquil spa temple that reflects the renowned stone carvings of nearby Angkor World Heritage Site.

Built on the principles of a traditional Khmer village, those inviting straw-thatched structures at Phum Baitang are made with local stone and wood. Using the wisdom of traditional construction techniques, the villas stand on stilts to protect them from floods and to allow for both storage and optimum ventilation. The Pool Villas come with a private plunge pool as well as a lush garden area.

Inside the rooms, one finds an earthy palette that gives off a light, breezy feel. Great care has been taken to ensure that the interiors of Phum Baitang reflect the traditional Khmer style, while also exuding a cool, understated aesthetic. Pieces of handmade furniture, such as the carved-wood headboards and lime-finished free-standing wooden baths in the villas, blend seamlessly with antiques plucked from nearby markets.

At Phum Baitang the local flavors color the luxury, creating a welcoming environment defined by innovation, integrity, simplicity, and the pursuit of excellence. —

WHERE
Siem Reap
Cambodia

MEMBER SINCE
05/2015

ARCHITECTURE
Reda Amalou
(AW2)

DESIGN
AW2,
Arnaud Zannier

VILLAS
45

RATES
USD 285–700

MEET THE ORIGINAL
Arnaud Zannier

"Innovation, integrity, simplicity, and the pursuit of excellence. Our hotels have neither trend nor strategy— what they offer is a way of living that is free of pretension."

ARNAUD ZANNIER

# Macalister Mansion

**WHERE**
Penang
Malaysia

**MEMBER SINCE**
10/2012

**ARCHITECTURE**
Ministry of Design

**DESIGN**
Colin Seah
(Ministry of Design)

**ROOMS**
8

**RATES**
MYR 990–1,660

**MEET THE ORIGINALS**
Datin Karen H'ng,
Dato Sean H'ng

If Sir Norman Macalister returned to the capital of the island he governed two hundred years ago, he'd be in for a surprise. Formerly a British shipping port, Penang's George Town is now a vibrant international metropolis that proudly displays its English, Chinese, Indian, and native Malaysian influences. A UNESCO World Heritage Site city, George Town strives to strike a balance between past and future, preserving its heritage buildings as it continues to develop into a vital center of industry and tourism. Experience this unique combination for yourself at Macalister Mansion, a quirky and sophisticated lifestyle destination that nods both to Penang's colonial past and to its colorful present. Macalister Mansion owners, Dato Sean and Datin Karen H'ng, worked with Colin Seah of Singapore's renowned Ministry of Design to renovate and revitalize this hundred-year-old colonial mansion, preserving the building's heritage aspects and original elements while adding modern-day amenities and contemporary design touches. Together, they conceived the hotel as a complete holistic concept, with all rooms, restaurants, and lounge areas belonging to a single, unique vision. Each room has its own bespoke features and artwork, from the privately commissioned love sonnet in the Bridal Suite, to the spiral staircase and turret room in Room 4. —

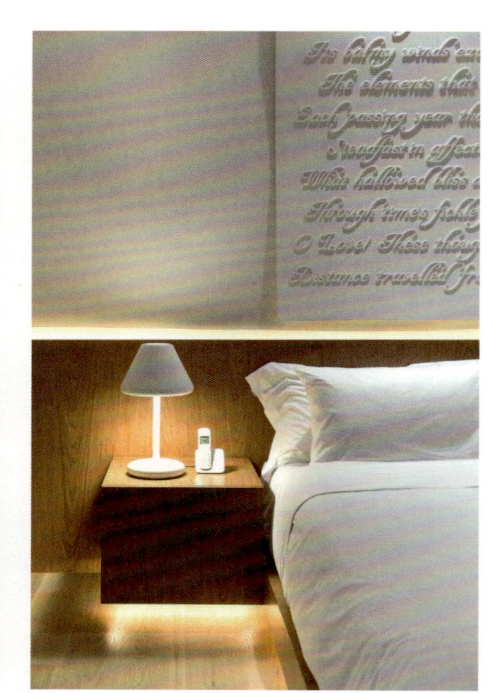

# Klapsons
## The Boutique Hotel

As guests step through the glass doors of Klapsons, one of Singapore's most distinctive boutique hotels, the combination of five-star luxury and a pronounced sensitivity toward contemporary design is immediately apparent. William Sawaya of Sawaya & Moroni spearheaded the design team, and the results are sensational. Klapsons, The Boutique Hotel attempts to change the face of both business and leisure travel to Singapore by affording a quiet sophistication and a subtle sense of luxury joined with profound functionality. Sawaya has carefully given each guestroom at Klapsons an individualized design identity so that no two are alike, ensuring that visitors have a new experience, and discover new comforts and indulgences, during every stay at the innovative hotel. The element that unites the guestrooms is without a doubt the opulent pampering, which ranges from Egyptian cotton sheets and goose-down bedding to WiFi and a Nespresso machine. The Sleeping Rhino, Klapsons' first-floor restaurant, features down-to-earth Western cuisine infused with contemporary elegance. Also on hand is Fabrika, an alfresco terrace bar on the 17th floor. Subtle yet suitable for the savviest, Klapsons brings a new frontier in hotel ideology to Singapore's Central Business District. —

| | |
|---|---|
| **WHERE** | **ROOMS** |
| Singapore | 17 |
| **MEMBER SINCE** | **RATES** |
| 08/2009 | SGD 390–950 |
| **ARCHITECTURE** | **MEET THE ORIGINAL** |
| RSP Architects Planners & Engineers | Adrian Lee |
| **DESIGN** | |
| Paolo Moroni, William Sawaya (Sawaya & Maroni) | |

# Colin

## SEAH

A CAREER THAT BEGAN ON A DARE IS NOW PRODUCING SOME OF THE WORLD'S MOST DARING DESIGNS. SEAH'S SECRET TO SUCCESS LIES IN FINDING A SPACE'S RELEVANCY THROUGH REINVENTION AND PERSONAL INTERACTION, AND IN AN UNDYING MODESTY THAT PUTS RESULTS FAR ABOVE EGO.

> *"Key to my work is a search for relevance—*
> *in terms of how our cultural norms*
> *and practices influence the way we interact*
> *and the spaces we need."*

COLIN SEAH

Colin Seah's success as an architect was born out of a pure desire to design rather than the ambition of owning his own practice. The Singaporean's firm, Ministry of Design (MOD), was founded in 2006 as a result of an ultimatum posed by friend and hotelier Loh Lik Peng, who wanted Seah to design the city-state's first boutique hotel, the New Majestic Hotel: Either stay at his day job teaching at the University of Singapore's Department of Architecture or dedicate his talents full-time to his own practice.

Seah took the challenge and has never looked back. He was named Interior Designer of the Year by International Design Awards in 2010 and has become a two-time Grand Prize Winner of the highest international hospitality accolade, the Gold Key Award.

"I have never really been entrepreneurial in spirit. I'm not ambitious in that way to be perfectly honest," Seah admits, although with a sense of modesty that belies the innovative vision behind his latest project, a new brand called A Good Thing, which will offer everyday, sustainable products designed for the masses and made from a new biodegradable plastic.

Most recently, MOD's Singapore office block, 100PP, was a finalist at the 2015 World Architecture Festival. It is a building that perfectly captures the city's forward-looking, entrepreneurial spirit. Praised for its fresh vision of what a 21st-century creative workspace should be, it mixes gritty industrial and commercial spaces together in a layer cake structure. It is a futuristic *mille feuille* of light, glass, and texture that allows for balconies and air-conditioned ledges.

Long before the awards and the praise, there was a need for a name. Most designers simply use their own name for their firms. But

again, Colin Seah is not most designers. "We didn't name the practice after myself or a person because I didn't really want it to be about personality," he says. "We called the company Ministry of Design, mirroring a desire to serve others through a God-given design ability, and I am just a steward of it." Seah's modesty feeds into one of the key elements of his design style: relevance.

"Key to my work is a search for relevance—in terms of how our cultural norms and practices influence the way we interact and the spaces we need," he explains. "There is a need to question, to redress convention, to reinvent." With this approach, each of his projects primarily conveys a cultivated individuality rather than a signature MOD design stamp.

It is a refreshingly un-egotistical quality that can be seen across his work, whether it's an historic reinvention like the New Majestic Hotel, that draws on all layers of the structure's past; a statement commercial gallery such as the Vanke Triple V by the sea in Tianjin, China, with its striking sculptural wave form; a design-art piece like his lighter-than-air revision of the traditional Chinese bow-back chair called the Ming 647; a Singapore retail space that elevates Durasafe's premium safety gear and equipment to cult fashion status; or a "Commune" country retreat by the Great Wall of China in Ba Da Ling that reflects the owner's love of nature, light, and simplicity, while also balancing local culture and foreign influences.

Seah also recalls how his "final lesson" as a young architect came after recovering from a rigorous stint working at architecture practice OMA under Rem Koolhaas. He had just paid a visit to Peter Zumthor's striking Therme Vals spa in Switzerland, an experience that prompts him to say now, "It is

## SIDE NOTES

NAME *Colin Seah*

COMPANY NAME *Ministry of Design*

COMPANY HEADQUARTERS *Singapore*

NUMBER OF PEOPLE IN COMPANY *33*

WEBSITE *modonline.com*

SIGNATURE PROJECTS *Singapore: New Majestic Hotel; Leo Burnett office; Royal China restaurant; Prologue bookstore; Durasafe Gallery; 100PP office building; Zig Zag House Tianjin, China: Vanke Triple V Gallery Penang, Malaysia: Ecoworld Flow Gallery Products: The Measure of Reflection mirror*

## SIGNIFICANT AWARDS

2014 *Red Dot Design Award for Durasafe Gallery*

2013 *Gold Key Award for Macalister Mansion*

2012 *Architectural Record Good Design Award for SOHO San Li Tun*

2011 *World Architecture Festival/Inside Awards*

2010 *International Design Awards, Designer of the Year*

2008 *Gold Key Award for Royal China restaurant*

*Far more than a mirror, Seah's "Measure of Reflection" explores the essence of why we do things and the motivations behind those acts, be they hubris, vanity, or insecurity.*

almost prehistoric thanks to the tectonic quality of the stone, the rawness of water." It reminded him of the sensory value of the spaces that surround us. "We forget that relevance also needs to address certain needs and phenomenological desires that people have had for eons. We still feel temperature through our skin, we respond to surfaces and textures. Our distant relatives 2,000 years ago would still hurt when they stepped on something sharp, would still luxuriate when they felt something soft—and that doesn't change. That's also relevance."

It is the coming together of these two qualities—relevant reinvention combined with an almost theatrical sensory experience—that has driven MOD's work under Seah's direction.

This is perfectly embodied in the New Majestic, the hotel that launched his career. Situated in a traditional Singaporean shop house, Seah wanted to add a new-old twist to its preservation. "When we removed the ceiling boards in the lobby we discovered layers of paint representing each previous owner's intervention. For us it was beautiful, so we treated it as a work of art. It is a great way to represent the old rather than return it to a quasi-heritage state."

Seah is also interested in how hotel guests aren't just passive participants of the design drama that surrounds them. "A guest should also be impactive, an actor, a proponent," he explains. The New Majestic's aquarium rooms each have a glass-box bathroom

inspired by a time when the neighboring buildings were brothels. In these brothels patrons would view the women from behind a huge glass aquarium. When guests step into the glass box and turn on the hot water it steams up, transforming the transparency of room.

Seah believes that good hotel design isn't necessarily about the property needing to reflect something cultural about its place. "But it should definitely reflect something specific—is it the owner's quirk or is it an obsession the designer has? It could be many things but it should transform you and leave an indelible memory in your mind—or in your heart."

*Text: Fiona Harkin*

I

2

1 *Seah's lobby for the New Majestic Hotel, in Singapore, has won seven international design awards thanks to his alluring use of natural light, bold sculptures, and an industrial-meets-contemporary look.*

2 *For Singapore's Royal China restaurant, Seah blends both traditional and modern aesthetics, utilizing six-meter vaulted ceilings and a large mirror to emphasize a strong visual axis, which further showcases furniture he also designed.*

3 *The stunning 100PP Office Building, in Singapore, intentionally blurs the definition of the structure's exterior elements (windows, balconies, air-condition ledges) with a series of horizontal stripes throughout the façade that emphasize the shifting and stacked nature of the different volumes.*

4 *The Vanke Triple V Gallery, in Tianjin, China, commands attention through its arresting triangular concept and contrasting exterior materials of Corten steel cladding and glass.*

3

4

5 *The 2010 Interior Design of the Year award went to Seah for the Leo Burnett office in Singapore, which presents bespoke desks, milky white mirrored resin flooring, and a giant graffiti-style mural of Leo.*

5

# New Majestic Hotel

It has a certain glamour, this revamped historic hotel on a China-town street once notorious for housing wealthy men's mistresses. The shophouse façade blends perfectly with the neighborhood, but inside, the juxtaposition of antique and modern, interior and exterior, provides a theatrical environment where guests can indulge their imaginations. The 30 guestrooms are individually crafted visions by a diverse group of creatives enlisted by Colin Seah of Ministry of Design. His core crew came up with four room "typologies." In the Hanging Bed Rooms, larger-than-life murals span whole walls, and the Attic Suites' vintage twin tubs look up on a loft-area sleeping space that appears to float. A glass-encased bathtub is placed center stage in the Aquarium Room. In the hotel's restaurant, ceiling portholes open onto the floor of the outdoor pool, with swimmers casting shadows onto the tables below. The high-ceiling lobby provides a grand space to make an entrance, and vintage chairs from owner Loh Lik Peng's personal collection can be rearranged to suit any drama. The sensuously curved white staircase seems to invite a line of chorus girls, like something from a classic Hollywood musical. Majestic, indeed.

Loh Lik Peng's global lifestyle draws him to different places for different reasons. The intimate scale of Dublin reminds him of his childhood, while London's East End is all about the energetic vibe and the sense that new things are happening all the time. He opened his first venture, Hotel 1929, in a former brothel in Singapore's red-light district in 2003. With its swanky design and instant buzz, 1929 became a popular destination for travelers and locals alike. Three years later, he opened the New Majestic and upped the style quotient in Singaporean hospitality even further. Three more properties followed (another in Singapore where he now lives, and one each in Shanghai and London). And not one of them is located in what your average guidebook would have considered the "right" kind of neighborhood—that is until his properties have put their once-undesirable districts on the style map. —

| | |
|---|---|
| WHERE | ROOMS |
| Singapore | 30 |
| MEMBER SINCE | RATES |
| 10/2009 | SGD 400–800 |
| ARCHITECTURE | MEET THE ORIGINAL |
| DP Architects | Loh Lik Peng |
| DESIGN | |
| Colin Seah | |
| (Ministry of Design) | |

# Wanderlust

Combining a sense of artistic whimsy with cutting-edge design, Wanderlust was created with adventurous travelers in mind. Hotel owner Loh Lik Peng, a local hero after the success of his New Majestic Hotel, gave four different design firms one floor each to create their own interpretation of contemporary style and comfort. Designed by Asylum, the lobby has a glam industrial vibe, and the hotel's casual French restaurant, Cocotte, has proved to be an instant hit with the locals. Upstairs, the 29 guestrooms run the gamut from vivid candy colors (Phunk Studio) and arty black-and-white minimalism (DP Architects) to one-of-a-kind duplex apartments (fFurious), guaranteed to give guests sweet dreams. Set in a historic 1920s building, the beautiful Art Nouveau mosaic on Wanderlust's façade hints at the cheeky patchwork of 21st-century design it now houses. The hotel's location in the city's colorful Little India neighborhood is the first hint that Loh Lik Peng, a lawyer-turned-hotelier, is committed to showing guests a livelier side of Singapore beyond the buttoned-up business and shopping districts.

Loh Lik Peng's global lifestyle draws him to different places for different reasons. The intimate scale of Dublin reminds him of his childhood, while London's East End is all about the energetic vibe and the sense that new things are happening all the time. He opened his first venture, Hotel 1929, in a former brothel in Singapore's red-light district in 2003. With its swanky design and instant buzz, 1929 became a popular destination for travelers and locals alike. Three years later, he opened the New Majestic and upped the style quotient in Singaporean hospitality even further. Three more properties followed (another in Singapore where he now lives, and one each in Shanghai and London). And not one of them is located in what your average guidebook would have considered the "right" kind of neighborhood—that is until his properties have put their once-undesirable districts on the style map. —

| | |
|---|---|
| WHERE | ROOMS |
| Singapore | 29 |
| MEMBER SINCE | RATES |
| 10/2009 | SGD 300–650 |
| ARCHITECTURE | MEET THE ORIGINAL |
| DP Architects | Loh Lik Peng |
| DESIGN | |
| Asylum, DP Architects, fFurious, Phunk Studio | |

# Luna2 Private Hotel

**WHERE**
Bali
Indonesia

**MEMBER SINCE**
10/2008

**ARCHITECTURE**
David Wahl
(Wahl Architects)

**DESIGN**
Melanie Hall

**ROOMS**
5

**RATES**
USD 3,000–4,000

**MEET THE ORIGINAL**
Melanie Hall

Named after the first spacecraft to land on the moon in the late 1950's, Luna2 Private Hotel is making waves in Bali with its retro-modernist design. In contrast to the ubiquitous modern Bali style found on fashionable Seminyak's prime beachfront, this exclusive-use five-bedroom private hotel boasts the superstar service of an exclusive hotel with the intimacy of a private home. Architecturally, its somewhat South Beach simplicity provides the ideal backdrop for founder and designer Melanie Hall's signature "funked-up

modernist" design, which references the great modernism of the past, fuelled with the innovation of the future and a sense of fun. It is the ultimate destination for discerning, design-conscious world travelers in Bali. —

# Luna2 Studiotel

**WHERE**
Bali
Indonesia

**MEMBER SINCE**
10/2011

**ARCHITECTURE /
DESIGN**
Melanie Hall

**ROOMS**
14

**RATES**
USD 350–600

**MEET THE ORIGINAL**
Melanie Hall

Luna2 Studiotel is located in fashionable Seminyak, and is adjacent to the neighboring beachfront Luna2 Private Hotel. Luna2 founder and designer Melanie Hall's design ethos is to "respect the past, welcome the future, and have fun in the process!" As such, this "studiotel" boasts 14 open-plan studios, and elements of nostalgia, futurism, and fun permeate throughout every aspect of the interiors. The simple, somewhat modernist architecture, with its "bubble-icious" Panton-esque façade, offers a glimpse of what to expect inside. Playfully colorful, the palette of primary blues, reds, yellows, and greens was inspired by classics such as Mondrian, Lego, Monopoly, and Rubik's Cube. Award-winning Orbit restaurant features signature Lunafood and leads outside to the Mondrian-inspired poolside—the ultimate escape. Descend underground to the Pop! lounge bar and to the Lunaplex 16-seat cinema beyond; ascend up to the Space champagne and caviar rooftop bar for cocktails with panoramic ocean views. —

WHERE
Bali
Indonesia

MEMBER SINCE
10/2009

ARCHITECTURE /
DESIGN
SCDA Architects

VILLAS
48

RATES
USD 650–10,000

MEET THE ORIGINAL
Mark Edleson

# Alila Villas Soori

Gracefully planted on Bali's southwestern coast just a few kilometers from the island's renowned Tanah Lot temple, the idyllic Alila Villas Soori lies on a gentle slope between lush, green rice terraces and a soft, volcanic-sand beach on the azure Indian Ocean. Managed by Alila Hotels and Resorts, Asia's leading boutique hotel management enterprise, the Alila Villas Soori offers 48 exquisitely designed villas, ranging in capacity from one to ten bedrooms. Each villa offers the epitome of relaxed luxury and unadulterated privacy. Designed by Singapore-based SCDA Architects, Alila Villas Soori integrates elements of its surrounding natural environment in an elegant expression of contemporary Asian design that is in perfect harmony with Alila's commitment to environmental sustainability. Guests further experience the balance between tranquility and vitality at Alila Villas Soori by exploring Bali's rich heritage with a trek or a cycling trip, a round of golf on the Greg Norman-designed course, or an afternoon of indulgence at Spa Alila, the zenith of this secluded sanctuary.

Mark Edleson believes in offering his customers the same luxury, beauty, and earthy aesthetic that he enjoys in his own life. A graduate of Stanford University and formerly a Vice President of Citibank, Edleson is a founder of the Nusa Pacific Group that owns several well-regarded upscale hotel properties in Indonesia. Edleson is also a founding partner of Mandara Spa Asia, the leading global operator of resort spas. With over thirty years in finance, real estate development, and the leisure industry in Southeast Asia, Edleson is the driving force behind Alila's green initiatives and community involvement projects, while presiding over Alila's new developments and corporate strategy. His latest initiative is to co-found the Bali Institute for Sustainable Agriculture (BISA) to raise the living standards of Bali's farmers which will have the further effect of preserving the Balinese agrarian based culture and landscape. —

More from Alila Hotels & Resorts:

INDIA
Goa, Alila Diwa Goa → P. 415

INDONESIA
Bali, Alila Manggis → P. 458
Bali, Alila Seminyak → P. 449
Bali, Alila Ubud → P. 454
Bali, Alila Villas Uluwatu → P. 450
Jakarta, Alila Jakarta → P. 459

OMAN
Jabal Akhdar, Alila Jabal Akhdar → P. 406

# The Elysian Boutique Villa Hotel

Part of a growing wave of condominium hotels, The Elysian Boutique Villa Hotel on Bali provides an island ambience that caters to short- and long-term guests. Located 200 meters from Bali's beaches, the hotel consists of 27 private villas, each with its own pool. The look of The Elysian is "modern Asian," a combination of traditional proportions with contemporary ambient twists: An open pavilion surrounded by water welcomes guests, and a 25-meter pool runs the length of the terrace, ending in a trellised waterfall and Balinese temple. Stepped pathways meander between tall wispy grasses and groves of banana and traveler's palms. A sense of openness abounds—walled gardens abut oversize wood-framed sliding windows and doors, creating a fluid and changeable space. Extensive use of teak and local stone and marble provides a luxurious variety of textures. But the pleasure is not limited to the indoors: That beach is calling, and the poolside Rush Bamboo Restaurant and Bar offers cool, comfortable dining, drinking, and snoozing possibilities. —

**WHERE**
Bali
Indonesia

**MEMBER SINCE**
01/2006

**ARCHITECTURE / DESIGN**
Brian Quirk (Quirk & Associates)

**VILLAS**
27

**RATES**
USD 385–900

**MEET THE ORIGINAL**
Henry Brett

# Alila Seminyak

Sanskrit for "surprise," Alila lives up to its reputation with a new property sited on a rare, undeveloped strip of beach on Bali's west coast. Comprising 240 ocean or garden facing rooms and suites—that surround a public area containing four swimming pools—and one three-bedroom penthouse that comes complete with its own private sundeck and pool, the tropical retreat is a blissful escape from Seminyak's urban bustle. Shrouded by vertical greens and leafy shrubs, the resort blends seamlessly into its surroundings, anticipating an oasis of calm that continues within. Among the facilities are a terrace restaurant, beach bar, gym, and Spa Alila that features a menu with Asian-inspired therapies. —

| | |
|---|---|
| **WHERE**<br>Bali<br>Indonesia | **ROOMS**<br>240 |
| **MEMBER SINCE**<br>12/2013 | **RATES**<br>USD 250–5,000 |
| **ARCHITECTURE /**<br>**DESIGN**<br>Gaurang Khemka<br>(URBNarc) | **MEET THE ORIGINAL**<br>Mark Edleson |

# Alila Villas Uluwatu

The Alila Villas Uluwatu is the first resort in Bali designed from the ground up to achieve EarthCheck certification, the highest level of Environmentally Sustainable Design (ESD) certification. Its leitmotif is harmony with nature, expressed in everything from the locally sourced building materials to the seamless transitions between indoor and out. The dramatic tropical landscape of Bali's Bukit Peninsula served as both foundation and inspiration. Atop a 100-meter cliff, the 65 luxuriously spacious villas are thus open to the outdoors, offering Indian Ocean views from bed to bathtub. Each villa is equipped with private pool, cabana, garden, and pavilion, and is executed in a contemporary design softened by traditional Balinese touches. Thanks to the resort's attention to water conservation, recycling, and energy-saving, guests can relax in guiltless bliss in the knowledge that their ecological footprint is being kept at a minimum. At the same time, they can enjoy all of the services and amenities inherent to a five-star resort. The Alila Villas Uluwatu proves that celebrating nature doesn't mean forsaking comfort.

Mark Edleson believes in offering his customers the same luxury, beauty, and earthy aesthetic that he enjoys in his own life. A graduate of Stanford University and formerly a Vice President of Citibank, Edleson is a founder of the Nusa Pacific Group that owns several well-regarded upscale hotel properties in Indonesia. Edleson is also a founding partner of Mandara Spa Asia, the leading global operator of resort spas. With over thirty years in finance, real estate development, and the leisure industry in Southeast Asia, Edleson is the driving force behind Alila's green initiatives and community involvement projects, while presiding over Alila's new developments and corporate strategy. His latest initiative is to co-found the Bali Institute for Sustainable Agriculture (BISA) to raise the living standards of Bali's farmers which will have the further effect of preserving the Balinese agrarian based culture and landscape. —

More from Alila Hotels & Resorts:

INDIA
Goa, Alila Diwa Goa → P. 415

INDONESIA
Bali, Alila Manggis → P. 458
Bali, Alila Seminyak → P. 449
Bali, Alila Ubud → P. 454
Bali, Alila Villas Soori → P. 446
Jakarta, Alila Jakarta → P. 459

OMAN
Jabal Akhdar, Alila Jabal Akhdar → P. 406

WHERE
Bali
Indonesia

MEMBER SINCE
09/2008

ARCHITECTURE / DESIGN
Richard Hassell,
Wong Mun Summ
(WOHA)

VILLAS
65

RATES
USD 885–4,710

MEET THE ORIGINAL
Mark Edleson

Mark Edleson

*Alila Villas Uluwatu*
*Bali, Indonesia*

WHERE
Bali
Indonesia

MEMBER SINCE
09/1999

ARCHITECTURE /
DESIGN
Kerry Hill
Architects

ROOMS
56

VILLAS
12

ROOM RATES
USD 220–310

VILLA RATES
USD 390–525

MEET THE ORIGINAL
Mark Edleson

# Alila Ubud

Mark Edleson understands the true meaning of travel. It is not just about bringing yourself to a new place, but about experiencing that place—and thus yourself—in a new way.

A native Californian who succumbed to the allure of Asia at a young age, Edleson is all about immersing guests into the region's most beautiful and hidden pockets. But even more, his properties serve as a gateway to authentic local experiences. Therefore, it is not uncommon for his guests to return to the local villages where members of his hotel staff live, so that they can understand, and even partake in, the cultural life of local residents.

Certainly, few places are as hidden, beautiful, and culturally enticing as Alila Ubud. Exquisitely situated on a secluded hillside in Bali's picturesque Ayung River valley, the 68-room property features one of the world's most spectacular infinity pools, with edges that seem to disappear into a terraced jungle hillside. For ultimate exclusivity, architect Kerry Hill developed eight Balinese villas here, each perched dramatically on stilts and featuring spacious wooden decks or large ponds and private gardens.

Guestrooms at Alila Ubud dot the landscape in a manner akin to the setting of a Balinese village, complete with a village center from which mini piazzas blossom out. Indeed, both the guestrooms and private outdoor space at Alila Ubud—expressions of understated luxury made from the finest natural, local materials—are designed to maximize wind flow and lure one's gaze out onto the verdant green of the valley below.

And it's that exquisite and secluded setting that makes Alila Ubud such a spectacular retreat, one where guests can experience the extravagance of profound peace and quiet. Not surprising, the property's architectural details effortlessly mix with natural elements. Straw roofs sit atop smooth plaster walls, while terracotta tiles blend into gravel and crushed rock, clearly delineating where the modern world ends and the traditional Balinese building begins.

And then there's that pool everyone is always talking about. An award winner, it spreads out to form an elongated rectangle until its edges seem to disappear into the jungle. The theme of water vanishing into green is also captured by the resort's locale—guests can hear the flowing waters of the nearby river as they admire a backdrop of volcanoes. As such, though it's located only five kilometers from Ubud, Bali's cultural center, guests might find it difficult to leave the Alila Ubud for even a moment.

But leaving is what travel is all about. Throughout Alila Ubud—indeed, across all the Alila properties—the theme of merging with the environment and becoming one with the surrounding culture persists. Perhaps this is why preservation is so important to Mark Edleson. The hotelier understands that his luxury hideaways are about more than just a place to relax. They are home to people whose way of life is steeped in wisdom and tradition, and should be preserved. He captures the sentiment perfectly: "From my first visit to the present day, what most attracts me is the link that Asia embraces between its rich, colorful past and the future." It's a past and future that is very much alive and celebrated at Alila Ubud. —

More from Alila Hotels & Resorts:

# Alila Manggis

With its breathtaking location between the sea and eastern Bali's sacred Mount Agung, Alila Manggis seduces guests with a free-flowing interaction between the buildings and their surrounding natural environment. The traditional thatched roof covering the lobby is beautifully offset by floors of polished ivory-colored concrete. This immediately sets the stage for the quiet luxury that permeates the property. A latticework screen of diagonally laid stones—a trademark of Kerry Hill Architects' work for the Alila group—is set upon either end of the lobby. Four two-story buildings of cool white stone, sensously lit after nightfall in beams of warm orange, contain guestrooms offering sea views that both soothe and inspire the soul. All of the rooms, and the two luxury suites, are set to face the open blue sea. A golden glow of lights shimmering against the pool's cool turquoise presents an enticing visual dialogue. Each guestroom building is both an exercise in contrasting mass and lightness and a skillful study of Balinese architecture. Guests are served a range of local flavors in interiors influenced by the colors of the nearby Bali Aga valley villages: comforting shades of cream, sand, and chocolate emphasize the warmth of handwoven textiles and indigenous woods. The resort's leisure concierge can also connect guests with local life by organizing private tours of the stunning surroundings or even deep-sea fishing. No matter what visitors choose to do, they can always bask in the understated sense of luxury that enhances this Balinese getaway's peace and serenity. —

WHERE
Bali
Indonesia

MEMBER SINCE
08/2002

ARCHITECTURE /
DESIGN
Kerry Hill
Architects

ROOMS
55

RATES
USD 180–410

MEET THE ORIGINAL
Mark Edleson

# Alila Jakarta

Rather than reflect the energy of the streets in the central Jakarta business district where it is located, Alila Jakarta goes for a minimalist design that seeks to shield its guests from the outside. Renowned architecture firm Denton Corker Marshall has set new hotel design standards with the Alila Jakarta, using local materials in their contemporary interiors to pleasing effect.

WHERE
Jakarta
Indonesia

MEMBER SINCE
03/2001

ARCHITECTURE /
DESIGN
Denton Corker
Marshall

ROOMS
246

RATES
USD 88–375

MEET THE ORIGINAL
Mark Edleson

# Mira Moon

Hong Kong's Mira Moon was conceived under the creative direction of Wanders & Yoo and overseen by businessman Martin Lee. Characters from China's Moon Festival mythology are artistically reinterpreted throughout the 91 rooms, while also reflecting the surrounding neighborhood's colorful nightlife. Guests can enjoy Spanish delicacies at Supergiant Tapas and Cocktail Bar or wind down at the alfresco Secret Garden.

WHERE
Hong Kong

MEMBER SINCE
08/2012

ARCHITECTURE
AB Concept,
Dennis Lau,
Ng Chun Man
Architects &
Engineers Ltd.

DESIGN
Marcel Wanders
(Wanders & Yoo)

ROOMS
91

RATES
HKD 1,600–12,000

MEET THE ORIGINAL
Martin Lee

# The Mira Hong Kong

Overlooking orchid-scented Kowloon Park in central Tsim Sha Tsui, one of Hong Kong's boutique-lined shopping districts, The Mira Hong Kong is an innovative urban retreat that inspires guests with polished glass panes and groundbreaking tech-friendly features. From the results-oriented, uber-pampering of its award-winning 21st century spa to the mirrored walls of its crisp contemporary bedrooms, The Mira Hong Kong has been designed as a sanctuary for inner-city reflection. The curving white fins of the lobby's vaulted ceiling create a sphere of open space, while jade-green stalks of bamboo add soothing natural textures to the private cabanas at Vibes bar, a sensational oasis in the courtyard that comes to life after dark. And although the landscape changes from floor to floor, personalized service remains a constant theme. Nowhere is this more visible than at Whisk, where diners are tempted by contemporary Western cuisine revolving around quality meats, fish, and eclectic wines served in a relaxed setting. The Mira Hong Kong's 492 rooms are dressed in shades of red, green, silver, or purple, encouraging you to creatively select a color that suits your mood. Each space is complemented by

functional furnishings like Arne Jacobsen's modernist Egg chair. Bose iPod docks create warm, resonant soundscapes that bounce off the translucent bathroom walls, while tropical-strength rain showers provide solace from the heat of Hong Kong's vibrant, neon-lit streets.

Martin Lee is all about creating a cultural context for the so-called new wave of China that is influencing the world. He is the vice-chairman of Henderson Land and the CEO of Miramar Hotel and Investment Company, as well as a director of The Hong Kong and China Gas Company. In 2009, he turned the timeworn Hotel Miramar into The Mira Hong Kong, a lustrous urban sanctuary. Lee brought in celebrity lifestyle guru Colin Cowie and spent $65 million renovating the 16-floor property. His latest endeavor is the Mira Moon, the most vibrant hotel in Hong Kong's pulsing Wan Chai, which draws inspiration from the vivacity of China's Moon Festival fairytale. With his sleek and chic hotels, the iconoclastic Martin Lee is infusing the Asian financial capital with his finely honed sense of style and sophistication. —

Martin Lee

| WHERE | ROOMS |
|---|---|
| Hong Kong | 492 |
| **MEMBER SINCE** | **RATES** |
| 08/2010 | HKD 3,300–48,000 |
| **ARCHITECTURE** | **MEET THE ORIGINAL** |
| Andrew Choy (Atelier C+), Edmond Wong (Designcorp) | Martin Lee |
| **DESIGN** | |
| Charles Allem (CAD International), Colin Cowie | |

# Ovolo Southside

Hong Kong's first warehouse-turned-hotel, Ovolo Southside is something you might expect to find more in New York's Meatpacking District than in Wong Chuk Hang. The hotel references the area's industrial past in its design, as seen in the exposed concrete and brick façade, and the utilitarian design of its Lo Lounge. Graffiti and art installations spread throughout the hotel's public spaces are a striking mix of local and international artists. Retaining the building's raw industrial character, the interiors have been conceived as a utilitarian loft environment with high plaster ceilings and industrial grilles. Each room includes mid-century-inspired steel furniture and heavy-duty fixtures and fittings accented by poured concrete walls, exposed piping and brickwork, and tactile flooring of burnished wood. Be it the art, the original design, or the buzzing restaurant and lounges, Ovolo Southside is the perfect springboard from which to explore this emerging cultural hub.

What can being a bonsai tree caretaker teach you about leading a business? In Girish Jhunjhnuwala's case, it enables you to direct your company (Ovolo) with a god-like patience for detail. Having strayed from the family watch business, Jhunjhnuwala ventured into property development in 2001. Inspired by boutique hotels in London and New York, he has since successfully opened seven hotels and serviced apartments in Hong Kong and one in Melbourne. His hard work has earned him the DHL/SCMP Hong Kong Business Award of Owner-Operator in 2012. The Hong Kong native is also an avid golfer, wine aficionado, and dedicated family man. —

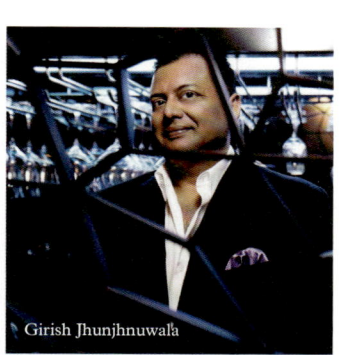

Girish Jhunjhnuwala

| | |
|---|---|
| **WHERE** Hong Kong | **ROOMS** 162 |
| **MEMBER SINCE** 03/2015 | **RATES** HKD 1,150–5,200 |
| **ARCHITECTURE** Paul Kember (KplusK Associates) | **MEET THE ORIGINAL** Girish Jhunjhnuwala |
| **DESIGN** KplusK Associates | |

# The Waterhouse at South Bund

The Waterhouse at South Bund, located on the banks of Shanghai's Huangpu river, inexorably raises the city's boutique hotel stakes, leaving its competitors trailing hopelessly behind. Its 19 guestrooms, destination restaurant, rooftop bar, and enormous all-purpose event space produce an exhilarating atmosphere and breathe new life into the Shanghai market. Neri & Hu Design and Research Office entirely transformed the 1930s building but maintained the original facade. Lyndon Neri explains the design ethos for The Waterhouse: "This is a hotel that puts the emphasis on the traveler in search of some meaning, and not just the luxury component of living." A conceptual blending of the antique and the contemporary, The Waterhouse is a complex dissociation and amalgamation of interior and exterior as well as public and private spaces, leading to a unique and entirely new experience for guests and locals alike. With magnificent views of the Pudong skyline, where the city's quaint low-rise architectural heritage is still largely intact, The Waterhouse at South Bund prides itself on integrating into the traditional local environment while challenging its boundaries. It distinguishes itself absolutely in order to provide each guest with an unforgettable experience.

Loh Lik Peng's global lifestyle draws him to different places for different reasons. The intimate scale of Dublin reminds him of his childhood, while London's East End is all about the energetic vibe and the sense that new things are happening all the time. He opened his first venture, Hotel 1929, in a former brothel in Singapore's red-light district in 2003. With its swanky design and instant buzz, 1929 became a popular destination for travelers and locals alike. Three years later, he opened the New Majestic and upped the style quotient in Singaporean hospitality even further. More properties followed in Singapore where he now lives, and one each in Shanghai and London. And not one of them is located in what your average guidebook would have considered the "right" kind of neighborhood—that is until his properties have put their once-undesirable districts on the style map. —

## More from Unlisted Collection:

AUSTRALIA
Sydney, The Old Clare Hotel → P. 484

SINGAPORE
Singapore, New Majestic Hotel → P. 440
Singapore, Wanderlust → P. 442

UNITED KINGDOM
London, Town Hall Hotel & Apartments → P. 108

Loh Lik Peng

**WHERE**
Shanghai
China

**MEMBER SINCE**
10/2009

**ARCHITECTURE /
DESIGN**
Neri&Hu

**ROOMS**
19

**RATES**
CNY 1,380–4,000

**MEET THE ORIGINAL**
Loh Lik Peng

# The PuLi
# Hotel & Spa

China's first urban resort combines traditional Asian charm with elegant contemporary design, transporting guests from their everyday lives into a world of luxury. The PuLi Hotel & Spa blends the relaxation of a resort escape with the excitement of an urban hotel. The sensitive and intuitive team behind the hotel is Urban Resort Concepts, a guest-centric management company that promotes design integrity and understated elegance. Their unique pilot destination holds 229 spacious and stylish guest-rooms, which nod towards old-world Shanghai with cast bronze basins and dragon-scaled screens—every chair, light fixture, and table is inspired by local traditions of craftsmanship. Located in one of Shanghai's most beautiful and central areas overlooking the Jing-An Park, The PuLi is not only an aesthetic achievement—it offers a spa operated by celebrated Anantara Spa; delectable cuisine at Jing'An Restaurant; the Long Bar and Garden Terrace; private dining rooms; and different meeting venues including, on Level 26, a multifunctional space which can host exclusive and intimate events and gatherings for up to 150 guests. However, it is The PuLi's incredible service philosophy, one that advocates going the extra mile for every guest, that really distinguishes it as one of Shanghai's most luxurious hotels.

Markus Engel is the CEO of Urban Resort Concepts, an innately bespoke hotel brand headquartered in the metropolis of Shanghai. Before cofounding the company, the veteran hotelier worked in senior management positions for such acclaimed hotels as The Dorchester London, The Datai Langkawi, The Peninsula Hotels in Beijing and Chicago, and Oberoi Hotels & Resorts. With URC, Engel incorporates contemporary urban ingredients that exude a sense of understated elegance with state-of-the-art amenities and all of the soothing subtleties of a resort. It is Engel's goal to provide his guests with an unparalleled experience touched by the pure essence of luxury. —

WHERE
Shanghai
China

MEMBER SINCE
11/2009

ARCHITECTURE
Kume Sekkei

DESIGN
Layan Design
Group

ROOMS
229

RATES
CNY 3,950–30,800

MEET THE ORIGINAL
Markus Engel

# The Swatch Art Peace Hotel

For your hotel to have roots that connect it to among the oldest in Shanghai is saying something. After all, long before the Song and Yuan dynasties, this ancient city belonged to the Kingdom of Wu, which was conquered by the Kingdom of Yue, which in turn was conquered by the Kingdom of Chu. Ok, the Palace Hotel, that bygone establishment that now houses The Swatch Art Peace Hotel, only dates back to 1906, but it feels almost timeless thanks to the events of historic importance hosted here, such as the International Opium Commission in 1909 and the engagement of then-President Chiang Kai-shek to Soong Mei-ling.

Following a recent and ambitious two-year revamp, the new Swatch Art Peace Hotel embodies all the glamour of this spot's rich history with its russet-and-white Victorian Renaissance façade, wood-paneled lobby, and restored Jacobean staircase, while taking a giant leap into the contemporary. Various spaces cohabit the structure—gilt retail shops on the ground floor, five stories of artist residences and workshops, the hotel, a restaurant, and a multipurpose exhibition and gallery space.

Indeed, the bold new interiors at The Swatch Art Peace Hotel take the property's underlying art-focused motif and create masterpieces of their own, including silk screens splashed with watercolor characters. Besides the Swatch Group's Blancpain, Omega, and Swatch boutiques on street level, the building is home to 18 workshops and apartments for artists chosen by an esteemed panel that includes the likes of Nick Hayek and George Clooney. These international artists are provided with the right aesthetic environment to aid the creative process—a chic communal library, kitchen, lounges with marvelous views of the Bund, sunlit studios, and blonde-wood gallery spaces. In return, the artists leave behind a "trace" of their stay, mostly a piece of art for the hotel collection. Lastly, there's a top floor terrace with bar with stunning views of Shanghai's skyline.

Yet, even non-artists here will find The Swatch Art Peace Hotel to be a creative and inspiring place. The seven individually designed rooms and suites of the Swatch Group's only hotel reiterate the brand's commitment to creative pursuits. The interiors interplay the historic elements from its past with one-of-a-kind sculptural pieces of furniture. For example, in the 250-square-meter (2,690-square-feet) Happiness Suite, the bed is encased in a rattan half-birdcage, while traditional Chinese benches inspire the custom furniture in the sitting room. In the decadent Prosperity Suite, each of the four rooms has a distinct function underlined by a color. The bright yellow living room, for example, is a place of inspiration, and is complemented by the soft-toned oval sleeping area. The spaces here artfully mix traces of the hotel's past with its new incarnation—the living room is full of materials used to create the art that adorns the walls.

The Kingdom of Wu may be a distant, ancient memory in Shanghai, but visitors who lose themselves in the artistic wonders and inspired design of The Swatch Art Peace Hotel can be excused if they feel they've entered into a new era in history here: The Kingdom of Wow! —

WHERE
Shanghai
China

MEMBER SINCE
05/2015

DESIGN
Patrick Jouin

ROOMS
7

RATES
CNY 2,900–50,000

# Humble House Taipei

Located on the top floors of a "Diamond-rated Green Building" in the heart of Xinyi—The Taiwan Capital's vibrant shopping, commerce, and entertainment district—the 235-room Humble House Taipei merges design, green living, and art into one breathtaking property overlooking the city's rooftops. With crisp lines and warm tones, the space boasts floor-to-ceiling windows to maximize natural light. The glass and aluminum façade of Humble House Taipei stands out from the crowd due to its height, which at 24 floors towers over the neighboring buildings, and also because of its unusual windows. Thanks to their shape and blue-gray shimmer, the windows resemble diamonds when seen from a distance. Deceptively simple in design, the architecture serves as a backdrop for over 600 exquisitely integrated works of art. Themed after Indian poet Rabindranath Tagore's sensual, naturalist trope, "Let life be beautiful like summer flowers," the vast collection of paintings, illustrations, installations, and sculptures selected and commissioned by acclaimed art curator Ellie Lai, creates a highly immersive visual experience. A highlight of this collection is the installation by Italian artist Paola Pivi in the restaurant. Titled "Crazy Ball," the piece masterfully combines miniature classical designer chairs and other items to dazzling effect. Each of the guestrooms feature frames from English artist Alexander James' arresting "Butterfly" series that captures these celestial creatures underwater. Guests can enjoy the allure of daily traditional tea ceremonies, relax with the healing power of scent and touch at the spa area, and savor refined cuisine at the gourmet Italian restaurant, La Farfalla. To top it off, Humble House Taipei boasts a rare inner-city perk: a lush sixth-floor garden, where guests can experience sprawling views while enjoying cocktails at The Terrace lounge.

Ellie Lai comfortably wears different creative hats. Formerly the principal flute of the Taiwan National Symphony Orchestra, Lai started taking on hotel interior design projects in 2002 to great appreciation. Her "modern Chinese" aesthetic won her many projects. In 2007, thanks to her love of contemporary art, the well-known flutist also became one of the most respected art curators in Taiwan. Her gallery, My Humble House, focuses on pushing contemporary Chinese artists around the world. With Humble House Taipei, Lai surprises yet again—the intimate yet impressively large collection, which she has been collecting since 2010, showcases works from Poland, Israel, Japan, Taiwan, and beyond. —

| | |
|---|---|
| **WHERE** | **ROOMS** |
| Taipei | 235 |
| Taiwan | |
| | **RATES** |
| **MEMBER SINCE** | TWD 12,000– |
| 10/2014 | 102,000 |
| **ARCHITECTURE** | **MEET THE ORIGINAL** |
| Kris Yao | Ellie Lai |
| (Kris Yao \| Artech) | |
| **DESIGN** | |
| Hirsch Bedner | |
| Associates | |

"I hope to change people's stereotype about art in hotels. I want the artwork I select to interact with the space, the design, and our hotel guests."

ELLIE LAI

# Glad Hotel Yeouido

**WHERE**
Seoul
South Korea

**MEMBER SINCE**
11/2014

**ARCHITECTURE**
Joh & Company,
Samoo Architects &
Engineers

**DESIGN**
Daehye Interior &
Architecture,
Joh & Company

**ROOMS**
319

**RATES**
KRW
240,000–700,000

**MEET THE ORIGINAL**
Suyong Joh

In the glimmering skyscraper-filled district of Yeouido, aptly nicknamed Seoul's Manhattan, Glad Hotel Yeouido is turning things on its head. The hotel's façade, with its unusual brick pattern, at once stands out from its neighbors' modernist glass buildings. Thanks to award-winning studio Joh & Company's singular vision, a local type of brick was used as the dominant structural material, giving the property the warmth and soul of a traditional South Korean home. The Brutalist interiors are rendered light thanks to a playful use of the material, giving depth and texture to the public spaces. Brick has also been wittily used in the hotel's interiors, with street signs playfully helping to guide guests to cozy rooms that feature posters quoting renowned thinkers about the hotel's "glad"

motif. Greets restaurant and café revels in natural materials and pure forms. A warm brown and bronze color scheme and cozy, high-backed sofas serve as backdrop to the fresh, seasonal dishes served here. The restaurant also features a daily, weekly, and monthly chef's live table, which is singular in the city. Bar Mark'T, inspired by Mark Twain, offers the city's most extensive and unique collection of Single Malt Whisky. Seoul's Yeouido island, meanwhile, feels like New York's Wall Street, complete with a Central Park-style green space bisecting the island from the north all the way to the south, and a see-it-to-believe-it Spring Cherry Blossom Festival. A trip to nearby Dongdaemun Market is to dive into the deep-end of Korean culture—lose your way at will. —

# Nest Hotel

The first Design Hotels™ property in South Korea, Nest Hotel is very much in keeping with its neighbor, the world's leading future city, Seoul. For starters, there is the hotel's location—the island of Yeongjongdo. Thanks to a slew of new development—from luxury resorts, cultural centers, golf courses, casinos, adventure parks, and malls, to Seoul's Incheon International Airport— Yeongjongdo is fast becoming Northeast Asia's cultural hub. Then there's the Nest Hotel's building itself: Not only is the 370-room structure a cubist-meets-modernist masterpiece, but it is cleverly designed to afford guests maximum views of pine trees, reed fields, and the calming Yellow Sea. Built as the ultimate retreat, the hotel is overflowing with services, including those you'd expect, such as a library, café, mini-theater, spa, and world-class dining, to the unexpected, such as glamping (glamorous camping) facilities for nature lovers, biking courses through the reed fields, and adventure-minded watersports. —

| WHERE | ROOMS |
|-------|-------|
| Incheon | 370 |
| South Korea | |
| | RATES |
| MEMBER SINCE | KRW |
| 09/2014 | 330,000–2,000,000 |
| ARCHITECTURE | MEET THE ORIGINAL |
| Kunwon | Youngjae Kim |
| Architecture, | |
| Joh & Company | |
| DESIGN | |
| Daehye Interior & | |
| Architecture, | |
| Joh & Company | |

# Park Hotel Tokyo

WHERE
Tokyo
Japan

MEMBER SINCE
09/2002

ARCHITECTURE
Frédéric Thomas
(Dé-Signe)

DESIGN
Dé-Signe

ROOMS
273

RATES
JPY
24,000–120,000

MEET THE ORIGINAL
Frédéric Thomas

The sleek, triangular skyscraper that houses the Park Hotel Tokyo embraces downtown Tokyo's lively milieu without succumbing to its fast pace. Located in the Shiodome Media Tower, the Park is home to leading international media organizations and television companies. But the tower also offers an oasis of elegant living amid the area's bustle and flow. While all of the guestrooms face outside, the interiors, by French designer Frédéric Thomas, feature gently curved furniture, cloth-covered walls, and a soft, off-white color scheme to cushion guests from the city's distractions—just as custom-fitted pillows cushion necks, ensuring a good night's sleep. Those who want to explore the city have a smooth transition from

the hotel's sanctuary to the Waterfront Transit Station by way of low-level exits that lead directly to the heart of Tokyo. Inside the hotel, natural light enters through a ten-story atrium, its illumination of the space truly one of the business district's wonders. Equally attractive is the soothing haven of sunlit trees and greenery planted on the obsidian and teak lobby floor, which embodies Japan's cultural tradition of incorporating nature into even the most forward-thinking man-made marvels. The Park Hotel Tokyo also provides venues for creative events, in support of the "Creative Tokyo" initiative promoted by the Ministry of Economy, Trade and Industry to spread Japanese culture around the world. —

# The Gate Hotel Kaminarimon

The northeastern Tokyo neighborhood of Asakusa has seen centuries of creative change and growth, from its time as a center for Kabuki theater during the Edo Period (1603–1868) to its legacy as a Japanese entertainment hub in the 1900s. Now, directly adjacent to some of Tokyo's most important historic sites, a contemporary creative center emerges. The Gate Hotel Kaminarimon stands poised between the cultural heritage of one the city's oldest districts and luminous modern-day Tokyo. Step out of the elevator and into the thirteenth-floor lobby, with its minimal, modern furnishings and large marble reception desk, and you are treated to a gently curving panoramic view of the city below, as well as stunning views of the Tokyo Skytree—the highest free-standing broadcasting tower in the world at 634 meters. Across the street, the Kaminarimon Gate houses sculptures of Shinto deities and a four-meter-tall lantern. Guests can also take in Asakusa's cultural contrasts from the 14th-floor terrace, which is open 24 hours a day, or unwind with a drink in the hotel's sleek, atmospheric restaurant that offers a distinct take on casual French fusion cuisine. Comfort is key in the Gate Hotel's 137 rooms and suites, each of which feature a spacious bed, textile designs by Marimekko designer Masaru Suzuki, and original artwork by the painter Katsuhiko Hibino. —

WHERE
Tokyo
Japan

MEMBER SINCE
08/2012

DESIGN
Shigeru Uchida
(Uchida Design
Studio)

ROOMS
137

RATES
JPY 16,170–95,865

MEET THE ORIGINAL
Shigeru Uchida

# Kimamaya Boutique Hotel

Kimamaya is the Japanese word for "be yourself," and here, you can do just that. Jazz music floats through the homey Living Lounge and all that's left to worry about is which wine you'll sip as you laze by the fireplace. The vintages served here come from a vineyard owned by the family of Nicolas Gontard, who renovated this nine-room retreat to help guests get closer to the beauty of Niseko, one of Japan's most popular ski resorts. But Kimamaya Boutique Hotel's mountain location has year-round appeal. In the summer and fall, pristine trails and mountain-biking tracks snake through the surrounding pine forests. Hokkaido star architect Koichi Ishiguro placed special attention on using sustainable, renewable, and recyclable materials, as well as the original wooden framework to retain the history of the building. The Swiss-chalet-style roof belies the Zen purity that awaits inside, with clean lines and a warm palette of chocolate wood, rich elm floors, and black granite, created by interior designer Andrew Bell. In The Barn restaurant, inspired by traditional Hokkaido farm architecture, fresh produce is served with French flair and warm hospitality. Kimamaya Boutique Hotel proudly bears the Odin brand. Created by Nicolas Gontard and his Norwegian partners Bjorn and Chris Fjelddahl, the brand is dedicated to developing real estate and creating hospitality experiences that encompass "intelligent luxury." But more than anything, Odin endeavors to create more of one of the most elusive currencies on earth: time.

Kimamaya Boutique Hotel by Odin is the product of Frenchman Nicolas Gontard's vision and passion. After selling an Asia-based international telecommunications business in 2006, he instinctively felt it was too early to retire to his vineyards in Burgundy. Together with Norwegian business partners, he embarked on building a luxury brand of residential properties and hospitality products. One of them was Kimamaya Boutique Hotel and its associated dining venue, The Barn by Odin—which in many ways became the social heartbeat of the property. Gontard's passion for Niseko and his involvement in the community mean he is often seen sharing a beer and sushi with locals, jumping on a mountain bike to test-ride the surrounding trails, or sharing best-kept neighborhood secrets and insider knowledge with his guests. —

WHERE
Hirafu-Niseko
Japan

MEMBER SINCE
10/2011

ARCHITECTURE
Koichi Ishiguro
(Atelier BNK)

DESIGN
Andrew Bell
(Earth Home)

ROOMS
9

RATES
JPY 16,500–70,000

MEET THE ORIGINAL
Nicolas Gontard

# Oceania

HOTELS

## 5

COUNTRIES

**Australia** »

# QT Sydney

Preserving two of the city's most iconic buildings, QT Sydney is destined to become a new landmark by reviving a rich and colorful past of theater and retail. Set within the historic Gowings department store and heritage-listed State Theatre in the heart of Sydney's central business district, the surrounding area is brimming with culture, art, fashion, cuisine, and design, while still being within easy reach of sandy beaches. With stars from stage and screen having performed in the State Theatre over the past 80 years, and the classic retail of the Gowings department store, QT Sydney captures the intrigue and excitement of the past in an edgy, contemporary design style. The 200 guestrooms come in 12 different styles—most equipped with a signature oversize bathtub and shower and unique design pieces that reference the building's past. The lower levels have remained unchanged, but important historic fittings and fixtures—such as original stone cladding, gargoyles, façade detail, original timber floors, and retail showcases—which have been damaged or removed over decades, have been carefully restored. The restaurant Gowings Bar & Grill, late-night Gilt Lounge, and luxurious SpaQ attract Sydney's "it" crowd, particularly those in the fashion and entertainment industries. The lively lobby, linked to a café and wine bar, creates an exciting aroma and buzz from early morning with barista coffee to a late afternoon aperitivo.

Sydney's State Theatre and Gowings buildings lie in the heart of the city, in both geography and sentiment. Recognizing the responsibility that comes with redeveloping a site treasured by so many, David Seargeant embraced the global trend toward cutting-edge hotel design and created a cool, 21st-century destination that pays homage to its heritage. As the managing director of Amalgamated Holdings Limited, one of Australia's leading entertainment, tourism, hospitality, and leisure companies, he set out to restore key architectural and design features while introducing a contemporary aesthetic that is both provocative and theatrical. The result, QT Sydney, takes the essence and culture of the city and expresses it through a cleverly curated mix of art, design, and history. —

WHERE
Sydney
Australia

MEMBER SINCE
12/2011

ARCHITECTURE / DESIGN
Nic Graham
(Nic Graham +
Associates),
Indyk Architects

ROOMS
200

RATES
AUD 380–2,200

MEET THE ORIGINAL
David Seargeant

# The Old Clare Hotel

Visionary hotelier Loh Lik Peng has transformed any number of structures not normally associated with hotels into creative beacons in the hospitality industry. Anything from a brothel to a town hall to a building notorious for housing wealthy men's mistresses have all been given new life and a bold look by the man who once worked as a corporate lawyer.

So when the opportunity arose to get his hands on an iconic corner hotel alongside what had once been the old Carlton & United Breweries building in Sydney's upcoming neighborhood of Chippendale, Peng jumped at the chance. And his excitement at the time was palpable. "Chippendale is one of the most interesting neighborhoods in Sydney right now," he explained. "The Old Clare Hotel is really fun and stylish and unconventional. That's really what this district is about."

Today, The Old Clare is all those things and more. And to make all that happen, Peng did what both a smart lawyer and an original-thinking hotelier would do: He brought in an architectural team with an integral understanding of and connection to the community that would house his new hotel. Sydney-based Tonkin Zulaikha Greer Architects have always demonstrated an immense respect for, and knowledge of, their home city. Thus, they understand the value of context, the desire to both fit into an existing urban model and to define a new one at the same time. In short, it was the perfect philosophical foundation upon which to build The Old Clare Hotel.

As Tonkin Zulaikha Greer explains of its mission here, which they saw as both reclamation and reinvention, the hotel is an "unbuilding" of the original Clare. The sensitive restoration retains significant historical elements, while also adding a new "sleeve" to join two buildings together. The hotel's 62 rooms and suites, divided into heritage and contemporary loft styles, offer a luxurious, semi-industrial feel and play up a mix of soaring ceilings, vintage furniture, and bespoke designer joinery. Exposed brick, bare concrete, and reclaimed timber paneling interact with each other, showcasing the heritage aspects of the buildings.

All rooms at The Old Clare feature king-size beds with highest quality bedding and linen, curated minibar items, complimentary WiFi, HD-IPTV supporting wireless streaming, and IP telephony for complimentary phone calls. Yet as welcoming as the guestrooms are, they serve as a base from which one can experience arguably the best rooftop bar and pool in the city, as well as three unique restaurants, which include the inspired work of Michelin-starred chef Jason Atherton.

Indeed, as with other Peng properties, the food is a big highlight at The Old Clare. In fact, Loh seems to have the Midas touch when it comes to creating restaurants that capture the zeitgeist and ascendant cuisine in each city, be it rustic French in Singapore or seasonal British cuisine in East London.

"Luckily, it's something I've managed to get right for every property—at the time of each hotel inauguration, there is so much buzz about the food that it feels as if I've created a restaurant with a hotel attached," he says. Fortunately, that hotel is far more than an afterthought. "We incorporated a lot of the history of the building and the brewing history," says Peng. "So when you come here you see a lot of the old structure, the old bar—a lot of the old features. There's a little bit for everyone, whether you are young or old."

Little wonder, then, that The Old Clare Hotel has become yet another neighborhood-defining property. —

More from Unlisted Collection:

CHINA
Shanghai, The Waterhouse at South Bund → P. 464

SINGAPORE
Singapore, New Majestic Hotel → P. 440
Singapore, Wanderlust → P. 442

UNITED KINGDOM
London, Town Hall Hotel & Apartments → P. 108

WHERE
Sydney
Australia

MEMBER SINCE
09/2014

ARCHITECTURE
Tonkin Zulaikha
Greer Architects

DESIGN
Tonkin Zulaikha
Greer Architects,
Neri&Hu,
Matt Darwon

ROOMS
62

RATES
AUD 250–1,500

MEET THE ORIGINAL
Loh Lik Peng

"Chippendale is one of the most interesting neighborhoods in Sydney right now. The Old Clare Hotel is really fun and stylish and unconventional. That's really what this district is about."

LOH LIK PENG

# Hotel Hotel

As the capital of Australia, Canberra is the place where some of the country's largest cultural institutions are found and best exhibitions occur. The city is clustered around Lake Burley Griffin and surrounded by hills of native eucalyptus forests and diverse wildlife; hence its nickname—the bush capital. The NewActon precinct is Canberra's new cultural hub, the main place where business and culture travelers, art lovers, university students, and locals all mingle. One uniquely Australian hotel stands out in this distinctive destination: Hotel Hotel, a holistic concept from the Australia-based Molonglo Group, founded on fertile principles of sustainability, community, diversity, and lifestyle. The hotel is located on three levels of the Nishi residential building, a sustainable "vertical village" that contains within it facilities delivering the best of global cinema, independent book and pop-up stores, music, and local cafés and bars. An exquisite grand stair, handcrafted from re-used and salvaged timbers, leads visitors to a hotel foyer more reminiscent of a living room than a lobby. The hotel public spaces are fashioned from humble materials, in unexpected ways that celebrate creative imagination and encourage diverse and intimate social uses day and night. Bespoke furniture commissions, art, and collected objects feature in all of the Hotel Hotel spaces and rooms. Monumental land-art works by Danish artist Alfio Bonanno and New York–based Steven Siegel bind the Nishi architecture to its immediate physical location and greater aspirational landscapes. The 68 rooms offer a rich mix of spaces, clothed in the raw organic beauty of natural materials to suit every guest: from cozy to meandering, no two rooms are exactly alike. The overall result is a place where guests are brought into contact with art, nature, and each other.

Hotel Hotel is the brainchild of the codirectors of the Molonglo Group, Nectar and Johnathan Efkarpidis. The brothers pursue a collaborative approach to the development of new ideas that help support the global sustainability movement, local artists, designers, and small industry. Nectar has a mixture of arts and commerce degrees; Johnathan is a graduate in humanities and takes an obsessive interest in sustainability. Having lived in London for many years and still a global nomad of sorts, Nectar provides creative narrative direction with a rigor seldom seen in the property industry. Nishi is the hub that cities often lack; Hotel Hotel is the access point to this hub. —

WHERE
Canberra
Australia

MEMBER SINCE
11/2012

ARCHITECTURE
Fender Katsalidis
Architects,
Suppose Design
Office

DESIGN
Broached
Commissions,
Don Cameron,
March Studio,
Oculus

ROOMS
68

RATES
AUD 285–915

MEET THE ORIGINALS
Johnathan
Efkarpidis,
Nectar Efkarpidis

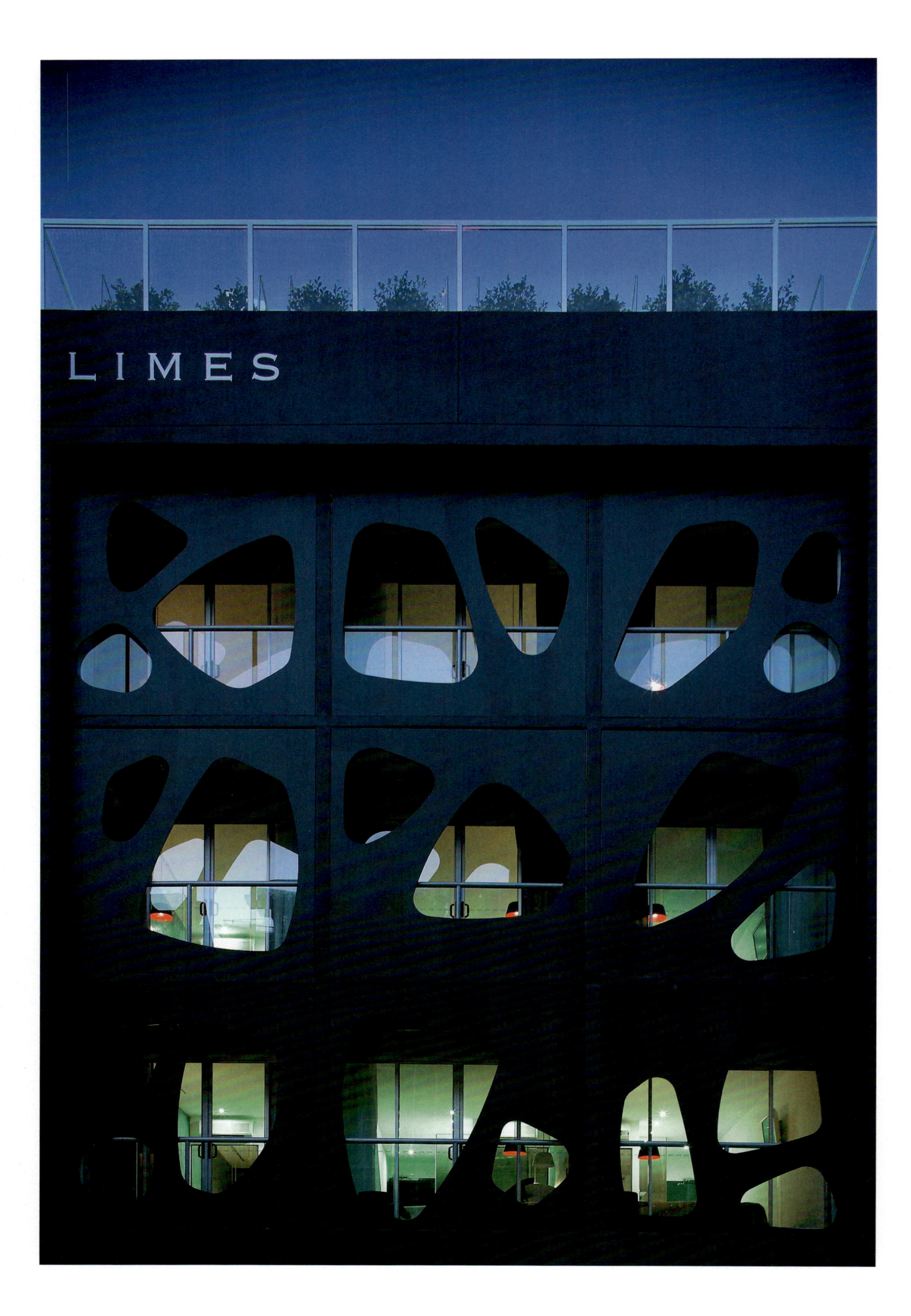

# Limes Hotel

Travel-savvy urbanites will appreciate the simple sophistication and contemporary energy at the Limes Hotel, in Fortitude Valley in the heart of Brisbane's nightlife and entertainment district. Award-winning Argentinean designer Alexander Lotersztain, a true global nomad, explains that he conceived the hotel as a holistic "design experience […] stripped of the associated design ideals of something unattainable. [I] shifted the design focus to make the guest feel special, yet not afraid of jumping into the bed like it was their own." His close attention to detail is reflected in all of the hotel's facets, from each of the cozy 21 rooms to the hip rooftop lounge bar and seasonal open-air cinema. Guests are welcomed with an iPod music system, wireless and broadband Internet, Appelles Apothecary toiletries, and the finest linens, not to mention a kitchenette and either balcony or courtyard. The eye-catching façade that reproduces the hotel's logo on a grand scale makes it a design statement as well as an urban landmark, while the hotel's sleek, modern interior with rich textures and finishings contributes to an intimate ambience unencumbered by excessive ornamentation.

Damian Griffiths is a dreamer. To most, an old run-down shack of a house is an eyesore, but for Griffiths, it was the site for a glorious feat of design—a 21-room boutique hotel where the beauty lies in the simple details. In 2008, the Australian entrepreneur opened the Limes Hotel, a world-class addition to Brisbane's landscape. Griffiths' love for hotels and big cities stems from his childhood growing up in the countryside of Queensland, and from inspiration he drew from cozy boutique hotels he visited in the tiny backstreets of Paris and Barcelona. Combining his entrepreneurial know-how with a background in the accommodation industry, Griffiths reached his dream destination in his own backyard. —

WHERE
Brisbane
Australia

MEMBER SINCE
01/2008

ARCHITECTURE
Kevin Hayes
Architects,
Tonic Design

DESIGN
Alexander
Lotersztain
(Derlot)

ROOMS
21

RATES
AUD 209–389

MEET THE ORIGINAL
Damian Griffiths

Dion Chandler & Fady Hachem

# Adelphi Hotel

The former queen of Melbourne's boutique hotel scene, the iconic Adelphi Hotel opened a new chapter on its 21st birthday in 2014 as the world's first "dessert-themed" hotel. Thanks to design guru Fady Hachem, the interiors feature rich, chocolate-toned furnishings, carpets patterned like cakes, "licorice allsorts" stools, and the smell of baking in the air. "The colors and textures of the hotel are all based on desserts," says Hachem. "But it's not weird. It's not too out there. It's very comfortable and done subtly." Originally constructed in 1938 as a warehouse for the rag trade, Adelphi's latest facelift retains the building's signature warehouse style with metal windows and a concrete façade. As the icing on the cake, the famed glass-bottomed rooftop pool that juts out two meters from the hotel's façade has been retained high above Flinders Lane, home to many of Melbourne's most popular restaurants, bars, cafés, shops, and theaters. But the sweet center of this dessert-themed tale is the hotel's signature Om Nom restaurant, which uniquely features desserts and cocktails as the highlights of the menu. French-trained patisserie chef Christy Tania, whose motto is "life is short, so eat dessert first," tempts and teases diners with decadent creations, such as the green tea gateau, pineapple verrine, and the mango and shiso profiteroles, as well as a multitude of small savory bites designed to share.

Hotelier Dion Chandler's fondest memories of traveling with his family as a child were the hotels they would stay in. It's no wonder that Chandler went on to explore the boutique hotel world, having stayed in over 70 hotels and guesthouses in Europe, and also having worked in high-end independent hotels. Together with business partners Ozzie Kheir and Simon Ongarato, and Fady Hachem, the founder of one of Australia's most progressive design studios, Chandler now has a unique product of his own—the iconic Adelphi. Hachem's innovative approach has not only won him a roster of prestigious clients but international accolades as well. When not undertaking a rigorous cross-disciplinary study of design, you can find Hachem hanging out with his two Pomeranians. —

WHERE
Melbourne
Australia

MEMBER SINCE
09/2014

ARCHITECTURE
John Denton
(Denton Corker
Marshall)

DESIGN
Fady Hachem

ROOMS
34

RATES
AUD 275–1,000

MEET THE ORIGINALS
Dion Chandler,
Fady Hachem

# Index

»

# W

# Z

»

# T

# V

# W

# Z

»

»

»

»

»

# Book Your Stay

It's your turn to make the transition from reader to traveler and become one of us. The Design Hotels™ Community is made up of people who, like you, crave luxury and uniqueness in all its forms. They are fans of bold artistic expression and that little something extra. For them, we offer first-looks at new hotels, special invitations to offers and events, great deals around the world and, of course, 24-hour dedicated assistance for all their travel needs (get in touch, see below). Join us online or on the phone—the Design Hotels™ Community is your ticket to a world of experiences: *designhotels.com / mycommunity*

## INTERNATIONAL TOLL FREE RESERVATIONS NUMBERS

### AMERICAS

ARGENTINA
00 800 37 46 83 57

BRAZIL
0021 800 37 46 83 57

CANADA
1 800 337 46 85

MEXICO
01 800 123 34 54

UNITED STATES
1 800 337 46 85

### AFRICA

SOUTH AFRICA
09 800 37 46 83 57

### ASIA-PACIFIC / OCEANIA

AUSTRALIA
0011 800 37 46 83 57

CHINA
40 01 20 60 71

HONG KONG
800 90 59 41

JAPAN
01 20 91 40 85

KOREA
001 800 37 46 83 57

NEW ZEALAND
00 800 37 46 83 57

SINGAPORE
001 800 37 46 83 57

TAIWAN
00 800 37 46 83 57

THAILAND
001 800 37 46 83 57

### EUROPE

AUSTRIA
00 800 37 46 83 57

BELGIUM
00 800 37 46 83 57

DENMARK
00 800 37 46 83 57

FINLAND
990 800 37 46 83 57

FRANCE
00 800 37 46 83 57

GERMANY
00 800 37 46 83 57

GREECE
00 800 49 12 90 54

HUNGARY
06 800 122 36

IRELAND
00 800 37 46 83 57

ITALY
00 800 37 46 83 57

NORWAY
00 800 37 46 83 57

PORTUGAL
00 800 37 46 83 57

RUSSIA
810 800 20 74 10 49

SPAIN
00 800 37 46 83 57

SWEDEN
00 800 37 46 83 57

SWITZERLAND
00 800 37 46 83 57

THE NETHERLANDS
00 800 37 46 83 57

TURKEY
00 800 491 37 46 83 57

UNITED KINGDOM
00 800 37 46 83 57

Terms and conditions apply

### FOR GENERAL INQUIRIES ABOUT DESIGN HOTELS™

Design Hotels AG
Corporate Headquarters
Stralauer Allee 2c
10245 Berlin / Germany

PHONE
+49 30 884 94 00 00

FAX
+49 30 257 698 96

E-MAIL
*reception@designhotels.com*

### GENERAL CONTACT DETAILS

RESERVATIONS
+49 30 884 94 00 40

WEBSITE
*www.designhotels.com*

E-MAIL
*res@designhotels.com*

GDS CODE
*DS*

Should your country not be listed, please use the general reservation number, but be aware that international call charges will apply.

PLEASE NOTE
The telephone numbers for the countries listed are for calls made within that country only.

Select Design Hotels™ properties are now available to book with Starwood Preferred Guest, the richest program for recognition and value in the hospitality industry. Earn, redeem, and enjoy SPG benefits with Design Hotels™ around the globe. To find out more and see our participating hotels, visit: *designhotels.com / original-experiences*

A PARTNER OF **spg**∗ Starwood Preferred Guest

# Imprint

## PUBLISHER

Design Hotels AG
Stralauer Allee 2c
10245 Berlin / Germany
*designhotels.com*

## FOUNDER & CEO

Claus Sendlinger

## VICE PRESIDENT BRAND, MARKETING & COMMUNICATIONS

Serdar Kutucu

## PROJECT MANAGERS

Laura Meier
Rebecca Milz-Bruland
Stefanie Sandl

## EDITORIAL PROJECT MANAGER

Ken Baron

## CREATIVE DIRECTOR

Johannes Schwark

## SENIOR ART DIRECTOR

Anne Prinz

## ART DIRECTORS

Claudia Collasch
Kathrin Kluckner
Vivian Nebelin

## ILLUSTRATOR

Hanni Pannier

## GRAPHIC DESIGNERS

Christine Daum
Julie Finkel
Lea Hinrichs

## COPY EDITOR

Tracey Kelliher

## CONTRIBUTING WRITERS

Ken Baron
Fiona Harkin
Vidula Kotian
Becky Sunshine
Nicole Swengley
Stephen Whitlock
Charly Wilder
Janelle Zara

## PROJECT COORDINATORS

Mathilde de Lame
Paul Radny
Charlotte Wiedemann

## CONTRIBUTING PHOTOGRAPHERS

Deniz Alaca
Nacho Alegre
Archivio fotografico Venini S.p.A.
Meritxell Arjalaguer
Artemide
Kate Ballis
Peter Boettcher
Claus Brechenmacher
Stephane Briolant
Simon Brown
Ulf Celander
Alessandra Chemollo
CI&A Photography
Courtesy India Mahdavi
Courtesy of Space Copenhagen
Andrea Ferrari
Ola Fogelström
Fotografie Schaulin
Klaus Frahm
Nicole Franzen
Freunde von Freunden
Johan Hellström
Steve Herud
Ana Hop
Rainer Hosch
Derek Hudson
Jacob Karström
Julien Lanoo
Yadid Levy
Åke E:son Lindman
Ministry of Design
Kerstin zu Pan
Undine Pröhl
Leo-Paul Ridet
Paolo Roversi
Carolin Saage
Matthieu Salvaing
Carsten Sander
Marc Schäfer
Milene Servelle
Michael Sinclair
Tord-Rickard Söderström
Wison Tungthunya
Vigilius Mountain Resort
Mario Webhofer
Wilmotte & Associes Architectes
Manuel Zublena

## IMAGE DATABASE MANAGER

Alina Soare-Rada

## DISTRIBUTION

Holger Müller

## PREPRESS & DATA SERVICES

Boris Brumnjak
Feyyaz Özdemir

## PRINTED IN GERMANY

Grafisches Centrum
Cuno GmbH & Co. KG
Gewerbering West 27
39240 Calbe (Saale) / Germany
*cunodruck.de*

## PAPER

FSCmix-Magno Volume
115 g/m²

## HARD COVER PRODUCTION

buks! GmbH
Wilhelmstraße 118
10963 Berlin / Germany
*buks-berlin.de*

## INTERNATIONAL DISTRIBUTION

gestalten, Berlin
gestalten.com
*sales@gestalten.com*